MW01034921

Unwatchable

Unwatchable

Edited by Nicholas Baer, Maggie Hennefeld, Laura Horak, and Gunnar Iversen

RUTGERS UNIVERSITY PRESS

New Brunswick, Camden, and Newark, New Jersey, and London

Library of Congress Cataloging-in-Publication Data

Names: Baer, Nicholas, 1985– editor of compilation. | Hennefeld, Maggie,
1984– editor of compilation. | Horak, Laura, editor of compilation. |
Iversen, Gunnar, 1959– editor of compilation.
Title: Unwatchable / edited by Nicholas Baer, Maggie Hennefeld,
Laura Horak, and Gunnar Iversen.
Description: New Brunswick : Rutgers University Press, 2019.
Identifiers: LCCN 2018009950| ISBN 9780813599595 (hardback) |
ISBN 9780813599588 (paperback)
Subjects: LCSH: Image (Philosophy) | Visual communication—Psychological
aspects. | Representation (Philosophy) | Visual perception—Philosophy. |
Mass media and the arts. | BISAC: PERFORMING ARTS / Television /
History & Criticism. | SOCIAL SCIENCE / Media Studies. |
ART / Criticism & Theory. | PERFORMING ARTS / Film & Video / History
& Criticism. | SOCIAL SCIENCE / Popular Culture. | ART / Film & Video.
Classification: LCC B105.I47 U59 2019 | DDC 153.32—dc23
LC record available at https://lccn.loc.gov/2018009950

A British Cataloging-in-Publication record for this book is available from
the British Library.

This collection copyright © 2019 by Rutgers, The State University of New Jersey
Individual chapters copyright © 2019 in the names of their authors
All rights reserved

No part of this book may be reproduced or utilized in any form or by any means,
electronic or mechanical, or by any information storage and retrieval system, without
written permission from the publisher. Please contact Rutgers University Press,
106 Somerset Street, New Brunswick, NJ 08901. The only exception to this prohibition
is "fair use" as defined by U.S. copyright law.

♾ The paper used in this publication meets the requirements of the American National
Standard for Information Sciences—Permanence of Paper for Printed Library Materials,
ANSI Z39.48-1992.

www.rutgersuniversitypress.org
Manufactured in the United States of America

CONTENTS

Unwatchable

Introduction

Envisioning the Unwatchable

NICHOLAS BAER, MAGGIE HENNEFELD, LAURA
HORAK, AND GUNNAR IVERSEN

In August 2017, the satirical newspaper the *Onion* published an article
titled "Most Americans Now Getting Their News While Peeking Out
between Fingers." Quoting a fictional research report, the article described
typical responses to current events among media consumers in the
United States: "Whether in print, online, or televised form, our research
indicates that 80 percent of Americans engage with news by cupping their
hands over their eyes and occasionally steeling themselves to glance at
the content before them."[1] When the news presents a ceaseless onslaught
of shocking headlines, sometimes staying informed necessitates braving
quick glances from between one's fingers, like moviegoers often do while
watching horror films.[2]

The *Onion*'s "fake news" story was aptly illustrated with the picture
of a man gaping reluctantly at his smartphone. Rather than "looking
awry" or with "downcast eyes,"[3] he uses his fingers as a makeshift frame
for narrowing the aperture, as if to form a protective shield against ret-
inal assault or partake in a childlike game of peekaboo. This act of cov-
ering one's eyes has become a representative gesture in our contemporary
media culture of proliferating screens and virally circulating images,
where potentially traumatic content is never more than a click, scroll,

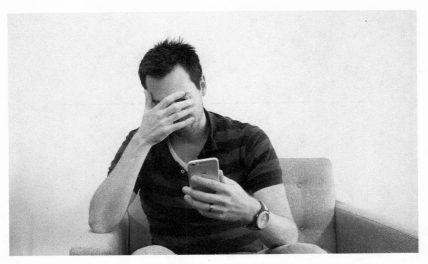

Used with permission granted by Onion, Inc., "The Onion" © 2018.

or swipe away. The *Onion*'s illustration suggests that if the smartphone has become the prosthetic extension of one of our hands, the other hand is used to maintain a visual filter.

The idea of filtering has acquired new meanings via the social media platforms that claim a central role in our daily lives and political discourse. In the *Onion* photo, the man's right hand might be seen as a placeholder for the digital algorithms and settings that track our habits and tailor our news feeds to our stated interests and assumed demographic preferences. Such media operations have come under scrutiny at a time when the Internet appears less as a new public sphere than as a medium of corporate profit, ideological manipulation, and partisan division.[4] For all its satirical bite, the *Onion* article notably elides the number of American news consumers who are untroubled by current headlines, or who receive different ones altogether.

It is a luxury to choose whether and how to confront the headlines that affect others firsthand, both in our own regions and across the globe. In *Regarding the Pain of Others* (2003), Susan Sontag cautioned against generalizing about contemporary viewing habits on the basis of "those zones in the well-off countries where people have the dubious privilege of being spectators, or of declining to be spectators, of other

people's pain."[5] For all too many people, war and terror are not sensational news stories but unresolved histories and lived experiences that can never be filtered at will. The horror of disbelief many of us feel when confronted by the current headlines may well signal a naïveté or complacent oblivion about entrenched realities.

Yet even the most horrific scenarios have served as enduring sources of fascination. Simply decrying the media's aestheticization of violence and suffering ignores the long traditions of religious iconography and artistic renderings that make spectacles of gruesome scenes, not to mention the industries of news, entertainment, and sports that entice viewers through titillating content. While many cultural critics fear the increasing habituation to images of brutal violence, others provide more hopeful perspectives. For philosopher Stanley Cavell, our ongoing capacity to feel revulsion at the horrors around us suggests that we haven't become fully inured or desensitized—that we may yet be able to change an often-uninhabitable world.[6]

Offering multidisciplinary approaches to the vast array of troubling images in our global media and political environment, this book posits the "unwatchable" as a concept that has gained currency in recent years, but that has also remained latent across the history of aesthetics. In what moments are we justified in covering our eyes, and when is it crucial to look intently upon the face of Medusa? If aesthetic judgment involves beholding an object, what kind of critical discourse is sparked by refusing one's gaze? Is the unwatchable that which exceeds traditional aesthetic frames, infringing on our reality? And what is the link between the unwatchable as an aesthetic category and the unwatchable as the possible basis for political transformation?

Countless phenomena can be deemed unwatchable, whether for ethical, political, or sensory and affective reasons. From news coverage of terror attacks to viral videos of police abuse, and from graphic horror films to incendiary artworks that provoke mass boycotts, many of the images in our media culture might strike us as unsuitable for viewing. Yet what does it mean to proclaim a media object "unwatchable": disturbing, revolting, poor, tedious, or literally inaccessible? And unwatchable to whom: an individual student requesting a trigger warning or an entire religious community that prohibits visual representations of

its prophet? A U.S. president who deems a satirical impersonation of himself on *Saturday Night Live* "unwatchable" or those who avoid his ubiquitous presence due to moral outrage and visceral disgust?[7] In our contemporary moment of shocking geopolitical developments and constant media stimulation, the concept of the unwatchable has become more urgent than ever to examine.

It is worth recounting some of the headlines that might have compelled American news consumers to cover their eyes in August 2017, when the *Onion* ran its satirical piece. On the very day the article appeared, a "Unite the Right" rally occurred in Charlottesville, Virginia, to protest the removal of a statue of Robert E. Lee. Galvanizing far-right groups (e.g., Klansmen, neo-Nazis) who propagated racist, anti-Muslim, and anti-Semitic banners and slogans, the event further escalated when a white supremacist rammed his car into a group of counterprotesters, causing one death and dozens of injuries. Responding to the events, President Donald Trump bafflingly condemned "hatred, bigotry, and violence on many sides."[8] This news story unfolded during an already tumultuous month across the globe, which included Brexit negotiations, ongoing crises and civil conflicts, terror attacks, the drowning of hundreds of refugees, devastating natural disasters, and rising nuclear threats between North Korea and the United States. Even if one wanted to be privy to the horrors of the world, what should one watch?

The accumulation of horrific, seemingly unimaginable developments in recent years has converged with a massive shift in our media environment. When Sontag wrote in 2003 that "nonstop imagery (television, streaming video, movies) is our surround,"[9] she could have hardly anticipated the changes effected by the smartphone and tablet along with platforms such as Facebook, YouTube, and Twitter. If daily life was once structured around the morning paper and the nightly news broadcast, it is now punctuated by relentless and unpredictable media alerts flashing from abundant devices. Digital culture has brought new levels of exposure to violent phenomena, which are documented firsthand and immediately circulated in intimate, uncensored detail. Observing these trends, one commentator has noted, "If J.F.K. were assassinated today, we wouldn't be poring over a single, grainy Zapruder film; we'd have scores of high-definition smartphone videos taken from all angles and thousands of eyewitness tweets."[10]

It is perhaps in response to heightened media competition that a new extremist cinema has emerged over the past two decades, one characterized by transgressive representations of graphic sex and brutal violence. These shock tactics are associated with auteurs such as Catherine Breillat, Michael Haneke, Gaspar Noé, and Lars von Trier, as well as with national or regional cinemas—whether "the New French Extremity,"[11] "the new-brutality film" of Hollywood,[12] or the East Asian horror films billed as "Asia Extreme."[13] As numerous critics and scholars have argued, such films challenge established genre designations along with the divides between high and low culture, art and popular entertainment. With their aggressive confrontation of viewers, they also probe cinematic ethics and compel a rethinking of theories of spectatorship and affective experience.[14]

Two approaches to "extreme" or "unwatchable" cinema are suggested by Asbjørn Grønstad and Mattias Frey, both of whom have contributed new essays to the present volume. In *Screening the Unwatchable: Spaces of Negation in Post-millennial Art Cinema* (2012), Grønstad examines the wave of films that render the act of viewing disturbing, painful, tedious, or otherwise problematic, thereby jolting spectators into critical and ethical awareness. Evoking the scene of eye mutilation in Luis Buñuel's *Un chien andalou* (1929), Grønstad argues that the "razorblade gestures" of these films should be seen as part of a tradition that extends back to modernism and early experimental cinema, which likewise sought to negate scopophilic pleasure.[15] Shifting focus from aesthetic and hermeneutic considerations to economic and institutional factors, Frey's *Extreme Cinema: The Transgressive Rhetoric of Today's Art Film Culture* (2016) offers a macro-study of controversial arthouse cinema on the basis of discourses around its production, distribution, and reception.[16]

While building on these studies, the current volume radically expands the conceptual parameters of the unwatchable. Rather than limiting the concept to twenty-first-century art cinema, we emphasize its broader import at a time when viewers encounter difficult content across a wide range of spaces and media forms—from cinema, television, and video games to museums and classrooms to laptops, smartphones, and social media platforms. Moreover, we stress the term's heuristic value in relation to the shocking and seemingly unfathomable political developments

of recent years, as the lines between fact and fiction, politics and media showmanship, reality and horror show have gradually dissolved.

In claiming the unwatchable as a critical term in our global media and political environment, this book raises a host of questions. Should one distinguish between weak and strong senses of the unwatchable—that is, between images that are merely difficult to behold and ones that are truly impossible to bear? Or between contextual and absolute definitions of the term, separating the content that particular individuals or groups find unwatchable from phenomena that breach the very physiological or metaphysical limits of vision? Is the unwatchable less a descriptive than a prescriptive claim, implying aesthetic, moral, or political judgment? What unique position does it assume in a conceptual force field that also includes the invisible, unseen, unimaginable, and sublime? And, finally, if "theory" (from the Greek *theoria*, which meant to behold or look attentively) implies a visual relationship between thinker and object, is theorizing the unwatchable itself a paradox or contradiction in terms?

This volume refrains from offering a single, unified definition of the unwatchable, allowing its essays to deploy the word in an exploratory and often conflicting manner. Thus, whereas Alenka Zupančič upholds the category of the "objectively unwatchable" against a neoliberal rhetoric of individual pain and self-care, other contributors detail the images that have unsettled them or their students, offering accounts of spectatorship that are irreducibly or even incommensurably personal. And though some authors use unwatchable in its commonplace meaning—as that which is too tedious, disturbing, revolting, or offensive to watch—others focus on images that are literally unobservable due to bad production values, material degradation, censorship, or the receptive thresholds of the human retina. For many, the unwatchable implies a dynamism and duration specific to audiovisual media, while others do not hesitate to integrate the concept into discussions of iconoclastic paintings and shocking photographs.

Even as we allow disparate meanings to accrue around the "unwatchable," we aim to establish three semantic points upfront. First, while the prefix "un-" expresses negation, the watchable and unwatchable are dialectically intertwined and often coterminous: to describe something as merely "watchable" is to damn with faint praise, while the more

explicitly pejorative "unwatchable" can serve (however ironically) as the ultimate temptation to watch or imagine. As the next syllable of the word suggests, the "unwatchable" privileges the visual realm, yet the phenomena that it describes are almost always audiovisual, involving the acoustic and other sensory dimensions and prompting fully embodied, kinesthetic responses. Finally, the suffix "-able" highlights questions of ability and disability, calling attention to the capacities and limits of the human perceptual apparatus (as juxtaposed, for example, with machinic vision) as well as the different modes of experiencing the world studied by critical disability scholars.[17]

The first recorded uses of the "unwatchable" date back to the nineteenth century, when the word described territories outside surveyable view,[18] and several essays in this book thematize the etymological connotations of "watching" as a state of being alert, on one's guard, and able to keep a person, thing, or place under surveillance.[19] The Google Books Ngram Viewer reveals that the adjective "unwatchable" began to gain currency in publications only in the late 1960s and has seen a remarkable increase in usage over the past half century.[20] Primarily referring to film and television, "unwatchable" is now defined by the Oxford Living Dictionary as "too poor, tedious, or disturbing to be viewed."[21] The wide range of content that can fall under this definition is evoked by the disparate works that have adopted Unwatchable as their title, from a 2006 John Waters exhibition to a 2011 British short film about rape and blood minerals in the Congo (which Leshu Torchin discusses in her essay for this volume on advocacy media).[22]

The rising discourse of the unwatchable since the 1960s may be attributed in part to unprecedented levels of image saturation. Even before the popularization of digital media, the introduction of television into the domestic sphere (and the later proliferation of cable news channels) had the effect of rendering horrifying events viscerally accessible— from the Vietnam War to the terror attacks of September 11, 2001. And yet, as one of our book's contributors, W. J. T. Mitchell, has noted, this trend fits into a broader historical pattern: "The deeply ambivalent relationship between human beings and the images they create seems to flare up into crisis at moments of technical innovation, when a new medium makes possible new kinds of images, often more lifelike and

persuasive than ever before, and seemingly more volatile and virulent."[23] Within this framework, the discourse of the unwatchable may be a cipher for the highly fraught position of images at critical junctures in the history of media and aesthetic theory.

An ambivalent combination of fascination and anxiety toward images can be discerned as far back as Plato's *Republic*. In book IV, Socrates recounts the story of Leontius, who is at once seduced and repulsed by the sight of corpses: "He had an appetitive desire to look at them, but at the same time he was disgusted and turned himself away. For a while he struggled and put his hand over his eyes, but finally, mastered by his appetite, he opened his eyes wide and rushed toward the corpses, saying, 'Look for yourselves, you evil wretches; take your fill of the beautiful sight.'"[24] While the story demonstrates the soul's tripartite division into rationally calculating, spirited, and appetitive elements, it also represents the author's own palpable dilemmas. Much as the conflicted Leontius alternates between covering and opening his eyes, between turning away and approaching the scene, Plato seeks to restrict mimetic arts in his ideal state even while narrating through imitation and using imagistic stories and myths.

Conceiving of images as mere copies and vehicles for sensory deception, Plato feared our easy susceptibility to illusion and irrational instincts. Aristotle, by contrast, offered a more expansive sense of mimesis, which he viewed as an imitative *techne* or art resulting in an aesthetic spectacle that is clearly distinct from the world of actual occurrences. In chapter IV of *Poetics*, Aristotle describes mimetic activity as an essential component of human nature and explores the pleasure we find in even the most gruesome of aesthetic objects:

> We take pleasure in contemplating the most precise images of things whose sight in itself causes us pain—such as the appearance of the basest animals, or of corpses. Here too the explanation lies in the fact that great pleasure is derived from exercising the understanding, not just for philosophers but in the same way for all men, though their capacity for it may be limited. It is for this reason that men enjoy looking at images, because what happens is that, as they contemplate them, they apply their understanding

and reasoning to each element (identifying this as an image of such-and-such a man, for instance).[25]

In contrast to the account of Leontius in Plato's *Republic*, Aristotle argues that we experience pleasure not through indulging our base desires, but rather by bringing our cognitive capacities to bear on identifiable material, even if the content is unpleasant in nature. Crucial here is that the images are enjoyable as long as the viewer recognizes them as mimetic representations enclosed within the aesthetic sphere, separated from the realm of historical reality.

While Plato and Aristotle emerged from an ancient Greek culture that treated the gods as both visibly manifest and representable in plastic, anthropomorphic form, the Israelites introduced a Second Commandment ("Thou shalt not make unto thee a graven image, nor any manner of likeness, of any thing")[26] that was restrictively aniconic or iconophobic by comparison. Even if the biblical prohibition on graven images has rarely been taken literally by Judaism, Christianity, and Islam, their restriction has spawned a dialectic between idolatry and iconoclasm, such that images, in Mitchell's words, "have been both adored and reviled, worshipped and banned, created with exquisite artistry and destroyed with boundless ferocity."[27] The religious taboo against image making has animated numerous controversies in recent years—including debates about the problematics of Holocaust representation,[28] scandalous artworks such as Andres Serrano's *Piss Christ* and Chris Ofili's *The Holy Virgin Mary*,[29] and the blasphemous cartoon depictions of Muhammad in *Jyllands-Posten* and *Charlie Hebdo*.[30]

As Peter Geimer contends in his essay for this volume, the virulent responses to offensive or shocking images also indicate the persistence of magical attitudes in our contemporary image culture. The ongoing capacity of photographs to "prick" or "wound" viewers—even in a digital age of heightened awareness of the possibilities for manipulation—attests to the continuation of a realist tradition that had conceived the photographic image, as Roland Barthes wrote, as "an emanation of *past reality*: a *magic*, not an art."[31] Using the same example as Plato and Aristotle, Barthes theorized the uncanny ability of the photographic image to certify the real presence and life of a human subject at a past moment:

"If the photograph . . . becomes horrible, it is because it certifies, so to speak, that the corpse is alive, as *corpse*: it is the living image of a dead thing."[32] Insofar as photographic representation is thus a form of reanimation, it can restore a magical belief in the potential for contact with the dead.

The question of magic has also been central to the philosophy and history of art over the past decades. In *The Philosophical Disenfranchisement of Art* (1986), Arthur C. Danto introduced the category of "disturbational art" to describe works that integrate disturbing elements of reality (e.g., obscenity, bodily fluids, actual pain and mortal danger) and thereby disrupt the divide between life and art, reality and mimesis.[33] Much as Friedrich Nietzsche and Martin Heidegger initiated a philosophical return to a pre-Socratic moment, "disturbatory" works reactivate a magical, prerationalist theory of images. David Freedberg's *The Power of Images: Studies in the History and Theory of Response* (1989) encouraged art historians to abandon the common distinction between "aesthetic" functions and "religious" or "magical" uses, considering the widest possible spectrum of images and taking seriously less intellectualized modes of response that continue into the modern age, however overlooked or repressed.[34]

Whereas Freedberg drew attention to the full range of human responses to images, others have focused on questions of vision and visuality.[35] Of the books that helped inaugurate visual culture as a scholarly field in the 1990s, Martin Jay's *Downcast Eyes: The Denigration of Vision in Twentieth-Century French Thought* (1993) is most directly related to the concerns of the present volume, arguing that sight—described by René Descartes as the "most comprehensive" and "noblest" of the senses in his *Discourse on Method* (1637)[36]—came under critical scrutiny in the twentieth century, most notably in French intellectual life. Offering a "synoptic survey" of antivisual discourses, Jay examines thinkers across various realms (e.g., art, cultural criticism, feminist theory, philosophy, psychoanalysis, poststructuralist and social theory) who waged an attack on the hegemony of vision in modernity.[37] Insofar as sight had been privileged not only in Cartesian thought but also in the project of Enlightenment, the critique of ocularcentrism often assumed, in Jay's words, "a self-consciously Counter-Enlightenment tone."[38]

Downcast Eyes raised a set of concerns that remain central to scholarship on twenty-first-century visual culture, from Irit Rogoff's "Looking Away: Participations in Visual Culture" (2005) to Frances Guerin's edited volume, *On Not Looking: The Paradox of Contemporary Visual Culture* (2015).[39] Why, these writers have asked, do we increasingly avert our gaze from images? Is the act of turning away a signal of disengagement and inattention, or can it also serve as a political gesture or alternative form of participation? Has the crisis of visual primacy compelled a retraining of our sight or facilitated the shift to a more embodied, multisensory mode of experience and knowledge? With a nod to Jay, we could add, does the refusal to watch intersect with disillusionment in the Enlightenment ideal of rational transparency? Have we returned to the original meaning of the "unwatchable," finding ourselves in an age of what Jürgen Habermas has called "the new unsurveyability" (*die neue Unübersichtlichkeit*)?[40]

Drawing from Hans Blumenberg's *Shipwreck with Spectator: Paradigm of a Metaphor for Existence* (1996),[41] Jay has identified two distinct modes of aesthetic spectatorship in the modern age. The first is a tradition that includes Enlightenment thinkers such as Ferdinando Galiani. Here the viewer's enjoyment is linked to a state of disinterested contemplation and judgment, whereby even scenes of horror and violent destruction remain bearable because of their containment within an aesthetic frame. This secure position of dispassionate observation is dismissed by the second mode of aesthetic experience, associated with Nietzsche and modernist movements like Surrealism and Futurism. In this latter, increasingly dominant perceptual regime, viewers are no longer firmly separated from the simulated disaster, relinquishing their critical distance and—in a phrase that Jay borrows from Adrienne Rich—"diving into the wreck."[42] For Jay, the aesthetic medium that helped popularize such immersive spectatorship was film.

Emerging alongside other mass-cultural entertainment forms (e.g., amusement park rides) at the end of the nineteenth century, cinema deemphasized passive, contemplative vision in favor of a more immediate, sensory-affective impact and the corporeal integration of the spectator into the events on-screen.[43] With its vertiginous, disorienting motion,

film dissolved the Cartesian or Kantian subject, eroding the distinction between viewer and viewed, spectator and spectacle. Even if the shift to narrative features gave rise to an internationally dominant "classical cinema," the earlier attractions-based cinema survived in various genres (e.g., action, avant-garde, comedy, horror, melodrama, pornography) that provoke tactile, "cinesthetic" responses, to use Vivian Sobchack's term.[44] Often deemed "excessive," these genres are characterized by an aesthetics of shock and visceral sensation—one that can hardly be aligned with classical aesthetic principles, as both Miriam Hansen and Linda Williams have emphasized.[45]

Early film theorists who sought to define the new mode of sensory perception and experience shaped by motion pictures often juxtaposed the capacities of the film camera with the perennial limitations of unaided human vision. In the manifesto "Kinoks: A Revolution" (1923), for example, Dziga Vertov heralded the camera as a mechanical "kino-eye" that significantly improves upon the human eye, overcoming its imprecision and limited spatiotemporal parameters.[46] (As Noël Carroll argues in his essay for this volume on Andy Warhol's eight-hour *Empire*, the "camera eye" is further separated from human vision through its sheer perceptual endurance.) Similarly invoking "another nature which speaks to the camera as compared to the eye," Walter Benjamin's 1936 essay "The Work of Art in the Age of Its Technological Reproducibility" contended that the advent of cinema had facilitated the discovery of the "optical unconscious" through techniques such as the close-up and slow motion.[47]

The link between the unconscious and visual media also assumed a role in André Bazin's "Ontology of the Photographic Image" (1945), where the French film critic wrote, "If we were to psychoanalyze the visual arts, the practice of embalming might be seen as fundamental to their birth."[48] Distinguishing the temporal art of cinema for its "mummification of change,"[49] Bazin nonetheless expressed concern about the implications of representing real death on-screen. In "Death Every Afternoon" (1951), Bazin recalled a 1949 newsreel showing the public execution of alleged communist spies in Shanghai: "The film did not even leave out the gesture of the policeman who had to make two attempts with his jammed revolver, an intolerable sight not so much for its objective horror as for its ontological obscenity."[50] Beyond the dreadfulness

of the botched act itself, Bazin suggested, was the more fundamental indecency of reproducing and repeating the singular, ultimate moment of death, "the unique moment par excellence."[51]

Perhaps the most sustained theorization of cinema's relationship to the unwatchable, however, comes in Siegfried Kracauer's *Theory of Film: The Redemption of Physical Reality* (1960), discussed by Meir Wigoder and Genevieve Yue in their essays for this volume. Asserting cinema's predilection for disastrous events that overwhelm consciousness,[52] Kracauer devoted a section of his book's epilogue to the myth of Medusa, a Gorgon whose face was such a petrifying sight that Perseus had to use Athena's reflective shield in the act of slaying her:

> The moral of the myth is, of course, that we do not, and cannot, see actual horrors because they paralyze us with blinding fear; and that we shall know what they look like only by watching images of them which reproduce their true appearance. These images have nothing in common with the artist's imaginative rendering of an unseen dread but are in the nature of mirror reflections. Now of all the existing media the cinema alone holds up a mirror to nature. Hence our dependence on it for the reflection of happenings which would petrify us were we to encounter them in real life. The film screen is Athena's polished shield.[53]

For Kracauer, film bears the unique capacity to mediate an encounter with horrific, real-life occurrences that would otherwise remain unwatchable. Implicit in this passage is the challenge that cinema poses to Aristotelian and Kantian aesthetics: inextricably bound to the very lifeworld that the viewer inhabits, film images move beyond the aesthetic realm into the order of "mirror reflections," collapsing the opposition between reality and mimesis, *parergon* and *ergon*.

While Kracauer identified the face of Medusa with documentary images—the slaughtered animals in Georges Franju's *Le sang des bêtes* (*Blood of the Beasts*, 1949), the human corpses in film footage of Nazi concentration camps—contemporary scholars have emphasized the potential of fictional genres to provoke reflection on historical atrocities that are often deemed beyond the pale of consumption. As Adam Lowenstein argues in *Shocking Representation: Historical Trauma, National*

Cinema, and the Modern Horror Film (2005), postwar horror films repeatedly allegorized historical traumas, confronting audiences with overdetermined images of graphic violence and carnage.[54] Such an allegorical mode of reading informs the present volume's essays on more recent horror films—whether *Ringu* (*Ring*, 1998), which Yue analyzes in relation to the atomic bombing of Hiroshima, or *Get Out* (2017), interpreted by Jared Sexton as a statement on the continuing legacy of racial slavery.

Films such as *Ring* and *Get Out*, wherein the act of viewing is linked to a state of docile powerlessness and existential threat, also recall a common trope of spectatorship as a form of masochism. Like the protagonist of Stanley Kubrick's *A Clockwork Orange* (1971), the cinematic viewer is at the full mercy of the filmmaker, passively submitting to a regime of visual assault.[55] Implicit in what Bazin (with a nod to Antonin Artaud) called "the cinema of cruelty,"[56] the trope of sadomasochism came to the fore in the 1970s psychoanalytic film theory of Christian Metz, Laura Mulvey, and others, who conceived film spectatorship in terms of perversion.[57] It is in this vein that Lesley Stern would invoke "the quintessential perverse pleasure of cinematic viewing, where we choose (no longer compelled by the parental voice) to watch even though it is painful or discomforting. For it is also pleasurable. What was once, in the past, unwatchable or unendurable becomes an image that fixates, from which we cannot tear ourselves away."[58]

Few films have enacted the structure of perversion as unbearably as Pier Paolo Pasolini's *Salò, or the 120 Days of Sodom* (1975), which Mauro Resmini analyzes in his essay for this collection. Revisiting Pasolini's scandalous film in 2004, Sontag lamented that its scenarios of brutal violence and sexual humiliation have become all too domesticated in the United States:

America has become a country in which the fantasies and the practice of violence are seen as good entertainment, fun. What formerly was segregated as pornography, as the exercise of extreme sadomasochistic longings—as in Pier Paolo Pasolini's last, nearunwatchable film, *Salò* (1975), depicting orgies of torture in the Fascist redoubt in northern Italy at the end of the Mussolini era—is now being normalized, by some, as high-spirited play or venting.

To "stack naked men" is like a college fraternity prank, said a caller to Rush Limbaugh and the many millions of Americans who listen to his radio show.[59]

Writing shortly after the publication of the Abu Ghraib photos, Sontag condemned conservative efforts to frame American soldiers' torture of Iraqi prisoners as typical behavior (like the more recent attempt by Donald Trump to dismiss his recorded boasting of sexual assault as mere "locker room talk"). For Sontag, the Abu Ghraib pictures also portended a shift in the status of images in our digital media environment, where violent computer games are a dominant form of teenage entertainment, pornography is freely accessible on the Internet, and photographs and videos are shot and disseminated more immediately than ever before.[60] Now that images are ubiquitous and eminently watchable, Sontag suggested, we move into a contested terrain of ethical and pragmatic questions, negotiating both what and how to watch.

Recent transformations in the nature of image making have also brought the question of unrepresentability into new focus. Whereas twentieth-century philosophers such as Theodor W. Adorno, Hannah Arendt, Emmanuel Levinas, and Jean-François Lyotard returned to the biblical taboo on images and the Burkean and Kantian idea of the sublime, contemporary thinkers are reconceiving the terms of debate. Dismissing common claims of the intrinsic unrepresentability of events such as the Holocaust, Jacques Rancière differentiates between "representative" and "aesthetic" regimes of art and highlights the expanded possibilities of expression specific to the latter regime, wherein everything is in fact equally representable.[61] In a thoughtful critique of Rancière from the perspective of information aesthetics, Alexander R. Galloway argues that power no longer resides in the image, but rather in "networks, computers, algorithms, information, and data" that pose significant new challenges of visualization.[62]

Problems of vision and visuality have maintained an important role in contemporary debates across the humanities and social sciences, especially as they have addressed forms of terror, torture, war, and state violence; nuclear threats and processes of climate change; the global refugee crisis and ongoing human rights violations; privacy and

surveillance in the age of digital networks; and, finally, neoliberalism as a new order of reason that, as Wendy Brown has argued, subjects all domains of human existence to "a specific image of the economic."[63] We limit our focus in this introduction, however, to recent work in critical race theory, feminist and queer theory, and critical disability studies. These fields have been centrally concerned with the consequences of "unwatchable" objects, both their injurious qualities and their affective potentials to promote previously unimaginable forms of social and political change.

Taking up Frantz Fanon's theorization of the "white gaze,"[64] critical race theorists have examined the long history of rendering black bodies as spectacles, particularly in moments of suffering and death. Of key significance in this context are images of state-sanctioned violence against African Americans, from the public lynchings in the periods of slavery and Jim Crow up to the Rodney King video and the most recent cases of police brutality.[65] Building on Elizabeth Alexander's "'Can You Be Black and Look at This?'" (1994),[66] contributor Fred Moten has written on Emmett Till, a viciously murdered fourteen-year-old boy whose mother opted for an open-casket funeral in 1955, allowing a photograph of his mutilated face to run in *Jet* magazine. In a critique of Barthes's writings on photography, Moten argues that the Till picture bears a phonic dimension with a sense of "dynamic universality" (a phrase that Emily Regan Wills borrows in her essay for this book on the photos of three-year-old Syrian refugee Alan Kurdi).[67]

Among the most widely discussed instances of mediated black death in recent years is Philando Castile's murder by a police officer in 2016, an incident that was recorded and streamed on Facebook Live by Castile's girlfriend, Diamond Reynolds. While some commentaries emphasized the necessity of bearing witness to the video in order to facilitate racial empathy and social transformation,[68] Alexandra Juhasz's "How Do I (Not) Look?" (2016) urged sustained deliberation on both the ethical and political ramifications of watching and the corporate platforms that provide the structural frameworks for such content.[69] In the present volume, Juhasz revisits her text, bringing viral black death into dialogue with the issue of Internet "fake news," while Michael Boyce Gillespie analyzes Ja'Tovia Gary's video art piece, *Giverny 1 (Négresse Impériale)*

(2017), which remediates Reynolds's Facebook Live footage, notably displacing the images of Castile's bloodied body off-screen.

The principled decision not to regard and reproduce images of racial violence is often articulated in terms of the history and legacies of slavery. In *Scenes of Subjection: Terror, Slavery, and Self-Making in Nineteenth-Century America* (1997), Saidiya V. Hartman sought to shift focus from the spectacle of black pain, suffering, and torture to more overlooked forms of subjugation: "Rather than try to convey the routinized violence of slavery and its aftermath through invocations of the shocking and the terrible, I have chosen to look elsewhere and consider those scenes in which terror can hardly be discerned."[70] Drawing from Hartman's book, Christina Sharpe's *In the Wake: On Blackness and Being* (2016) offers the metaphor of "the wake"—a term that evokes "the keeping watch with the dead, the path of a ship, a consequence of something, in the line of flight and/or sight, awakening, and consciousness"—to forge an analytic for envisaging new modes of black life following racial enslavement.[71]

The status of black life in the aftermath of slavery has been a key line of debate between the Afro-Pessimism associated with Fanon, Hartman, Jared Sexton, and others, and the Black Optimism championed by Moten and Stefano Harney.[72] Whereas Afro-Pessimism emphasizes that black life emerges from a position of continual negation—or, in Sexton's words, is "*lived* in social *death*"[73]—Black Optimism affirms the ontological primacy of blackness vis-à-vis the structural forces of antiblackness, maintaining the possibility for what Moten calls "fugitive movement in and out of the frame, bar, or whatever externally imposed social logic."[74] These differences in theoretical position find elaboration in the present volume, as Sexton reads *Get Out* in terms of "the active and ongoing *production* of a society structured in dominance," while Harney and Moten claim a greater measure of elusiveness in relation to power: "Blackness is unwatchable . . . from the outside, which is to say from its anti-black and worldly effects."

The link between vision and systems of oppressive power and violence has also been a crucial point of emphasis in theorizations of gender and sexuality since the 1970s. While Luce Irigaray took aim at a phallomorphic and ocularcentric economy that defined women in terms

of lack, or "*the horror of nothing to see*,"[75] Mulvey introduced the concept of the "male gaze," critiquing the passive "to-be-looked-at-ness" of women in dominant narrative cinema.[76] The ongoing relevance of Mulvey's analysis of patriarchy and visual culture has been powerfully reinforced by recent revelations about Harvey Weinstein and countless other sexual predators in Hollywood and beyond. In the present volume, Jack Halberstam revisits *Manchester by the Sea* (2016), whose lead actor, Casey Affleck, won an Academy Award despite allegations of sexual harassment. For Halberstam, the film itself was symptomatic of a culture in which white male perpetrators could envision themselves as misunderstood and tragically incapable of love.

Halberstam is one of many contemporary feminist and queer scholars who have explored questions of feeling, corporeality, and relationality.[77] In *The Cultural Politics of Emotion* (2004), Sara Ahmed argues that "uncultivated or unruly emotions" (e.g., pain, hate, fear, disgust, shame) thwart the formation of the rational, autonomous subject and provoke alternative kinds of orientation toward objects and other individuals, compelling a shift in our conception of collective bodies and social ideals.[78] Mel Y. Chen's *Animacies: Biopolitics, Racial Mattering, and Queer Affect* (2012) expands on Ahmed's notion of "affective economies," theorizing mediations between the human and inhuman along lines of race, sexuality, and ability.[79] In the present volume, Chen returns to these concerns in an essay on the popular "What Could Go Wrong?" GIFs: "While I find police murders or violence against feminine people unwatchable, here I avidly learn . . . how I will try to survive a like 'accident' when the time comes."

Concerns over unsettling content and personal injury further inform student demands for "trigger warnings" as they confront films and other cultural objects that present sexual violence, racism, transphobia, suicide, and eating disorders, among other difficult topics. Such requests have launched heated debates over university pedagogy and the relative merits of difficult viewing experiences.[80] Taking up these debates in the present volume, Kataiina Kyrölä underscores the ethical value of extreme discomfort in the classroom and suggests that the discourse of triggering can itself produce traumatic responses, while Jennifer Malkowski points to the phenomenon of "suicide contagion" as a compelling case for exception. For Malkowski, the documentary *The Bridge* (2006),

which includes footage of people jumping off the Golden Gate Bridge (notably violating Bazin's taboo on representing actual death), is "unteachable" due to the risk of provoking spectators struggling with depression or mental illness to follow suit.

Critical disability scholars tend to view requests for trigger warnings through the lens of accessibility, with the goal of creating classrooms in which students with a wide range of bodyminds can participate. Whereas some embrace trigger warnings as, in Melanie Yergeau's words, "a cripped kind of metadata that anticipate a disabled response," others, like Angela M. Carter, see them as an insufficient tactic that can nonetheless initiate discussions of trauma as "an important social justice issue in our classrooms."[81] Halberstam and some other feminist and queer scholars, by contrast, have adopted a fully contrarian stance, positing trigger warnings as the product of a neoliberal rhetoric of personal offense and psychic pain.[82] In "You Are Triggering Me!" (2014), Halberstam dismisses common approaches to political difference in terms of individual harm and wounded subjectivity, calling for a broader coalitional fight against the structural forces of aggressive exploitation and intensified social inequality.[83]

As our introduction has demonstrated, the concept of the unwatchable cuts across disciplinary divides and entails questions of taste, judgment, identity, and embodied experience. The thematic breadth of our book compelled us to feature a widely diverse and international field of contributors, including scholars across the humanities and social sciences as well as artists, critics, archivists, and curators. Prompted to write 750 to 1,500 words, our contributors have adopted a variety of approaches and styles, often dispensing with distanced analysis. Their short prose pieces might be seen as continuous with the "small forms" embraced by literary modernists and critical theorists as they reflected on the visceral experience of rapid sociopolitical change and heightened media competition.[84] Taken together, the essays here demonstrate that describing an object that is challenging or impossible to watch can provoke a personal and vividly ekphrastic mode of writing—one at once anecdotal and philosophical, intimate and far-reaching.

With its extensive range of meanings and resonances in our time, the unwatchable might threaten to become a buzzword or catchall

category, losing its critical purchase or heuristic value. To minimize this risk, we have structured the volume conceptually, with analytical sub-headings that help readers locate topics of special interest. Featuring fifty-four contributions, the book is divided into three thematic parts, each of which contains five chapters composed of multiple essays. We have assembled the chapters as imagined conversations around common themes, prefacing them with brief synopses that highlight the interconnections between texts and draw links to broader fields of inquiry. More suggestive than prescriptive, these orderings and editorial summaries provide readers with a form of what Fredric Jameson has called "cognitive mapping," outlining the contours of a large-scale concept whose hidden yet fundamental reality can be examined only on the basis of its figurations across the globe.[85]

The book's first part, "Violence and Testimony," sets forth the unwatchable as a critical category for engaging with past and present forms of political violence. Beginning with reflections on the unwatchable from a number of theoretical perspectives, part I then surveys contemporary modes of destruction (e.g., nuclear and drone warfare, ecological disaster) that challenge or exceed established models of visualization. The subsequent chapter explores the problematics of visual evidence, media coverage, and political advocacy in relation to the overwhelming atrocities of the twentieth and twenty-first centuries, from the Armenian Genocide through World War II and the Holocaust up to the current Syrian Civil War and refugee crisis. Contemplating the role of the gaze in everyday and structural forms of violence, the last two chapters of part I address the dynamics of oppressive power and minoritarian subjectivity, with particular attention to issues of race, gender and sexuality, and ability.

"Histories and Genres," the book's second part, approaches cinema through the lens of the unwatchable, studying the traditions of auteurist and genre filmmaking that place viewers in uncomfortable positions. The section starts by tracing a lineage of directors who have carried the torch of modernist provocation and initiated the recent trend of "extreme" or "unwatchable" cinema. Shifting focus to nonnarrative cinema, the following chapter considers the limits of filmgoers' visual capacities vis-à-vis grueling experimental works by Isidore Isou, Guy Debord, Andy Warhol, Tony Conrad, and others. Long scrutinized by

feminist film scholars, the genres of horror and pornography are known for eliciting visceral bodily responses that often straddle the line between pleasure and abject fear or pain. A final chapter in part II contains deliberations on the material bases of cinema, detailing how films can become unwatchable through censorship, lost or incomplete prints, and severe physical deterioration.

Concentrating on our contemporary moment, part III, "Spectators and Objects," shuttles between deeply personal experiences and shared cultural phenomena in charting moments of aversion, outrage, and traumatic recollection. This section opens with humorous and often polemical reflections on the directors, film franchises, and genres that individual contributors detest with a passion. Such antipathy is also palpable in the following chapter on films and digital images that warrant strong identitarian critique, particularly in their figurations of whiteness. The limit case is provided by *The Apprentice* host-turned-politician Donald Trump, widely deemed aggressively off-putting and yet the unmistakable product of popular televisual and new media logics. The volume's concluding two chapters center on campus politics and situations of triggering as they unfold on university campuses, in classroom settings, and in the private spaces of viewers confronting disturbing images on television and other screens.

As extensive as this book has proven to be, there are, of course, many more relevant cultural objects than the ones discussed between these covers. If, as we have argued, the unwatchable has become a crucial category across global media and politics, then our volume must relinquish any claims to comprehensiveness. Future scholarship might contribute to a further understanding of the concept by examining works, aesthetic traditions, and sociohistorical contexts beyond the scope of the essays collected here. No less illuminating would be a theorization of the relation between covering one's eyes and refusing one's sensory faculties to other media—deeming them unreadable, unlistenable, unplayable, and so on. It is our hope that this book marks the beginning, not the end, of a radically expanded conversation on the unwatchable. For, at a time of horrifying injustices, intractable conflicts, and escalating global threats, an alleviation of unwatchable phenomena is, alas, nearly impossible to envision.

Notes

1 "Report: Most Americans Now Getting Their News While Peeking Out between Fingers," *Onion*, August 11, 2017, https://politics.theonion.com/report-most-americans-now-getting-their-news-while-pee-1819580200.

2 See Vivian Sobchack, "What My Fingers Knew: The Cinesthetic Subject, or Vision in the Flesh," in *Carnal Thoughts: Embodiment and Moving Image Culture* (Berkeley: University of California Press, 2004), 53–84.

3 Slavoj Žižek, *Looking Awry: An Introduction to Jacques Lacan through Popular Culture* (Cambridge, MA: MIT Press, 1991); Martin Jay, *Downcast Eyes: The Denigration of Vision in Twentieth-Century French Thought* (Berkeley: University of California Press, 1993).

4 See, e.g., Whitney Phillips, *This Is Why We Can't Have Nice Things: Mapping the Relationship between Online Trolling and Mainstream Culture* (Cambridge, MA: MIT Press, 2015).

5 Susan Sontag, *Regarding the Pain of Others* (New York: Picador, 2003), 141.

6 Stanley Cavell, "On Makavejev on Bergman," *Critical Inquiry* 6, no. 2 (1979): 305–330. On disgust, see also Tina Kendall, ed., "The Disgust Issue," *Film-Philosophy* 15, no. 2 (2011): 1–105; and Eugenie Brinkema, *The Forms of the Affects* (Durham, NC: Duke University Press, 2014).

7 Jessica Contrera, "Trump Says 'SNL' Is 'Unwatchable.' Then Why Can't He Stop Watching?," *Washington Post*, December 4, 2016, www.washingtonpost.com/news/arts-and-entertainment/wp/2016/12/04/trump-says-snl-is-unwatchable-then-why-cant-he-stop-watching/?utm_term=.e7ecc8319639.

8 Dan Merica, "Trump Condemns 'Hatred, Bigotry and Violence on Many Sides' in Charlottesville," *CNN*, August 13, 2017, www.cnn.com/2017/08/12/politics/trump-statement-alt-right-protests/index.html.

9 Sontag, *Regarding the Pain of Others*, 26.

10 Teddy Wayne, "The Trauma of Violent News on the Internet," *New York Times*, September 10, 2016, www.nytimes.com/2016/09/11/fashion/the-trauma-of-violent-news-on-the-internet.html.

11 James Quandt, "Flesh & Blood: Sex and Violence in Recent French Cinema," *Artforum* 42, no. 6 (2004): 126–132; Martine Beugnet, *Cinema and Sensation: French Film and the Art of Transgression* (Edinburgh: Edinburgh University Press, 2007); Tim Palmer, *Brutal Intimacy: Analyzing Contemporary French Cinema* (Middletown, CT: Wesleyan University Press, 2011); and Alexandra West, *Films of the New French Extremity: Visceral Horror and National Identity* (Jefferson, NC: McFarland, 2016).

12 Paul Gormley, *The New-Brutality Film: Race and Affect in Contemporary Hollywood Cinema* (Portland, OR: Intellect, 2005).

13 Patrick Galloway, *Asia Shock: Horror and Dark Cinema from Japan, Korea, Hong Kong, and Thailand* (Berkeley, CA: Stone Bridge Press, 2006); Jinhee Choi and Mitsuyo Wada-Marciano, eds., *Horror to the Extreme: Changing Boundaries*

in Asian Cinema (Hong Kong: Hong Kong University Press, 2009); and Daniel Martin, *Extreme Asia: The Rise of Cult Cinema from the Far East* (Edinburgh: Edinburgh University Press, 2015).

14 See Richard Falcon, "Reality Is Too Shocking," *Sight and Sound* 9, no. 1 (1999): 10–13; Tanya Horeck and Tina Kendall, eds., *The New Extremism in Cinema: From France to Europe* (Edinburgh: Edinburgh University Press, 2011); William Brown, "Violence in Extreme Cinema and the Ethics of Spectatorship," *Projections* 7, no. 1 (2013): 25–42; Aaron Michael Kerner and Jonathan L. Knapp, *Extreme Cinema: Affective Strategies in Transnational Media* (Edinburgh: Edinburgh University Press, 2016); Elena del Río, *The Grace of Destruction: A Vital Ethology of Extreme Cinemas* (New York: Bloomsbury, 2016); and Troy Bordun, *Genre Trouble and Extreme Cinema: Film Theory at the Fringes of Contemporary Art Cinema* (Cham: Palgrave Macmillan, 2017). On cinematic ethics, see, e.g., Asbjørn Grønstad and Henrik Gustafsson, eds., *Ethics and Images of Pain* (New York: Routledge, 2012); Jinhee Choi and Mattias Frey, eds., *Cine-Ethics: Ethical Dimensions of Film Theory, Practice, and Spectatorship* (New York: Routledge, 2014); and Robert Sinnerbrink, *Cinematic Ethics: Exploring Ethical Experience through Film* (New York: Routledge, 2016).

15 Asbjørn Grønstad, *Screening the Unwatchable: Spaces of Negation in Post-millennial Art Cinema* (Basingstoke: Palgrave Macmillan, 2012), 6. See also Grønstad, "On the Unwatchable," in Horeck and Kendall, *New Extremism in Cinema*, 192–205.

16 Mattias Frey, *Extreme Cinema: The Transgressive Rhetoric of Today's Art Film Culture* (New Brunswick, NJ: Rutgers University Press, 2016). See also Frey's article on disgust, boredom, and the incomplete consumption of films: "Tuning Out, Turning In, and Walking Off: The Film Spectator in Pain," in Grønstad and Gustafsson, *Ethics and Images of Pain*, 93–111.

17 See, e.g., Georgina Kleege, "Blindness and Visual Culture: An Eyewitness Account," *Journal of Visual Culture* 4, no. 2 (2005): 179–190.

18 See, e.g., "View of the State of Europe, &c.," *Literary Panorama* 4 (1808): xxi: "This state [America] continues her embargo. That many of her citizens endeavour to elude it, by shipping their goods from obscure and *unwatchable* places on their extensive coast on the ocean is true: some escape; others are caught and punished."

19 On the nineteenth-century origins of visuality, see also Nicholas Mirzoeff's *The Right to Look: A Counterhistory of Visuality* (Durham, NC: Duke University Press, 2011).

20 "Unwatchable," *Google Books Ngram Viewer*, http://books.google.com/ngrams.

21 "Unwatchable," in *English: Oxford Living Dictionaries* (Oxford: Oxford University Press, 2018), https://en.oxforddictionaries.com/definition/unwatchable.

22 John Waters, *Unwatchable* (Zurich: de Pury & Luxembourg, 2006).

23 W. J. T. Mitchell, "Image," in *Critical Terms for Media Studies*, ed. W. J. T. Mitchell and Mark B. N. Hansen (Chicago: University of Chicago Press, 2010), 38.

24 Plato, *Republic*, trans. C. D. C. Reeve (Indianapolis: Hackett, 2004), 127–128, 440a.

25 Aristotle, *Poetics*, trans. Stephen Halliwell (Chapel Hill: University of North Carolina Press, 1987), 34.

26 Exodus 20:4, in *The Holy Scriptures* (Philadelphia: Jewish Publication Society of America, 1917), 104.

27 Mitchell, "Image," 36. See also Bruno Latour and Peter Weibel, eds., *Iconoclash: Beyond the Image Wars in Science, Religion, and Art* (Cambridge, MA: MIT Press, 2002).

28 See, e.g., Shoshana Felman and Dori Laub, *Testimony: Crises of Witnessing in Literature, Psychoanalysis and History* (New York: Routledge, 1992); Saul Friedlander, ed., *Probing the Limits of Representation: Nazism and the "Final Solution"* (Cambridge, MA: Harvard University Press, 1992); Gertrud Koch, "Mimesis and *Bilderverbot*," trans. Jeremy Gaines, *Screen* 34, no. 3 (1993): 211–222; Miriam Bratu Hansen, "*Schindler's List* Is Not *Shoah*: The Second Commandment, Popular Modernism, and Public Memory," *Critical Inquiry* 22, no. 2 (1996): 292–312; Giorgio Agamben, *Remnants of Auschwitz: The Witness and the Archive*, trans. Daniel Heller-Roazen (New York: Zone Books, 1999); and Georges Didi-Huberman, *Images in Spite of All: Four Photographs from Auschwitz*, trans. Shane B. Lillis (Chicago: University of Chicago Press, 2008).

29 See, e.g., W. J. T. Mitchell, *What Do Pictures Want? The Lives and Loves of Images* (Chicago: University of Chicago Press, 2005), 125–144.

30 See, e.g., Talal Asad, Wendy Brown, Judith Butler, and Saba Mahmood, *Is Critique Secular? Blasphemy, Injury, and Free Speech* (New York: Fordham University Press, 2013).

31 Roland Barthes, *Camera Lucida: Reflections on Photography*, trans. Richard Howard (1981; New York: Hill & Wang, 2010), 88, emphasis original.

32 Ibid. 78–79, emphasis original.

33 Arthur C. Danto, "Art and Disturbation," in *The Philosophical Disenfranchisement of Art* (New York: Columbia University Press, 1986), 117–133.

34 David Freedberg, *The Power of Images: Studies in the History and Theory of Response* (Chicago: University of Chicago Press, 1989). See also Alfred Gell, "Technology and Magic," *Anthropology Today* 4, no. 2 (1988): 6–9; and Hans Belting, *Likeness and Presence: A History of the Image before the Era of Art*, trans. Edmund Jephcott (Chicago: University of Chicago Press, 1994).

35 See, e.g., Hal Foster, ed., *Vision and Visuality* (Seattle: Bay Press, 1988); Susan Buck-Morss, *The Dialectics of Seeing: Walter Benjamin and the Arcades Project* (Cambridge, MA: MIT Press, 1990); Jonathan Crary, *Techniques of the Observer: On Vision and Modernity in the Nineteenth Century* (Cambridge, MA: MIT Press, 1990); David Michael Levin, ed., *Modernity and the Hegemony of Vision* (Berkeley: University of California Press, 1993); and Teresa Brennan and Martin Jay, eds., *Vision in Context: Historical and Contemporary Perspectives on Sight*

(New York: Routledge, 1996). See also earlier works such as John Berger, *Ways of Seeing* (New York: Viking Press, 1972).

36 René Descartes, *Discourse on Method, Optics, Geometry, and Meteorology*, trans. Paul J. Olscamp (Indianapolis: Hackett, 2001), 65.

37 Jay, *Downcast Eyes*, 17.

38 Ibid., 82.

39 Irit Rogoff, "Looking Away: Participations in Visual Culture," in *After Criticism: New Responses to Art and Performance*, ed. Gavin Butt (Malden, MA: Blackwell, 2005), 117–134; and Frances Guerin, ed., *On Not Looking: The Paradox of Contemporary Visual Culture* (New York: Routledge, 2015).

40 Jürgen Habermas, *Die neue Unübersichtlichkeit* (Frankfurt am Main: Suhrkamp, 1985).

41 Hans Blumenberg, *Shipwreck with Spectator: Paradigm of a Metaphor for Existence*, trans. Steven Rendall (Cambridge, MA: MIT Press, 1996).

42 Martin Jay, "Diving into the Wreck: Aesthetic Spectatorship at the *Fin-de-siècle*," *Critical Horizons* 1, no. 1 (2000): 93–111.

43 See, e.g., Tom Gunning, "'Now You See It, Now You Don't': The Temporality of the Cinema of Attractions," *Velvet Light Trap* 32 (1993): 3–12; Anne Friedberg, *Window Shopping: Cinema and the Postmodern* (Berkeley: University of California Press, 1993); Leo Charney and Vanessa Schwartz, eds., *Cinema and the Invention of Modern Life* (Berkeley: University of California Press, 1995); Lauren Rabinovitz, *For the Love of Pleasure: Women, Movies, and Culture in Turn-of-the-Century Chicago* (New Brunswick, NJ: Rutgers University Press, 1998); Vanessa Schwartz, *Spectacular Realities: Early Mass Culture in Fin-de-Siècle Paris* (Berkeley: University of California Press, 1998); Ben Singer, *Melodrama and Modernity: Early Sensational Cinema and Its Contexts* (New York: Columbia University Press, 2001); Jennifer M. Bean, "Technologies of Early Stardom and the Extraordinary Body," in *A Feminist Reader in Early Cinema*, ed. Jennifer M. Bean and Diane Negra (Durham, NC: Duke University Press, 2002), 404–443.

44 See David Bordwell, Janet Staiger, and Kristin Thompson, *The Classical Hollywood Cinema: Film Style & Mode of Production to 1960* (New York: Columbia University Press, 1985); Tom Gunning, "The Cinema of Attraction: Early Cinema, Its Spectator and the Avant-Garde," *Wide Angle* 8, nos. 3–4 (1986): 63–70; and Sobchack, *Carnal Thoughts*, 53–84. See also Vivian Sobchack, *The Address of the Eye: A Phenomenology of Film Experience* (Princeton, NJ: Princeton University Press, 1992); Steven Shaviro, *The Cinematic Body* (Minneapolis: University of Minnesota Press, 1993); Laura U. Marks, *The Skin of the Film: Intercultural Cinema, Embodiment, and the Senses* (Durham, NC: Duke University Press, 2000); and Jennifer M. Barker, *The Tactile Eye: Touch and the Cinematic Experience* (Berkeley: University of California Press, 2009).

45 See Miriam Hansen, "The Mass Production of the Senses: Classical Cinema as Vernacular Modernism," in *Reinventing Film Studies*, ed. Christine Gledhill

and Linda Williams (New York: Oxford University Press, 2000), 332–350; and Linda Williams, "Film Bodies: Gender, Genre, and Excess," *Film Quarterly* 44, no. 4 (1991): 2–13. On cinematic excess, see also Jeffrey Sconce, ed., *Sleaze Artists: Cinema at the Margins of Taste, Style, and Politics* (Durham, NC: Duke University Press, 2007).

46 Dziga Vertov, "Kinoks: A Revolution," trans. Kevin O'Brien, in *Kino-Eye: The Writings of Dziga Vertov*, ed. Annette Michelson (Berkeley: University of California Press, 1984), 11–21.

47 Walter Benjamin, "The Work of Art in the Age of Its Technological Reproducibility: Second Version," trans. Edmund Jephcott and Harry Zohn, in *Selected Writings, Volume 3, 1935–1938*, ed. Howard Eiland and Michael W. Jennings (Cambridge, MA: Belknap, 2002), 117.

48 André Bazin, "Ontology of the Photographic Image," in *What Is Cinema?*, trans. Timothy Barnard (Montreal: Caboose, 2009), 3.

49 Ibid., 9.

50 André Bazin, "Death Every Afternoon," trans. Mark A. Cohen, in *Rites of Realism: Essays on Corporeal Cinema*, ed. Ivone Margulies (Durham, NC: Duke University Press, 2003), 31.

51 Ibid., 30.

52 Siegfried Kracauer, *Theory of Film: The Redemption of Physical Reality* (1960; Princeton, NJ: Princeton University Press, 1997), 57–58.

53 Ibid., 305.

54 Adam Lowenstein, *Shocking Representation: Historical Trauma, National Cinema, and the Modern Horror Film* (New York: Columbia University Press, 2005).

55 Already in 1913, one cinephobic commentator could characterize film as a form of "optical torture"; see Naldo Felke, "Cinema's Damaging Effects on Health," trans. Michael Cowan, in *The Promise of Cinema: German Film Theory, 1907–1933*, ed. Anton Kaes, Nicholas Baer, and Michael Cowan (Oakland: University of California Press, 2016), 235. On cinephobia, see also Francesco Casetti, "Why Fears Matter: Cinephobia in Early Film Culture," *Screen* 59, no. 2 (2018): 145–157.

56 André Bazin, *The Cinema of Cruelty: From Buñuel to Hitchcock*, ed. François Truffaut, trans. Sabine d'Estrée and Tiffany Fliss (New York: Seaver, 1982). On the legacy of Artaud, see also Martin Harries, *Forgetting Lot's Wife: On Destructive Spectatorship* (New York: Fordham University Press, 2007); and Maggie Nelson, *The Art of Cruelty: A Reckoning* (New York: Norton, 2011).

57 See Christian Metz, *The Imaginary Signifier: Psychoanalysis and the Cinema*, trans. Celia Britton, Annwyl Williams, Ben Brewster, and Alfred Guzzetti (Bloomington: Indiana University Press, 1982); Laura Mulvey, "Visual Pleasure and Narrative Cinema," *Screen* 16, no. 3 (1975): 6–18; Kaja Silverman, *Male Subjectivity at the Margins* (New York: Routledge, 1992); and Gaylyn Studlar, *In the Realm of Pleasure: Von Sternberg, Dietrich, and the Masochistic Aesthetic* (New York: Columbia University Press, 1988).

58 Lesley Stern, *The Scorsese Connection* (Bloomington: Indiana University Press, 1995), 72.

59 Susan Sontag, "Regarding the Torture of Others," *New York Times Magazine*, May 23, 2004.

60 See also Judith Butler, "Photography, War, Outrage," *PMLA* 120, no. 3 (2005): 822–827; and W. J. T. Mitchell, "The Unspeakable and the Unimaginable: Word and Image in a Time of Terror," *ELH* 72, no. 2 (2005): 291–308.

61 Jacques Rancière, *The Future of the Image*, trans. Gregory Elliott (London: Verso, 2007), 109–138.

62 Alexander R. Galloway, *The Interface Effect* (Cambridge: Polity, 2012), 92.

63 Wendy Brown, *Undoing the Demos: Neoliberalism's Stealth Revolution* (New York: Zone Books, 2015), 10. See also Elaine Scarry, *The Body in Pain: The Making and Unmaking of the World* (New York: Oxford University Press, 1985); Ariella Azoulay, *The Civil Contract of Photography*, trans. Rela Mazali and Ruvik Danieli (New York: Zone Books, 2008); Judith Butler, *Frames of War: When Is Life Grievable?* (London: Verso, 2009); Adriana Cavarero, *Horrorism: Naming Contemporary Violence* (New York: Columbia University Press, 2011); W. J. T. Mitchell, *Cloning Terror: The War of Images, 9/11 to the Present* (Chicago: University of Chicago Press, 2011); Jürgen Martschukat and Silvan Niedermeier, eds., *Violence and Visibility in Modern History* (New York: Palgrave Macmillan, 2013); Timothy Morton, *Hyperobjects: Philosophy and Ecology after the End of the World* (Minneapolis: University of Minnesota Press, 2013); Jon Greenaway, "Let the Traumatic Image Haunt Us," *JSTOR Daily*, September 19, 2015, https://daily.jstor.org/photographs-european-refugee-crisis/; Wendy Hui Kyong Chun, *Updating to Remain the Same: Habitual New Media* (Cambridge, MA: MIT Press, 2016); and Sarah Sentilles, "How We Should Respond to Photographs of Suffering," *New Yorker*, August 3, 2017, www.newyorker.com/books/second-read/how-we-should-respond-to-photographs-of-suffering.

64 Frantz Fanon, *Black Skin, White Masks*, trans. Richard Philcox (New York: Grove, 2008), 90.

65 See, e.g., Judith Butler, "Endangered/Endangering: Schematic Racism and White Paranoia," in *Reading Rodney King/Reading Urban Uprising*, ed. Robert Gooding-Williams (New York: Routledge, 1993), 15–22; Safiya Umoja Noble, "Teaching Trayvon: Race, Media, and the Politics of Spectacle," *Black Scholar* 44, no. 1 (2014): 12–29; and Courtney R. Baker, *Humane Insight: Looking at Images of African-American Suffering and Death* (Urbana: University of Illinois Press, 2017).

66 Elizabeth Alexander, "'Can You Be Black and Look at This?' Reading the Rodney King Video(s)," *Public Culture* 7 (1994): 77–94.

67 Fred Moten, "Black Mo'nin'," in *Loss: The Politics of Mourning*, ed. David L. Eng and David Kazanjian (Berkeley: University of California Press, 2003), 72. See also the recent debate around Dana Schutz's painting *Open Casket* (2016):

Randy Kennedy, "White Artist's Painting of Emmett Till at Whitney Biennial Draws Protests," *New York Times*, March 21, 2017, www.nytimes.com/2017/03/21/arts/design/painting-of-emmett-till-at-whitney-biennial-draws-protests.html; Siddhartha Mitter, "'What Does It Mean to Be Black and Look at This?' A Scholar Reflects on the Dana Schutz Controversy," *Hyperallergic*, March 24, 2017, https://hyperallergic.com/368012/what-does-it-mean-to-be-black-and-look-at-this-a-scholar-reflects-on-the-dana-schutz-controversy/; and Coco Fusco, "Censorship, Not the Painting, Must Go: On Dana Schutz's Image of Emmett Till," *Hyperallergic*, March 27, 2017, https://hyperallergic.com/368290/censorship-not-the-painting-must-go-on-dana-schutzs-image-of-emmett-till/.

68 Kimberly Fain, "Viral Black Death: Why We Must Watch Citizen Videos of Police Violence," *JSTOR Daily*, September 1, 2016, https://daily.jstor.org/why-we-must-watch-citizen-videos-of-police-violence/.

69 Alexandra Juhasz, "How Do I (Not) Look? Live Feed Video and Viral Black Death," *JSTOR Daily*, July 20, 2016, https://daily.jstor.org/how-do-i-not-look/.

70 Saidiya V. Hartman, *Scenes of Subjection: Terror, Slavery, and Self-Making in Nineteenth-Century America* (Oxford: Oxford University Press, 1997), 4.

71 Christina Sharpe, *In the Wake: On Blackness and Being* (Durham, NC: Duke University Press, 2016), 17–18.

72 For perspectives on the debate, see, e.g., Saidiya V. Hartman and Frank B. Wilderson III, "The Position of the Unthought," *Qui Parle* 13, no. 2 (2003): 183–201; Frank B. Wilderson III, *Red, White & Black: Cinema and the Structure of U.S. Antagonisms* (Durham, NC: Duke University Press, 2010); and Jared Sexton, "The Social Life of Social Death: On Afro-Pessimism and Black Optimism," *InTensions* 5 (2011): 1–47.

73 Sexton, "Social Life of Social Death," 29, emphasis original.

74 Fred Moten, "The Case of Blackness," *Criticism* 50, no. 2 (2008): 179.

75 Luce Irigaray, "This Sex Which Is Not One," in *This Sex Which Is Not One*, trans. Catherine Porter and Carolyn Burke (Ithaca, NY: Cornell University Press, 1985), 26, emphasis original.

76 Mulvey, "Visual Pleasure and Narrative Cinema," 11.

77 See, e.g., Ann Cvetkovich, *An Archive of Feelings: Trauma, Sexuality, and Lesbian Public Cultures* (Durham, NC: Duke University Press, 2003); Sianne Ngai, *Ugly Feelings* (Cambridge, MA: Harvard University Press, 2005); Lauren Berlant, *The Female Complaint: The Unfinished Business of Sentimentality in American Culture* (Durham, NC: Duke University Press, 2008); and Lauren Berlant and Lee Edelman, *Sex, or the Unbearable* (Durham, NC: Duke University Press, 2014).

78 Sara Ahmed, *The Cultural Politics of Emotion* (New York: Routledge, 2004), 3.

79 Mel Y. Chen, *Animacies: Biopolitics, Racial Mattering, and Queer Affect* (Durham, NC: Duke University Press, 2012).

80 See, e.g., Emily J. M. Knox, ed., *Trigger Warnings: History, Theory, Context* (Lanham, MD: Rowman & Littlefield, 2017).

81 Allison Hitt, "Melanie Yergeau, 'Disable All the Things' ~ KN₁," June 24, 2014, http://www.digitalrhetoriccollaborative.org/2014/06/24/melanie-yergeau-disable-all-the-things-kn1/; and Angela M. Carter, "Teaching with Trauma: Disability Pedagogy, Feminism, and the Trigger Warnings Debate," *Disability Studies Quarterly* 35, no. 2 (2015), http://dsq-sds.org/article/view/4652/3935. See also Eleanor Amaranth Lockhart, "Why Trigger Warnings Are Beneficial, Perhaps Even Necessary," *First Amendment Studies* 50, no. 2 (2016): 59–69; Logan Rae, "Re-focusing the Debate on Trigger Warnings: Privilege, Trauma, and Disability in the Classroom," *First Amendment Studies* 50, no. 2 (2016): 95–102; and Alison Kafer, "Un/Safe Disclosures: Scenes of Disability and Trauma," *Journal of Literary & Cultural Disability Studies* 10, no. 1 (2016): 1–20.

82 See, e.g., Laura Kipnis, *Unwanted Advances: Sexual Paranoia Comes to Campus* (New York: Harper, 2017).

83 Jack Halberstam, "You Are Triggering Me! The Neo-liberal Rhetoric of Harm, Danger and Trauma," *Bully Bloggers*, July 5, 2014, https://bullybloggers.wordpress.com/2014/07/05/you-are-triggering-me-the-neo-liberal-rhetoric-of-harm-danger-and-trauma/.

84 See Andreas Huyssen, *Miniature Metropolis: Literature in an Age of Photography and Film* (Cambridge, MA: Harvard University Press, 2015).

85 Fredric Jameson, "Cognitive Mapping," in *Marxism and the Interpretation of Culture*, ed. Cary Nelson and Lawrence Grossberg (Urbana: University of Illinois Press, 1988), 347–360.

Part I

Violence and Testimony

1

Theorizing the Unwatchable

Positing the unwatchable as a key concept in the history of aesthetics and in our contemporary media and political environment, the essays in this opening chapter address a core set of questions. What distinguishes watching from other modes of vision (e.g., seeing, gazing, beholding), and how do we differentiate the watchable from the unwatchable, and the unwatchable from the invisible? Is any particular content ontologically or metaphysically unwatchable, or does the category function instead as an aesthetic judgment or moral imperative? And, lastly, what political work does the concept of the unwatchable perform (or fail to perform) in our time, characterized by neoliberal threats to democracy, the resurgence of right-wing populism, and accumulating incidents of political violence and ecological disaster?

Media theorist W. J. T. Mitchell traces the idea of the unwatchable back to religious notions of aniconism and iconoclasm and discerns an ongoing dialectic between prohibition and desire in the field of visual culture. Whereas Mitchell discusses Chris Ofili's painting *The Holy Virgin Mary* and an episode of the TV series *Black Mirror*, philosopher Boris Groys concentrates on contemporary installation art, which has assumed the project of early twentieth-century avant-garde movements in dissolving the distinction between art and life. Drawing from Hegel's and Heidegger's philosophical aesthetics, Groys argues that

living *inside* art is the sole way of relating to a truth that cannot be presented in external, imagistic form.

Cultural theorists Stefano Harney and Fred Moten extend Groys's argument to the sphere of politics, suggesting that blackness is unwatchable from an outside position—a point they elaborate in a Marxist and Schmittian-informed discussion of security and surveillance apparatuses and issues of law, criminality, and spatiality. Psychoanalytic philosopher Alenka Zupančič defines the unwatchable as the "melting into visibility" of an ontological impossibility, using the Buchenwald concentration camp and the 2017 "Unite the Right" rally in Charlottesville as her examples. She further critiques the neoliberal rhetoric of self-care, calling for a focus on what Lacan termed "objective feeling" rather than personal triggers.

Like Zupančič, film and media scholar Meghan Sutherland maintains that the watchable and unwatchable have become interchangeable designations. Bringing the chapter full circle to the discussion of social anxiety, moral prohibitions, and modes of vision, Sutherland argues that insofar as watching relates to formal qualities of visual attention, the unwatchable is undefinable in terms of specific content. It is for this reason, she finally suggests, that the concept of the unwatchable cuts across the traditional division between "high" and "low" culture.

Unwatchable

W. J. T. MITCHELL

A dear friend of mine loves movies so much that the worst thing he can find to say about a film is that it is "watchable." We know that when he says something like this, it really means that the movie is terrible, but nevertheless there is something in it, however minor, that deserves attention. The great film director John Waters, asked in an interview which films he cannot bear to watch, confessed that he simply loves to watch movies, and when he sees a bad one, he always finds something to enjoy, something as simple as the miraculous apparition of a lamp glowing in the corner of a room.

I find the question "what do you find unwatchable?" very difficult to answer. In fact, I am tempted to say that I cannot think of anything that I find unwatchable, except, increasingly, professional football with its unending parade of injuries. Still, I find myself making exceptions with no good reason except that it is a Big Game. As a scholar of something called "visual culture" or "visual studies," moreover, I feel professionally obliged to study the unwatchable, the watchers, and their guardians.

But first, perhaps we should consider things that are invisible or unsee-able, things that I am physically prevented from seeing. Clearly I can-not watch things that cannot be seen. If my TV is broken, I can't watch

Title image for Charlie Brooker's *Black Mirror*.

it, though if I wanted to be perverse, I could sit for a while and watch the TV set itself. Since, as I write, my eyesight is failing and I am looking forward to a cataract operation, there is an increasing number of things in the world I cannot see. Road signs are becoming increasingly illegible. As they grow faint, however, my desire and need to watch for them only grows, and my wife spends more time telling me to watch where I am going when we drive into the city.

So seeing and watching are quite distinct activities, the passive and active poles of the scopic field. We see lots of things that we do not watch, or (more precisely) watch *for*. In fact, most of the things we watch for are things that we cannot see, things we are looking for, waiting for, trying to bring into focus. Should we say that the less we see, the more watchful we become? Is watching a form of trying to see? Of keeping your eye on the ball? Watching is attentive, focused seeing, but perhaps not the only kind. Beholding, staring, and gazing, for instance, seem to occupy some middle zone between seeing and watching. The beholder (especially of art) is usually portrayed as a kind of hybrid figure, cultivating a "wise passiveness" of looking, receptive but well trained. Staring is, of course, impolite. It is the shameful moment when someone is caught watching in a way that he or she shouldn't, closely related to a voyeur who is caught in the act. And gazing is closely related to beholding, but perhaps even more passive: it is a kind of ruminative, contem-

plative, even bovine exercise of seeing, abstract and detached—a bit like John Waters's finding of pleasure in even the worst movies.

So what does the "un-" add to or subtract from watching and the watchable? How does this negation of seeing work? The obvious starting point is to divide what *should not* be watched, because it is prohibited, forbidden, from what we *cannot bear* to watch because it is too painful or disturbing. But this distinction is frequently blurred in practice. The feeling that I cannot bear to watch something can, under the right social conditions, become a moral imperative that *no one* should watch it. If I cannot stand to see pornography, and "I know it when I see it," the next step is to ban it for everyone else. Scenes of cruel violence and torture that are unbearable to some are prohibited from being seen by others. So "unwatchability" is frequently accompanied by an asterisk that divides those who can or must watch (e.g., grown-ups, police, and other professionals) from those who should not (e.g., children and vulnerable, sensitive souls). There is also the prohibition on *merely* watching something, particularly the suffering of others, while remaining detached and even taking pleasure in the spectacle. Why is there something deeply tasteless about a president of the United States visiting the spectacular flooding of a city, praising the size of the crowd that comes to meet him, and never bothering to meet a single victim? Why did George W. Bush's flyover of the disaster of Hurricane Katrina prove so politically damaging? If one is going to watch, so goes the feeling, one should also be prepared to act. "I just like to watch" is almost always a morally ambiguous declaration, especially when it has to do with what someone else regards as the unwatchable.

Moral prohibitions on seeing and showing are everywhere: images of god are forbidden, not because we *cannot* see them, but because we *should* not. Therefore, when they are shown, there is a powerful urge to destroy the images themselves, sometimes right along with their beholders. Iconoclasm is the attempt to transform the morally or politically unwatchable into the literally unseeable, and to convert or disappear the watchers. When a pious Roman Catholic smeared paint over Chris Ofili's famous *The Holy Virgin Mary* (aka "Madonna with Elephant Dung") at the Brooklyn Museum some years ago, his intention was not to disfigure or erase the Madonna (whose image is not prohibited but celebrated) but to protect the Madonna from being seen in the

wrong way, accompanied by the obscene material of shit. He was happy to venerate the Madonna as represented in visual images, but this particular image he found unbearable, unwatchable. His action had the predictable effect of making many more people come to the Brooklyn Museum just to see the defaced painting.

The best rendering I have seen of the dynamics of the unwatchable is the first episode of the British television series *Black Mirror*. In this episode, a popular British princess has been kidnapped and is threatened with death if the prime minister refuses to fuck a pig on live television. As popular sentiment trends toward the minister giving in to this demand, he is finally compelled to do it. The government urges viewers not to watch this obscene spectacle as a way of resisting terrorism. But of course the mandate has exactly the opposite effect, and pubs all across England are jammed with eager spectators who await the broadcast in a kind of festival atmosphere. When the telecast is finally shown, however, a strange alteration occurs in the faces of the spectators. It takes the disgusted PM over an hour to fulfill the demand by completing the sex act. As the show goes on, the faces in the audience begin to shift to appalled disgust and horror. People begin to look away. The princess is released unharmed on a bridge over the Thames, but no one notices because they are all jammed into the pubs. It turns out that the kidnapper was not a terrorist, but an artist who was staging the entire thing as a performance. He had already released the princess and hanged himself *before* the deadline he had given the PM. His performance is quickly declared by sophisticated critics to be the first great work of art of the twenty-first century.

The declaration of the unwatchable, then, can often have just the opposite of its intended effect. To be told you must not see or show something is arguably the greatest temptation to do both. Thankfully, *Black Mirror* does not show the sex act, focusing instead on the faces of the spectators. I think that may be the general lesson to be learned from the category of the unwatchable. There is nothing in the world that is metaphysically and absolutely unwatchable. Or at least I personally have not been able to come up with an example of something I find unwatchable, because the minute I think of something, I begin to imagine what seeing it would be like, and how I would manage the pain or the shame. What we need to keep watch over, clearly, is ourselves.

The Gaze from Within

BORIS GROYS

The most famous statement concerning art and the unwatchable belongs to Hegel. Almost at the beginning of his *Aesthetics*, Hegel writes that in the relationship to its highest goal, which is to present the truth, art is for us a thing of the past.[1] Already in his *Phenomenology of Spirit*, Hegel insists on the critique of "picture-thinking" (*Bilddenken*).[2] To the ancient Greeks, the gods presented themselves as statues, as images. But already Christianity taught us to distrust images, proclaiming God to be invisible. However, Hegel's attitude toward images is more complicated. He does not believe that art cannot present the truth as an image because the truth is hidden behind the surface of the visible, sensible world. Hegel does not share Kant's understanding of truth as a transcendent "thing in itself" (*Ding an sich*). Rather, he believes that truth resides in the "Spirit that is in and for itself" (*Der an- und fürsichseiende Geist*).[3] In other words, we are not outside but inside the truth. And, being inside the truth, we cannot see it—we can only move within it following the movement of the truth itself by submitting our own thinking to the rules of dialectical logic. Our social life is regulated by a system of laws. Our relationship to nature is defined by science. We can understand law and science, we can think them—but they do not show themselves as images. The only way in which art can relate to the truth is not through

39

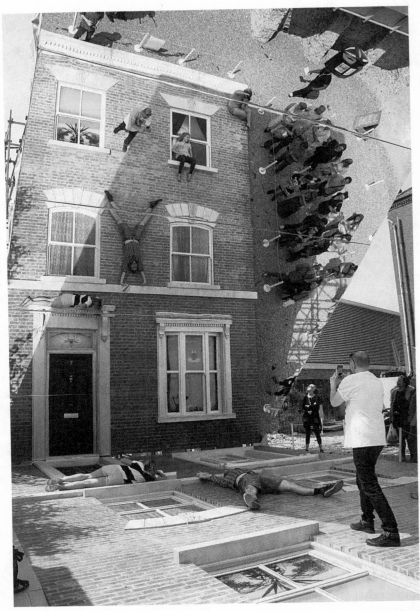

Dalston House installation by Leandro Erlich in Dalston, London in July 2013, via Creative Commons.

contemplation of images but rather their production. By producing art, we present our thinking in the context of the outside, sensible world. But our thinking is presented there in an alienated (*entäußerten*) form.[4] Hegel sees art as a low level of spirit, but he also believes that the true spirit cannot ignore any of its levels and forms—even the alienated ones. Thus, the goal of philosophy is to bring art back into the realm of the spirit and on the level of the "notion" (*Begriff*) that is obviously invisible.

Therefore, the true problem in the relationship between art and truth is that we are always inside and not outside the truth. And because this is so, we are not able to see the truth and, thus, to produce an image of truth. This is the same problem that Heidegger confronted as he tried to reestablish the relationship between art and truth in his *Origin of the Work of Art*.[5] Heidegger defines human existence as "being there" (*Dasein*)—actually, as being in the world. Here human existence is defined again by the impossibility of making a picture of the world (*Weltbild*). The human being is not a subject who is able to see the world as an object. Humans are always inside the world—surrounded by "concealment," by darkness. Of course, Heidegger believes that from time to time Being opens a clearing in this darkness (*Lichtung des Seins*).[6] And the individual can see something in this clearing that looks like a picture, an image. But at the next moment—when the artist creates an artwork based on his vision—the concealment, the darkness around him closes again.[7] The artwork becomes only a thing among other things, an object for the art business: for the practice of selling, buying, exhibiting, and so on. Here again, art functions as an alienated form of our existence inside the obscure movement of Being—similar to Hegel's view that art is an alienated form of our thinking inside the dialectical movement of Spirit.

So what should artists do if they want to make art the medium of truth again? Obviously, they should not produce images because such production is a lie: it suggests that we are subjects who can see the world as an object, whereas in truth we live inside the world and cannot see it. Thus, the only way for art to become true is to substitute life. Instead of living inside Spirit or inside the world dominated by Being, humans should begin to live inside art. That was basically the project of the radical avant-garde. I mean here Russian Constructivism, Bauhaus,

De Stijl. The ultimate goal of these artistic movements was to put man into a new, totally artificial environment. Here art is understood not as the production of images that should be contemplated but as the creation of new conditions of human existence. Here man does not see art but lives inside art. Art ceases to be visible, watchable—but becomes experienceable from within. These avant-garde projects were not realized in their totality. But they have been inherited and partially realized by contemporary installation art.

What is the main difference between the artistic installation and curatorial project, on the one hand, and the traditional exhibition, on the other? The traditional exhibition treats its space as an anonymous, neutral one. Only the exhibited artworks are important—but not the space in which they are exhibited. Thus, these artworks are perceived and treated as potentially eternal, and the space of the exhibition as contingent, accidental. By contrast, the installation—be it an artistic or curatorial installation—inscribes the exhibited artworks in this contingent material space. The installation is a *Gesamtkunstwerk* because it instrumentalizes all the exhibited artworks, makes them serve a common purpose that is formulated by the artist-curator. Any particular installation is able to include all kinds of objects—some of them traditional artworks, some of them time-based artworks or processes, some of them everyday objects, documentations, texts, and so forth. All these elements, along with the architecture, sound, or light of the space, lose their respective autonomy and begin to serve the creation of the whole in which visitors and spectators are also included. So one can say that the artist-curator functions here not as a form-giver but as a lawgiver. He or she creates an order to which all the elements of the installation are submitted. The visitor of the installation also becomes submitted to this order because it guides the visitor's gaze and the trajectory of movement inside the installation space. The visitor cannot see the installation space in its totality. The visitor's gaze is always the gaze from within. Law and order that organize the space of the installation cannot be seen—they can be only thought. Here art crosses the border between "picture-thinking" and "notion." To use a concept introduced by Carl Schmitt, one can say that the space of installation is the space of the state of exception: here the artist-curator becomes the sovereign lawgiver—and, thus, the law reveals its artificiality.[8]

Nowadays, one speaks time and again about the theatralization of the museum and the art system in general. However, there is a crucial difference between the installation space and the theatrical space. In theater, the spectators usually remain in an outside position vis-à-vis the stage—in the museum, they enter the stage and find themselves inside the spectacle. Thus, the contemporary installation space realizes the modernist dream of a theater in which there is no clear boundary between the stage and the space for the audience—the dream that theater itself was never able to realize fully. Even if Wagner speaks about the *Gesamtkunstwerk* as an event that erases the border between stage and audience, the Festspielhaus in Bayreuth that was built under the direction of Wagner not only did not erase this border but, rather, made it more obvious.

The installation is an event—it cannot be kept forever. It also cannot be moved to another place because it is dependent on a particular space. Because the installation cannot be seen from the outside but only experienced from the inside, it also cannot be reproduced but only documented. But, unlike reproduction, the documentation always produces a certain nostalgia for missed presence. Traditional artworks can be contemplated because they are artificially protected and stabilized in time by the technology of conservation, restoration, and reproduction. In this respect, traditional art simulates the eternal presence of Platonic ideas by creating the technological conditions for *vita contemplativa*. But in our time, art has begun to practice the strategies of self-fluidization instead of self-eternalization. In this way, art simulates and aestheticizes the unobservability and unpredictability of the "real" world of action. In the space of installation, we are artificially put in the clearance of being of which Heidegger spoke. But our next step is not a passage to an action leading us back into the obscurity of being. Rather, the next step is toward the exit sign.

Notes

1 G. W. F. Hegel, *Vorlesungen über die Ästhetik I*, in *Werke in 20 Bänden*, Band 13 (Frankfurt am Main: Suhrkamp, 1970), 25.
2 Hegel, *Phenomenology of Spirit*, trans. A. V. Miller (Oxford: Oxford University Press, 1977), 35–36.
3 Ibid., 325.

4 Hegel, *Vorlesungen über die Ästhetik I*, 28.
5 Martin Heidegger, *The Origin of the Work of Art*, trans. Albert Hofstadter, in *Basic Writings*, ed. David Farrell Krell (San Francisco: HarperCollins, 1977), 143ff.
6 Ibid., 147.
7 Ibid., 178.
8 Carl Schmitt, *Political Theology*, ed. and trans. George Schwab (Chicago: University of Chicago Press, 2005), 5ff.

The Unwatchable and the Unwatchable

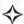

STEFANO HARNEY AND FRED MOTEN

1.

What can't be watched? What violates the idea of security and surveillance, makes this idea unworkable, short circuits and overflows and overheats and enrages the watch? The watch chain allows for policy questions like who watches the watchers. Checks and balances. No, we bounced. The unwatchable are the intolerable. Who does not accede to being watched but turns unwatchable instead? Was always unwatchable but not in relation to the watchable? Never there, never a population, but declare, in violation of being watched, "watch meh now!?" We, that's who, we say to more + less than one another, which is us. Who can't you look at? Who you lookin' at, motherfucker? Who'd rather go blind?

2.

Security and surveillance, in all their guises, can't be watched, either. It's not just that we don't want to; it's also that even if we did, they're bound to disappear. Part of why we can't watch that shit is its constant

Jack Tan (2015). Visitor Service Officer (durational performance) in *How to Do Things with Rules*. Exhibited at the Institute of Contemporary Art Singapore, August 12–September 29, 2015. Photo: Olivia Kwok, © Courtesy the artist.

overlooking of what it can't watch, of who won't be watched, us saying "watch me!" to one another being no one in particular. Such overlooking is a brutal form of overseeing. It leaves a trace effect, some residue, the left. It takes up the space it disavows in overlooking like a big ol' gentrifier, a hip settler, the one with the public-private police and the worldly, deictic frame; the one who imagines himself to be constantly outsmarting himself with certain geometric maneuvers—like triangulating, or taking the center, or taking over a school in the name of STEM. The left not only hates the place it takes up but also the people it represents in overlooking and overseeing them. It thinks they are deplorable and, in its dotage, it's stupid enough to say so. Its game of position and removal is where surveillance and disregard converge. You could call this convergence emessenbeseeing but that lets all manner of loud decolonizers of the gentry off the hook. We see you, they say. We're the night watch. You know, artists and shit.

3.

Marx says somewhere that the criminal produces the criminal justice system. So, what does criminality, which is to say what do we who produce laws made to be broken, produce? Doesn't criminality call order into being with its call to general disorder? Then if we who produce laws made to be broken produce, or perhaps call into being, politics, we necessarily fall before, beyond, and outside of politics. Indeed, we fall, in other words, outside, under, and around the state of exception that is politics' essence and its end. To watch us is to fall into politics; to watch with us is to fall outside of politics with us; it is to fall into our arms. And they could never watch us without falling for us, we who hold them up by holding each other up. Their crush is deadly. They are the refuse that refuses refuge and visitation. They fall on us when their eyes fall on us. In our fallenness we are befallen by their upright stance. Blackness isn't unwatchable because of whiteness, because whiteness needs it to be, or because whiteness cannot see it; it's not invisible, or surveilled or evaded in dark sousveillance, or exaggerated, or desired; it's not subject to (color) correction even in the total, broken ubiquity of the institution, though the unwatchable may be given all these explanations. Blackness is unwatchable because there's no way to watch it that ain't in it, no way to watch it from the outside, which is to say from its anti-black and worldly effects: politics, policy, legality.

4.

Once there was an artist who was a lawyer. He was demonstrative in his doubleness[2], always showing himselves[4] making a show of himselves[16] with meta-prosecutorial zeal. There was nothing unsettling about it. It was reassuring to the edifice, like a buttress. He only said, "watch me!" to them and they loved it, saying so through him, his having been encrypted long before he declared the need for secrecy. In this regard, which is disregard, he played an agent from below, and we weren't even there. We don't show up for him when he shows out in uniform. He holds up the one he can't take his eye off and we are indirectly overseen by a leftover, an activist in a hall of mirrors. He overlooks us. He won't watch with us. He misses all the little differences we feel. Our flesh is ours. His will ain't his. We hand around. He looks away. He can't watch us. We can't watch him.

Melting into Visibility

ALENKA ZUPANČIČ

One should be careful not to reduce the quality of the unwatchable to any particular content. For the problem is not simply that the unwatchable usually (re)presents certain things—actions included—which we think should have never taken place and/or are too painful to watch. The unwatchable also has to do with (the laws and the logic of) visibility, of (re)presentation or (de)monstration as such.

Let me start with what is undoubtedly a commonplace example—but one that is commonplace for a reason. My most traumatic experience with the unwatchable was a visit to Buchenwald concentration camp some fifteen years ago. This may seem to be "obvious" and self-evident—after all, we were all brought up to be horrified by the Nazi extermination camps. But this obviousness makes us miss what is really unwatchable (unbearable) in such sites. When travelling and sightseeing, we usually visit places of certain significance. These can be places for which we have some kind of admiration, awe, or respect, or else ones in which horrors are explicitly turned into thrilling and exciting tourist experiences (such as the London Dungeon).[1] To put it even more simply: when we visit a tourist site, we are expected and encouraged to find the whole experience (even if it is related to some horrors of the past) aesthetically and/or intellectually rewarding, interesting, satisfying, and

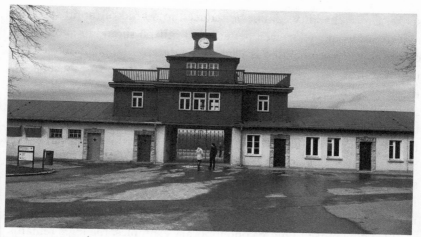

Visiting Buchenwald.

pleasurable—although this pleasure may not be of an immediate kind, but may involve negativity and be more complex and reflective. When it comes to "visiting" a concentration camp, however, the idea that we could find the whole experience somehow rewarding, interesting, and satisfying is itself a source of horror, a factor of the "unwatchable." Strictly speaking, there is no subjective position from which to watch this "sight." There is nothing unbearable in what is on display there; in the remains of the concentration camp, it is all very trivial. What is unwatchable is that its "ovens" (crematoriums) inadvertently figure as its main "attractions"—which they do the moment we approach them with the guide map of the camp in our hands. What is unwatchable is not the ovens themselves, but the very facility with which they are being watched.

As Tomo Stanič forcefully put it in his recent (yet unpublished) dissertation: "The indescribable horror is not without description, it is a shadow of extremely precise and technicistically describable events. . . . The problem is not that there would be something unthinkable and impossible [in these events], on the contrary, the problem is that too many things came to be thought—something that ought not [do so] melted into visibility." I think this is the most concise definition of the "unwatchable": something that ought not (do so) melts into visibility. The "ought not" is used here not in the moral sense, but in a stronger, ontological

sense. Unwatchability cannot be reduced to a kind of moralistic out-rage about what we (or even better, what others) should or should not do or show. Unwatchability is a subjective declaration of an ontological impossibility: "This simply cannot be (or else I disappear as a subject), this is 'ontologically wrong'!" In this precise sense, the effect of unwatch-ability, interrupting the smooth-running stream of visibility, is some-thing positive. The impossible-real that is excluded from the thing as the latter appears in perfect visibility returns in the form of a subjective affect. Yet there is nothing really "subjective" in this affect (in the usual sense of being dependent on individual idiosyncrasies), which is why Jacques Lacan called this kind of affect an "objective feeling" or a "feel-ing which does not deceive."

If we now move to more contemporary examples, the logic remains the same. Images from the recent white supremacist rally in Charlot-tesville were unwatchable because they were so watchable, so easily and widely watched. Things were said there that should have been impossi-ble to be said (publicly). Something melted into words, into visibility, that ought not do so. The shock was there. On a (public) stage, the U.S. president then sought desperately not to declare this unwatchable, but to frame it in such a way that it would become perfectly watchable: simply one of the human follies taking place "on many sides," as he infa-mously put it. Unwatchability as objective feeling, with possible political consequences, is becoming a prime victim of the (neo)liberal "democ-racy of the watchable" (or "democracy of the unwatchable," which amounts to the same thing). To everyone his or her "unwatchable"! To absorb this, the other side of this same neoliberal discourse invented political correctness and (more recently) "trigger warnings." The issue has become that of how to protect yourself from your own personal unwatchable. This personalized unwatchable is favored because it has precisely zero political weight.

But this does not mean that the objectively unwatchable is disap-pearing. On the contrary, it is accumulating on a scale so grand that it is easy to miss. Things that ought not (do so) are rapidly melting into visibility, as well as into "sayability," *all over the place*. This is why I would say that our world itself has become an unwatchable object or place. Yet the problem is precisely not how to protect ourselves from the unwatchable, but how to reclaim its *objective* point and to unite and

organize around it. The question is how to move from what is in truth a perfectly *apolitical correctness* to a collective, and hence political, "this cannot be!"

Note

1 People being tortured and killed has never really been among "unwatchable" experiences, at least not for most people—and I'm not only talking about modern pop culture, but also massively attended public tortures and executions that Foucault talks about in his *Discipline and Punish*.

Pro Forma

MEGHAN SUTHERLAND

Like many kids born in the seventies, I spent the Saturday mornings of my youth watching television—not television shows, but the television set. The shows were of course a welcome addition to the screen when they came on at eight o'clock, but they were not essential. The anticipation of their arrival was enough to draw me from my bed to the TV in the living room well before the programming day began. I simply knelt in front of the console, face-to-face with the screen, and waited in expectation for the dawn of ABC. And if the iconic image of the little girl kneeling before the television set in the horror film *Poltergeist* (1982) is any indication, I was not alone. And that frightened people.

Such is the horror evoked by the act of *watching* in its barest, most baldly televisual sense. Although parents, teachers, and cultural dieticians of every sort tend to couch their concerns about those of us who watch lots of television in the language of specifics—*this* violent film, *that* image of sex—the truth of the matter is that they are worried first and foremost that we are simply watching nothing. That watching itself is nothing, and that it is not *one* bad thing we are willing to watch, but *anything at all, indefinitely.* Worse yet, they worry that we'll watch this undefined stream of bilge flowing into the holes in our faces in a state of bleary receptivity, either because we are "impressionable" young

Still from *Poltergeist*.

children—or worse yet, impressionable young girls—or else because we threaten to become so on account of the watching we're doing.

It would be hard to dismiss this worry entirely. The concept of "watching" comes from the Old English word *waecce*, "a state of being or remaining awake" that derives from the Latin for "vigilance," and for most of its etymological history the term has been used to refer to the wakefulness of religious rituals, military guards, and penitents.[1] In other words, the concept of watching itself has less to do with actually *seeing* something bad or good, pleasurable or unpleasurable per se—or for that matter, with seeing any particular *content* or *text* in its discrete specificity—than it does with an expressly *formal* and *institutional* disposition of mandated yet indeterminate attentiveness. In fact, none of the primary definitions for the term even mention vision itself, let alone the forms of passivity that typically serve to explain the anxiety of watching in the context of modern critical and cultural theory.

One can hear the traces of this etymological history most clearly in the Italian verb "to watch," which is simply *guardare*—a gesture toward the active vocational responsibilities of protection and of witness, rather than seeing or not seeing a specific thing, liking or not liking what we saw, or even *perceiving* anything in the first place. After all, if we are guarding something it's because we cannot anticipate the precise moment or embodiment of whatever threatens it, and because we feel

responsible to do just that. But this case is really just an exclamatory instance of all the others. Indeed, to "watch" in any of the circumstances mentioned above is not simply to engage in an extension of attention that is defined above all by its temporal, territorial, and instrumental scope, and is compelled by the disciplinary authority of a spiritual or social structure to which we actively subject ourselves regardless of our personal inclinations and sensibilities; it is also to engage in this labor of responsibility preemptively, without any predetermined outcome or predictable target of scrutiny apart from the spatiotemporal parameters established for our attention.

In this sense, the concept of watching should be recognized as part of a discourse of visual conduct that specifically implies the *absence* of both specificity and content as such, to say nothing of visual pleasure and desire. It is the subjective silhouette of this absence in all its generality, the name for an expressly technological deployment of visual awareness that is carried out *pro forma* as an end with no single end in sight—a liminal drive toward the formal ideal of vision-as-coverage that effectively purges that vision, to the fullest and most paradoxical extent one can imagine, of the very same affective and sensorial properties on which that ideal of vision depends for its most basic claim to efficacy. So if we enjoy the experience of watching or would like to say that we do, it's presumably for the same reason that any Lacanian would tell us that we enjoy doing anything: because we like the work.

This set of circumstances may help to explain why the experience of worry and the transmission of this worry to others—the watching that watching requires—seem so fundamental to the act of watching and its ethos. Because the activity of watching has more to do with a *formal* disposition of attentiveness that is compelled by an institutional structure than with seeing or with content per se, and in many cases is implicitly devoid of either one, the very formality of this disposition almost inevitably conjures the threat of its own supersession by the experience of sensory plenitude that is its condition. After all, everyone with any authority knows that you have to *watch* a person given to such a generalized vocation of perception—that every instrumental extension of the senses, especially one that demands a degree of indeterminacy or excess, is haunted by the prospect of its exhaustion, corruption, and negation as such. And in this sense, the anxiety produced by watching

is ultimately just one more reflection of the voluptuary system of liberal democracy more generally—a system predicated on the nonsystematic, despite all claims to the contrary.

Incidentally, this same set of circumstances may also explain why the discourse of the watchable, like the discourse of the *un*watchable it animates, is so hopelessly bound to an aesthetic compass of morality— and also why it inevitably sets that compass spinning to its antipodal extremes, wherein the watchable and the unwatchable become indistinguishable from one another. To the extent that the authority of an institution serves as the essential point of reference for this discourse, the designation of what *can* or *cannot* be watched is always implicitly a statement on what one perceives one *should* or *should* not watch according to the ideal of visual conduct set in place by that authority, and one is always already either violating or fulfilling its logics. And as the suffix -*able* in the term further underscores, the violation or fulfillment of these logics is implicitly understood as the product of a disciplinary faculty or a cultivated skill. But for precisely the same reason—namely, because the discourses of watchability and unwatchability invariably refer back to an institutional standard or ideal of mandated looking and attention, and because the very notion of an "ideal" vision implicitly purges that vision of both pleasure and vision at once—the two swap places as freely as any other pair of uncanny doubles.

For instance, if we declare a film or a TV show to be watchable, it's only ever as a gesture of faint damnation. It means this *should* be watchable—at least according to a cultural authority and a set of programmatic tropes of taste and capacity that I would not even bother to countenance as a matter of sensibility—but it brings me little if any pleasure, and demands even less of my attention. I simply *humor* the paradigm, either happily or unhappily. I watch without watching anything. Conversely, if we declare something *unwatchable*, it usually amounts to a dismissal from the opposite pole of emphasis—such that we *can* see something, literally, but we reject the very possibility of either enduring or feeling genuine aesthetic appreciation for something so clearly defined by the protocols of a system and its taboos. And yet, in another reflection of the interchangeability of these two designations, declaring something unwatchable can also amount to a gesture of aesthetic and political defiance—such that we embrace the sensorial experience of

watching precisely what the system declares we either cannot or should not be able to watch, and we do so to demonstrate the very formal possibility of "watching" in its purest dispositional mode of existence. But because the institutional imperatives of "high" culture can seem just oppressive as those of "low" culture when it comes to the protocols of sustained visual attention, it matters little whether we are declaring Warhol's *Empire* (1964) or *All My Children* (1970–2011) to be unwatchable, and it means almost the same thing to declare them merely watchable. Simply put, the institutional imperative of visual attention embedded in the concept of "watching" itself ensures that it is always an inverted and thoroughly polarized statement on the disciplinary paradigms of mandatory viewing that structure the relation between the "high" and "low" institutions of visual culture and their contravening protocols of sensibility—such that "watching" is always a form of not watching, and the critical categories of the watchable and the unwatchable are the equal and opposite negatives of aesthetic moralism writ large. These categories are, in short, the very essence of nullified vision—not simply a state of activity or passivity, instrumentality or excess, but the *pro forma* of visual consciousness writ large that renders the relation between all such terms undecidable.

Note

1 "Watch, n." and "watch, v.," in *Oxford English Dictionary Online*, www.oed.com.

2

Spectacles of Destruction

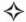

As Susan Sontag noted in *Regarding the Pain of Others* (2003), images of catastrophe haunt modern life. Since the nineteenth century, photographic technologies have afforded endless opportunities to view calamities occurring across the world. Yet what remains unrepresented, abstracted, obscured from view, or beyond our capacities for vision and understanding? The essays in this chapter focus on the problems of visualizing atrocity, whether nuclear detonation, remote-controlled warfare, climate change, or natural disaster.

Take the Tsar Bomba, a hydrogen bomb dropped by a Soviet aircraft on an arctic archipelago in 1961. For art historian Jonathan Crary, the Soviet nuclear test is not only horrifying, but also quasi-pornographic: "a convulsive discharge of energy on an unimaginable scale." Situating the development of nuclear weapons within the history of vision and science, Crary emphasizes that the Tsar Bomba footage represents a phenomenon that no human eyes can view directly, exceeding established aesthetic categories such as the sublime.

Addressing a similar aesthetic dilemma, literary scholar Poulomi Saha analyzes the unmanned aerial vehicle (UAV) technology that "remove[s] the human eye from the pilot's seat." While the collateral damage of drone strikes is often obscured within political discourse and unseen by the American public, the issue of civilian casualties has nonetheless been thematized across various media—from the popular television

show *Homeland* to data visualization projects that have pushed for greater transparency and accountability.

Like modern technological warfare, climate change often remains invisible and is enormously difficult to counteract. Film and media scholar Alex Bush discusses media coverage of an Antarctic ice shelf, Larsen-C, which saw a trillion-ton iceberg break off in 2017. The unthinkable implications of global warming and the simultaneous imperative to remain ethically responsible haunt Bush, who historicizes her paralysis by spectacles of ecological catastrophe through the archive of silent films depicting polar exploration.

Problems of representation are also central to photography theorist Meir Wigoder's discussion of television disaster coverage. With their satellite weather images and drone shots, news reports make a spectacle of hurricanes and other storms, abstracting viewers from the actual devastation and suffering. Drawing from Siegfried Kracauer and Roland Barthes, Wigoder focuses on contingent moments that break the logic of sensationalist television broadcasts, laying bare the unwatchable as "all that we cannot bear to anticipate and imagine."

Terminal Radiance

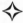

JONATHAN CRARY

Among the many billion diversions accessible on YouTube is video footage taken through the window of a Soviet bomber on October 30, 1961, moments after dropping Tsar Bomba on the island of Novaya Zemlya above the Arctic Circle. The film records what is by far the largest human-caused explosion ever on the planet, that of a fifty-eight-megaton hydrogen bomb, four times more powerful than any prior or subsequent blast. When set against the hundreds of films of other nuclear explosions, its singularity isn't visually obvious. One listens to the narration of stupefying statistics: the mushroom cloud is over forty miles high, the fireball five miles in diameter, it is thirty-eight hundred times the destructiveness of a Hiroshima-size weapon, ensuring the annihilation of anything living within a sixty-mile radius of its impact. But to watch this film and gape at the colossal radial symmetries of the detonation and its ghostly luminosities is to succumb to an aestheticization of this extreme limit of nuclear terror.

Beginning in the 1950s, film clips from U.S. nuclear tests were woven into the kitsch of Cold War consumer culture. Images of the South Pacific blasts were part of an iconography of scientific mastery that partly domesticated nuclear savagery and aligned it with fantasies of material progress and middle-class affluence. In his explorations of the links between kitsch

Tsar Bomba. Still from YouTube.

and death, Saul Friedlander remarks that kitsch produces "the neutraliza-
tion of extreme situations," by making death into something ritualized or
stylized that effaces the actual horror.[1] He identifies, in Nazi kitsch, a con-
sistent presentation of death as "paroxysm" or "explosion." The atomic
test films obviously are the product of different historical factors, but their
fascination can clearly be traced to some of the same psychic processes.
The video of an atomic bomb explosion replicates a pornographic image
in its endlessly repeatable display of a convulsive discharge of energy on
an unimaginable scale, and the Tsar Bomba film is the ultimate, unsur-
passable "money shot" of a potency and expenditure beyond measure.

Steven Shaviro has noted the interconnection between pornography
and horror as crucial to understanding the attraction of the cinematic
image.[2] His association of film spectatorship with "the extinction of
sight" is extravagantly demonstrated by film of an event that is, from a
human vantage point, literally unseeable: even distant viewers of a
nuclear blast will be blinded by third-degree burns on an unshielded ret-
ina. Part of the obscenity of the test films, made solely for analysis in the
development and enhancement of future weapons, is the making visible
of the unwatchable. A viewer occupies the vantage point of the recording
device, the mechanical eye of the perpetrator, of the weapons designers.
Using the formulation of Rey Chow, these films position the world itself
as a target, and thus an object to be destroyed.[3] The formal properties of

TERMINAL RADIANCE ✧ 61

the spheroidal fireball or the swirling undulations of the mushroom cloud lodge the event within the confines of the image and spectacle. The unthinkable, unutterable violence of this outer limit of the real is deleted.

It's perhaps understandable, if not justifiable, that Alain Badiou chose to omit any reference to the leveling of Hiroshima and Nagasaki (or to the nuclear arms race) in his book *The Century*, on the implacable violence that he sees as the defining heart of the twentieth century.[4] Badiou postulates a pervasive and quasi-heroic "passion for the real" that sanctioned remorseless violence in the name of various emancipatory dreams, militant programs, or aesthetic experimentations. But his imagined history of "an absolute politics" of purification and antagonism is hopelessly irreconcilable with the visionless, futureless, biocidal madness of nuclear war. The Tsar Bomba, built by a team led by Andrei Sakharov, is the culmination of a "project" that points only to the annihilation of historical time and the vaporization of any space of social or political relations.

The filmic representation of a nuclear explosion is an erasure of its invisible lethality. The physics of the bomb are inseparable from the scientific investigations of the nonvisible wavelengths of the electromagnetic spectrum beginning in the late nineteenth century. During the years 1886 to 1914 there came a cascading accumulation of research discoveries that spawned nuclear weapons and many other features of the techno-political-social world we inhabit more than a century later. A very cursory outline of these years would include the names Hertz (radio waves), Roentgen (x-rays), Becquerel and the Curies (radioactivity), Villard and then Rutherford and Bohr (gamma rays). Of course these discoveries and their irrevocable remaking of visibility did not occur fortuitously or as part of some inevitable advancement of objective scientific knowledge. Rather, the devaluation of human sight happened within powerful institutional complexes specific to the nation states who were, during the same years, competing for military and economic domination on a global scale.

One of the most important developments of that 1886 to 1914 period was the research on the radioactive properties of uranium, which culminated over two decades later with the discovery of nuclear fission and the making of an atomic bomb. The use of these weapons brought into being, for the first time, conditions in which both visible and invisible wavelengths of the spectrum were directed against human life. In the initial

microseconds after a nuclear blast, invisible gamma radiation is the first to hit the human body, destroying it at a cellular level, ripping apart DNA molecules. Following the gamma ray burst are intense and blinding levels of visible light accompanied by the thermal flash of heat that sets clothes and hair on fire and melts eyeballs. Human vision becomes irreversibly exiled from a world in which this threshold of technological terror has been crossed, in which forms of radiant energy are manipulated to produce harmfulness on an unimaginable scale. This is the energy that Akira Lippit refers to as "the catastrophic light of atoms."[5]

When the Tsar Bomba detonated, the temperature of the five-mile-wide fireball reached 150 million degrees Fahrenheit, hotter than the sun. That human enterprise was able to rival, even briefly, the heat of the sun on earth might tempt some to invoke the "technological sublime." But there is no possible standpoint from which a ruinous demonstration of malevolent scientific tinkering can be framed by aesthetic categories. The supposed disabling of the imagination by the sublime and the accompanying inadequacy of representation become irrelevant, preposterous problems. Referring to the accumulated consequences of Hiroshima, Auschwitz, and Fukushima, Jean-Luc Nancy writes that human life, in its capacity to think and to create, "is precipitated into a condition worse than misery itself: a stupor, a distractedness, a horror, a hopeless torpor."[6] It's amid such a pervasive collective stupor that Barack Obama's 2016 authorization of a trillion-dollar program to "modernize" America's nuclear weapons arsenal elicited not even a whisper of protest from his admirers.

Notes

1 Saul Friedlander, *Reflections on Nazism: An Essay on Kitsch and Death*, trans. Thomas Weyr (New York: Harper & Row, 1984), 42–43.

2 Steven Shaviro, *The Cinematic Body* (Minneapolis: University of Minnesota Press, 1993), 54.

3 See Rey Chow, *The Age of the World Target* (Durham, NC: Duke University Press, 2006).

4 Alain Badiou, *The Century*, trans. Alberto Toscano (Cambridge: Polity, 2007).

5 Akira Mizuta Lippit, *Atomic Light (Shadow Optics)* (Minneapolis: University of Minnesota Press, 2005), 81–84.

6 Jean-Luc Nancy, *After Fukushima: The Equivalence of Catastrophes*, trans. Charlotte Mandell (New York: Fordham University Press, 2015), 11.

Unwatched/Unmanned

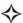

Drone Strikes and the Aesthetics of the Unseen

POULOMI SAHA

A little over halfway through Season 1 of Showtime's war-on-terror thriller *Homeland* (2011–), returned POW turned Al-Qaeda operative Nicholas Brody reveals the cause of his radicalization: Having been held and tortured, he is asked by cell commander Abu Nazir to teach Nazir's young son Issa how to speak English. The plot to conscript Brody through the child intensifies sharply when Issa is killed by an unmanned drone. We do not see the drone or the moment of explosion; we are apprised of it when Brody is catapulted, in slow motion, out of his chair by its force. Indeed, the entire scene operates by way of unsubtle insinuation. As Brody walks through the rubble, looking for Issa, children stumble by with bloody stumps in lieu of arms and parents cradle corpses like babies. Though the visible damage is largely debris and smoke, the casualties are clear long before we glimpse Issa's tiny unmoving hand. The scene revels in the sight of horror, as if in stark reminder of narrative television's ability to depict aspects of drone strikes that cannot be seen in real life—that remain unwatchable to the everyday eye.

The stage is thus set for a corrupt American official to announce that these captured images of civilian casualties (i.e., photographs of the

Aerial drone footage.

attack's aftermath) are all manufactured propaganda. Yet, otherwise, as the show suggests not inaccurately, the American public would not have seen the drone strike's wreckage. Photographic images of bodies after the strike are figured as fabrications, false narratives (or fake news) that falter in the face of the promised technological precision of unmanned aerial vehicle (UAV) technology employed by the American government. Photographs can be manipulated, altered, and decontextualized in their circulation—this is a deceitful medium in the hands of an untrustworthy foe. The development of precision drone technology—with devices such as facial recognition and advanced geospatial imagining capacities—produce a fantasy of irrefutable justification. Thus, aerial drones are imagined to be beyond technological oversight.

In eight years, the Obama administration authorized 563 drone strikes and publicly announced that an estimated 64 to 116 civilians and 2,372 to 2,581 combatants were killed between 2009 and 2015. President Obama curried some public and policy favor for his precipitous spike in the use of drone strikes, because they removed from view the spectacle of collateral damage. If drones can be made to identify individuals, to track their movements, and to drop payloads with digital accuracy, then they can absolve the public of having to see their work. The value of

the drone's unmannedness is also its liability. At the limits of what the public can see, the unaccountable can occur. Rather than quell criticism, the release of strike data heightened a public demand for transparency. Transparency is a condition of making viewable as much as visible the abstracted form of statistics, incommensurate with anecdotal and reported accounts, that neither added up nor truly disclosed the death toll. Perhaps it is the failure of quantification (however contested) to account for the loss of human life by machines that has given rise to what we might call an aesthetics of drone strike data visualization. Many artworks have attempted to problematize the relationship between technological vision and political belief. For example, Pitch Interactive's "Out of Sight/Out of Mind" (2013) digitizes attacks in Pakistan from 2004 to 2013 as individual flare colliding with and then boring through the axis of a timeline—strikes shot through chronospace.[1] Evoking the breathtaking beauty of a meteor shower, the project startles the affective and physiological response to the idea of an unmanned killing out of abstraction into awe.

"Out of Sight/Out of Mind," like Jonathan Fletcher Moore's "Artificial Killing Machine" (2015) installation and the crowd-sourced site Dronestagram (2013), is a prosthesis of sensorial empathy, supplementing and overriding the bureaucratic blinding by which drone strikes are made to vanish.[2] These projects digitally short-circuit the core of the drone program's success. The unmanned aerial drone was designed to be a perfect killing machine—not because of its precision but because, flying high above the heads of its targets and their neighbors, off the radar of public scrutiny, it is beyond oversight. Unmanned, autonomous military drones like the MQ-1 Predator and MQ-9 Reaper mobilize the designed exactness of their surveillance capabilities: the combination of spectral sensors, radar, and laser designation has removed the human from the pilot's seat, lightening its load to allow for longer flights and heavier weapons, and spatially shifting the responsibility of accuracy to a control room. Various members of the operational crew "see" through the transmitted digital image captured by the drone. However, what they see is not what the public will see, when apprised of the strikes later (if at all). What they see is not what the people on the ground see, when they scan the skies for the unpiloted aircraft or when the bodies

on the ground are counted. Having removed the man from the machine, unmanned drones now rely on an unwatchable promise of their own accuracy. Claims of civilian casualties and of the collateral damage that seeps through the incision site of surgical precision meet the unseeing wall of a surveillance state that will not reveal what the machine has captured.

"Bugsplat," the name of the program used by the U.S. government to identify and minimize civilian casualties from drone attacks, comes from the term used by drone operators to describe both what targets look like from the perspective of the machine aloft and the effect of that machinic success. The surveilled human on the ground is ins(p)ected before being exterminated. Bugsplat is the satisfaction of witnessing the obliteration of a nuisance, a pest, a minor inconvenience. So the installation #NotABugSplat in Khyber Pakhtunkhwa, Pakistan, the heavy bombing of which illuminates the screen in "Out of Sight/Out of Mind," of an image of an unnamed child—large enough to be seen by a drone—attempts to expand the scale of the aesthetics of drone strike data visualization as it radically rehumanizes the bug into child. Perhaps it is on the scale of the monumental, the vast, that which can be seen from the elevated eye of the drone, that its casualties become seeable. Perhaps this is for the best. Perhaps what we cannot see of what the drone sees, of what the drone destroys, is unwatchable. Perhaps we could not bear to see the decimation of human life, the evidence of perfect annihilation, the proof of contactless warfare. Perhaps the way in which an American public maintains itself and the fantasy of moral authority is by not watching. By handing over the realm of surveillance to the machine who both sees and destroys, we have liberated ourselves from the responsibility to know, to count, to be held accountable.

In the end on *Homeland*, Brody carries out his promise to kill Vice President Walden. He takes one life in retribution for the one life he counted as lost. Nazir sets off a bomb that demolishes the entire CIA, eradicating the global surveillance apparatus and all of its operators. Unlike the artistic renderings of drone strike casualties that translate death into pixelated images, in *Homeland*, the casualties of drone strikes are translated into direct violence. Life for life. This too is a

calculus of collateral damage and the accounting of what is lost in a drone strike.

Notes

1 Pitch Interactive, "Out of Sight/Out of Mind" (2013), http://drones.pitchinteractive .com/.
2 Jonathan Fletcher Moore, "Artificial Killing Machine" (2015), https://vimeo .com/131357384; Eric Dupin, "Dronestagram" (2013), www.dronestagr.am/.

Breakaway

ALEX BUSH

The entirety of human civilization, with its great metropolises,
suddenly seems so provincial—like a remote area of the
planet—when one views this unending expanse of white,
where the Antarctic night flows immediately
into the night of the universe.
—Béla Balázs, 1925[1]

In the late spring of 2017, the U.S. media, seemingly en masse, picked up on a story about Larsen-C, the fourth largest ice shelf in Antarctica. Some months earlier, a large fissure had developed in the shelf, and by June 1—nearly midwinter on the southernmost continent—a trillion-ton iceberg variously described as "the size of Delaware" or "four times bigger than London" was poised to break off and float away into the Weddell Sea, reducing the size of Larsen-C by more than 10 percent.[2] I became aware of this impending event in the usual way: headlines in my Facebook feed, push notifications from my *New York Times* app, episode titles of podcasts I subscribe to. Because I was in the thick of writing a dissertation about glaciers and media, more direct communiqués were also forthcoming: an email from my partner, a text from my dad.

I refused to click on anything.

Photo by John Sonntag for NASA.

Coming off several months' immersion in film and news coverage about Antarctica from 1910 to 1930, the period of moving image media's first encounter with "the Great White South," I found myself unable to bear witness to the rupture in Larsen-C.[3] Like so many writers, scholars, and explorers before me, I have been drawn to the ice by its extreme force, its overwhelming expanse. It was the nothingness that repelled human intrusion for centuries, its utter indifference a source of fascination. To see it quite literally reduced by the grotesque successes and collective failures of the industrialized world, to confront the results of our return indifference, was more than I could bring myself to do. Paralyzed by a feeling familiar to many citizens of wealthy nations in late capitalism—abashed awareness of my own contributions to the problem matched by powerlessness to stop it—I ignored the text, archived the email, scrolled past the headlines, and turned away from the breakaway.

Certainly, this paralysis had something to do with the enormity of the issue at hand. Already nearly unthinkably big on its own terms, this largest iceberg ever recorded bore a significance magnified by its synecdochic relationship to global climate change. Polar scholars Lisa E.

Bloom and Elena Glasberg have noted in the early twenty-first century "a marked concentration in the way the Earth is being represented. [Stuart] Brand's iconic 'Whole Earth' has today been displaced by just two regions—the Arctic and the Antarctic—parts that now stand in for the whole earth on the verge of ecological collapse."[4] Perhaps it is the apparent blankness of the polar ice caps that render them so symbolically available. Unlike those now passé signifiers of crisis, the burning forests of the Amazon (which, lest we forget, still rage on), the ice is like an eternally empty sheet of paper, waiting for the next clever journalist or scholar to write on it their own doomsday saga. A vessel for calamitous tales of all shapes and proportions, Larsen-C is not just an iceberg the size of Delaware; it is also a drought the size of California, flooding the size of Indonesia, famine the size of the MENA region, an extinction event the size of the globe.

There is a still image of the rupture I have not been able to shut out. It appears, unwilled, with the headlines: framed on the left by an airplane's jet engine, a dark, jagged line etches its way into an otherwise smooth and unbroken expanse of pristine white, receding toward a horizon line where the ice meets the gentle gradient of the clear blue sky. This picture's beauty is undeniable, even breathtaking; but its implications are almost too horrifying to contemplate. This tension, between the gorgeous image and its hideous causes, its violent effects, in some way reflects how the current crisis of climate is also a crisis of images. Extending, like Borges's map, over the entirety of the globe, the approaching catastrophe, whose tightening grip begins to shatter even our most fortified strongholds, exceeds the limits of vision. It can be rendered only through impressions, visual metaphors, and extended explanations that carry the mind away from its immediate material threats.

Like climate change itself, this problem is nothing new. Antarctica has long been a place fraught with death, whose representation challenges the viewer's ability to grapple with the limits of conscious experience. In 1924, Herbert Ponting released a documentary called *The Great White Silence*, composed from footage shot on Robert Falcon Scott's fateful expedition to Antarctica in 1910–1912. The film includes the last moving images of Scott and four other crewmembers before they died of starvation and exposure in an attempt to reach the South Pole. Upon viewing *The Great White Silence*, Béla Balázs described

Scott as "the Antarctic explorer who filmed his own death just as if he had screamed his death cry into a phonograph."[5] Contemplating the film's uncanny power, he asserts that "what is special and new in this case is that these men looked death in the eye through the lens of the camera."[6] Nearly one hundred years ago, people looked at moving images of Antarctica and saw what makes me tremble today: the inescapability of death.

The final result may be the same, yet the factors in this equation have shifted. In 1912, Scott staged a grand struggle between man and nature in which nature emerged the decisive victor. Human endeavor appeared pathetic, microscopic, inane against the vastness. Now, we see it is human behavior that diminishes the ice; and it is humans, as an inextricable part of the global ecosystem, that will suffer. (Not evenly; never evenly.) With this new—or newly understood—set of processes also comes a change in mediation's temporal operation. Scott's demise feels so inevitable because it is already long in the past. He addresses the camera like Lewis Payne, the young prisoner on death row in the hundred-year-old photograph that made Roland Barthes shudder: "he is dead and he is going to die."[7] To watch *The Great White Silence* is to be haunted by visions of men long dead, to "observe with horror an anterior future of which death is the stake."[8]

Our own doom, on the contrary, still looms in the future, as we rush toward demons we struggle to imagine. As Dipesh Chakrabarty incisively notes, climate change is so confounding in part because it unfolds on a temporal scale unintuitive to the human mind: what happens to us today was set in motion hundreds of years ago, and what we do tomorrow will continue to play out long after we are dead.[9] With causes buried centuries in the past, effects seem to mock us as they arrive. "Too late! Too late! The time to act was yesterday." And this may ultimately be what makes these ubiquitous videos so difficult to engage: to watch them feels like seeing the death of the entire earth, and all its inhabitants, in advance. Communities, civilizations, species, all wiped out in a few terrible minutes, without a mushroom cloud in sight. A future perfect, if you will. At the end of the day, which feels like the first day of the end, one truth is plain to see: the crack in the Larsen-C ice shelf opens a window onto the future, and I cannot bear to look.

Notes

1 Béla Balázs, "Reel Consciousness," trans. Christopher M. Geissler, in *The Promise of Cinema: German Film Theory 1907–1933*, ed. Anton Kaes, Nicholas Baer, and Michael Cowan (Oakland: University of California Press, 2016), 60.

2 Judith Vonberg, "Large Ice Sheet 'Very Close' to Breaking Away from Antarctica," *CNN*, June 1, 2017, www.cnn.com/2017/06/01/world/iceberg-antarctic-larsen-c/index .html; "Iceberg That's Four Times Bigger Than London Breaks from Antarctica," *Twitter*, July 12, 2017, https://twitter.com/i/moments/885125929206333440?lang=en.

3 I borrow the term "the Great White South" from the title of explorer Herbert Ponting's 1921 photographic narrative of the 1910–12 Scott expedition to Antarctica.

4 Lisa E. Bloom and Elena Glasberg, "Disappearing Ice and Missing Data: Climate Change in the Visual Culture of the Polar Regions," in *Far Field: Digital Culture, Climate Change, and the Poles*, ed. Jane D. Marsching and Andrea Polli (Bristol: Intellect Press, 2012), 120.

5 Balázs, "Reel Consciousness," 58.

6 Ibid., 59.

7 Roland Barthes, *Camera Lucida: Reflections on Photography*, trans. Richard Howard (1981; New York: Hill & Wang, 2010), 96.

8 Ibid., 96.

9 See Dipesh Chakrabarty, "The Climate of History: Four Theses," *Critical Inquiry* 35, no. 2 (2009): 197–222.

The Watchability of the Unwatchable

Television Disaster Coverage

MEIR WIGODER

The abstract shapes of the satellite weather images shift and create ever-new kaleidoscopic patterns on television news screens. They show us the eye of the hurricane, with its unpredictable direction and speed. Appearing like Rorschach test images, the graphics trace the intended path of the storm, which will wreak havoc on densely populated areas that are not visible from the satellite views—abstraction, distance, and elevation have always served as aesthetic tools to diminish the effect of images of pain, suffering, and horror. In today's breaking news alerts, which interrupt regular programing, such bright technicolor images are meant to warn us of the imminent natural disaster whose coverage suits our 24/7 culture.

In an unprecedented sequence of natural disasters in 2017 that included hurricanes, earthquakes, flooding, and wildfires, we followed the *expectable* path of news coverage that tries to create a semblance of order in the *unpredictable* events: disaster coverage has a prologue (experts anticipate what may happen) and a past (similar disasters are cited as precedents), and it moves on to the *live* coverage of the event (which may turn out to be much less harsh than the scaremongers predicted). The

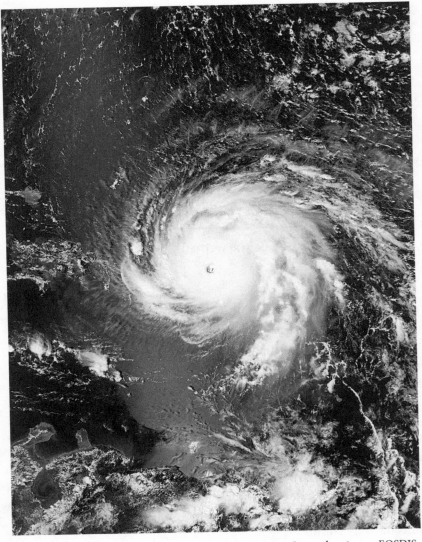

Hurricane Irma over the Virgin Islands at peak intensity on September 6, 2017. EOSDIS Worldview/MODIS image captured by NASA's Aqua satellite.

immediate aftermath is preferable to reporters, who take an interest in the consequences of the destruction while gathering witnesses' testimonies. Finally, the true, painful impact of the disaster sets in only months later, when the devastation is far less amenable to being photographed, having lost its shocking "luster." At this stage, members of the population are busy rebuilding their homes and trying to return to their daily lives after the television lights have been turned off and the camera crews have returned home.

It is worth recapitulating some of the strategies of turning disasters into televisual images that reveal the extent of the damage but still remain within the tasteful boundaries of what is watchable. Under the rubric of *live coverage*, the anchors and gatekeepers of the information use the slickest transitions between live recordings and edited footage. Windows open to separate the live reporting of the correspondents from the pre-edited visual information that shows the progressive stages of the natural disaster, presenting a time frame that could not have been foreseen. Added to this is the growing trend of drone shots that glide gracefully and show us bird's-eye views of devastation. Such aerial views are the only spatial indicators capable of presenting the full scale of the ruins (recalling Walter Benjamin's figure of the angel of history),[1] but they elide the extent of the suffering, aestheticizing the terrains and transforming them into picturesque and sublime landscapes. Inserted into these arrays of images are the personal testimonies of mobile phone users, who often react to the shock of the event by automatically recording it rather than running away from it. These images are usually shot *vertically* and must be assimilated into the *horizontal* format of television screens. Graphic artists create a larger black background on either side of these images so they don't jar the viewer by calling attention to the white borders of the screen; still images are grabbed from the videos and are stretched to fill the entire screen, like a decorative desktop wallpaper, to accommodate the new vertical format of amateur videos.

In September 2017, during a few days when television news networks were simultaneously covering the earthquake in Mexico City and the hurricane in Puerto Rico, my attention was attuned to a mobile phone testimony that encapsulated the present way of witnessing disasters: people were fleeing the scene as a building was collapsing. The shot was

not an automatic response to something that had surprised the amateur mobile phone user, but a moment in which *the event entered a scene* that was already being recorded. (This reminds us of the iconic video recorded by Jules Naudet, who, upon hearing a plane flying overhead in New York City, swerved his camera from street level up to the World Trade Center exactly when American Airlines Flight 11 was about to crash into the North Tower.)

This unexpected moment, in which a recorded scene alters dramatically during shooting, made me wonder about the grammatical tense of such a situation: Roland Barthes's photographic tense, the "that has been" of the image that exists in the *now of the past*, is not applicable here.[2] Even the digital affirmation of the *now of the present* (disseminated immediately to enable us to pass on quickly to the next momentary image) cannot describe this situation of emergency. Instead, it might be more reminiscent of a *now-future* moment in which what makes the scene horrific *is not necessarily what we see* but the realization that such an *interruption* during the recording stands for a much broader aspect of our present way of living. The *now-future* moment represents the uncertainty and lack of continuity that so many people feel in their daily lives. Natural disasters and terror attacks are two of the main triggers of this overall sense of anxiety that something bad is about to happen over which we have no control.

We can conjecture that the frantic use of mobile phones in our present age is no different from the photographic craze that Siegfried Kracauer described in the Weimar Republic, in which the use of small candid cameras and the popularity of the illustrated press created an ever-growing appetite for recording daily life as a form of defense against the fear of death.[3] Decades later, Kracauer drew an analogy between the film screen and the reflective shield from the myth of Medusa. Just as Perseus uses Athena's shield as a mirror to look indirectly at Medusa, who would have turned him into stone had he looked at her face head-on, so the film screen enables the audience to view images of horror that they would not be able to face in reality.[4] The same could be said about mobile phone cameras today. The *gestured-sight* of hands holding out such cameras echoes the gesture that Perseus enacted with his shield: the *indirect-direct look* at reality makes it possible to make the unwatchable watchable. It also applies to the way Barthes characterized the

photographic image as "mad,"[5] mainly because it represents the referent in such an unbearably forceful manner, which makes us want to tame it by inventing an aesthetic grammar of visual representation.

In our anxious age, the equivalent of Athena's shield is the television remote that enables us to have a sense of control over our viewing: zapping is not only a form of distraction or an expression of boredom but also a tool *to look away* from what is no longer watchable. A tsunami of unwatchable images has made us more cynical and blasé—whether images of horror, violence, and verbal abuse or Facebook Live videos of rapes, killings, and terror. (At present, zapping is also replaced by the gesture of either scrolling up and down mobile phone screens, tablets, and laptops or swiping, which lends us some illusory sense of mastery over the onslaught of information and images in social media.) Once unwatchable images become watchable, either because they are *tamed* by the sleek machine aesthetics of television media corporations or because people have become apathetic to such unmediated, disturbing images on social media, we must wonder not simply about how the unwatchable becomes watchable but whether certain kinds of unwatchable moments can still surprise us. In other words, despite the taming of the image by television coverage, is there a possibility, even for a moment, that the sense of *temporality* of the event, which may not yet be totally harnessed by the artifice of television, can break through by genuinely touching us and making us think about it?

Perhaps such moments can take place, either when there are *glitches* in the television broadcast that make us reflexively aware of the medium (e.g., drops in sound quality, delays in the arrival of sound during live interviews between the anchor and reporter, and problems in the transmission of the image) or when the amateur recordings are shown during the first wave of news bulletins, before they get edited into the longer broadcasted pieces. Especially in such cases, we may react emotionally to the *gestured-sight* of the witnesses: the sound of mobile phone operators whose voices (off camera) respond loudly to what their own cameras record makes us aware of their subjective point of view as *participants* and not only as onlookers of the event;[6] the jerky movements of mobile phone cameras, whose amateur operators react hysterically to extreme events and cause the images to become blurry, testify to the visceral bodily responses of the witnesses in the scene; the moments when the

camera pans away from the subject of the scene because the action is too overwhelming to look at; and the *body-camera* shots from the policemen's and firefighters' points of view that show us the scenes of mass murder and wildfires from much lower angles, which are no longer an extension of the human gaze.

Finally, an example of an unwatchable moment that caught my attention in the aftermath of the earthquake in Mexico City on September 19, 2017 (the anniversary of the horrific earthquake that rocked the same city in 1985, as if fate and not chance had struck the citizens of the city once again), was not necessarily the camera shots that showed bodies being carried away and wounded persons being dragged out of the rubble, but, in a far subtler way, the gestures of individuals raising their hands, not in order to use their mobile phones, but to hold up signs that read "Silencio." In these moments of camaraderie that are possible only during states of emergency, when the crowds of onlookers fall silent in order for the rescuers to hear the possible sounds of survivors crying for help, one has the impression that the noise of the television coverage that makes such scenes watchable has given way to an almost pure denotative moment, in which the disaster *can speak for itself* and can be heard in silence with no intermediaries. Such moments remind us of the way Barthes discussed the significance of "the grain of the voice" and "the rustle of language," in which the resonances rather than the meanings of language are significant.[7] Finally, we come to realize that the unwatchable has become all that we cannot bear to anticipate and imagine rather than all that we dread to look at on the television screen during the coverage of disasters, terror attacks, and other images that we dread seeing.

Notes

1 See Walter Benjamin, "On the Concept of History," trans. Harry Zohn, in *Walter Benjamin: Selected Writings: Volume 4, 1938–1940*, ed. Howard Eiland and Michael W. Jennings (Cambridge, MA: Belknap, 2003), 389–400.

2 Roland Barthes, *Camera Lucida: Reflections on Photography*, trans. Richard Howard (1981; New York: Hill & Wang, 2010).

3 Siegfried Kracauer, "Photography," in *The Mass Ornament: Weimar Essays*, ed. and trans. Thomas Y. Levin (Cambridge, MA: Harvard University Press, 1995), 47–63.

4 Siegfried Kracauer, *Theory of Film: The Redemption of Physical Reality* (1960; Princeton, NJ: Princeton University Press, 1997), 305–306.

5 Barthes, *Camera Lucida*, 115.

6 As I edit this essay in August 2018, the television news reports of the horrific collapse of the Morandi Bridge during a rainstorm in Genoa, Italy, interrupt the scheduled programing. The first representation of the scene is a smartphone video by Davide Di Giorgio, who was filming the storm for his parents through his office window. Suddenly he realized that part of the bridge was collapsing and he started screaming "Oh, God! Oh, God!" The shocking effect of the footage is due more to the sound of his voice than to what the video actually shows us.

7 Roland Barthes, "The Grain of the Voice," in *Image, Music, Text*, trans. Stephen Heath (New York: Hill & Wang, 1977), 179–189; and Roland Barthes, "The Rustle of Language," in *The Rustle of Language*, trans. Richard Howard (Berkeley: University of California Press, 1989), 76–79.

3

Bearing Witness

Philosopher Giorgio Agamben has identified a paradox: the "true" witnesses to historical atrocity are those who cannot bear witness. To have experienced the full horrors of the gas chambers at Auschwitz is to have perished, rendering testimony a logical impossibility. Reflecting on the aporias and unavoidable lacunae of testimony, the essays in this chapter analyze audiovisual figurations of atrocities over the past century, from the Armenian Genocide through the Second World War to the contemporary Syrian refugee crisis. All texts discuss whether and how the most horrific forms of suffering and death should be represented.

Art historian and photography theorist Peter Geimer considers a question regularly faced by photo editors—namely, which images of violence to show and which to withhold from public view. Extending the insights of Roland Barthes and Susan Sontag, Geimer argues that the virulent reactions provoked by shocking images indicate the persistence of realist understandings of photography, even in an age of digital manipulability. Faith in the evidentiary quality of the image is especially essential for advocacy media, as film scholar Leshu Torchin emphasizes. Discussing two films separated by nearly a full century, *Ravished Armenia* (1919) and *Unwatchable* (2011), Torchin highlights the perennial challenges confronted by politically committed filmmakers as they attempt to attract, educate, and galvanize viewers.

The next two essays analyze short experimental films that use various formal and stylistic devices to redress the ideological veils and blind spots of national narratives. Film scholar Frances Guerin offers a close reading of *Eût-elle été criminelle* (*Even If She Had Been a Criminal*, 2006), which repurposes and repeats archival footage to spark critical recognition of France's displacement of guilt onto the bodies of women following Nazi occupation. Film scholar and curator Federico Windhausen focuses on a video by the Mexican collective Los ingrávidos, *Transmisión/Desencuadre* (*Transmission/Deframing*, 2014), which approaches the Tlatlaya massacre by deframing the visual evidence of state-sanctioned violence.

Returning to Geimer's opening discussion of photojournalism, political scientist Emily Regan Wills addresses some of the most harrowing images of our time: the widely disseminated photos of three-year-old Alan Kurdi's corpse on the shore of Turkey in the wake of his family's effort to reach Europe by inflatable raft. While recognizing the efficacy of the images in prompting international response to the Syrian refugee crisis, Wills theorizes her own need to avert her eyes, especially as the mother of two sons. Taking up Fred Moten's concept of "dynamic universality," Wills draws an analogy between the Kurdi photos and images of Emmett Till, pointing forward to the following chapter on scopic regimes of antiblack violence.

The Incommensurable

PETER GEIMER

Among the countless images that turn up on the monitors of photo editors every day, there are often particular ones that are left unpublished or appear flanked by editorial notices and warnings. Such cases involve depictions of extreme physical violence, hijacker videos, and pictures of war casualties and victims of terror attacks. It is common knowledge that such images of violence imprint themselves on the mind with great and enduring intensity, and one does well to be economical in their exhibition. But how exactly should we envision such an economy of atrocity? What should one show and not show? Where should one display the images, to whom, and for how long? It is striking that the discourse around these images is often shaped not by the simple binary of showing and not showing, but rather by hybrid formations of both modes at once: One doesn't exhibit the images but talks about them at length; one withholds them but reports what *could have been seen* in them. In this way, a curious dialectic is activated involving showing and hiding, seeing and imagining, not viewing and wanting to watch. There are just as few generally binding provisions here as there are developed ethical codes or clear juridical regulations.

Media that feature such images can generally count on virulent reactions from their readers. When the Swiss magazine *Folio* included a

This photo may show graphic violence or gore.

Uncover Photo

Content warning on Facebook obscuring footage of the 2017 Las Vegas shooting.

photograph of the severed head of a Palestinian female suicide attacker in 2005, as part of a special issue on the ubiquitous threat of bombs, the reactions were so vehement that the editors felt compelled to set up a separate home page to channel the debate. While part of the readership supported the printing of the photograph ("Thank you for showing the reality . . ."), others chimed in with fierce statements of protest, finding the publication of the image "unnecessary," "senseless," "horrifying," "tasteless," "abominable," "sickening," "revolting," and "an effrontery." "Have you gone crazy?" one reader asked. Several people threatened to cancel their subscriptions and considered filing a complaint (for "attempted psychic injury," among other things). Others declared that they had "disposed" of the issue immediately, leaving it unread—as if the sheer existence of the photograph, hidden inside the issue, could directly contaminate one's living quarters.

It would undoubtedly be absurd to publish, as a matter of principle, *all* shocking photos that are available. So, too, would it be questionable to withhold them all and expunge them from our culture's visual

memory. In each individual case, the subject of the image, the circumstances of its emergence, and the site of its subsequent presentation must be taken into consideration: Why was it taken, by whom, and for which prospective viewers? Why and in which context should it be shown or not? Yet my objective here is not to take a principled stance for or against the exhibition of such images. Instead, I am interested in which understanding of photographic images finds expression in the reactions outlined above.

Whoever refuses to exhibit or view certain photographs presumes them capable of something, confirming the old insight that the prohibition on images (*Bilderverbot*) does not attach little value to images, but rather accords them a particular power. Moreover, in the case of shocking photographic and filmic images, the reticence around showing or watching them stands in curious opposition to the widespread view today that images invariably lie and have lost any relation to the real through the possibilities of digital manipulation. Shocking images assert a disquieting presence, and they obviously do so through completely different means than renderings of the Passion from the history of art.

Toward the end of her book *Regarding the Pain of Others* (2003), Susan Sontag arrives at a positive appraisal of shocking images: "Let the atrocious images haunt us."[1] Sontag describes numerous photos of violence and offers detailed accounts of the subjects—but she *shows* not a single one. The reticence with which we confront images of horror suggests a remnant of the idea that something of the physical substance of the subject enters into his or her photographic likeness. When Roland Barthes took up this tradition of construing photography as a form of magic in *Camera Lucida* (1981), he was aware that his reflections appeared quite old-fashioned. Among modern commentators on photography, as Barthes wrote, relativity was in vogue. There was great contempt for the "realists," who failed to see that photographs are always coded.

A comparable observation can still be made today. Even for images such as the torture photos from Abu Ghraib, interpretive paradigms are readily available that insist on the artificial, constructed quality of the photos. There is no picture, however extreme, for which one could not almost automatically recite iconographic prototypes from the history of art, bringing them back into the world of familiar images that one is able to analyze with ease. The question, though, is whether such associations

defuse the explosive power of the images and obscure the particular conditions in which they emerged. Does one do justice to images like the torture photos from Abu Ghraib when, upon viewing them, one is always already thinking of *other known* images, instead of considering their specificity—and possibly even their incommensurability?

The awareness that even technically generated images do not emerge without presuppositions is by now widespread. No one dedicated to analyzing images would want to fall behind this state of knowledge and make the case again for the objectivity of photography. As I have nonetheless argued, we first encounter images of violence in the most naïve conceivable way: as if the image bore an immediate imprint of the subject represented. By the looks of things, images of violence have withstood the scrutiny of cultural criticism quite well. The suspicion that they might be manipulated can always be raised—and with good reason. But to this day, they are exhibited and viewed under the presumption that those whom they depict existed at the moment when the photograph was taken and that the photograph testifies to this very existence (or to its end). From this, we cannot deduce a theory of the truth of images, but we can at least add a point of residual uncertainty to the routinized talk of their social construction. It is not a matter of altering one's thinking under the spell of horrifying images. But the images in question at least remind us that their actual reception often occurs somewhere else entirely than in the deconstructionist routines of cultural criticism.

Translated by Nicholas Baer

Note

1 Susan Sontag, *Regarding the Pain of Others* (New York: Picador, 2003), 115.

Not Seeing Is Believing

The Unwatchable in Advocacy

LESHU TORCHIN

In 1919, the film *Ravished Armenia* was released in cinemas and other venues, not simply to entertain, but to educate, advocate, and fundraise on behalf of the Armenians who had suffered mass rape, murder, and deportation under the Turkish government. A co-production of the proto-Hollywood studio Selig Polyscope and the humanitarian organization Near East Relief, the film played a significant role in the latter's $30 million fundraising campaign.

Introducing one of the screenings, a Mrs. Harriman announced the film's function to "visualize conditions so there will be no misunderstanding in the mind of any one about the terrible things which has transpired."[1] For her, film was a crucial tool for outreach, capable of reaching many and convincing them of the truth of the suffering abroad. Her conviction is in keeping with that of today's human rights activists: If people see, they will know, believe, and act. Exposure is a necessary precursor to mobilization.

Yet despite the emphasis on exposure, the question of unwatchability necessarily haunts advocacy media. Can, or should, one make visible everything that has happened? Even with *Ravished Armenia*'s reliance on reports and the firsthand testimony of its protagonist,

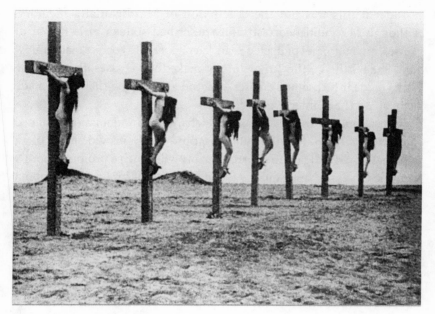

Still from *Ravished Armenia.*

Aurora Mardiganian (who played herself in the film), not everything shown transpired and vice versa.

Take, for example, the scene of a mass crucifixion of naked women. It conveys meaning and titillation, but its evidentiary function is suspect. Among the few scraps of footage remaining of this feature-length film, the shots are striking. The wide shots cultivate a sense of magnitude, with figures receding into the horizon. A close-up shows a young woman, her eyes rolled upward to the heavens. A vulture looms in the corner, auguring her fate. This composition evokes images of martyrdom made familiar in the arts, while the wide shot inscribes the violence as martyrdom en masse, articulating the vulnerability, innocence, and Christianity of the Armenian victims.

Meanwhile, the nudity promises thrills, attempting to appeal to a broader audience. The advertisements used these images and, like the film, replaced accounts of rape with images of the harem. As such, these express the combined desire and reluctance to traffic in anguish, a combination that establishes a limit case for watchability.

Indeed, this was not the crucifixion of Mardiganian's memory. Although her published testimony described sixteen girls nailed to crosses, an interview conducted years later appears to correct that impression. She recalled, "The Turks did not make their crosses like that. The Turks made little pointed crosses. . . . And after raping them they made them sit on the pointed wood."[2]

"Sensationalism" seems a reasonable charge for an adaptation designed more to thrill than horrify, but "sensation" might provide more of an explanation. Mardiganian's correction provides such a profound bodily identification and haptic quality that it raises significant questions about the work it could do. Who would want to recommend the film, or aid in sharing such testimony? Even the written testimony, distributed in the United States and the United Kingdom and filled with horrific detail of children's bodies mixed into cement for the walls of new homes, did not include this information.[3]

This hesitancy speaks to the limits and challenges of using film for advocacy. Transformative expectations may be built into the witnessing function of audiovisual media, but these are achieved through a host of activities uniting rhetorical strategies with tactics of production, distribution, and exhibition. The stakes rest not only in the real-world circumstance these images can represent, but also in the tactics of representation. In *Distant Suffering*, Luc Boltanski advances a "politics of pity" that refers to ways spectacles of suffering can be rendered both comprehensible and acceptable to an audience.[4] However, as others have noted, these politics are embedded in and reproduce power imbalances. For Lillie Chouliaraki, such representations produce "hierarchies of human life." Wendy Hesford has observed the ways the abject representation of the human rights subject, divested of humanity and rights, reasserts the power of the spectator as actor. Moreover, representations risk capitalizing on the suffering of others to produce what may be pleasurable spectacles. Critics of Holocaust art have levied the charge of "pornography," referring to "the reduction of human beings to commodity and the exposure of vulnerable people at the moment of their most profound suffering."[5]

The crucifixion scene offers a curious moment, then, providing both a sensational spectacle of suffering with its attendant delights, and a

protective veil between the actual atrocities, the vulnerable subjects, and the spectators. The deployment of fiction is consternating as the Armenian Genocide has been subject to over a century of denial, and yet also a relief as it refuses to supply scopophilic pleasures in the representation of such horrors.

If it is necessary for people to watch and to receive the visual testimony of distant crimes, the work should not cause the viewer to shut down, to turn away more than an instant, or to be disinclined to share. Images of suffering and atrocity may seem useful to mobilization, but the challenges proliferate: The extreme image might allow disgust to displace empathy or solidarity. The extreme image might shock and thrill, but it might also foreclose on action. As such, Sandra Ristovska's term, "strategic witnessing," offers an appealing description for this crucifixion scene. It illustrates a shift from "witnessing as constitutive of the (traumatic) world to witnessing as socially embedded mechanism for change."[6] It is less about bearing witness to the specifics of suffering and more about making the necessary claim to inspire action.

These issues persist. In 2011, Save the Congo sponsored a film literally titled *Unwatchable* (Mark Hawker). Based on the testimony of Congolese woman Rebecca Masika Katsuva, the short film depicts an attack on a white upper-middle class family in England by an unidentified militia. The father is murdered before the mother, while the daughter is gang raped on the dining room table. Although somewhat tenuous in the connections, the film's aim is to bring attention to conflict minerals mined in the DRC, an economy maintained through war and rape.[7]

What renders this unwatchable? The shift of venue for the scenes of horror aims to secure identification of a Western audience, but the title tacitly suggests that the victimization of white bodies, rather than black bodies, is unwatchable. After all, the violation of black bodies has been a fungible commodity in advocacy media since the abolitionist movement.[8] Did this film earn the title *Unwatchable* because of the visceral brutality visited on an imaginary European family?

The "unwatchable" can also refer to the discomfiting content that hampered the willingness to share. "Did *Unwatchable* make me want to act to stop this horror? Yes it did. Will I want to share this clip with friends and colleagues and urge them to get involved? No, I'm afraid I

won't," wrote Jane Martinson. It may have been moving and illuminating, but the film would go no further, deemed unwatchable for others.

Similar to the situation almost a century earlier, this campaign film stops considerably short of the horrors Masika relates in her testimony. Both of her daughters, nine and thirteen, were raped and made pregnant. Masika witnessed her husband's dismemberment and his pleading with the torturers, silenced only when they removed his heart. Masika was forced to eat her husband's penis and to gather up his body parts, upon which she was raped until she lost consciousness.[9] The unwatchability here is compounded. The actual events are too horrible to be visualized in an adaption. The spoken testimony could be instrumentalized, and even then it did not receive the amplifying platform given to the film.

To investigate critically the issue of watchability in advocacy opens questions of how an audience receives suffering. It reminds us that whiteness, Europeanness, and Christianness offer the watchable points of identification and that rape continues to inhabit a space in the sensational. It indicates that even with the best intentions, power is inscribed on the body and the globe in these representations. As such, it forces us to ask the question of what must be seen in order to inform a broad public and to encourage them to action. There is no single answer for these questions, but the questions must be asked, always.

Notes

1 "Ravished Armenia in Film; Mrs. Harriman Speaks at Showing of Turkish and German Devastation," New York Times, February 15, 1919, 4.
2 Quoted in Anthony Slide, ed., Ravished Armenia and the Story of Aurora Mardiganian (Lanham, MD: Scarecrow Press, 1997), 6.
3 Aurora Mardiganian, Ravished Armenia, trans. Henry Leyford Gates (New York: Kingfield Press, 1918), 175.
4 Luc Boltanski, Distant Suffering: Morality, Media, and Politics, trans. Graeme D. Burchill (Cambridge: Cambridge University Press, 1999), 7.
5 Carolyn J. Dean, The Fragility of Empathy after the Holocaust (Ithaca, NY: Cornell University Press, 2004), 16.
6 Sandra Ristovska, "Strategic Witnessing in the Age of Video Activism," Media, Culture & Society 38, no. 7 (2016): 1041.

7 Jane Martinson, "Unwatchable Is Just That—Is It Doing Anything to Help Congo?," *Guardian*, September 28, 2011, www.theguardian.com/commentisfree /2011/sep/28/unwatchable-congo-rape-short-film.

8 Saidiya V. Hartman, *Scenes of Subjection: Terror, Slavery, and Self-Making in Nineteenth-Century America* (Oxford: Oxford University Press, 1997).

9 Unwatchablethefilm, "Unwatchable: Masika Tells Her Story," www.youtube.com /watch?v=fYUsMD3BbZg.

Even If She Had Been a Criminal

A Past Unwatched

FRANCES GUERIN

> The counterfeits of the past assume false names and readily call
> themselves the future. This ghost, the past, is liable to falsify its
> passport. Let us be aware of the trap. . . . The past has a face,
> superstition, and a mask, hypocrisy. Let us denounce
> the face and tear off the mask.
> —Victor Hugo, *Les Misérables*

Documentary images of historical violence should never be classified as "unwatchable." They can be so disturbing that there is no language with which to articulate their horror. But this does not make them unwatchable. Images may arouse feelings of terror, confront us with our greatest fears, challenge our understanding of the world, but they must be watched—again and again. How else will we know what happened? How else do we learn about the past and prevent history from repeating itself? For this very reason films such as Alain Resnais's *Nuit et brouillard* (*Night and Fog*, 1956) and *Frontline*'s *Memory of the Camps* (1985) reused archival images as evidence of past crimes to expose the past in their own present moments. As long as crimes against humanity continue, we have not yet learned the lessons of the past and we must keep watching.

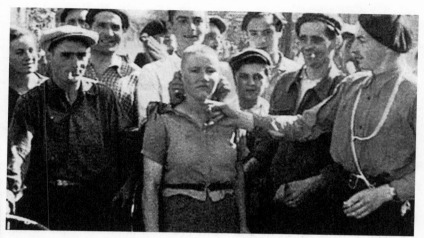

Still from *Eût-elle été criminelle*.

Jean-Gabriel Périot's film *Eût-elle été criminelle* (*Even If She Had Been a Criminal*, 2006) recycles footage of *les femmes tondues*, women ritualistically shorn for "horizontal collaborations" with the Nazis during the occupation. The images are now very familiar, having been often republished over the past twenty-five years.[1] However, Périot's film claims that they must be watched again if the chain of repetition of the past is to be broken. They may be of a different genre, but for Périot, these 1944 archival images of French men humiliating French women accused of sexual relations with Germans suffer the same fate as images of the Holocaust: we are blind to their message. Périot's film asks us to watch these images and recognize the hypocrisy of a strain of French history for which no official acknowledgment has been given, no responsibility has been assumed, and no justice has been served. We must keep watching this history to arrest its perpetuation into the present and the future.

The film opens with color images of the 1938 celebration of Joan of Arc's liberation of the city of Orléans. The aristocracy, clergy, and officials in ceremonial vestments parade through streets in Kodachrome footage, bathing in the glory of French history. Suddenly, the French gentry are placed in a montage with Nazi rallies, and war then breaks out in fast motion on the fields of Normandy, in color and black and

white. The montage speeds up, and with success on the horizon, General de Gaulle meets the Germans. The film cuts to a rally in which the masses salute the Führer. "The Marseillaise," the French national anthem as a revolutionary hymn to freedom, accompanies these archival fragments.

When the film arrives in 1944, people dance, clap, and hail the nation's freedom. Crowds raise their hands to the camera, their fingers signing V for victory, faces in close-up, holding the French tricolor, seen from a viewpoint on high, from moving vehicles passing through the streets. Everyone in the crowd is watching, but the object of their fascination remains outside of the frame.

"The Marseillaise" slows down, and the camera finds a woman struggling on the back of a truck in long shot; she tries to free herself from the man shaving her head. The crowds part for another woman being led by three men, her face is slapped by an onlooker, and her body shies away from her attacker, the crowd, and the camera. This second time, the framing is wider and deeper to reveal what the crowds watch: the parade of women, their heads being shaved, publicly humiliated. Patriotism and allegiance to the flag, whether by followers of Vichy or the Liberation, are easily distorted to suit the occasion. France might be free, but the war continues: in the chaos of peacetime, the battleground is transposed to the bodies of women as the receptacle of the nation's guilt for its having been in bed with the Nazis. Scholars remind us that "she slept with a German" is the false narrative of the *tondue* stories. Men and women were shorn for a variety of activities labeled "horizontal collaborations." And women who had sexual relations with Germans were not always punished.[2] But the spectacle of women being paraded and shorn has captured the postwar French imagination and been upheld to symbolize national rehabilitation.

As Périot repeats the *tondue* footage, so we are twice confronted. First, we are met with what French history chooses to ignore: the Vichy regime's celebration of Joan of Arc—another woman, accused of betrayal and spectacularly burned at the stake for dubious reasons—to invoke authority, national pride, and conservative family values.[3] The film doesn't ask who among the *tontes* (shearers) gave up Jewish fellow citizens to be persecuted, deported, and annihilated. Their cruelty begs the question: who are these perpetrators to hand out retribution for collusion with the Nazis? Punishment of allegedly errant women as a way to alleviate the

nation's guilt is familiar in French history. As with the fifteenth-century sacrifice of Joan of Arc, the *tontes* project their shame of collaboration onto the bodies of women: it's a strategy that has been used before, and will, we assume, be used again.[4] This is the mask of hypocrisy, and as Victor Hugo warned, the mask must be torn off if the past is to be put to rest. History is celebrated, for Hugo in 1789, for the Vichy regime in 1938, and for Liberation in 1944, disguised as honorable and progressive. Périot, like Hugo before him, implores us to recognize the ghosts of the past so they can be put to rest.

Accordingly, the second lesson of repetition is addressed to the viewer: Périot implicates us in the humiliation and claims it is our responsibility to stymie the repetition of French history in the present, in the twenty-first century.[5] We watch the performance of perpetrators: Men pull a woman's hair to distort her face in direct address to the camera, a man tickles another woman under her chin while she stands shorn and held in place by two others. He repeats the action with one eye on the camera, making sure his gesture is documented.[6] Throughout their ordeal, the women look unflinchingly into the camera while the razor is dragged over their heads. We are thus also the addressed of their gaze. We are the audience of the audience, the performers and the persecuted, and are thus, as has been argued of the cameramen before us, complicit in the continuing act of humiliation.[7]

Women are ritualistically paraded with their shaven heads on trucks as onlookers applaud their degradation. Humiliation is thus proliferated: from shaving, through performance for a camera, to public spectacle at a particular height and angle to ensure full view of the crowd and the camera. "The Marseillaise" is sung louder on the soundtrack, and the fervor of national pride is intensified. The proliferation forces us to recognize that the shearing of women's hair is a performance, not a punishment. Their crimes are not necessarily sexual, but such performances that displace the nation's shame for its own penetration by the Nazis most certainly are. As the onlookers of crimes, crowds, and their victims, we are asked to take responsibility for the significance of historical events to which we had previously been blind.

For Hugo, the revival of the past masked in celebrations of revolution, or in this case, liberation, is a "hideous progress" toward evil. Périot's film shows how easy it is to get lost in the excitement of liberation, and

implores us as viewers to assume our responsibility to expose the lies of the celebration. Périot shatters the fragile certainty of our knowledge of history: until France can remove the mask of its own hypocrisy, history will be repeated, and its counterfeits and violations therefore remain, as yet, unwatched.

Notes

1 For a nonexhaustive list of the appearance of these images, see Alison M. Moore, "History, Memory and Trauma in Photography of the *Tondues*: Visuality of the Vichy Past through the Silent Image of Women," *Gender & History* 17, no. 3 (2005): 678, n. 5.
2 Fabrice Virgili, *Shorn Women: Gender and Punishment in Liberation France*, trans. John Flower (London: Bloomsbury, 2002).
3 Miranda Pollard, *Reign of Virtue: Mobilizing Gender in Vichy France* (Chicago: University of Chicago Press, 1998).
4 Moore, "History, Memory and Trauma."
5 Political philosophers discuss the inheritance of past injustice by each generation when a nation does not admit and atone for its doings. See, for example, Janna Thompson, *Taking Responsibility for the Past: Reparation and Historical Injustice* (Cambridge: Polity, 2002).
6 The humiliation as a performance for the camera was widespread in the "documentation" of the events. See Moore, "History, Memory and Trauma," 664.
7 Ibid.

Deframing Evidence

A Transmission from Los ingrávidos

FEDERICO WINDHAUSEN

On June 30, 2014, the Mexican military killed twenty adults and two minors in the municipality of Tlatlaya, acting on official orders to "take down criminals," presumably in order to create the appearance of law enforcement. Mexico's National Human Rights Commission would later conclude that between twelve and fifteen of the victims had been executed "arbitrarily."[1] Soon after the massacre, the Mexican collective that calls itself Los ingrávidos, a name that can be translated as "the weightless ones" or "those without gravity," responded to the crime and its immediate cover-up by releasing on their website (losingravidos.com) a video titled *Transmisión/Desencuadre* (*Transmission/Deframing*). It is a work with a deceptively simple substitution or displacement at its center, as it presents one evidently symbolic moving image while speaking of a still image—left unseen and doubtless regarded by some as unwatchable. Emerging out of a very specific place and time, this video solicits thinking about the various possible contexts for difficult imagery, and I offer here a few ways of framing and interpreting its operations and provocations.

Transmisión/Desencuadre was shot in black-and-white, in a single take that lasts four minutes and thirty seconds. What the video initially shows, via a wide-angle lens that curves objects in the center of the frame

Still from *Transmisión/Desencuadre*.

toward the viewer, is a deckle-edge photograph that has been placed on the dry, cracked earth; the photograph contains a stock image of five soldiers, one of whom is holding up the Mexican flag, in what could be the tail end of a military procession. A colony of ants scrambles around and underneath the photograph, and by the midpoint of the video the ants have pushed it offscreen, revealing a hole in the ground that is the hub of their rapid activity.

The video's soundtrack combines two fragments of spoken audio with an ominous electroacoustic score. The voices heard in *Transmisión/Desencuadre* belong to Carmen Aristegui, a left-wing broadcast journalist, and José Miguel Vivanco, director of Human Rights Watch's Americas division.[2] The first words spoken are those of Aristegui, who announces on her Spanish-language radio program that "we are talking about an image" and describes a photograph of Tlatlaya victims that was reproduced in the newspaper *La Jornada*. Summarizing the conclusions of a criminologist who examined the photograph, she explains that he determined that the victims could not have died in a two-sided armed conflict in the manner that the military had asserted. Then Vivanco, speaking through a telephone connection, points out that the photographs are "traveling around the world" and that their widespread dispersal has become a major factor in the "dismantling" of the official version of events. As Vivanco continues to remark upon the global

reception of those images of the dead, we watch the ant colony move toward and away from its hole, and an aural collage of percussive and electronic sounds gradually supplants his voice on the soundtrack.

Transmission, the first word in the video's title, underscores the urgency of its production and dissemination: it was produced and made available online shortly after the killings. The term also suggests that the work is a counter-communiqué, manifestly repugning the armed forces' false narratives and resisting the typical display of images of the corpses in sensationalist ("nota roja") newspapers and television channels. Indeed, the video can be seen as extending and renewing—particularly through its audio—the prominent tradition of ideological dissent and political protest associated with the New Latin American Cinema. But in contrast to a film such as Octavio Getino's and Fernando Solanas's *La hora de los hornos* (*The Hour of the Furnaces*, 1968), which not only reclaims found footage of state-sponsored violence but presents staged scenes of such abuses as well, *Transmisión/Desencuadre* brackets out the image of violence, electing instead to mediate it through language.

Deframing, the second word in the title, is associated with an essay by Pascal Bonitzer, who asserts that cinematic images dominated by negative or empty space move the viewer away from that which seems to be alive toward that which is not. According to Bonitzer, "the radical off-centredness" of deframing as a compositional strategy "mutilates the body and expels it beyond the frame to focus instead on dead, empty zones barren of décor . . . on the bleak or dead sections of the scene."[3] In *Transmisión/Desencuadre*, deframing becomes a visible action: we see the removal of a photograph of a military spectacle, carried out by the commotion of living creatures inhabiting an arid, desiccated surface. Yet the video is not simply offering a poetic moving image of mobility and immobility, plenitude and emptiness, that can be interpreted symbolically; its voices argue forcefully for the photograph as evidentiary document, affirming its value through acts of denunciation carried out by the living in the name of the dead.

Some might see this work by Los ingrávidos as offering a model, at once exclusionary and generative, for addressing unwatchable imagery. Photographs of actual murder victims are left out of the frame, after all, and in place of such readily sensationalized images we are provided with a form of political resistance that allows us to avoid any unpalatable

visuals. But such a view would, in my estimation, overlook some of the defining tensions of this short. Obviously, one of these is the tension between its assertion of the probative and forensic significance of the photograph and the visual absence of the photographic record in the video itself. But another key tension is perhaps even more multifaceted. It involves the continual citation or framing of one medium by another: embedded within *Transmisión/Desencuadre* are digital moving images, radiophonic and telephonic voices, and photographs described and framed. Media artifacts are thus set in dynamic relation to each other, in the service of a broader questioning of the primacy of any one source of audiovisual access and information. What the Los ingrávidos collective constructs is a series of cross-media translations and displacements, offering the viewer a complex of visual, sonic, and verbal phenomena with multiple referents. Rather than ask whether the images taken in the immediate aftermath of the Tlatlaya atrocity should be seen at all, *Transmisión/Desencuadre* suspends or delays this seeing, in order to linger over other questions regarding how, where, and for whom the mediated struggle over their meanings should take place.

Not content to rely on others to disseminate its provocative responses to Mexico's political culture, Los ingrávidos has produced its own online space for its videos and writings. I will note, in closing, that their website provides ample demonstration of a significant trend within politically engaged strains of short-form video from Latin America, namely the increased reliance on Internet platforms for self-distribution. Along with Los ingrávidos, other projects such MAFI.tv (Filmic Map of a Country) in Chile and individual filmmakers like Edu Yatri Ioschpe in Brazil seek to add their voices to larger national, regional, and international political debates; in doing so, they refuse to restrict themselves to the more traditional venues offered by film festivals, galleries, and microcinemas (without rejecting them altogether). Across a diverse array of modes of address and representational norms, they share a commitment to durational brevity and fragmented forms that evinces a reluctance to represent their chosen subject matter comprehensively—but also an investment in the type of charged visual content (of mass rallies, violent conflicts, performative protests, and so on) that will likely provoke further discussion and debate. As the use of deframing in *Transmisión/ Desencuadre* suggests, the broader discursive functions and effects of

this work are as important as the aesthetic experiences it offers viewers. Seen against the backdrop of a region still strongly dominated by corporate and state-run media outlets, these audiovisual transmissions clearly belong to Latin America's counterpublic sphere, and what practitioners like Los ingrávidos have brought to that increasingly important arena is an exploration of alternative strategies of representation, including a "radical off-centeredness" that leaves us considering an image out of joint.

Notes

1 Raúl Plascencia Villanueva, *Recomendación 51/2014: Sobre los hechos ocurridos el 30 de junio de 2014 en Cuadrilla Nueva, comunidad San Pedro Limón, municipio de Tlatlaya, Estado de México* (October 21, 2014), www.cndh.org.mx/sites/all /doc/Recomendaciones/ViolacionesGraves/RecVG_051.pdf.

2 Aristegui identifies Vivanco by name in the audio excerpt, but he refers to her only by her first name. Her voice is easily recognizable, however, to those in Mexico who follow national reporting on human rights issues.

3 Pascal Bonitzer, "Deframings" (1978), in *Cahiers du Cinéma, Vol. 4, 1973–1978: History, Ideology, Cultural Struggle*, trans. Chris Darke, ed. David Wilson (New York: BFI, 2000), 200.

Alan Kurdi's Body on the Shore

EMILY REGAN WILLS

In September 2015, Alan Kurdi, a three-year-old Syrian Kurdish refugee, boarded an inflatable raft in Bodrum, Turkey, with his parents and brother to make what Syrian refugees call the "death trip," the crossing from Turkey to the Greek islands and on to potential safety in the European Union. As with so many others crossing the water in the dark, their boat capsized. Alan, his mother, and his brother drowned, while his father survived. Alan's body washed up on the shore of Bodrum, which is where he was spotted and photographed by Nilüfer Demir— first lying on the sand as if sleeping, eyes closed at the water's edge, and then cradled in the arms of a Turkish policeman, being carried away.

The photos of Alan, particularly the one of him lying on the sand, spread rapidly online. Newspapers debated whether to print them or not; world leaders reacted in public statements and private phone calls to each other; pro-migrant charities and activists used the sustained international shock of the image to raise funds and galvanize public opinion; artists and activists remixed the image as critique. Though the photo followed the German decision to accept one million refugees in 2015 as well as the Swedish decision to accept over 150,000 in the same year, it helped to drive public support for those decisions. Here in Canada, the combination of the photos and the fact that the Kurdi family was

attempting to join family in Canada shifted public opinion, drove a massive increase in private refugee sponsorship, and helped Justin Trudeau's Liberal Party win the tightly contested 2015 election.

For many, the photos of Alan Kurdi on the beach lent reality and meaning to the toll of irregular and conflict-driven migration and the Syrian refugee crisis more generally. As a scholar of Arab migration and diaspora politics, I was closely attuned to these issues. In May 2015, I had traveled to Lebanon to help start a university program to support Syrian refugees there, and I saw the conditions on the ground: the roads full of cars with Damascus plates, the refugee mothers holding their babies and begging on the sidewalk, the families lined up to receive services in community centers, the exhaustion among social service providers.

That summer was one of the busiest for irregular migration across the Mediterranean in recent years, and ended with that searing photo of Kurdi's body, which made clear the consequences of European and North American inaction. That fall, I found myself guest lecturing as often as possible to anyone who would listen to me talk about the immense hurdles refugees faced to living in safety. My work was conducted in the shadow of the image of Alan Kurdi dead on a Turkish beach.

And I can't look at it.

The norms around photography of the dead have changed over time and vary by place. Memorial photos of dead family members were commonplace in the 1800s,[1] and persist today in limited form, through photography of stillborn children.[2] Contemporary Western photographic norms see photographing the dead as a violation of their privacy and the privacy of their family members.[3] But an exception exists for photojournalists like Nilüfer Demir; photographing the wartime dead has been central to the history of photojournalism. But not all dead are treated the same. As Susan Sontag says, "The frankest representations of war and of disaster-injured bodies are of those who seem most foreign, therefore least likely to be known. With subjects closer to home, the photographer is expected to be more discreet."[4]

In the Arab world, norms around photographs of death are different. During times of war, uprising, or destruction, injuries are documented photographically in great detail, and are shared and included in formal commemorations of deaths.[5] Those who are killed in conflict are referred

to as martyrs—whether they are civilians killed by bombs or combat-
ants killed by the opposing side[6]—and showing their bodies is a central
way to make a political statement about who is responsible for these
deaths. At pro-Palestine rallies, in the news media, and on Twitter and
Facebook, politically engaged and not-so-engaged Arabs circulate pho-
tos of martyrs, showing their wounds, their mutilated bodies, their ashen
faces peering out of shrouds as they are carried to their rest.

The photos of Kurdi are arresting because of the way they move
between these different normative worlds. They violate contemporary
Western taboos about photographing the dead, using the photojournal-
istic exception, and circulate in a way that other photos of the dead do
not. His death is "frankly" depicted, in Sontag's terms, but his position-
ing does not show the signs of violence carried out upon his body. Unlike
the stark realism and gore of Arab activist documentation of violent
death, the photos are beautiful, calm, peaceful—and all the more hor-
rific for it.

In graduate school, I took a seminar on visual politics. One of the key
cases we examined was the story of Emmett Till, crucially the political
effects of his mother's decision to hold an open-casket funeral and to
allow the circulation of photos of his brutalized body. I remember sit-
ting in the classroom where we watched a documentary on the case,[7]
taking us through Emmett's life, his death, and the aftereffects of it. My
wife was newly pregnant.

When we came to the images of Emmett in his casket, a feeling swept
over me so powerfully that it eclipsed any other thoughts: *This is some-
one's baby. Somebody did this to somebody's baby.* The feeling rose up
until it pressed out all other thoughts or feelings. My baby was a zygote
the size of my thumbnail, but the horrifying possibilities of the love I
would have for him buried me like a wave on the shoreline, and I was
dragged along its undertow, breathing the grief and horror of that
impossible, unsurvivable loss.

Sitting in that classroom, I closed my eyes.

In the early phase of the civil war I spoke to a Syrian diaspora activist
who said she was constantly negotiating with dissidents back home
over the images they were circulating of martyrs. "I understand that it's

normal for the folks back home" to show pictures of the martyrs after death, she said. "But I keep telling them, Americans don't like these pictures. We need to find photos of the martyrs alive, smiling. I want to make sure that Americans look at these photos and see them as people."

Courtney Baker, in her work on images of African American suffering and death, articulates the concept of humane insight, "an ethics-based look that imagines the body that is seen to merit the protections due to all human bodies ... recognizes violations of human dignity, and bestows or articulates the desire for actual protection."[8] Humane insight requires "the transformation of the task of looking into a task of recognition—a task whose terms are not only expressed in the language of emotion but also in the language of justice."[9] When we look with humane insight, we engage in the act of recognition that is at the core of so many claims for justice. This look acts, in Fred Moten's words, "in the name, too, of a dynamic universality (which critically moves in, among other things, grief, anger, hatred, the desire to expose and eradicate savagery) whose organization would suspend the condition of possibility of deaths like Emmett Till's."[10] The recognition of Alan Kurdi through humane insight motivates action toward justice for those like him—the possibility of deaths like his that the photo means to suspend.

But looking at that image, the recognition that occurs for me is not (merely) the political recognition that drives the claim for justice. (I had seen Syrian refugees before, after all; I already believed and advocated for their claims for justice before the world saw him dead on a beach.) Instead, what resonates is what Moten calls "dynamic universality": this child is not my child but is like my child. I am a mother of two sons, like Rehana Kurdi; the younger of them is the same age now as Alan was when he slipped into the water. I have watched my parents and my in-laws mourn children lost before adulthood. The overwhelming nature of parental love and the earthquake of parental grief are not abstract to me. In recognizing Alan—or recognizing Emmett—I recognize the hole that has been torn in someone's universe. The mourning to which I am called by that recognition overruns its boundaries, rises up and beyond the shores of my body. It becomes what Moten calls "the complex musics" of the photograph, the sound that carries all the

meaning that cannot be contained within "some organizations of and for light."[11]

In order to study terrible things—a fundamental job I have as a political scientist—I must render them abstract enough to get my hands on them, to think them through. But there always rests, just on the other side of that abstraction, a wave of affect churning at its edges. The recognition created by the photo of Alan Kurdi lets the wave of affect loose. Alan Kurdi is Abdullah and Rehana Kurdi's baby. He is the babies I saw in mothers' arms in Beirut and the baby who wakes me in the morning, because he is a baby, and exists relationally to all babies. His loss is a hole that cannot be filled.

Often, humane insight opens up the possibility for political action. For many, this is what the photo of Kurdi did. Syrian refugees became seen, became human, and that changed how the world acted. I cannot bear it; I feel my connection to Alan, to his parents, too sharply. I turn away from the image itself, but I cannot turn away from the fact of Alan, and thousands of other children, dead on the shores of politics. Moten asks, "Does the blindness held in the aversion of the eye create an insight that is manifest as a kind of magnification or intensification of the object— as if memory as affect and the affect that forges distorted or intensified memory cascade off one another, each multiplying the other's force? I think this kind of blindness makes music."[12] The music of the photo resonates in me, behind my averted eyes. I cannot look at it, but I open my mouth, and its song emerges.

Notes

1 Jay Ruby, "Post-Mortem Portraiture in America," *History of Photography* 8, no. 3 (1984): 201–222.

2 Ingrid Fernandez, "The Lives of Corpses: Narratives of the Image in American Memorial Photography," *Mortality* 16, no. 4 (2011): 360.

3 Ibid., 348.

4 Susan Sontag, *Regarding the Pain of Others* (New York: Picador, 2003), 61–62.

5 For examples, see Lina Khatib, *Image Politics in the Middle East: The Role of the Visual in Political Struggle* (London: IB Taurus, 2013), 89, 159–160.

6 Lori Allen, "The Polyvalent Politics of Martyr Commemorations in the Palestinian Intifada," *History and Memory* 18, no. 2 (2006): 130.

7 Stanley Nelson, dir., *The Murder of Emmett Till* (Boston: American Experience, 2003), https://www.pbs.org/wgbh/americanexperience/films/till/.

8 Courtney R. Baker, *Humane Insight: Looking at Images of African-American Suffering and Death* (Urbana: University of Illinois Press, 2017), 5.

9 Ibid., 77.

10 Fred Moten, "Black Mo'nin'," in *Loss: The Politics of Mourning*, ed. David L. Eng and David Kazanjian (Berkeley: University of California Press, 2003), 72.

11 Ibid., 65.

12 Ibid., 64.

4

Visual Regimes of Racial Violence

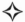

In 2013, the social media hashtag #BlackLivesMatter went viral in the wake of George Zimmerman's acquittal for murdering black teenager Trayvon Martin, spurring an international movement to combat the systemic regimes of racism, police brutality, and antiblack violence. For the authors in this section, theorizing the unwatchable means addressing the ideological structures of white supremacy and their inheritances from the history of racial slavery.

Photographer and scholar Stanley Wolukau-Wanambwa returns to an unwatchable scene of black death in the film *American History X* (1998) that he had partially edited out of his memory. Drawing on Frank B. Wilderson III's notions of black fugitivity and filmic imagination, Wolukau-Wanambwa places the film in constellation with the 2017 "Unite the Right" political rally in Charlottesville, where neo-Nazis, Klansmen, and other far-right groups protested the removal of a statue of Confederate army commander Robert E. Lee.

Critical race theorist Jared Sexton also contemplates images of black subjugation in popular American cinema, reading Jordan Peele's satirical horror film *Get Out* (2017) as a commentary on social death. Of particular interest to Sexton are the protagonist's screen memories of his mother's untimely death, which render him hypervulnerable to hypnosis and phenomenological banishment (to a "sunken place") by a family

of modern-day slave traders, who auction off virile black bodies to infirm white bidders for neurosurgical transplantation.

While Sexton zeroes in on television—the privileged medium for negating black subjectivity in *Get Out*—media scholar Alexandra Juhasz looks to the Internet for considering issues of visuality. Revisiting her op-ed, "How Do I (Not) Look?" (2016), Juhasz asks why she categorically refused to watch viral, live-feed videos of black death but could devote an entire project to documenting the epidemic of "fake news": "Where once I had chosen scarcity and clarity (don't look), here I went for over-abundance and onslaught (never look away)."

Like Juhasz, film scholar Michael Boyce Gillespie concentrates on questions of media testimony and racial violence. Gillespie opens with a story about a white bully, Jimmy, who rather astonishingly apologizes for the horrors of American slavery after watching the opening episode of *Roots*. In montage form, Gillespie cuts forward to Ja'Tovia Gary's video art piece, *Giverny 1 (Négresse Impériale)* (2017), which intersperses images of the Giverny Gardens in France with Diamond Reynolds's Facebook Live footage of Philando Castile's murder.

Held Helpless in the Breach

On American History X

STANLEY WOLUKAU-WANAMBWA

As I write these lines on Saturday, August 12, 2017, a mass of neo-Nazis, Klansmen, and other assorted white supremacists have converged on the town of Charlottesville, Virginia, in a symbolic effort to "Unite the Right." Last night, they congregated in Emancipation Park wielding tiki torches, chanting "Blood and soil!" and "Jews won't replace us!" interspersed with healthy sprinklings of "nigger!" as they sought to encircle the protuberant base of a memorial to Confederate General Robert E. Lee. The threat of the statue's imminent removal—not its destruction, but its displacement—served as a convenient pretext for their subsequently violent and ultimately murderous acts.

These protests occurred in a week when news broke of a Department of Justice effort to recruit lawyers to investigate and sue "universities over affirmative action admissions policies deemed to discriminate against white applicants."[1] These policies are in keeping with a reactionary need for what Carol Anderson aptly describes as "a narrative of white legitimate grievance."[2] Such policies have been the hallmark of the current administration, which sees the exacerbation of unfounded claims to white victimhood as good political strategy, regardless of the horrors that such fictions bring into visceral and lethal being.

Still from *American History X*.

All of this is a necessary preface to my remarks on the unwatchable murder scene at the heart of Tony Kaye's film *American History X* (1998). How else to write about an iconic scene of American Nazi violence in a moment increasingly shaped by a deeply radicalized strain of white nostalgia, which seeks to provide "a sanctuary for White people, a guaranteed matrix of safety, security, and respite," as Frank B. Wilderson III wrote in an essay on *12 Years a Slave*?[3]

DENNIS VINYARD: It's everywhere I look now . . .
DEREK VINYARD: What?
DENNIS VINYARD: This affirmative "blacktion"!

American History X is a film about race relations structured by a notional form of reparation. A young Derek Vinyard (Edward Norton), whose father is fatally shot attending to a fire in a "suspected Compton drug den," becomes radicalized by a local white supremacist. Sometime later, when his car is being stolen from his home by local black gang members, he opts to arm himself and kill two of the three thieves rather than call the police, resulting in a three-year prison sentence. While he is first enthusiastically welcomed in prison by his Aryan brothers, his puritanical Nazi zeal leads to them disciplining

him with rape, and to his subsequent excommunication from their fraternity.

It is noteworthy that in his expulsion, Vinyard becomes a "nigger" to his Nazi brethren, his puritanical zeal resulting in his relegation to the status of that which his entire ideology is organized to hate. It is especially noteworthy that his survival, in fact his rescue by a fellow black prisoner, occurs in response to the vulnerability that this abject status exposes him to: he is saved by symbolically becoming that which he has abjured and murdered in ritual and violent fashion, which is to say he both is *served by* and *survives through* being positioned *as* a "nigger." Following Vinyard's release, another young black gang member shoots his younger brother Danny dead. The calculus of reparation in the film thus hinges not on the body count (two dead on each side of the color line) but rather on the iconic, indeed the spectacular nature of Vinyard's second murder.

My memory of *American History X* begins with this scene—not the epigrammatic version at the opening, but the brutal second sequence shown halfway through the film. In it, having wounded the second thief with a gunshot, Vinyard drags him unarmed and prone into the street, spinning him through a 180-degree turn so that his head bisects the sweeping curve of the pavement. With a gun pointed at the back of his head, Vinyard screams at the thief to "put your fucking mouth on the curb," then bids him to "say goodnight!" and stamps on the back of his head with his black jackboots, splitting it open, and eviscerating him in graphic and literal terms.

I remember the crystalline sound of the man's enamel teeth on the coarse texture of the curb: the way they seemed both to tinkle and squeal in the low-slung cinema where I first saw the film in 1998. I remember how alone I was in that near-empty room. I remember an unbearable ratcheting up of inner tensions, and the instinctive decision to shut my eyes as the film cut from a close-up of the black man's bright white teeth to a wide shot of Vinyard on a suburban Los Angeles street, clad in bright white boxer shorts, gun pointed at the wounded figure, black jackboot raising up in order to sweep downward and split his skull.

My rejection of this scene's audiovisual content was so effective that I had believed, through all the intervening years, that the moment of desecration—the murder—was not in fact shown on-screen. I now know that it is. However, my resistance to the film went beyond my inability to witness this rupturing scene. I objected then, and still do, to the film's self-serving calculus of reparation. The ruptured black body around whose death the entire story pivots ends up freeing Vinyard from the ideological bonds of Nazi captivity: first, by precipitating the aid and care of his former principal, an African American, then by distancing him in his radical zeal from the impure Nazism of his brothers in prison, which engenders his rape and excommunication; then by occasioning the concern of his black workmate in the laundry, whose protection saves his otherwise endangered life.

The price Vinyard pays for his salvation is the death of his younger brother, whom he is able to save from the clutches of white supremacy in a last rite in which he recounts to him his experiences in prison. Thus, throughout the film, black death renders indispensable service to white redemption, so that the structure of the plot can "harness" black bodies as "necessary implements to help bring about . . . psychic and social transformation," and thus "vouchsafe the coherence" of Vinyard's "human subjectivity."[4]

In truth, the film's logic of transformation and reparation emanates from the sunken heap of that black corpse, its skull collapsed and concave on that concrete littoral. I think that I sensed that calculus in my instinctive evasion of the death-bringing image: that blackness is, or would always be, figured in and through death, that it is inseparable from violence, integral to producing progress but necessarily exempt from its rewards, and thus that black bodies must serve as the expurgated grounding of white (supremacist) identity.

I resisted—or attempted to resist—my interpellation into that murderous act of splitting, and the frozen frame depicting that immanent death became something both *obscene* and unseen. Obscene in Ross Chambers's sense, in that it rendered blackness as a "liminal phenomenon" that is "neither completely beyond cultural ken nor squarely acknowledged as integral to the cultural scene."[5] The freeze frame fixed

and figured blackness as emerging through the violence of erasure, and the image reduced my black male body to death in a moment of seizure *anterior* to the oncoming murder, leaving me held helpless in that breach—unable to watch, and yet incapable of not seeing.

Notes

1 Charlie Savage, "Justice Dept. to Take on Affirmative Action in College Admissions," *New York Times*, August 1, 2017, www.nytimes.com/2017/08/01/us/politics/trump-affirmative-action-universities.html.

2 Carol Anderson, "The Policies of White Resentment," *New York Times*, August 5, 2017, www.nytimes.com/2017/08/05/opinion/sunday/white-resentment-affirmative-action.html.

3 Frank B. Wilderson III, "Close-Up: Fugitivity and the Filmic Imagination: Social Death and Narrative Aporia in *12 Years a Slave*," *Black Camera* 7, no. 1 (Fall 2015): 148.

4 Ibid., 139.

5 Ross Chambers, "Death at the Door," in *Untimely Interventions: AIDS Writing, Testimonial, and the Rhetoric of Haunting* (Ann Arbor: University of Michigan Press, 2004), 24.

The Flash of History

On the Unwatchable in Get Out

JARED SEXTON

The real thing at hand here is slavery.
—Jordan Peele

Get Out (2017)—a "social thriller" written and directed by Jordan Peele about a black man, Chris (Daniel Kaluuya), in the present-day United States going to meet the parents of his white girlfriend, Rose (Allison Williams), for the first time—is one of the most commercially and critically successful black-directed films ever made. Despite its macabre themes, it is an eminently watchable film, and so may seem a strange selection for the present volume. But *Get Out* is fundamentally concerned with staging and confronting the unwatchable image of a history of violence at once deeply personal and inescapably political. It has been described as a film that "dares to reveal the horror of liberal racism in America,"[1] and yet while there is surely something to that claim, the film's target seems more expansive, a statement on the very rudiments of modern society, a living history of the global present. It works against the pervasive tendency to relegate history to the past and, more to the point, to reduce the massive history of racial slavery to a recent peculiarity of British colonial North America and the United States,

115

Chris (Daniel Kaluuya) confronts the hypnotizing power of television in Jordan Peele's *Get Out.*

much less the American South. So when Peele states that the "real thing at hand here is slavery,"[2] he means not simply a residual problem of racial inequality, but rather the active and ongoing *production* of a society structured in dominance: slavery as the real thing at hand, here and now, and not only as an African American's local concern.

Get Out attempts to capture history by "appropriating a memory as it flashes in a moment of danger."[3] At the heart of the film is Chris's childhood memory of his mother's death, her sudden and permanent absence. She was the victim of a hit-and-run driver while walking home from work one evening. Chris, an eleven-year-old latchkey kid raised in a single-headed household, waited alone for her return, mindlessly watching television in a state of paralyzing shock and anxious denial. He learned from the police report that his mother survived for several hours before succumbing to her roadside injuries that night, dying "in the early morning, cold and alone," as he later reveals in a distraught

confession to Rose. Just before that scene, Chris admits under hypnosis by Rose's psychiatrist mother, Dr. Missy Armitage (Catherine Keener), that he did not call anyone at the time because "it would make it real." That memory of his silence and inaction, prompted by a desperate attempt to preserve the *irreality* of his mother's life after death, becomes the psychic kernel of Chris's sustained guilt and the principal means by which he is rendered captive, subject to the Armitages' violent designs.

Because he cannot bear to lose his mother, Chris is especially vulnerable to becoming stuck in "the sunken place" to which he is phenomenally banished. There he finds himself *horrified*, looking on at his life "as a passenger," watching it like "an audience" of one, "able to see and hear what [his] body is doing," but unable to make any decisions or determinations of his own. Peele's visual concept-metaphor dramatizes for contemporary viewers the central mechanism of enslavement, a situation marked by a "severing of the captive body from its motive will, its active desire."[4] Accepting his mother's loss, for Chris, means coming to terms with her inability to protect *herself* and *her child* against all harm, including the harm of her premature death, and recognizing that there are limits, period, to his mother's capacities. Chris must also learn the fine art of discerning which of those maternal limitations constitute a manifest injustice demanding courage and which constitute an existential given requiring serenity, or both. The achievement of his reasonable happiness depends entirely upon the gift of that wisdom. It may also save his life and limb. In the meantime, Chris sublimates an unaddressed and overwhelming grief into the cultivation of a powerful vision, an eye driven to capture monochrome photographic images of the daily surround, images described admiringly by the blind white man who will bid for "rights" to take possession of his body and mind: "so brutal, so melancholic."

We can infer a similar dynamic at work for Walter (Marcus Henderson), Georgina (Betty Gabriel), and Logan (Lakeith Stanfield), those unwitting black people who were subdued, abducted, and taken over by dead, dying, or disabled white people prior to Chris's ordeal. Each of their underlying, rump state personalities is brought to the fore, momentarily crowding out their white owner-occupiers, by the blinding flash of Chris's camera or the utterance of some poignant comment. Logan, for instance, issues the eponymous "GET OUT" in a cryptic warning to

Chris during the lawn party, while Georgina cries through her stunned look and choked words when Chris confides his discomfort around large groups of white people. The literal or figurative flash that shutters the eyes is the moment of danger in which unsovereign black ~~subjects~~ try to seize control of a memory in captivity; it is the unwatchable flash of history as an unbearable knowledge about which there is no direct way to testify.

The crucial scene: Chris is induced in a state of heightened suggestibility to revisit the screen memory of his mother's demise. He does not imagine her suffering body directly (we see a doubled *refraction* of that agonizing figure, first in the body of the deer that is struck and killed by Rose en route to her family home and again in Georgina's badly injured body after Chris inadvertently runs her over in the course of his escape). Instead, he implies its present absence in the image of his younger self, sitting on the bed, dressed in pajamas, immobile before the flickering television screen. Importantly, we cannot see what young Chris is watching; the *content* of the programming is unwatchable because the screen is unseeable from the dreamer's vantage. It is the *form* of his watching that unnerves him and his engagement with the *medium* that seemingly enables it, the technology most associated with the personal and political pacification of the post–civil rights Reagan/Bush era and the postwar Eisenhower era before that: the TV, the idiot box, the boob tube.[5] His unconscious response is to make it his life's mission to become an active viewer, a *seer*, a witness versed in the aesthetic and technical aspects of professional photography, a social commentator with a complex documentary impulse.

The menacing, mind-numbing television, sapping all strength and disabling the critical faculties, reappears in the penultimate sequence of the film to inform Chris of his impending fate: he will lose his mind, for all intents and purposes, as a rich, powerful white man assumes physical control of his body, appropriating his refined tastes and hard-won talents in the process. We again see Chris from behind, now strapped into a cotton-stuffed leather chair. There is initially nothing to see on the television screen until the departed patriarch, Dr. Roman Armitage (Richard Herd), appears in an outdated video to explain the evil genius of the collective project he has spearheaded with and for his racist community. "The Coagula," as it is called, heralds the more perfect dispos-

session of the enslaved, one in which black people are rendered more perfectly into beasts of burden, domesticated animals directed almost entirely by the whims of their white or nonblack handlers, as we duly note Hiroki Tanaka's (Yasuhiko Oyama) attendance at the auction and his impossibly overloaded question—"Do you find that being African American has more advantage or disadvantage in the modern world?"

It stands to reason that the supplanting of his executive function is what renders the whole scene unwatchable for Chris, who turns away from the television screen with the same dejected incredulity that washes over his face in the moment he confirms that Rose has seduced and betrayed him. But, as the project name suggests (*cogere*: to gather, restrict, combine, or drive together), and the careers of Walter, Georgina, and Logan clearly demonstrate, the "real horror story" of "being black in America"[6] is the forced and permanent bonding, the "monstrous intimacies"[7] that white society imposes upon its black counterparts. The violent cohabitation entailed in the Coagula brain transplant is only the most pointed incarnation of this horrifying relation, but it is there all along in Chris and Rose's uneasy interaction. And it is present in all of the shameless poking, prodding, ogling, and groping exhibited by the Armitage family and friends, their relentless, consuming overfamiliarity. The desire, the life-and-death need, to escape from antiblack whiteness is inversely proportional to black people's *exposure*, not to white people per se but to an understanding of the actual situation, the real thing at hand.

Notes

1 Lanre Bakare, "*Get Out*: The Film That Dares to Reveal the Horror of Liberal Racism in America," *Guardian*, February 28, 2017, www.theguardian.com/film/2017/feb/28/get-out-box-office-jordan-peele.

2 Brandon Harris, "The Giant Leap Forward of Jordan Peele's *Get Out*," *New Yorker*, March 4, 2017, www.newyorker.com/culture/culture-desk/review-the-giant-leap-forward-of-jordan-peeles-get-out.

3 Walter Benjamin, "On the Concept of History," trans. Harry Zohn, in *Walter Benjamin: Selected Writings: Volume 4, 1938–1940*, ed. Howard Eiland and Michael W. Jennings (Cambridge, MA: Belknap, 2003), 391.

4 Hortense Spillers, *Black, White, and in Color: Essays on American Literature and Culture* (Chicago: University of Chicago Press, 2003), 206.

5 Amy Boyle Johnston, "Ray Bradbury: Fahrenheit 451 Misinterpreted," *LA Weekly*, May 30, 2007, www.laweekly.com/news/ray-bradbury-fahrenheit-451-misinterpreted-2149125; Michele Lingre, "Turning Off TV Gives Child a New View of Life," *Los Angeles Times*, January 9, 1994, http://articles.latimes.com/1994-01-09/local/me-10102_1_sesame-street.

6 Caity Weaver, "Jordan Peele on a Real Horror Story: Being Black in America," *GQ*, February 3, 2017, www.gq.com/story/jordan-peele-get-out-interview.

7 Christina Sharpe, *Monstrous Intimacies: Making Post-Slavery Subjects* (Durham, NC: Duke University Press, 2010).

Nothing Is Unwatchable for All

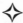

In July 2016, I published an opinion piece, "How Do I (Not) Look? Live Feed Video and Viral Black Death."[1] It was a personal and professional coming to terms with this disruptive, horrific cultural media event. There I explained why "I just can't watch" one particular video that was, at that moment, ricocheting across the screens, hearts, and minds of the world: "Diamond Reynolds' live feed video of the brutal murder of her boyfriend Philando Castile at the hands of the police with her child as witness in the backseat." I went on to name and delineate four traditions from visual culture, media studies, and critical Internet studies that could serve as "a brief primer of ways to understand how or why we might (not) look": Don't Look, Look Askance, Look at Death, and Look at Death's Platforms.

Looking now, back and through and about death's visual platforms, I see that my earlier writing served at least four critical functions:

- It provided a process for my own disorienting but strongly felt reactions to a series of highly circulating images: namely, I'm not going to watch.
- It opened a space to ruminate upon and share a long tradition of scholarly thinking (including my own) that granted this intuitive self-protective impulse a more rational or political basis.

Screen grab of the final twenty "hardtruths" from http://scalar.usc.edu/nehvectors /100hardtruths-fakenews.

- It allowed me to offer up one—my own—unique reaction to the raucous conversation about Reynolds's video and similar images. Not why I found it unwatchable, or why I chose not to watch it, but more that every look at violence and brutality in this, our moment of persistent, total, sharable, encompassing visibility, is an ethical choice and a political act.
- It implicated me, as a white woman, as a scholar who writes on and makes video, who has celebrated outsiders' voices for decades, who had once believed in the politics of visibility. It implicated me as one player within a dynamic ecosystem of words and images emanating from our diverse bodies and formats of work, our many watchings, our clicking and forwarding, our not watching, and our associated actions. My not watching was not necessarily being irresponsible or disconnected or somehow safe and outside of this logic of seeing and violence. I had to account for myself, publicly, as a form of penance.

Over the next year, another wave of viral images, and their linked and co-constitutive words and violence, momentarily and brilliantly sucked

up all the air of our shared looking space. The images and sounds of fake news (in all of its confusing multiplicity and mutability, referring, as the phrase now does, depending upon who is speaking, to media images from *The Daily Show* or Breitbart, or to what Trump calls the failing *New York Times* and CNN, or to intentional propaganda or profiteering click-bait) grew to become, in their/our moment, fully reprehensible and utterly deplorable. But with only a little hindsight (and it does seem so hard to see clearly in this new era of Trumpian image-blitzkrieg), I can see how fake news videos continue and expand the logic of images of viral black death that had so recently demanded all of our viewing attention.

Of course, such images aren't new, only newly fascinating, following on a decade of related viral video of first-person mayhem and cruelty and a millennium of racist depictions of brutality in ways that define today's new and also very horrific video zeitgeist. Both bodies of viral media are real-time; people-made; immediately trans-medial and thus corporate-influenced and controlled; utterly and definitively subjective and political; manifestations and at the same time witnesses of hatred, fear, and violence; image projects that observe and then render more real-world suffering; entirely dependent upon context and audience for meaning; and spellbinding in their capacity for saturating the senses and spirit so that dissociation, denial, and self-hatred (not watching) seem as reasonable and righteous a response as does anger, action, or analysis.

Perhaps this linking of viral live-feed images of black death and fake news is crazy. Or downright wrong. Shortsighted or insensitive. Simplifying? Generalizing? I do know that one body of viral video defined a highly topical media moment that was followed by the next; but I also know that I chose not to look at one, while I ended up staring much too closely at the other: a look that also, ultimately, brought me to myself. My ethical, political, personal choice to look *every day for 100 days* at fake news, and then share my responses online, is a stunning parallel to and reverse of my earlier gesture, non-choice, and act of self-punishment in the ominous endless sight of black death.

When I built the online primer of digital media literacy, *#100hardtruths-#fakenews*[2]—working steadily from January 20 to April 19, 2017, and with the help of my colleague, the technologist Craig Dietrich—my impulse was not to sustain the offenses held therein nor the conversations about or

responses to those self-same transgressions. Rather, I was moved, as a citizen, to act in alignment with and all the while against this mounting visual information travesty: as witness to, teacher about, and interlocutor with an escalating media abomination. Linked as I was to our illicit and new president, Donald Trump, his news, and our media, my project (in social media and on the stand-alone website) was at once sordid and pained, if sometimes hopeful. It was just one offering among many but still became over-full with too much. And thus, also, it became one woman's real-time testament to and hording of a hundred days' detritus left over from a digital life attending to fake news. Where once I had chosen scarcity and clarity (don't look), here I went for overabundance and onslaught (never look away).

Fake news, I decided—and the Internet's mountain of attempts to better see it, know it, defang, debunk, and stop it—should be carefully looked at for no better reason than that it was and is. More so, in its unseemly existence it proved itself at once inordinately powerful within the fleeting attention economy of the Internet and also for its associated material manifestations of aggression. For *#100hardtruths-#fakenews*, all of my attention was beelined to see and show the connections that the Internet and its president were attempting to hide: how sick consolidations of falsehoods and their seemingly trifling swirls of online reaction in the form of memes, reposts, likes, and more fake news congeal into corporate, governmental, and patriarchal power that is unleashed in the form of punitive projections, escalating restrictions, and literally, inevitably, the mother of all bombs.

This I called "virality is virility," and its gross material enactments were what I was watching for. I knew and found that this kind of looking—his, ours, the media's, mine—would end with bullying, arrests, deportations, people not going to college, others not getting to use bathrooms or stay in the military, and yes, bombs: falling, landing, killing, destroying, blindly.

Needless to say, averting our gaze with disdain or otherwise censoring the visual unpleasantness that was made by and for us in the current format of the Internet-minute—fake news—would be the responses that any despot would wish for. So, yes: let's watch.

But, let's also face it: "Fakenews r us." This self-reflexive, self-fulfilling, skeptical mandate (another of my hardtruths) is central to all watching

on the Internet. While the fake news is bogus, by definition, so too must be our watching and linked writing about it. Yuck.

So why did I choose to look at and be fully dirtied by one unwatchable body of work while selecting to not and never to look at the other (even so, not staying clean)? How do my diametric positions of watching allow me to understand better my own limits as well as the boundaries and differences between two appalling bodies of viral video and the actions that each might inspire, produce, or crush?

First, there is the matter of Internet time. Last year's insults must be biggered and bettered in a logic of neoliberal growth. We tire so quickly. Our eyeballs become numb.

Then there is a matter of truth. For one short, horrific moment last year, a series of viral images of black death moved fully—not via the logic of fakery or uncertainty that I, for one, argue defines all Internet viewing (see above)—but rather on the force of their authenticity: images that were unarguably, unutterably so true that no one (white) could undermine, unsee, unknow their structuring logic of viciousness, even if not looking.

Which gets us to #BlackLivesMatter, and the power of that movement's ultra-true images, and *#100hardtruths-#fakenews* and the insipid helplessness of this newer moment underwritten by image deception, just one year and one president later. Which allows me to end with difference, context, shame and forgiveness.

My watching patterns, as a white middle-aged queer academic in the time of Trump (difference), are situated in what I can bear (context), what I can do (by virtue of privilege and passion . . . shame), and who I might work to join so as to get and do better (forgiveness). Nothing is unwatchable for all, so perhaps we need to do better in sharing the burden of viewing image-based brutality with and for each other.

Notes

1 Alexandra Juhasz, "How Do I (Not) Look? Live Feed Video and Viral Black Death," *JSTOR Daily*, July 20, 2016, https://daily.jstor.org/how-do-i-not-look/.
2 Alexandra Juhasz, "*#100hardtruths-#fakenews*" (2017), http://scalar.usc.edu/nehvectors/100hardtruths-fakenews.

~~Empathy.~~ Complicity.

MICHAEL BOYCE GILLESPIE

Monday. January 24, 1977. Albuquerque, New Mexico. Land of Enchantment. Queen of Heaven elementary school. I was frozen in a library aisle with my eyes closed, body tightened, and braced to be hit. I was seven. Standing in front of me was Jimmy. He was the biggest white boy I had ever seen for a second grader. Jimmy was mentally handicapped. Jimmy was also impressionable. So much so that the more enterprising and dwarfish bullies had discovered that for a candy bar, Jimmy was willing to beat anyone they desired. It was common for the sounds of the schoolyard to be interrupted by a scream followed by the sight of Jimmy atop someone on the ground. He would be swinging away with chocolate smeared across his lips and blood smeared across his knuckles. So, there he was blocking the aisle in front of me. I had seen him watching me that morning and begun to assume that it was now my turn to scream. I worked all day to stay invisible in the crowds while keeping the nuns in the corner of my eye. I decided to skip recess and safely read the *Book of Lists* again in the library. Yet, now I was frozen with my eyes closed, body tightened, and braced to be hit. But, the blows did not fall. So, I opened my eyes and looked into his. He spoke. "I, I, I, I'mmmmm. Sorry. For. What. We. Did. To. Your. People." Then

Still from *Giverny 1 (Négresse Impériale)*.

Jimmy walked away. Monday. January 24, 1977. The day after the first night of *Roots*.

Summer, 2016. It was incredibly bloody. Philando Castile. Alton Sterling. They were murdered. Then, I'm also hearing news about the ongoing immigration crisis, boats filled with migrants capsizing in European waters—not to mention various expressions of antiblack violence cropping up all over the globe. I felt like I was inundated with these accounts of gratuitous, yet routine violence. Only, now I lacked my usual support system, my community. But, there I was in the elaborately bucolic and luxurious dreamscape of Giverny scrolling through Facebook and being repeatedly assailed with brutal imagery. My double consciousness was acutely triggered.

Ja'Tovia Gary[1]

Giverny 1 (Négresse Impériale) (2017) is a short video shot by Ja'Tovia Gary in the summer of 2016 during her residency in Giverny, France, at the Claude Monet Gardens. Gary circulates through Monet's idyllic gardens and canonical resonance. In the spirit of Nicole Fleetwood, Gary's movement—a black woman's movement—in this space of whiteness, beauty, and earthly delights engenders a "reinscription" of her body, a

disarticulation of her black aberrance in and by this aesthetic. Gary's navigation of this space occurs as what Fleetwood calls "excess flesh," performative acts by black women artists that engage the perception and conception of the black female body, its hypervisibility, by the visual regimes of antiblack whiteness. As Fleetwood crucially notes, "Excess flesh is an enactment of visibility that seizes upon the scopic desires to discipline the black female body through a normative gaze that anticipates its rehearsed performance of abjection."[2] Critical disobedience. Black visuality. High art. Common space. Gary's presence entangles an encounter of power, pleasure, and complicity. Throughout, the film camera operates with rumors of portraiture coupled with canted abstraction. Multiscalar frame effects and in-camera rack focusing consistently shifts and redirects the focal points. Calibration, sharp and clean. A chopped and screwed version of Louis Armstrong's 1950 cover of "La Vie En Rose" plays throughout. Triggers.

In total, the film archives and indexes the following images: the Giverny gardens, archival footage, images of flora from the gardens affixed to film stock and projected, Gary posing and moving through the gardens, animation sequences, and Diamond Reynolds's Facebook Live footage of her boyfriend, Philando Castile, dying. Wounded by five bullets. Two pierced his heart. The film's editing structure suggests the prosaic coding of an essay film. Moreover, the film's tableau is deeply compromised, conflicted by patches of glitches. Rectangles. Squares. Precise pockets and zones that destabilize the pastoral, rendering it as a deliberate patchwork of codes and conceits. The glitches unsettle the patchwork as crash points, deceleration spots, and disintegration loops. These breaches are affective textures that stress the surface of the image and expose an unstable beneath. "Hold me close and hold me fast / The magic spell you cast / This is la vie en rose."

The archival element of the film includes footage of Monet painting in the gardens (1915) and Fred Hampton (1969). One is a record of mastery and the other of revolutionary consciousness. Along with Diamond Reynolds's video and Gary's record of her presence in the gardens, there are thus four visual historiographies that the film negotiates and meters. The pitching down of Louis Armstrong's voice thrives above opiated pathology scripts by operating as the sonic grounding of

this gathering. The chopped and screwed signature of Satchmo accents the song's measure of love, breaking from the specificity of more classical mixes and arrangements of the song. With this remix, the song's protagonist no longer inhabits the place of the lovelorn source. A black and blue B-side concentration. With Satchmo now grieving, the song acts as a dirge pitched with the new ordinance of black death. T.R.O.Y.

Gary does not feature any of the footage of Castile. Instead, his death becomes rearticulated through a blocking shift in perspective. The footage of the dying Castile is cropped away as offscreen space that results in the amplification of another spectacle and focal point: Diamond Reynolds and her despaired commentary. As Gary has noted, "I opted to not use the bloodied body of Philando Castile. I just couldn't view that footage. To this day, I still haven't watched the video in its entirety. I'm enraged, saddened, and disrupted in the worst way possible and have no desire to incorporate the violent deaths of Black people in my art. My work is ancestral. I'm not sure I'm honoring the ancestors by reproducing violent deaths."[3] Black death virality. A lynching souvenir? A finger, a toe, an ear, testicles, and a video stream? "Hold me close and hold me fast / The magic spell you cast / This is la vie en rose."

What happens when you suspend the never neutral visual spectacle, the evidentiary record that at no time guarantees justice?[4] As the remediation of a death scene, Reynolds's witnessing seethes and calls out the systemic claims that enabled her boyfriend's murder. Her real-time accounting commands something very particular of the spectator. As Julie Beth Napolin writes, "When Reynolds narrated what was happening in the car at that moment . . . an alternate and urgent relation is demanded by the narrating voice: neither projection nor identification, but recognition."[5] A broken tail light, a notification to the officer that a weapon was present in the car, deliberate and nonaggressive movements, and the conclusion of black death. "We don't deserve this," she said. Recognition. Do you fuckin' see this?

 She strolls, she smokes, she is nude, and then she screams. Her direct addresses of the camera root her place in this garden, in this palette, and in this world. *I'm standing here thinking. It's not about you.* A fugitivity bloom for all the world to see. She screams in a garden, a system

not broken but very much at work. The film does not claim that this is not a time for flowers. Instead, it is a beautiful and devastating musing on why all will not have a place in this garden. Throughout the film, Gary recodes the exquisite labor, care, and design of the garden. In the end, the scream as performative break radically shifts the spatiotemporal privilege of the gardens to another. Her scream is not strictly about rituals of mourning. Perhaps it is a cry of love or about the capacity to imagine what happens when black folks stop being nice. "Hold me close and hold me fast / The magic spell you cast / This is la vie en rose."

Notes

Thanks to Annie J. Howell, Amber Musser, Lisa Uddin, Dana Seitler, and the editors of *Unwatchable* for their comments. Much love to Ja'Tovia Gary for her work and the conversations.

1 Ja'Tovia Gary, personal communication, September 8, 2017.

2 Nicole R. Fleetwood, *Troubling Vision: Performance, Visuality, and Blackness* (Chicago: University of Chicago Press, 2011), 112. Fleetwood's analysis of Renee Cox's photography and her consequential engagement with the work of Édouard Manet and art history have importantly informed my thinking about Ja'Tovia's engagement with Claude Monet and his gardens.

3 Gary, personal communication.

4 Judith Butler, "Endangered/Endangering: Schematic Racism and White Paranoia," in *Reading Rodney King/Reading Urban Uprising*, ed. Robert Gooding-Williams (New York: Routledge, 1993), 17. See also Jennifer Malkowski, *Dying in Full Detail: Mortality and Digital Documentary* (Durham, NC: Duke University Press, 2017) and Alexandra Juhasz, "How Do I (Not) Look? Live Feed Video and Viral Black Death," *JSTOR Daily*, July 20, 2016, https://daily.jstor.org/how-do-i-not-look/.

5 Julie Beth Napolin, "Scenes of Subjection: Women's Voices Narrating Black Death," *Sounding Out!*, December 19, 2016, https://soundstudiesblog.com/2016/12/19/scenes-of-subjection-womens-voices-narrating-black-death/.

5

Spectacularization and Resistance

Through personal storytelling and political arguments, the essays in this chapter explore the interconnections between gender disciplining, settler colonialism, and disability oppression. Written by trans non-binary artists and scholars, they explore what it means to be made into an object of spectacle and how this spectacularization connects to systems of violence, poverty, and diminished life chances. The essays recount everyday and structural violences, many of which are tied into normative subjects' fascination with the bodies they declare repellent. Alok Vaid-Menon, a trans non-binary performance artist of color, describes how it feels to be filmed instead of greeted and wonders what their gender would look like if it were not mediated by spectacle. Métis Two-Spirit intersex playwright Alec Butler recounts their mediated experiences of some of the most iconic violences of the twentieth century and their sharp reaction to white gays and lesbians obliviously donning "redface" on Hallowe'en. Danielle Peers, a non-binary disabled scholar and artist, reveals the hypocrisy of American leftists who use ableist and sanist language to disparage U.S. president Donald Trump while decrying his impersonation of a disabled journalist. Peers argues that even the organizing concept of this book—the "unwatchable"—centers vision at the expense of other senses and of people who do not experience the world visually. They point to the "unwitnessable" as a more inclusive concept.

Entertainment Value

ALOK VAID-MENON

It is October of 2016 and I am giving a keynote presentation at a conference in Melbourne about promoting feminism in the music and entertainment industry. As a trans performance artist, this is my jam.

I talk about how gender-nonconforming transfeminine people are only permitted to exist on a screen, in a photograph, on a stage. We are always understood as a spectacle and never as real; we are reduced to parodies and costumes whose only purpose is to entertain. This is why transgender representation is misleading and warped: the only parts of our lives that are deemed worthy of recognition are determined by our entertainment value. While prevalent discourse around trans people dismisses us as woefully unwatchable ("why would anyone want to look like that?"), on the ground we are made into conspicuous figures of relentless public scrutiny.

I receive a standing ovation.

On the tram home after the talk I am bashed. It is three in the afternoon. A white man punches me in the face. He says, "I am okay with gay people but you are too much!" I say, "I am sorry." I am not sure quite what I am apologizing for but it feels like something that might help, like traveling with a friend, or saying "text me when you get home." There are formalities we take in the face of constant fear—these rituals we have

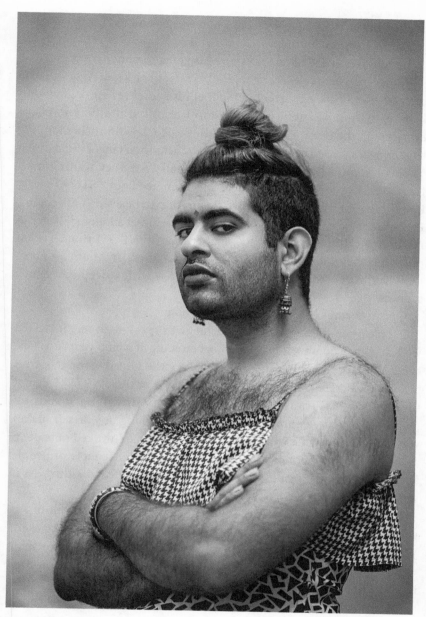

Portrait of the author.

devised to get by, like turning pain into theory and using big words to pretend we are not scared.

He tells me that if I don't shut up he is going to punch me harder.

There are twenty-seven people on the tram. I know this because somewhere in between listening to all of his expletives and calculating how many minutes until the next stop I also find the time to count everyone in the tram. I look at them, these people with their shopping bags, loneliness, and student debt. I watch them watch me. I watch them sit there silently, like the audience at my talk. Are they waiting until this is finished to rise? Part of me wants them to shout, "STOP," say, "I know them" or maybe even "I love them," or maybe even "I am them." Part of me knows they will do nothing: maybe tweet about it, talk about it one night drunk at a bar, "Remember that time. . . ." I wonder what pronouns they will use for me. I wonder if it matters. It is hard for me to mobilize blame anymore; instead I am filled with a deep and heavy sadness.

One of them is holding up a camera phone.

People often find it easier to film me than speak with me. It started with a white woman who recorded me dancing at a club years ago (she could have just said "hi"). There was the man who filmed me on the street just last week. He kept shouting, "WTF! Look at this. WTF!" I sheep-ishly smiled as if I was amused by myself too. (Laughing at yourself makes them more comfortable with you. Laughing at yourself makes you more comfortable with you.) But the first time I walked outside in a dress with a camera crew, no one harassed me. A couple of people asked what was going on. "Making a film." They smiled, nodding. As if we were in on the joke together.

In the moment right before the tram stops, I think about all of the videos online I've seen of gender-nonconforming people being attacked. Would I become one of those videos? Is this a rite of passage (or shall we say, "transition")? Who would watch it and why? Is a reshare the digital version of a standing ovation?

Recently the human rights group WITNESS released a report called "Capturing Hate," about viral video attacks of trans and gender-nonconforming people.[1] They review 392 videos, which have been viewed 86,233,760 times. These videos are so popular, in fact, that companies sponsor branded content on them.

I did not cry after I was bashed on the tram. But I did cry reading the report; and I cried watching the videos. I thought about the 86,233,760 viewers. Those people with their dreams, desires, and escape mechanisms. And I wondered why they watch these videos of us. And I wondered if maybe "they" could actually sometimes be "us"—and how "us" and "them" is sometimes a question of who is filming and who is being filmed, who is watching and who is being watched.

I find it difficult to imagine what it means to end violence when millions of people find pleasure in your denigration. I find it difficult to watch videos of anti-trans attacks without having flashbacks to all the times I have been assaulted in public—offered a camera instead of a helping hand. I find it difficult to understand how something so mortifying, so vile, could be so viral. I find it difficult to swallow that the only forms of harassment elevated to the level of tragedy are the spectacular ones. I find it difficult to imagine what my gender would look like if it were unmediated by spectacle.

Would "trans" exist if "cis" did not want—require—something to watch for its pleasure?

Would "trans" exist if it was unwatchable?

That night after the attack I found myself back on a stage performing poetry. These days I find myself repurposing the camera, the stage, all of those institutions built to watch me, in an attempt to create moments of rupture—and maybe even transcendence—where I can be understood.

Note

1 Karen Stevenson and Kyle Broadus, "Capturing Hate" (New York: Witness Media Lab, October 2016).

Holocausts, Hallowe'en, and Headdresses

ALEC BUTLER

As a playwright, filmmaker, and author whose work has dealt with intersex/trans/2spirit identity, as well as experiences of violence, loss, and grief, there is not much in the world from which I would avert my eyes. From a young age, I was aware of the horrors that humans can inflict on each other. At the tender age of seven, my family toured the Bergen-Belsen concentration camp. My dad was a Canadian soldier, and we were stationed in West Germany for five years. By the time we arrived in our sky-blue, four-door American Motors Rambler at the entrance to Bergen-Belsen in the summer of 1966, the former death camp had become a tourist and education center about the crimes of Nazism.

The night before, my dad had sat my older brother and me down on the couch in the living room of our cookie-cutter army housing to tell us exactly where we were going. Some would say it was a terrible idea to take a child my age to a former death camp, but I like to believe that my father trusted that we were mature enough to handle it. My father, who had been proud to serve as a peacekeeper for the United Nations in the 1950s during the Suez Crisis, said the reason we were going on a tour of a concentration camp was so we would know where hate and prejudice

First Trans March, Toronto, Canada, 2009. Photo and banner by Alec Butler.

lead, so we would not be taken in by Nazi ideology, so we would not forget. The next day the message was delivered. Years later, I can trace my desire to be an artist, a communicator, a lover of freedom of expression, and an anti-fascist back to that very day.

When we arrived back in Canada in 1968, I had rarely seen a television. Some of the first television images I recall were in a seedy motel room on the outskirts of Montreal, next to the Trans-Canada Highway. My family had just landed in Toronto earlier that day. We were all exhausted from the long flight and had to wait hours for the sky-blue Rambler to come rolling out of the belly of the airplane before we could start our two-day journey to my father's next posting in Gagetown, New Brunswick.

It was a hot August evening and the motel windows were wide open. The relentless sound of traffic going both ways on the Trans-Canada filled our motel room. It was a tight, hot, muggy, cheap room with two double beds shared by my parents, my two brothers, and me. The television was the only expensive-looking item in the room—it looked like the newest RCA model. The gleaming television was on a flimsy looking, shit-brown bureau of drawers against the wall at the foot of the beds. I was standing in front it in wonderment; the shiny on/off knob called

irresistibly to me. My dad said "Don't turn that TV on yet," but he was too late.

The picture and sound took a millisecond to sync up. The colors were sharp and exploded into the dingy room. We were watching an American news report. I had turned the television on in the middle of a broadcast. Walter Cronkite was speaking in subdued, somber, measured tones about the Vietnam War. The words he spoke faded in and out of my hearing—not because there was anything wrong with the sound on the television, I don't think, but because what we were witnessing was so horrible that it affected our ability to take in both the sound and the images at the same time.

I have never forgotten the grainy, jumpy film footage, set on a war-torn street in Saigon. A Viet Cong insurgent with his hands tied behind his back was being shot through the head by the South Vietnamese national police commander. The footage is famous now, but then it was shocking to see a human being murdered on television. This was my introduction to television in Canada at the age of nine.

After my dad took early retirement, we moved back to my parents' hometown on Cape Breton Island. School was rural and rough, and I was bullied most of the time. I sought solace in the magazine room of the junior high library, where I found a story in *Time* magazine about a work called *Tulsa* (1971) by photographer Larry Clark. It was a book about the photographer's friends in the drug subculture of Tulsa, Oklahoma, in the 1960s. The review featured a number of Clark's riveting photos of people shooting up heroin and a dead baby in a coffin.

One photo really affected me, a photo of a young man with jet-black hair sitting with crossed legs on rumpled white bed sheets holding a handgun. He is smiling playfully, not pointing the gun at the camera menacingly, but holding it like a lover. This photo inspired *Shakedown*, the first play I wrote when I was twenty-one, about the effects of a brother's suicide on one of the two male characters, a play about male mental health, male violence, and male toxicity. I had come out as a lesbian while writing a play about two men, inspired by a black-and-white photo of a man holding a gun.

Memories of my most unwatchable moment came up a couple of years ago when I was asked if I would like to be paid to take photos in a booth of Hallowe'en revelers on Church Street, the gay mecca of Canada,

in downtown Toronto. For years in the 1960s and 1970s, the homo-phobes would attack drag queens and dykes coming out of the clubs on Church Street. Then, in the 1980s, the community started fighting back by marching down nearby Yonge Street. It became the scene of Canada's "Stonewall" moment on February 4, 1981, when protestors fought police after a raid on three gay bathhouses during which three hundred men were arrested.

In more recent years, Hallowe'en on Church Street has devolved into a tourist attraction, where people come from the suburbs of Toronto and are surprised that people—poor, working-class people—still live there. It feels more like a gay pride party where the straights come out to gawk and take photos of the drag queens and the now-acceptable LGBT community in assorted costumes. The spirit of community resistance to oppression and violence is gone now, the rebellious heart of Hallowe'en has devolved into a crush of bodies jockeying for position to take the best pictures of the drag queens in their outrageous wigs and costumes, or take the best selfies in the foreground of an endless river of intoxicated celebrants. The original spirit of Hallowe'en in sixteenth-century Europe has transmuted into a capitalistic costume party that acts as a stop valve on the revolutionary urges of the masses.

Twenty years ago, I wrote a play, *Medusa Rising*, which spoke to this revolutionary discourse. The play opened on Hallowe'en night, a time of the pagan cycle of the year when the veil between the worlds is thin. In the play, I call this night "Hallowed Queen," in honor of the goddess-worshipping witches and lesbians that I had admired from my teenage years onward. Inspired by my involvement with the pagan Wiccan reli-gion in the 1970s, the play began as a healing ritual in the form of a "feast for the dead" for friends who had died of AIDS, suicide, and murder over the preceding ten years, performed by a group of seven white witches and Two-Spirits. This was years before I found out in the 1990s that I was thrice a mixed Indigenous/Settler and Two-Spirit. Two-Spirit is a First Nations term for people who embody multiple genders or identify as LGBTQ. A major theme of the play was about how to direct righteous anger toward the right targets instead of against each other based on our perceived differences and our own colonized minds and bodies.

Twenty years later, I still celebrate Samhain (the Pagan New Year) mostly alone and try to avoid Hallowe'en on Church Street as much as

possible. Returning to the memory of my most "unwatchable" moment—I had to turn down a paid gig to take photos of piss-drunk Hallowe'en revelers on Church Street, even though I could have badly used the money to buy food or pay an overdue bill.

The last time I had ventured out to Church Street on Hallowe'en night I couldn't handle seeing all these people in redface, with their tacky headdresses and store-bought costumes. I had to escape the crowds of tourists with flashing cameras and hordes of straight white hetero suburban photographers, taking photo after photo after photo of fake Indians, portrayed by drag queens and white straight people in redface everywhere I looked.

I have a hard time watching the continuing colonization of these beautiful cultures, and seeing this carried out by my own LGBTQ community made it even more painful. I remember wishing for an end to this pain of erasure and colonization that continues to violate the First Nations, Métis, and Inuit communities of Canada. Recently, I found hope in the fact that more people, both Indigenous and Settler, are speaking up on various media platforms against these acts of appropriation. Show me images of empowered colonized and colonizing people decolonizing their minds through art, and I will watch and be inspired.

Unwitnessable

Outrageous Ableist Impersonations and Unwitnessed Everyday Violence

DANIELLE PEERS

On November 24, 2015—just five months into his presidential campaign—Donald Trump was filmed at a South Carolina rally mocking disabled reporter Serge Kovaleski: exaggeratingly mimicking the reporter's hand contracture and adding in spasms, vocal affects, and facial expressions often used to insinuate and mock intellectual disability. Despite Trump's many explicitly racist, misogynist, anti-Hispanic, and illegal antics, an August 2016 Bloomberg poll found that the disability impersonation was widely considered his "worst offense" of the presidential campaign.[1] Most of the people on my news feed seemed to agree.

It started out with fervently expressed outrage and claims of "unwatchability," followed by eager repostings of the video, often tagging me: one of the only disabled activists many of them know.

I certainly found the video offensive, an insult I preferred not to continually rewitness, but not the unwatchable assault they claimed it to be. After all, mocking disability is something I witness almost daily on playgrounds, at the office, and in the media. I use the term "witness" here, rather than "watch," because such incidents are experienced not only through visual stimuli, and not only by those who engage with their world visually. What I found much harder to witness than the video

itself was the ways that this event—and disability more broadly—has been leveraged by the nondisabled white "left" without much concern about or input from actual disabled people.

I found it hard to witness the repeated postings, purportedly outraged on behalf of disabled people, yet seemingly unconcerned about how the constant reposting might affect us. It was hard to witness the celebratory sharing of chastising speeches by nondisabled Hollywood stars and late-night comedians. One of the most notable was Meryl Streep's viral chastisement of Trump's impersonation in her acceptance speech at the 2017 Golden Globes—an awards show (among many) widely critiqued by disability communities for systemically celebrating offensive disability performances.[2] And peppered among all of the videos and chastisements, these same outraged activists continuously tried to insult Trump through the use of ableist (and often eugenic) jokes, impersonations, and terminology—constructing Trump as crazy, a lunatic, a moron, an idiot, and a degenerate.

For me, such ableist engagements are as hard to call out as they are to witness. Ableism is so deeply legitimated, even (or perhaps especially) on the left, that saying "don't call Trump a moron" can only be read as a defense of Trump, the preface to an ableist punchline, or a prudish call for political correctness. But, I argue here that the stakes of such everyday ableism are deeply tied to the larger ongoing and impending violence that Trump seeks to enact.

First, and most obviously, the use of such sanist and ableist terms to "write off" Trump belittles Mad and disabled people. It reproduces the notion that our lives are less valuable, our perspectives less legitimate, our existence undesirable. Such insults (like homophobic or misogynist ones) both leverage and reproduce hierarchies of categorical human (un) worth, and in so doing, reinforce systemic inequality, oppression, and resulting violences. This violence is much more than symbolic. In the United States, Deaf, Mad, and disabled people are more than twice as likely to live in poverty.[3] We are incarcerated at four times the rate of nondisabled folks.[4] Of disabled women, 83 percent are sexually assaulted, and this is likely much higher for gender-nonconforming disabled people.[5] We also face major barriers to immigration in North America, including being barred from immigration in Canada because we are constituted as "undue burdens."[6] We also account for up to half of

those killed by police in the United States.[7] Under Trump, the stripping of civil rights, increases in police powers, curtailing of social safety nets, limits to health care eligibility, and tightening of immigration will disproportionately affect the life chances of Deaf, Mad, and disabled people. These everyday threats to survival and flourishing, rather than one outrageous impersonation, are how I wish my leftist community could witness disability oppression in the age of Trump.

Instead, I witnessed the following dangerous juxtaposition on my news feed: on the one hand activists were claiming disability mockery was worse than racist immigration bans; on the other, activists were calling Trump "moronic" and "crazy" for having suggested racist immigration bans. In both cases, white supremacist nationalism and ableism are played off each other, each belittling the importance of the other, and they are misconstrued as entirely separate and separable oppressions. Many white disabled activists on my news feed also construe them as unconnected. The statistics above, for example, are so often quoted without acknowledging that all of these are forms of violence and oppression to which Indigenous, racialized, and gender-nonconforming people are also far more likely to be subjected. Despite the tokenistic white male wheelchair user in virtually every disability news story, those who experience racial, colonial, and gender-based oppression are far more likely to experience disability, and to be pathologized as mentally ill.[8] Further, racialized Deaf, Mad, and disabled people are far more likely to experience most of the violences articulated above than white disabled folks are.[9] Playing racial and ableist oppression against each other negates overlapping histories (and presents) of eugenic institutionalization, sterilization, immigration bans, and extermination: eugenic projects that have been instigated and supported by white feminists and progressives at least as much as by the political right.[10] Playing oppressions against each other hides our complicity in, and betrays our complacency toward, the interlocking violences of colonialism, white supremacy, and eugenics.

The use of ableist or sanist slurs—and, more recently, the use of formal diagnostic labels to construct Trump as incapable or dangerous—not only reproduces contemporary ableist violence and serves to hide our complicity in overlapping systems of oppression, it also helps to blame systemic violence on those being violated. It perpetuates widespread neo-eugenic myths that Deaf, Mad, and disabled people are likely

perpetrators of violence, rather than people who are far more likely to have violence perpetrated against them.[11] Such discourses directly enable the increased surveillance, institutionalization, immigration bans, and police engagement with folks who are some of the most likely to be killed or violated by these very systems of "protection."

The final reason I find my supposed activist allies "writing off" Trump through ableist slurs or diagnostic language unwitnessable is because it continues the misrecognition of widespread and systemic violence as the result of a few "pathological" individuals, rather than as fundamental characteristics of North American settler-colonial states. The use of pathologizing language (whether slurs or recognized diagnostic criteria) thus relieves each of us of the responsibility to witness each moment of violence, to recognize it as systemic rather than an individual outlier, to reflect upon our role in its perpetuation, and to reimagine the ways we must work together to transform it and ourselves.

I refused to witness the outrage-filled posts about Trump's outrageous act of ableism because all of this hype renders unwitnessable the everyday, insidious acts of ableism in which we are all complicit, and which—unlike Trump's mockery—we have the capacity to change.

Notes

1 Irin Cormon, "Donald Trump's Worst Offense? Mocking Disabled Reporter, Poll Finds," *NBC News*, August 11, 2016, 1.

2 See, for example, Maysoon Zayid, "Disability and Hollywood, a Sordid Affair," *Women's Media Centre*, February 8, 2017.

3 Carmen DeNavas-Walt and Bernadette D. Proctor, *Income, Poverty, and Health Insurance Coverage in the United States* (Washington, DC: U.S. Census Bureau, Current Population Reports, 2015), 13.

4 Jennifer Bronson and Marcus Berzofsky, *Disabilities among Prison and Jail Inmates, 2011–12* (Washington, DC: U.S. Department of Justice, Office of Justice Programs, Bureau of Justice Statistics, 2015), 1.

5 Liz Stimpson and Margaret Best, *Courage Above All: Sexual Assault Against Women with Disabilities* (Toronto: DisAbled Women's Network, 1991).

6 Roy Hanes, "None Is Still Too Many: An Historical Exploration of Canadian Immigration Legislation as It Pertains to People with Disabilities," *Developmental Disabilities Bulletin* 37, nos. 1–2 (2009): 118.

7 David Perry and Lawrence Carter Long, *Media Coverage of Law Enforcement Use of Force and Disability* (Washington, DC: Ruderman Foundation, 2016), 4.

8 See the edited volume by Elizabeth Anne McGibbons, *Oppression: A Social Determinant of Health* (Winnipeg: Fernwood, 2012).

9 Bronson and Berzofsky, *Disabilities among Prison and Jail Inmates*, 1.

10 Ladelle McWhorter, *Racism and Sexual Oppression in Anglo-America: A Genealogy* (Bloomington: Indiana University Press, 2009), 154–156, 210.

11 Margaret Price, *Mad at School: Rhetorics of Mental Disability and Academic Life* (Ann Arbor: University of Michigan Press, 2011), 163.

Part II

Histories and Genres

6

The Tradition of Provocateurs

In its earliest years, cinema attracted and stimulated spectators through a variety of visual shocks, from onrushing trains through electrocuted elephants to recalcitrant female crooks. While modernist artists sought to elicit shock effects through painting, literature, and theater, film directors could exploit the unique formal properties of the new medium. Extending his concept of the "montage of attractions" from theater to cinema, Sergei Eisenstein argued that image juxtapositions bearing an aggressive emotional impact (e.g., the suppression of a workers' strike and the slaughtering of a bull) could provoke intellectual associations for viewers.

Written by four film scholars, the essays in this chapter explore the tradition of directors who have carried the torch of early twentieth-century artists and filmmakers in assaulting the audience and violating representational decorum. From Luis Buñuel to Gaspar Noé, these pro-vocateurs have prompted reflection on the relations between reality and illusion, aesthetics and ethics, art and commerce, and, above all, the watchable and unwatchable.

Asbjørn Grønstad traces unwatchable cinema back to the confronta-tional art associated with modernism, seeing the recurrence of a trans-gressive aesthetic in the postmillennial art cinema of directors such as Catherine Breillat, Michael Haneke, and Lars von Trier. For Grønstad, the unwatchable has two separate connotations: while the term can

describe one's affective response to particular images, it can also serve as a self-conscious aesthetic principle on the part of filmmakers, for whom the refusal of pleasure bears a critical and ethical potential.

The next two essays consider the positioning of the spectator in two controversial films from the 1970s, both adaptations of literary works. Akira Mizuta Lippit analyzes Stanley Kubrick's *A Clockwork Orange* (1971), focusing on the convergence of reality and simulation, violence and its representation. Mauro Resmini theorizes Pier Paolo Pasolini's *Salò, or the 120 Days of Sodom* (1975), discussing the film's perverse schema of desire and anxiety.

Few contemporary directors have provoked audiences as unremittingly as Gaspar Noé, whose first feature film, *Seul contre tous* (*I Stand Alone*, 1998), even warned, "You have 30 seconds to leave the screening of this film." Placing Noé's *Irréversible* (2002) in the tradition of extreme cinema, Mattias Frey highlights the dynamics of reverse psychology in film discourse, arguing that claims of unwatchability are, not least, an effective promotional strategy.

The Two Unwatchables

ASBJØRN GRØNSTAD

Having written a book on unwatchable cinema does not make you unsusceptible to the impact of grueling, unbearable images. I was reminded of that not long ago, as I was watching the sixth episode of *Twin Peaks: The Return* (David Lynch, 2017). In one of its scenes, the diabolical Richard Horne (played by Eamon Farren)—enraged, high on the drug Sparkle, and driving a flatbed truck way too carelessly—veers off into the opposite lane at a backed-up intersection. Refusing to slow down at the stop sign, he runs over and kills a young boy using the pedestrian crossing. As a viewer, one feels violated. While not as extravagantly unhinged as, say, the moment with the fire extinguisher in *Irréversible* (Gaspar Noé, 2002), the reckless killing of the boy in fact seems worse. *Irréversible* felt like a fist, this feels like a sin. It is not just the fairly graphic depiction of the accident/murder itself, it is also the highly distressing inevitability with which it is presented to us. Before we even see Richard's approaching vehicle, the improvised game that the boy and his mother are immersed in portends calamity. We already know something horrendous is about to happen. The growing discomfort accompanying the buildup of the sequence is further intensified by a couple of small gestures; the driver in the stopped truck waiving his hand to indicate that it is safe to walk, and the unaware mother gently

pushing her son into the street only seconds before he gets hit. Devastated, the viewer has been left privy to something that should never have been shown, nor seen. At least that was what I was thinking at the time.

There are two senses of the unwatchable, maybe more. One is descriptive, the other critical. If I cannot go on looking at an image because it upsets my sensorial or moral faculties, we are dealing with the former. In this case, the unwatchable relays to us not much about the object itself but rather about the particular form of affect that the object—which could be anything—generates in the beholder. Unwatchability in this descriptive sense implies something that is *literally* hard to watch, something that may cause nausea or that makes us stop viewing. The unwatchable here denotes a responsive or reactive mechanism. My own experience of the scene from *Twin Peaks* falls in this category, as does Roger Ebert's appraisal of the aforementioned *Irréversible* back in 2003. That film, he considers, is "so violent and cruel that most people will find it unwatchable."[1] According to largely unverified reports, 250 audience members were so repelled that they left the screening at the film's premiere in Cannes, a pretty sizeable walkout. Ebert's opinion is consistent with *Merriam-Webster*'s definition of the term "unwatchable," first logged in 1886, as something that is "not suitable or fit for watching" and that works "to discourage watching."[2] Not only could this "something" manifest itself in a multitude of ways and in a number of different media, it is also historically contingent. Once a form of popular entertainment, lynchings and other public executions, for example, would be considered unwatchable material today.

Approaching unwatchability in this literal sense usually involves vast and vastly diverse catalogues of images that individual viewers find objectionable. While certainly a phenomenon worthy of intellectual pursuit, this sense of the unwatchable seems less captivating to me than the second and more conceptual sense of the term. Because the unwatchable can also be a rhetorical gesture, in which case the context and meaning of its appearance—perhaps we could say its cultural function and value—supersede that of its emotional effect. Even though Gaspar Noé can insert a warning such as "You have 30 seconds to leave the screening of this film" into his controversial debut feature *Seul contre tous* (*I Stand Alone*, 1998), the makers of unwatchable images do not *really* want their audience to cease watching. This is possibly the principal miscon-

ception about the unwatchable, that its success might be gauged according to the number of viewers forced to avert their gaze, that its ultimate point is continuously to push the envelope as far as audience tolerability is concerned. But the notion of the unwatchable is also a critically productive concept. As such, it describes the enactment of the refusal of pleasure as an aesthetic principle in certain traditions of art, literature, and filmmaking. In such traditions, shock is never an end in itself (like it seems to be in, say, *Game of Thrones* [2011–]) but always a means to convey social critique and to massage the critical capabilities of the viewers. Forms of visual transgression are harnessed to serve ethics. As a rhetorical gesture, the unwatchable is closely linked with the notion of transgression, a theme that has been explored in depth by, among others, Kieran Cashell, who argues that transgressive art is not a genre defined by its forms but rather an oppositional practice defined by its political intentions.[3]

One way of distinguishing between the two unwatchables would be to suggest that the first primarily involves the surface layer of the work. Its purview is the empirical inventory of more or less unendurable imagery, from the slicing of the eyeball in *Un chien andalou* (Luis Buñuel, 1929) to the genital mutilation in *Antichrist* (Lars von Trier, 2009), the latter scene described by Ebert as a "fork in the eye."[4] It is easy to become overwhelmed by the intensity of unwatchable material, which might be one reason why it can be hard to look beyond it to ask what its purpose might be. When we do that, we soon find ourselves in the vicinity of the second and more conceptual sense of the unwatchable, which has to do with what lies beneath the surface manifestations of emotionally upsetting images. What is their meaning in the context of the work as a whole? What is their wider social and cultural purpose? What work are they made to do besides making the viewer uncomfortable, or, put differently, what is really the point of our discomfort?

In the age of patronage, artworks aimed to please. After Cézanne, Manet, Courbet, Daumier, Rodin, and others, provocation and discord found their way into aesthetic expressions, on the level of both subject matter and form. Modernism provided a discursively fertile ground for the emergence (and, some would claim, dominance) of confrontational art. Aesthetic pleasure was viewed with some suspicion. This legacy, associated for instance with the work of Theodor W. Adorno,[5] has especially

made itself felt in a particular strain of postmillennial art cinema (a subject to which I have devoted a book-length study).[6] A conspicuous number of the most celebrated contemporary film directors have made significant contributions to this poetics of negation: Michael Haneke, Lars von Trier, Catherine Breillat, Claire Denis, Ulrich Seidl, Bruno Dumont, Tsai Ming-liang, and Lukas Moodysson, to name a few. For these filmmakers, the unwatchable often occurs as a self-conscious figuration intended to jolt our bodies in such a way as to produce critical awareness and ethical insight. Borrowing Martine Beugnet's words, we could say that this process demonstrates "the intelligence of the affective."[7] This conceptual sense of the unwatchable—maybe we should call it the *in*watchable, to avoid confusion with the first—pertains above all to images that through their taxing forms escape the logic of commodification, thus opening up a space for a new humanist aesthetic whose chief rationale is an exploration of the amorphous limits of ethical thought.

Notes

1 Roger Ebert, Review of *Irréversible*, *Chicago Sun-Times*, March 14, 2003, http://rogerebert.suntimes.com/apps/pbcs.dll/article?AID=/20030314/REVIEWS/303140303/1023.

2 *Merriam-Webster*, "Unwatchable," www.merriam-webster.com/dictionary/unwatchable.

3 Kieran Cashell, *Aftershock: The Ethics of Contemporary Transgressive Art* (London: I.B. Tauris, 2009).

4 Roger Ebert, "Cannes #6: A Devil's Advocate for *Antichrist*," *Roger Ebert's Journal*, May 19, 2009, www.rogerebert.com/rogers-journal/cannes-6-a-devils-advocate-for-antichrist.

5 See, for example, Theodor W. Adorno, *Aesthetic Theory*, trans. Robert Hullot-Kentor (1970; London: Continuum, 1997).

6 Asbjørn Grønstad, *Screening the Unwatchable: Spaces of Negation in Postmillennial Art Cinema* (Basingstoke: Palgrave Macmillan, 2012). See also Tanya Horeck and Tina Kendall, eds., *The New Extremism in Cinema: From France to Europe* (Edinburgh: Edinburgh University Press, 2011).

7 Martine Beugnet, *Cinema and Sensation: French Film and the Art of Transgression* (Edinburgh: Edinburgh University Press, 2007), 178.

Real Horrorshow

AKIRA MIZUTA LIPPIT

As the film begins to roll, Alex DeLarge (Malcolm McDowell), protagonist and antihero of Stanley Kubrick's dystopic *A Clockwork Orange* (1971), remarks, "It's funny how the colors of the real world only seem really real when you viddy them on a screen." Aroused by the color of blood on the screen, Alex discovers in cinema a superrealism. The "colors of the real world" seem most real to him in the cinema. His cinema, in this instance, is a customized apparatus, designed as part of an experimental treatment program for violent criminals. It is just for him. Alex is one of them, the worst of the worst, appearing to enjoy equally the violence he enacts daily and the daily violence that engulfs him. Alex's entire experience of pleasure—sexual, sensual, aesthetic, and athletic—is tied to violence, performed and consumed.

Based on Anthony Burgess's 1962 novel of the same name, Kubrick's *A Clockwork Orange* imagines a cure for violence mediated by cinema. Cinema, in Kubrick's work, is equally an apparatus and a trope. Alex becomes in Kubrick's mise-en-scène a primal spectator. His frequent expression for pleasure and approval, "real horrorshow," reflects the idiom and genre that drive the film's aesthetic regime.

Alex's excitability and underdeveloped conscience prevent him from feeling remorse for his actions, and thus from any possibility of

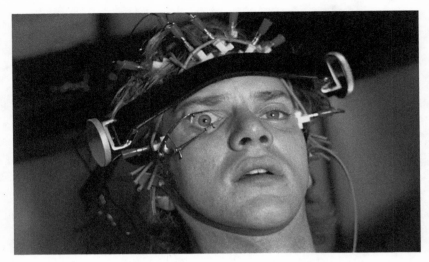

Alex's aversion therapy with unwatchable images in *A Clockwork Orange*.

self-reform. As a result, he has landed in jail following a brutal assault and murder. Alex is among the first volunteers for a novel treatment that paralyzes violent individuals through Pavlovian conditioning. The stimulant is cinema.

At the scene of his transformation, Alex is captive to his violence, and to the therapeutic cinema that will suture his violence to displeasure. Alex describes the conditions of his spectatorship: "I was bound up in a straight-jacket and my gulliver was strapped to a headrest with like wires running away from it. Then they clamped like lidlocks on my eyes so that I could not shut them, no matter how hard I tried. It seemed a bit crazy to me, but I let them get on with what they wanted to get on with. If I was to be a free young malcheck again in a fortnight's time I would put up with much in the meantime, oh my brothers."

The program involves a series of injections that induce in Alex a violent and prolonged experience of severe nausea. The supervising doctor describes the experience of this compulsory cinema as "being like death." At the thresholds of death, this cinema is a torture machine, a virtual death. While the subject's body is overcome by the unbearable rejection of the very condition of physiological being, the subject is exposed to scenes of extreme violence—beatings, rapes, murders, and

war—in a film theater. Like the citizen-spectators imagined by Plato in his allegorical cave, the subject cannot turn away; body constrained, head fixed ahead, eyelids forcibly held open. There is, from this cine-matic nightmare, *no exit*. Alex's cinema springs from Plato's grotto and resembles the punishing machine that Kafka depicts in his crucible of justice, "In the Penal Colony."[1]

As the nausea courses through his body, Alex comes to reject not only those images of ultraviolence, the ultraviolent world it engenders, but also the medium that delivers them. A miniature *Clockwork Orange* opens up within *A Clockwork Orange*; a metonymy of spectatorship forges a vital line of contact between the spectator and Alex. What happens in this mise en abîme strikes at the heart of the film's unwatchability: the divide that separates reality from cinema collapses onto Alex's body. Reality and cinema merge, and the violence depicted becomes embodied. Alex becomes himself a cinema; his body a lived projection.

Over the course of this treatment, violence, or more accurately a cinema of violence, is injected into Alex's body. Cinema enters Alex's body through his lacerated eyes, fusing the figurative penetrations that cinema effects through tropes of identification, projection, or representation into his veins and his brain. Alex is himself grafted onto the apparatus and vice versa. In *A Clockwork Orange*, cinema disappears into Alex's body, and with it the line that distinguishes actuality and simulation. Cinema becomes in Alex's ontology, "really real."

His intolerance for violence is induced through the experience of a hypervigilance. Through a series of psychophysiological negations, Alex's inability *not to watch* those films renders them unwatchable. His treatment makes all forms of violence, real and imagined, practiced and observed, unwatchable. It does this by erasing the subjectivity that would otherwise render the outside an object. Through the treatment, the very distinction between subject and object collapses, and Alex is rendered both at once, abject. His treatment reduces life as such to a series of unwatchable images.

The nausea that Alex experiences in his encounters with violence is mediated by the cinema: his violent impulses have been turned into representations. As such, the violence he imagines becomes indistinguishable from the violence he enacts or longs to enact. In this way, his life is transformed into a "cine" in which he viddies himself as if from

the eyes of another. His is a true cinema of cruelty, not unlike the theater that Artaud imagines.

It is in space of this virtual cinema, of a compulsory spectatorship that Alex comes to experience the effects of unwatchability: he discovers the "colors of the real world" in this horrorshow cinema of the "really real." If cinema is unwatchable in Alex's world, it is because cinema as such no longer exists in it: he has interiorized cinema, and has become himself a perpetual cinema.

Kubrick's stylized depiction of pure violence is itself in equal parts irresistible and unwatchable. In each instance, the intersection of the real and unreal frames the economy of watchability. The rape scene in the writer's house may be one of cinema's most unwatchable scenes of ultraviolence, paralleling those moments in Pier Paolo Pasolini's *Salò, or the 120 Days of Sodom* (1975), or in any number of films by ultraviolent auteurs Miike Takashi or Sono Sion.

On the second day of his treatment, Alex consumes extended scenes from Leni Riefenstahl's *Triumph of the Will* (1935). During this session, a second orifice, the ear, is subjected to reprogramming. Alex is conditioned inadvertently against his preferred music, "Ludwig van." The music, his favorite, is the "Ninth symphony, fourth movement." Unwatchability now enters Alex through his eyes and ears, completing his ethico-sensory reorganization. *A Clockwork Orange* is replete with such instances of unlistenability: Alex's rendition of "Singin' in the Rain" during a violent sexual assault, a scene of masturbation accompanied by "Ludwig van," and the unnerving Wendy Carlos synthesizer soundtrack that suffuses *A Clockwork Orange.*

Audiovisuality now exists within Alex DeLarge's corpus, his body a vast and mucous cinema.

Alex's cure comes in the form of a reversal of the treatment that had forged an association between lived and imagined, performed and consumed scenes of violence. Violence had become unwatchable because it had become indistinguishable from its representation. Cinema had been grafted onto Alex's body like a prosthesis, becoming an extension no longer distinct from his psychophysiological being. Only when reality and cinema are again uncoupled, when the "really real" returns to an extension of cinema and not its enfoldment, is Alex released back into his horrorshow. The final scene of the film is Alex, no longer sickened,

imagining himself assaulting a woman in the snow. It returns Alex to his primal cinema, to the scene of his violence imagined and viddied, as he smirks, "I was cured alright."

Note

1 Franz Kafka's 1919 short story "In the Penal Colony" prefigures Alex's corrective cinema in the form of a punishing apparatus that inscribes on the convict's body his crime. The criminal learns for the first time of his crime on the occasion of its inscription onto his body.

Asymmetries of Desire

Salò, or the 120 Days of Sodom

MAURO RESMINI

[*Salò*] is not shocking. It's worse.
—Catherine Breillat[1]

Before it was unwatchable, Pier Paolo Pasolini's *Salò, or the 120 Days of Sodom* was literally invisible. The tortuous vicissitudes of the film's release are well known: *Salò* premiered at the Paris Film Festival in 1975 and was then released in Italy in January of the following year only to disappear suddenly, banned by the authorities until 1978 but de facto never screened publicly again until 1985. Considering also the theft of some of the original negatives, the criminal prosecution of the film's producer for obscenity and corruption of minors, and, most importantly, the brutal murder of Pasolini on a beach in the vicinities of Rome during the last days of editing, it becomes clear why this film has long been enshrouded in myth.

The plot of the film remains substantially faithful to its inspiration, Sade's *120 Days of Sodom*, while resetting the action in 1944. In that farcical and violent last stand that is the Fascist Republic of Salò, four lords (the Duke, the Bishop, the Judge, and the President) have a group of local teenagers kidnapped and taken to a villa, where for four months they are subjected to acts of extreme physical and psychological violence—all for

Still from Pier Paolo Pasolini's *Salò, or the 120 Days of Sodom*.

the pleasure of the lords. Four middle-aged prostitutes act as storytellers, titillating the fantasy of the lords with erotic anecdotes. Four fascist soldiers and four collaborationists, chosen among the boys, complete the group at the villa, together with the servants. The cadence of orgies, tortures, rapes, and the like is highly ritualized and regulated by a strict code, to which lords and victims must adhere unconditionally.

Much has been written about the uncomfortable position in which *Salò* puts the spectator, forcing her or him to share the gaze of the torturers.[2] But what if the unwatchability of the film derived not from occupying an unwanted position, but from the possibility that this unwanted position *doesn't satisfy us enough*? What if, in other words, the burden of unwatchability lay less with the film's brutal imagery than with the unbearable spectacle of our own unfulfilled desire? We wish to argue that the dimension of unwatchability in *Salò* cannot be reduced to a matter of revulsion, but must be understood primarily as a matter of *anxiety*. To trace the vicissitudes of this anxiety-producing spectacle of desire, it is necessary to take a step back and look at the basic schema of perversion that the film stages.

According to Jacques Lacan, perversions are defined by a particular relationship that the subject establishes with the Other, that is, the radical alterity that transcends any empirical-individual manifestation and constitutes the site of the Law. The sadist, specifically, knows what the

Other wants: it wants to be tortured, and the sadist is only too happy to oblige. But—here is the remarkable twist of sadism—the sadist's victims, the ones whose desire the sadist knows and exploits for his own enjoyment, are not the Other. A split, in fact, occurs: the victims are reduced to *others*, that is, dispensable instruments in the hands of the sadistic executioners, while the Other as Law is elevated to a transcendental guarantee of the executioner's acts.[3] This is the perverted structure behind the lords' complete control over their victims: under the aegis of a Law that demands total submission from the lords as much as the victims, the true otherness of the teenagers—the obscurity of their desire—is annihilated, their lack manipulated against them.

The lords, for their part, do not lack anything. In this sense, the mannequin receiving a demonstrational hand job in the first dinner scene is their perfect doppelganger: an indifferent presence, soulless and inorganic, that is but a tool in the hands (quite literally) of someone else. In fully submitting to the Law, an inflexible Other that bears no desire, the sadist becomes its docile instrument. This is the essence of the pervert's position: it disavows the lack in the Other by projecting it onto the other. In doing so, the lords become incarnations of this nondesiring despot: the moment in which this transfiguration occurs is the opening scene, where they sign the contract that binds them to one another (they marry each other's daughters) and to the code of conduct that will rule over the villa for 120 days. The Other, in the form of this original covenant, stands witness to the horrors that take place in the film, not only by authorizing them, but by *requiring* them—an injunction to enjoy incarnated in the figures of the four lords.

But in the film this schema of perversion has another side, one that has often gone unnoticed. One must agree with French film critic Serge Daney, who wrote that *Salò* has much less to do with a "triumphant fascism" than with the fundamental disconnect between two heterogeneous dimensions:[4] one, which I have outlined above, speaks to the sadist's enjoyment in his knowledge and control of the victim's desire; the other has to do with another form of enjoyment—namely, that of the teenagers themselves, who, as opposed to the lords, know nothing of their own desire and simply enact it. Consider, for instance, the lesbian lovers, or the collaborationist Ezio who has sex with the black servant: in both cases, while the sadistic rule of Law in the villa is supposed to be absolute, we

witness the formation of pockets of heterogeneity within and against it. The desire embodied by Ezio and the lesbian lovers marks a dimension of enjoyment that the lords do not have access to, something they can neither know nor control. Indeed, one of the most revealing moments of the film occurs when the lords, guns in hand and ready to kill Ezio, are confronted with his communist salute and experience palpable hesitation. Is this not the only fleeting moment of anxiety experienced by the lords? Anxiety is the result of an undue proximity to the object-cause of one's desires (Lacan calls it object *a*). For the sadistic lords, Ezio's enjoyment is precisely that object: Ezio's raised fist symbolizes the desire that the lords will never know nor manipulate, and, as such, it puts their own desire on display, thus *reminding them of their own lack*—a lack they tried to disavow at all costs. Their reaction is telling: the rather unsadist-like fury with which they unload their guns on Ezio is in stark contrast to the cool and collected demeanor that they display throughout the film.

This asymmetry splits the film in two, along the axis of enjoyment: on one side, a totalitarian fantasy of sovereign power and absolute control that encounters its own failure; on the other, the episodic emergence of fragments of desire heterogeneous to the Law presiding over the villa. (It is worth pointing out in passing that this asymmetry of enjoyment conflicts with the obsessive pursuit of symmetry in the mise-en-scène, as though to remind the spectator that this is still the lords' world). Pasolini juxtaposes the transgressive enjoyment of ignorance embodied by the teenagers with the repetitive enjoyment of knowledge associated with the lords. The teenagers' ignorance transgresses the rule of Law because it resides outside of it—or does it? It is tempting to read the teenagers' blithe pursuit of pleasure as a sort of rebellious stance against the Law, and Ezio's episode seems to attest to that. But there are other instances in which the teenagers' desire assumes different forms. What are we to make, for example, of the smile that one of the victims directs at the Duke while being fondled? Or the final vignette, in which two guards converse amiably about a girl, and then dance to the tune of a waltz? Isn't their obliviousness to the horror that surrounds them yet another form of the enjoyment of ignorance that we have just described? And yet it would hardly count as an active resistance against the powers that be, quite the contrary.

Salò, writes Italian film scholar Roberto Chiesi, "remains one of the cinematographic enigmas of the postwar period."[5] One wonders whether part of the enigma might lie with the ambiguous status that Pasolini bestows upon innocence. It is not enough to say, as some have done, that the kidnapped teenagers are complicit, nor that they constitute the last line of defense against fascist rule. In a way, for Pasolini they are both, and neither. In his work, the young body has always been the site of an equivocal bliss-in-ignorance (think about the *Trilogy of Life* [1971–1974], for instance). In *Salò*, this undecipherability reaches a climax. The spectator, then, occupies the position of the lords in the sense that she or he is caught in the same topology of perversion, the same desire to know and master the Other's enjoyment. The lords, in this sense, pose no issue: we, as spectators, know exactly what their desire is, so there is no real anxiety in our relation to them. Instead, we know nothing of the teenagers' desire. That which is truly unbearable is the undecipherability of their enjoyment: the film puts us in the position of the sadist, but then confronts us with our own lack, insinuating the doubt that all we really are is just neurotics, prey to doubt and anxiety in the face of an Other we can't know. Perhaps what makes *Salò* so difficult to endure is precisely its enigma: beyond the smoke screens of shock and revulsion, there arises anxiety—the only affect "that does not deceive."[6]

Notes

1 Interview in *Salò: Fade to Black* (Nigel Algar, 2001).
2 See, for instance, Fabio Vighi, *Sexual Difference in European Cinema: The Curse of Enjoyment* (New York: Palgrave Macmillan, 2009), 70–73; and Simona Bondavalli, *Fictions of Youth: Pier Paolo Pasolini, Adolescence and Fascism* (Toronto: University of Toronto Press, 2015), 213–215.
3 Lacan discusses sadism throughout his oeuvre, but the pivotal text on the topic remains "Kant with Sade." See Jacques Lacan, "Kant with Sade," in *Écrits*, trans. Bruce Fink (New York: Norton, 2006), 645–668.
4 Serge Daney, "Notes sur Salò," *Cahiers du Cinéma*, nos. 268–296 (July–August 1976): 102–103.
5 Roberto Chiesi, *Pier Paolo Pasolini: Salò o le 120 giornate di Sodoma* (Turin: Lindau 2001), 9.
6 Jacques Lacan, *The Seminar of Jacques Lacan, Book X: Anxiety*, ed. Jacques-Alain Miller, trans. A. R. Price (Cambridge: Polity, 2014), 116.

Unstomachable

Irréversible *and the Extreme Cinema Tradition*

MATTIAS FREY

To my knowledge, only two students have thrown up during my university screenings. The film that produced the most vomit was Gaspar Noé's *Irréversible* (2002).

Any number of film directors have baited audiences with the "unwatchable," whether via detailed portrayals of violence, graphic or deviant sex, social taboos, or simply the mundane and therefore profoundly boring.[1] Apart from such representational strategies, these provocateurs rehearse in interviews various pedagogical principles, artistic motivations, or outright warnings to admonish spectators to discontinue (or not even begin) viewing their films.[2] Michael Haneke says that he seeks to "rape" his viewers into adopting a critical mode of spectatorship; those who stop watching have actually understood his message: "the film worked, it spoiled the fun for the consumer of violence."[3] The distributors of Miike Takashi's *Koroshiya 1* (*Ichi the Killer*, 2001) provided complimentary sick bags to viewers at its Toronto International Film Festival screening.[4] Of course, as marketing devices and items of reverse psychology, such claims of unwatchability are simultaneously titillating,

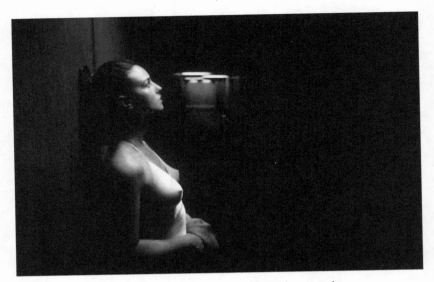

Monica Bellucci as Alex in *Irréversible*. Courtesy of REX Shutterstock.

effective advertisements and thinly veiled calls to consume. Can you withstand the films' effects? Are they as unwatchable as claimed?

This cinematic phenomenon has long, varied roots: in shrewd international distributors' "hot" edits of *Extase* (*Ecstasy*, 1933) and *Sommaren med Monika* (*Summer with Monika*, 1953), in Buñuel and Dalí's sliced bovine eyeball, in the raunchy one sheets for Italian neorealist classics that hung in mid-twentieth-century U.S.-American art houses, in the butter-aided buggery of *Last Tango in Paris* (1972) and the homemade penectomy of *Ai no korīda* (*In the Realm of the Senses*, 1976), in modern art-world confessionalism and Catherine Breillat's didactic porn-pap, in international censors' misguided blood counts and peter meters and self-aggrandizing PR claptrap, in self-righteous red-carpet festival antics and critics' breathless reportage thereof. These provocations—canny conflations of art and exploitation, earnest social missions and cheap thrills—defy facile geographic pigeonholes, their makers equally at work in Chile, France, Korea, and elsewhere. But Gaspar Noé is the contemporary archetype, a festival-circuit *enfant terrible* never shy to share his program of audience discomfort. In an article he wrote for the *Guardian* called "I'm Happy Some People Walk Out during My Film" (1999), he fantasized about a mob descending upon the British Board of

Film Classification with axes and declared that "to shock is not a goal, it's a medium. . . . If you want the show to have any emotional impact, then you had better push [graphic violence] further than you yourself have seen in other movies."[5] His early feature *Seul contre tous* (*I Stand Alone*, 1998), a ghastly portrayal of a xenophobic, homicidal, misanthropic butcher, features a literal appeal to leave during the viewing experience itself. It begins with the flashing text, "You have 30 seconds to leave the screening of this film," only for the 30 seconds to wither away in real time to 29, 28, 27, and so on, a dreadful countdown to a certain abyss. His most recent effort, *Love* (2015), described as the "first 3D porn film," reproduces the hardcore iconography of hand-job money shots in its posters. These, and the film itself, in which the actors had penetrative sex in front of the camera, drew scrutiny, restrictive ratings, and threats of cuts from regulators in France, India, and elsewhere, deemed unwatchable in part or whole.[6] Noé is no stranger to depicting violence even against animals; his early short *Carne* (1991) details the slaughter of a horse.

But it was *Irréversible* that caused my student to heave. He was long gone before the infamous pièce de résistance, an eleven-minute take of Alex (Monica Bellucci) being anally raped and then brutally assaulted in a dingy underpass, her cries and entreaties for help echoing through the space and ignored by a fleeting passerby. Nor did he stay long enough to experience a few other depictions of graphic, gruesome, literally mind-numbing violence: a notable sequence portrays a character using a fire extinguisher to bash in someone's head. He was done well before the dénouement, a fade to white via a strobe light engineered to induce epileptic seizures. Indeed, he barely made it through the opening sequence, which anticipates the film's larger stylistic signature: a sound design of wide-ranging dynamics meant to overwhelm and communicate dread, ending with piercing squeals pitched at frequencies that cause headaches; vertiginous camera movements and an altogether shaky handheld camera characterize the visuals.

As for a plot, there is not much to speak of. It is a by-the-numbers rape-revenge tale in which Alex's boyfriend, Marcus, and a friend search for her rapist, told with doses of dramatic irony (they kill the wrong man) and in reverse chronology: the result of an action precedes its cause and so we must realize Alex's innocence after already witnessing her

horrible fate. Although the reversal provides the proceedings with a false happy ending, the flow of information enacts its own traditional three-act structure replete with inciting incident, climax, and resolution. Of course, beyond the graphic violence itself, the performances and cinematography serve to illustrate men unleashed from their humanity and out of control, stimulated by drink and drugs and animalistic in their responses to, and expressions of, anger and revenge. Jarring, disorientating, severely underlit shots, most often steeped in a sleazy red, mask cuts and narrative ellipses and create the illusion of experiencing the proceedings in real time. There is also the unsubtle flirtation with gay panic, a mock-POV search through a filthy S&M club called the Rectum that both anticipates Alex's rape in *la passage* and resounds with the titillating homophobia of *Cruising* (1980).

Is *Irréversible* unwatchable? For my student, who had to retreat to the toilet under duress early on, clearly the answer is yes. Some others, I recall from many screenings of the film over the years, choose to look away, close their eyes, or cover their ears during the rape scene or the fire extinguisher sequence. (In my Film Criticism module, I show *Irréversible* to prompt discussion on writing about "difficult" films, projects that elicit uncomfortable emotions, that bore, horrify, or offend, or exemplars that defy easy classification or require the critic to evaluate something aimed at an audience segment beyond himself or herself. Noé's film also features as a core text in my Extreme Cinema class.) Many other potential viewers will have deemed the film unwatchable simply from reading a critic's review, its DVD cover, an Amazon Video description, or the director's name. But for hardy remainers—and the film has a cult following, its rape scene discussed, excised, and uploaded to You-Tube and other peer-to-peer sites extraordinarily often—*Irréversible* is eminently worthy of being seen. For them it provides great pleasure, whether because of the (sexual) violence (a small minority, according to empirical audience research on the film), the jouissance of dwelling in the Bataillean abject, rebelling against bourgeois taste norms, virtue signaling among like-minded peers, successfully "surviving" a disturbing horror scenario, or demonstrating immune system strength.[7] For me, the film is a placeholder for a workplace memory and a reminder of the powerful effects of audiovisual expression and artistic self-promotion.

Notes

Mattias Frey gratefully acknowledges the support of the Leverhulme Trust, whose Philip Leverhulme Prize (PLP-2015-008) is funding this research, as well as the Arts and Humanities Research Council, whose grant (AH/J00801X/1) funded earlier research for this project.

1 For a discussion of the reasons why viewers choose to discontinue watching films, see Mattias Frey, "Tuning Out, Turning In, and Walking Off: The Film Spectator in Pain," in *Ethics and Images of Pain*, ed. Asbjørn Grønstad and Henrik Gustafsson (New York: Routledge, 2012), 93–111.

2 See Mattias Frey, *Extreme Cinema: The Transgressive Rhetoric of Today's Art Film Culture* (New Brunswick, NJ: Rutgers University Press, 2016).

3 See Philipp Oehmke and Lars-Olav Beier, "Jeder Film vergewaltigt," *Der Spiegel*, October 19, 2009, 112–114, quote on 113 (my translation).

4 "Censors Slash 'Extreme' Japanese Film," *BBC News*, November 13, 2002, http://news.bbc.co.uk/1/hi/entertainment/2465265.stm.

5 Gaspar Noé, "I'm Happy Some People Walk Out during My Film: It Makes the Ones Who Stay Feel Strong," *Guardian*, March 12, 1999, www.theguardian.com/film/1999/mar/12/features3.

6 See, for example, Nancy Tartaglione, "Gaspar Noé's 'Love' at Heart of Film Ratings War; Age Limit Upped Mid-Run," *Deadline Hollywood*, August 5, 2015, http://deadline.com/2015/08/gaspar-noe-love-french-rating-controversy-vincent-maraval-1201492107/; Vinayak Chakravorty, "No Censors Here! Gaspar Noé's Graphic 3D Film 'Love' Defies 'Sanskari' Rules at IFFI 2015," *Daily Mail*, November 30, 2015, www.dailymail.co.uk/indiahome/indianews/article-3339978/No-censors-Gasper-Noe-s-graphic-3D-film-Love-defies-sanskari-rules-IFFI-2015.html.

7 For an empirical study of audience reactions to *Irréversible* and similar films, see Martin Barker et al., *Audiences and Receptions of Sexual Violence in Contemporary Cinema* (Aberystwyth: University of Wales, 2007). For a discussion of audiences' reasons for engaging with extreme cinema, see Frey, *Extreme Cinema*, 31ff.

7

Enduring the Avant-Garde

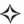

As Maggie Nelson observes in *The Art of Cruelty* (2011), avant-garde movements of the twentieth century often embraced brutal "shock and awe" tactics. This chapter focuses on experimental films that provoked such visceral discomfort, thematizing the very limits of what spectators can endure. The five essays consider vanguardist uses of violent agitation and extreme monotony in restoring viewers' sensory capacities and initiating a different social order.

The opening two texts revisit the cinematic works of Lettrism, the French avant-garde movement established by Isidore Isou and Gabriel Pomerand. Media scholar Christophe Wall-Romana discusses Isou's 1951 film, *Venom and Eternity*, which disjointed sound and image, attempting to "liquefy and liquidate" the audiovisual economy of postwar studio cinema. Directed by fellow Lettrist (and later Situationist) Guy Debord, *Howls for Sade* (1952) is devoid of images altogether, alternating between a black and white screen. As film scholar Kenneth Berger explains, Debord attempted to negate what he termed "spectacle," referring to both the mass image and the basic conditions of existence in consumer societies.

Few films have tested viewers' stamina more than Andy Warhol's eight-hour *Empire* (1964), consisting entirely of a silent, fixed image of the Empire State Building. Film critic J. Hoberman characterizes Warhol's film as an "unwatched and unwatchable" masterpiece and offers new

insight into its production, exhibition, and reception. Situating *Empire* among monumental works that thematize temporal experience, philosopher and film theorist Noël Carroll argues that the film not only highlights the distinction between the "camera eye" and human vision, but also challenges the "acquaintance principle" in philosophical aesthetics, whereby one has to experience a work fully and directly in order to appreciate it.

Sustaining the focus on issues of time and durational experience, media scholar Erika Balsom explores the trope of "watching paint dry" across a trajectory of works, from Tony Conrad's paracinematic *Yellow Movies* (1972–1975) to Charlie Lyne's silent, ten-hour film *Paint Drying* (2016). As Balsom notes, whereas Warhol's *Empire* was tethered to the limitations of celluloid film (necessitating ten different reels), Lyne's work can achieve a more infinite, unsegmented duration with the radical potential to recalibrate viewers' attention.

Unwatchability by Choice

Isou's Venom and Eternity

CHRISTOPHE WALL-ROMANA

> I'd rather hurt your eyes than leave them indifferent. And by
> messing up vision, voice alone will be coherent and
> ferocious.... Film-viewers must come out blind, ears crushed,
> quartered by this disjunction of speech and image.... The
> rupture between words and image will form what I call
> "Discrepant Cinema."
> —Isou, *Venom and Eternity*

Fully rendered as *Treatise of Slobber and Eternity*, Isou's 1951 film is an anti-studio-system manifesto spewing its vociferous spittle at the viewer's eyes and ears. Originally four and a half hours long, which were meant to feel like, well, an eternity, it was cut down to two hours at release.[1] While Buñuel and Dalí's 1929 *Un chien andalou* flashed a close-up of an eye oozing with jelly to make our sight swerve, *Treatise* prosecutes an "all-over" unwatchability, to cite Greenberg's 1948 term for abstract expressionism. With its five-minute opening sequence of black screen and chanted nonsensical phrases repeated every two seconds, the film seeks to liquesce—both liquefy and liquidate—the visual and aural economy of postwar mainstream cinema.[2]

Still from *Venom and Eternity.*

Charismatic and self-assured Isou resembled Elvis Presley in hound-dog pouty-lipped rebellious prettiness.[3] He was born Goldstein in 1927, a Jew from Romania like his idol Tristan Tzara. Surviving pogroms and the Shoah, he landed in Paris in 1945, meeting another young Jew in a refugee cantina, Gabriel Pomerand, whose mother was killed in Auschwitz. They conspired to launch an avant-garde. Since Dada and Surrealism had laid waste to language and words, only letters were left to unravel. They called their movement Lettrism. Choosing a pseud-onym that echoed "Jesus [*Iisous*]" in Romanian and the "zazou" coun-terculture of occupied Paris, Isou published with Gallimard in 1947 a bilious tome presenting himself as a Jewish messiah, calling for the "Judaification" of guilty Christian Europe, and refusing quiet reassimi-lation as a Jewish survivor. Such chutzpah was intemperate to say the least.[4] He fell back on the currencies of liberated Paris: music, cinema, poetry, sex, and disillusion. In *Isou or Women's Mechanics* (1949) he

tried revolutionizing phallocratic eroticism and was briefly incarcerated for obscenity.[5] He performed shrill vocal symphonies in mishmash languages, including an ode to the Jewish victims of the Shoah.[6] He ponderously theorized the pseudo-Hegelian historical logic leading to what, naming their first journal, the two acolytes called *The Lettrist Dictatorship* (1946). In *Treatise*'s voice-over, the narrator Daniel (alter ego to Isou), explains that he left the Communist Party because he hated his supervisor, a woman "too ugly even to be gang raped." Such all-out misogyny, akin to Boris Vian's 1946 pedophilic novel *I Spit on Your Graves*, caused Éric Rohmer, the most astute commentator of *Venom*, to tag the Lettrists "a fascist shock brigade."[7] Indeed, in 1950 Pomerand compared himself and Isou to kamikaze pilots in his *Discourse by a Terrorist*.[8]

Venom famously disconnects the soundtrack from the image track, leading viewers to venture on a long sound bridge teetering over the void. The first chapter, "Principle," instantiates this novel technique of "discrepant cinema," showing Isou walking around St. Germain-des-Prés, multiplying pat shots of streets, buildings, and Isou meeting aging male literary celebrities. The voice-over, meanwhile, unfolds an unrelated dialogue between the filmmaker defending his work and a cine-club audience interrupting and heckling him ("dirty Jew!" "anti-Semite!"). The second chapter, "Development," introduces scratched and painted frames on footage Isou found at flea markets or at the dump of the French Army's film services. The voice-over recounts the abusive relations of rebel-without-a-cause Daniel and his hapless female victims, Eve and Denise, on a background of melancholy jazz. The third chapter, "Proof," has Denise and Daniel witness a performance featuring Lettrist poems by François Dufrêne, while the image-track transforms the graffiti-style painted frames into full-blown abstract and vibrating squiggles as though the film apparatus had melted into biomorphic floaters. The assistant director Maurice Lemaître was also its editor: in his 1952 *Has the Film Already Started?* he generalized this all-over painted technique.[9] *Venom* ends with the deportation from France of Eve (a Norwegian) driven mad by Daniel.

Demoting photography and narrative to make them subservient to unsynchronized speech, it is arguably the first *willfully unwatchable* film in cinema history. There are nevertheless flashes of synchrony,

such as a quick shot of a baby carriage as Daniel describes the notorious scene of Eisenstein's *Potemkin,* or documentary shots of Vietnamese road workers as he denounces modern slavery, or the opening shot showing the street sign "rue Danton" to underline the film's revolutionary intent. Hence, the montage of the film is not systematically discrepant, and perhaps through such winks at synchrony it means to keep viewers engaged in the new affordances of asynchronous cinema. We should note finally that all the faces of officers and civil administrators in found footage of the French occupation in Indochina were carefully scribbled over in order to prevent the film from being censored. This *preemptive unwatchability* thus belies the political foreclosure of free expression in postwar French cinema.

When *Venom* premiered in April 1951, only the soundtrack was ready, so after the first chapter the screen went blank. The audience took it as a slap in the face and one irate viewer returned the same to Isou.[10] Another viewer, a high school student who took part in the underground graffiti campaign advertising the film, was so enthused he soon joined the group: Guy Debord.[11] The fully edited film screened at the Cannes Festival in May, confounding even allies of Lettrism like Cocteau, who bestowed it a prize just in case Lettrism became the "it" thing. It did not. Lettrism splintered, Debord starting Lettriste International in 1952 later spawning into the Situationist International in 1957. While Debord's first film, *Howls for Sade* (1952), got rid of images altogether, his 1973 film *The Society of the Spectacle* returned to discrepant editing by keeping the voice-over and subtitled quotes entirely separate from its found footage and sampled fiction films. Stan Brakhage adopted the etching and scratching techniques after seeing *Venom* in 1952—an esthetic revelation so powerful he viewed it "15 to 20 times" by 1962.[12] Others such as David Larcher's 1969 *Mare's Tail* and of course Lettrist filmmakers like Lemaître and Frédérique Devaux made the film stock into a fully pictorial substrate.[13] Unwatchable outside of cine-club programing, *Venom* is one of these source films everyone knows about but few could, did, or do actually watch.

Viewing it today, I am struck by how assured it is of itself for a first experiment of "anti-cinema" by a twenty-three-year-old who never made another film. I'm also taken aback by how much Isou's self-aggrandizement relies on exclusion. Invoking the Marquis de Sade, it separates "*gonzesses*

[bitches]" from "*jeunes filles*," the better to stage the transformation of the latter into the former, while explicitly holding women responsible for the ruinous dominance of melodramatic cinema. Comparing himself to Columbus, Isou wants his film to open "the path to the West Indies of cinema, a geographical map for a new exoticism." He berates African American jazz musicians for giving up on "primitivism" by adopting white musical instruments—a primitivism that only Lettrism now properly expresses. In spite of the found footage of the French occupation of Indochina, of military maneuvers and athletes—suggesting a denunciation of fascist masculinism—the leitmotiv word "conquest" links Daniel's sexism and Isou's and Lettrism's takeover of the avant-garde to an unreconstructed neocolonial mind-set.

I screen *Venom* for my students to exemplify the unwatchable part of the archive constitutive of its other part: the canon. When Rohmer reviewed *Venom*, he confessed: "It is my duty to say that this first chapter in which we see Isou walking on the Boulevard St.-Germain affected me a thousand times more than did the best of the noncommercial films I've seen."[14] He also objected to its thin intellectual rationale, and its ultimately conservative politics. Watching *Venom*, we yearn for the heftier yield of *The Society of the Spectacle* or Schneemann's and Anger's unapologetically deviant claims of and against their subalternity. All three nonetheless built on the technical waywardness and bricolage esthetics of *Treatise* to reengage cinema. Narboni pointed out that the vaunted cheap and loose cinematography of New Wave filmmaking holds an unacknowledged debt to Isou.[15] Discordant, discrepant, and illiberal, *Venom* sabotages watchability to let the palimpsestic slime of history ooze out, together with the hope for "a new cinema to come."[16]

Notes

1 The version of the film commented on here is *Venom and Eternity* (Jean Isidore Isou, Fr., 1951), in *Avant-Garde 2: Experimental Cinema 1928–1954* (Kino Video: Raymond Rohauer Collection, 2007).

2 See Pavle Levi, *Cinema by Other Means* (Oxford: Oxford University Press, 2012), 86–90, 105–106.

3 Greil Marcus, *Lipstick Traces: A Secret History of the Twentieth Century* (Cambridge, MA: Harvard University Press, 1990), 245–255.

4 On Lettrists as Jews, see Sami Sjöberg, *The Vanguard Messiah: Lettrism between Jewish Mysticism and the Avant-Garde* (Berlin: Walter de Gruyter, 2015).

5 Isou published soft porn/sex manuals in the 1950s and 60s: *Belles d'Europe* (Lausanne: Escaliers de Lausanne, 1955); *Histoire de la volupté* (Paris: Le Terrain Vague, 1957); *Étrangères à Paris* (Paris: Éditions de la pensée moderne, "série rose," 1956); *Les Démons me déchirent* (n.p: Presses noires, 1969); *Notre métier d'amant: confessions d'un séducteur moderne* (Lausanne: Escaliers de Lausanne, 1954), etc.

6 See Christophe Wall-Romana, "Reembodied Writing: Lettrism and Kinesthetic Scripts," in *Cinepoetry: Imaginary Cinemas in French Poetry* (Bronx: Fordham University Press, 2013), 205–257.

7 Éric Rohmer, "Isou or Things as They Are (Views of the Avant-Garde) [1952]," in *The Taste for Beauty*, trans. Carol Volk (Cambridge: Cambridge University Press, 1990), 53–58, 54.

8 Fabien Danesi, *Le Cinéma de Guy Debord, 1952–1994* (Paris: Paris expérimental, 2011), 32.

9 Frédérique Devaux, *Le Cinéma lettriste, 1951–1991* (Paris: Paris expérimental, 1992), 69. This is the best source on Isou and the film (37–67).

10 She was Sonika Bô, a woman of Indian background and a pioneer of the cine-club for children (ibid., 57).

11 Danesi, *Le Cinéma de Guy Debord*, 33.

12 Kaira M. Cabañas, *Off-Screen Cinema: Isidore Isou and the Lettrist Avant-Garde* (Chicago: University of Chicago Press, 2015), 135–136.

13 Wheeler Winston Dixon, *The Exploding Eye: A Re-visionary History of 1960s American Experimental Cinema* (Albany: State University of New York Press, 1997), 101.

14 Rohmer, "Isou," 57.

15 Ibid., 16.

16 *Venom and Eternity*.

The Refusal of Spectacle

Debord's Howls for Sade

KENNETH BERGER

In 1952, five years before the founding of the Situationist International, Guy Debord completed his first film, *Howls for Sade*. Made when Debord was just twenty years old and a member of the Paris-based Lettrist movement, *Howls for Sade* runs seventy-five minutes in length and does not include a single image. Instead, it is composed from beginning to end of alternating sequences in which the screen is either entirely black or entirely white. During the approximately twenty minutes of the film in which the screen is white, the audience hears a disjointed voice-over narration, delivered by either Debord or one of his Lettrist colleagues and appropriated or "detourned" from an array of sources, including literary texts, popular films, Lettrist writing, and the French civil code. When the screen is instead black and the theater is thus completely dark—which is the case for the bulk of the film, including its final twenty-four-minute sequence—there is no sound whatsoever. *Howls for Sade* is, in multiple senses, an unwatchable film.

What, then, is at stake in making such a film? Why create a film entirely devoid of images? It is clear, to begin with, that *Howls for Sade*, as with Debord's subsequent films, is designed to agitate and upset its audience, to create a "situation" that will provoke an active and critical response in the spectator.[1] The film, in this sense, aims to challenge and

178

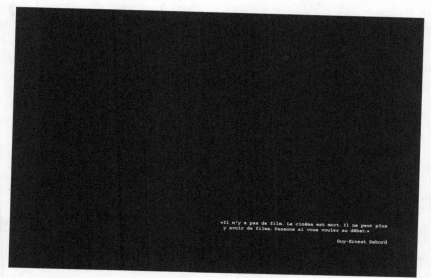

«Il n'y a pas de film. Le cinéma est mort. Il ne peut plus
y avoir de films. Passons si vous voulez au débat.»

Guy-Ernest Debord

"There is no more film. Cinema is dead."

contest what Debord calls "spectacle," which he conceives not simply as the mass image (cinema, television, advertising, etc.), but also, and more fundamentally, as the defining condition of life in modern consumer societies. "All that was once lived," Debord writes, "has become mere representation."[2] Appearance, he asserts, has replaced real existence, inducing "passivity" and "alienation" at a mass scale and leaving individuals entirely "separated" from their own lives.[3] Spectacle is the "prevailing model of social life"; it is the very mechanism through which social relations are maintained and reproduced.[4] *Howls for Sade*, for Debord, is thus a negation of spectacle, a negation of a social reality that itself is the negation of life. Where spectacular film reinforces passivity by meeting its audience's consumerist demand for immediate satisfaction, *Howls for Sade*, as anti-spectacular, denies any such satisfaction and so disrupts the audience's experience of passive contemplation, inciting the spectator to act rather than look and therefore "to revolutionize his own life."[5]

This is not, however, the only way to understand the film. The concept of spectacle, as Debord formulates it, is indispensable in many ways: it recasts commodity fetishism in terms of the image, and in turn

brings to view the extent to which, in consumer societies, social rela-
tions are themselves mediated by images; it draws out the image's capac-
ity to induce the individual to look and consume more and more; and it
makes evident the close link between the exercise of social power and
the mechanisms of mass communication. But Debord's argument is
also marked by problems. In focusing almost exclusively on the effects
of mass consumerism, Debord gives virtually no attention to the role of
production in postwar capitalism. He does not address the ways in
which, with the rise of post-Fordist modes of production, communica-
tion itself becomes a form of labor. He does not discuss the intensifying
demand for constant work to which these developments lead, and as a
result he does not account for the corresponding pressures and anxi-
eties that increasingly define everyday existence in this context.[6] More-
over, in setting the false image against authentic reality, Debord grounds
his argument in a long-standing opposition between appearance and
truth, one that has been repeatedly called into question throughout the
last century. His view of the deceptive image echoes the Platonic cri-
tique of mimetic representation, and his account of "separation," drawn
largely from Georg Lukács and the early Marx, insists on a lost individ-
ual unity and the future promise of a non-alienated social totality. Thus,
while the concept of spectacle remains crucial to understanding modern
consumer culture, it also needs to be rethought. To this end, I propose
an alternative reading of spectacle, one premised on a psychoanalytic
account of visual experience.

In his influential 1964 seminar *The Four Fundamental Concepts of
Psychoanalysis*, Jacques Lacan asserts that there can be no opposition
between the false image and authentic reality, because the image neither
conceals nor distorts anything. Rather, he argues, the image preserves
the fantasy that there is something beyond its surface, some hidden
reality or thing-in-itself just out of vision's reach. The image, Lacan argues,
serves to "feed" the "eye," which, he says, is "filled with voracity."[7] The
eye, that is, ceaselessly pursues its "lost object" or *objet a* (what Lacan
refers to here as the "gaze")—that phantasmatic missing thing that, at
the level of the drive, will fully and finally satisfy the subject's uncon-
scious desire for wholeness or unity. The image, in this sense, does not
give the eye what it "wants"; rather, it "pacif[ies]" the eye by preserving
the fantasy that this missing object is still out there and attainable.[8] It is

only when this fantasy starts to break down, when there is potentially no more lost object to sustain desire, that the subject becomes anxious. In this way, the image, by ensuring that the eye remains "unsatisfied," functions to keep anxiety at bay. This is why the eye, in turn, will ceaselessly consume whatever images are put in front of it. And this is why a society of the spectacle, in which images are not only everywhere and but also more and more instantly accessible, is a society designed to keep the subject pacified, to mitigate the anxiety that increasingly penetrates everyday life. Spectacle, reconceived in this way, is not what deceives us and separates us from reality; rather, it is a central mechanism for managing the intensifying anxiety that pervades our existence.

With this in mind, we can return to *Howls for Sade*. The film, as noted above, is designed to create an experience—or situation—that leaves its audience upset and confused. The spectator, fixed in place, sits waiting and anticipating; and as the waiting persists, the spectator grows more agitated in turn. In the film's concluding twenty-four-minute sequence, in which the theater is not only dark but also completely silent, this experience of agitation is pushed to an extreme. The spectator, unsure how long this silent darkness will last, is made increasingly aware not simply of the insistent absence of any filmic image or sound, but also of the mounting restlessness of other spectators, whose muffled noises and growing discontent become progressively more audible. Indeed, according to accounts of early screenings of the film, audiences regularly became "bored and nervous, if not violent" by the film's end, often erupting into angry protests.[9] This is not, however, because the film denies the spectator satisfaction. Rather, *Howls for Sade* is, in effect, *too* satisfying. It withholds nothing from its audience; it gives spectators nothing to see, and therefore offers nothing to keep them looking and consuming. There is no pacifying the eye because the fantasy of something more, something beyond the surface, is entirely undercut. As a result, instead of keeping anxiety at a distance, as with spectacular films and images, *Howls for Sade* serves only to make its audience more anxious.

But to what end? Why, given the anxiety that increasingly pervades life in late capitalist societies, attempt to counter spectacle's pacifying function at all? Why induce more anxiety? In this context, in which the individual is expected to be more and more productive, he or she is

confronted with numerous mechanisms—political, cultural, techno-
logical, pharmaceutical, etc.—designed to keep anxiety at bay, to keep
it from overrunning life and thus interfering with work. It is the aim
of these mechanisms—of which spectacle is only one—to ensure, regard-
less of the pressures that are brought to bear on us, that we keep working.
To refuse spectacle, then, is one way to disrupt this process, to interrupt
spectacle's functioning and in turn to create space for responding in a
different way to the intensifying demands with which we contend. In the
domain of cinema, this is a matter not simply of opposing or rejecting
the spectacular image, but of mobilizing unwatchability in order to
instigate an entirely different experience of looking.

The refusal of spectacle, therefore, as with refusal in other contexts—
in the contexts of work or of politics—has an aim beyond pure negation.
In postwar consumer societies, in which life is dominated by specta-
cle, looking is almost entirely interwoven with consuming; consum-
ing, in effect, marks the limit of vision's capacity, of its potentiality. In
Howls for Sade, however, such consuming is impossible, because there is
literally nothing to see. As a result, *Howls for Sade* introduces a differ-
ent possibility into the field of vision—the possibility of looking without
consuming, of looking at nothing. The film creates an opening for this
other potential to arise, for perception to break with the mode of seeing
conditioned by spectacle. Yet if *Howls for Sade*, in its total refusal of the
image, pushes cinematic refusal almost to its limit, this is not to exhaust
the possibilities of such refusal; rather, *Howls for Sade* establishes refusal
as a key cinematic strategy, one that is extended and elaborated in the
decades that follow. In the postwar avant-garde cinema of this period,
one thus finds not only the frequent and repeated use of the blank
screen, but also an array of other strategies—sustained freeze frames,
prolonged static shots, unexplained interruptions, narrative incoher-
ence, etc.—all designed to disrupt and undermine spectacle's pacifying
function. These strategies, as strategies of refusal—and unwatchability—
aim to render one mode of perception inoperative so that another mode
of seeing, and of thinking, might emerge. In this way, cinematic refusal,
as *Howls for Sade* shows us, takes part in a larger and ongoing political
project, the project of continuously refusing and reenvisioning the
conditions that define our everyday lives.

Notes

1 The notion of the "situation," which becomes a central concept for Debord and the Situationists in the years to follow, appears at several points in *Howls for Sade*. See Guy Debord, *Complete Cinematic Works: Scripts, Stills, Documents*, trans. and ed. Ken Knabb (Oakland, CA: AK Press, 2003), 2, 4.

2 Debord, *The Society of the Spectacle*, trans. Donald Nicholson-Smith (New York: Zone Books, 1994), 12.

3 Ibid., 15, 22–23.

4 Ibid., 13.

5 Debord, "Report on the Construction of Situations," in *The Situationist International Anthology*, ed. and trans. Ken Knabb (Berkeley, CA: Bureau of Public Secrets, 1981), 25.

6 On this count, see Paolo Virno, *A Grammar of the Multitude: For an Analysis of Contemporary Forms of Life*, trans. Isabella Bertoletti, James Cascaito, and Andrea Casson (New York: Semiotext(e), 2004), 31–45.

7 Jacques Lacan, *The Four Fundamental Concepts of Psychoanalysis*, trans. Alan Sheridan (New York: Norton, 1977), 101, 115.

8 Ibid., 101.

9 Thomas Y. Levin, "Dismantling the Spectacle: The Cinema of Guy Debord," in *On the Passage of a Few People through a Rather Brief Moment in Time: The Situationist International, 1957–1972*, ed. Elisabeth Sussman (Boston: Institute of Contemporary Art, 1989), 82. See also Kaira M. Cabañas, *Off-Screen Cinema: Isidore Isou and the Lettrist Avant-Garde* (Chicago: University of Chicago Press, 2015), 98–99.

Warhol's *Empire*

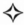

Unwatched and Unwatchable

J. HOBERMAN

There is a movie that I have never watched and most likely never will, yet recognize as a cinematic masterpiece and a monumental film-object: Andy Warhol's *Empire*.

In 1964, Warhol liquidated the entire cinematic apparatus, even as he asserted its existence, by making an epic documentary that one didn't have to see to "see." *Empire*, an eight-hour-plus, ten-reel, sixteen-millimeter film, is a fixed-camera contemplation of the Empire State Building that, as the Warhol scholar Callie Angell put it, "has thrived on a purely conceptual level since its creation."[1] Precisely because of its primary existence as a mental image, *Empire* dematerialized the screen.

"Last Saturday I was present at a historical occasion," Jonas Mekas reported in the July 30, 1964, issue of the *Village Voice*. "From 8 P.M. until dawn the camera was pointed at the Empire State Building, from the 41st floor of the Time-Life Building. The camera never moved once."[2] Although shot with a sound-on-film Auricon camera, the footage would be shown silent and at silent speed.

In a brief essay, the art critic Gregory Battcock declared that Warhol's notoriously unwatched and unwatchable movie demonstrated that the passing of time was "the most important single element that distinguishes film from the other visual art forms."[3] The same point was made

Andy Warhol's reflection in reel 7 of *Empire* (1964). 16 mm film, black-and-white, silent, 8 hours 5 minutes at 16 frames per second. © 2017 The Andy Warhol Museum, Pittsburgh, PA, a museum of Carnegie Institute. All rights reserved.

by Andrey Tarkovsky regarding Lumière actualités: "For the first time in the history of the arts, in the history of culture, man found the means to take an impression of time. Time, printed in its factual forms and manifestations: such is the supreme idea of cinema as an art."[4]

Seven months after Mekas suggested that *Empire* would become "the *Birth of a Nation* of the New Bag Cinema,"[5] Warhol's movie had its world premiere on March 6, 1965, at the City Hall Cinema. Ten minutes into the projection, Mekas would write in the March 11 *Voice*, "a crowd of thirty or forty people stormed out of the theatre into the lobby, surrounded the box office, Bob Brown, and myself, and threatened to beat us up and destroy the theatre unless their money was returned. 'This is not entertainment! This movie doesn't move,' shouted the mob."[6]

Rudolph Siegel described a more thoughtful response in a letter published in the following week's *Voice*:

After paying my $2 admission, I entered a comfortably appointed theatre and to the rousing notes of Beethoven's Fifth Symphony

prepared myself for the upcoming presentation. About midway through the third movement the house was darkened and a brilliant white square of light shone on the screen. It remained there, trembling slightly, for approximately 10 minutes, after which some dancing, greyish dots appeared, only to fade and be replaced by the indistinct image of a fog-shrouded Empire State Building. For the next half-hour, along with the other members of the audience, were witness [sic] to this wavering image of what the title of this presentation referred to as Empire. Upon the realization that this was going to be the whole show, I picked up my coat and left.[7]

It is not known how many spectators stayed on or if any were present for the entire film. Certainly the filmmaker was not among them. According to Warhol's studio assistant Gerard Malanga, Warhol stood at the rear of the auditorium "observing the audience rather than the film": "People were walking out or booing or throwing paper cups at the screen. Andy turned to me, and in his boyish voice said, 'Gee, you think they hate it . . . you think they don't like it?' Empire was a movie where nothing happened except how the audience reacted."[8] A single screening was enough to secure Empire's notoriety.

In January 1965, the fashion photographer Howell Conant rented the film, along with several other Warhol films, as research for a Life spread on "underground clothes." The same month, Warhol used material from the film as background for a performance at the Film-Makers' Cinematheque which included the Velvet Underground and Nico, "Andy Warhol Up Tight," and subsequent reels from the film were included in Warhol's multimedia presentation "The Exploding Plastic Inevitable."

In December 1965, Gregory Battcock showed at least the first reel to his class at Hunter College; another excerpt was screened in late 1966 by the Atkins Museum in Kansas City as part of the exhibition "Sound Light Silence: Art That Performs." The following April, excerpts from Empire were included in the free Festival of New York Films organized by the New York City Department of Recreation and Cultural Affairs at the Regency Theater, on Broadway at Sixty-Seventh Street.[9]

Withdrawn from distribution in 1972, Empire seems to have had no further screenings until February 1994, when Callie Angell presented it

in Sydney, Australia; a few months later, it was included in a program of newly preserved Warhol films at the Whitney Museum. In a booklet published on the occasion, Angell made a number of illuminating points, two of which are crucial. The first is that, possibly unknown to Warhol and his associates, *Empire* is a sort of clock: a light atop the Metropolitan Life Insurance Tower, to the left of the Empire State Building in the frame, flashes every fifteen minutes and the correct number of times on the hour.

The second is that, again inadvertently, Warhol signed his work. Throughout the movie, members of the crew are briefly visible as reflections in the window, and Warhol himself can be seen at the beginning of the seventh reel. Angell noted that "the fact that this brief appearance of the filmmaker in his own work has never been mentioned in the literature suggests, unsurprisingly, that no one may ever have seen the film in its entirety before."[10]

She was the first.

Notes

1 Callie Angell, *The Films of Andy Warhol: Part II* (New York: Whitney Museum, 1994), 15.

2 Jonas Mekas, *Movie Journal: The Rise of a New American Cinema, 1959–1971* (New York: Macmillan, 1972), 150. The inspiration for *Empire* evidently came from eighteen-year-old John Palmer, then an assistant to Jonas Mekas, living on the roof of the Film-Makers' Cooperative, six blocks from the Empire State Building. Palmer gave the idea to Mekas, who passed it on to Warhol. The movie was shot with the Auricon that Mekas rented to make his film *The Brig* (1964). Mekas framed the composition; Warhol approved and turned on the camera. In addition to Warhol and Mekas, Gerard Malanga was present, as was Palmer, who received a codirecting credit (at least initially) because his mother came up with the $350 necessary to get developed footage out of the lab. See Steven Watson, *Factory Made: Warhol and the Sixties* (New York: Pantheon, 2003), 160–161.

3 Gregory Battcock, "Notes on Empire: A Film by Andy Warhol," *Film Culture* 40 (1966): 39–40.

4 Andrey Tarkovsky, *Sculpting in Time*, trans. Kitty Hunter-Blair (New York: Knopf, 1987), 62–63.

5 Mekas, *Movie Journal*, 150.

6 Ibid., 180–181.

188 ✧ J. HOBERMAN

7 Rudolph Siegel, "Not Art," *Village Voice*, March 18, 1965, 4.

8 Victor Bokris, *Warhol: The Biography* (New York: Da Capo Press, 1997), 207.

9 This chronology is pieced together from material in the *Empire* film file, Archives of the Andy Warhol Film Project, Whitney Museum of American Art, New York, as well as Andy Warhol and Pat Hackett, *Popism: The Warhol '60s* (New York: Harcourt Brace Jovanovich, 1980).

10 Angell, *Films of Andy Warhol*, 16–17.

Warhol's *Empire*

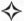

NOËL CARROLL

In the sixties in New York—roughly from 1963 to 1976 by my reckoning—
we had a lot of time to spare. As the city emptied out and lurched toward
bankruptcy, things were cheap. My first apartment in Manhattan was
sixty-nine dollars a month for four rooms. It didn't take much to get by.
The choreographer David Gordon told me that he only needed to work
for a couple of days a week as a window dresser to make a living. The
rest of the time could be devoted to art—making it, watching it, talking
about it, and so on. As a result, the era spawned a number of monu-
mental temporal artworks, along with audiences with the time to watch
them. Not surprisingly, many of these films thematized the experience
of temporality. For example, Michael Snow's *Wavelength* (1967) engaged
anticipation and Hollis Frampton's *Zorns Lemma* (1970), memory. But
perhaps the most challenging of these monuments was Andy Warhol's
eight-hour *Empire*, which premiered at City Hall Cinema at 170 Nas-
sau Street on March 6, 1965.

When I was a film student, there was a (perhaps apocryphal) rumor
floating around the Anthology Film Archives that Jonas Mekas screened
Empire twice for Stan Brakhage. The first time Brakhage was unim-
pressed. Mekas asked him whether he watched it at sound speed
(twenty-four frames per second) or silent speed (sixteen frames per

189

Still from *Empire*. 16 mm film, black-and-white, silent, 8 hours 5 minutes at 16 frames per second. © 2017 The Andy Warhol Museum, Pittsburgh, PA, a museum of Carnegie Institute. All rights reserved.

second). Brakhage said he had watched it at sound speed; Mekas pointed out that it was a silent film. Brakhage soldiered back into the screening room, emerging eight hours later to declare it a masterpiece. In those days, there were giants.

Needless to say, few, even in the sixties, had the stamina of a Brakhage when it came to film viewing. But the truth is—as with its predecessor, Warhol's six-hour *Sleep* (1963)—that one did not have to watch *Empire* from end to end in order to appreciate it. You could view it for a while, duck out and get a smoke, a drink, or even a meal, discussing what you'd seen, and then slip back and catch a bit more. Indeed, the film was designed to be unwatchable by mere mortals, but this practical unwatchability proved to be the source of its various philosophical points.

Empire was shot from the forty-first floor of the Time-Life Building. Warhol, John Palmer, and Jonas Mekas aimed a new Auricon camera at the Empire State Building and held that image steady from daylight to

darkness. Lights flitted off and on in the windows of the building, but there seemed to be no observable human movement.

The image taxed the perceptual capacities of most viewers. The human visual system samples the environment for change and tracks movement. Warhol's virtually lapidary image provided the viewer with little stimulus to chase and exhausted the prospects for scanning almost immediately. Warhol's image is simply inhospitable to human viewing; it makes the perceptual system idle, engendering the unpleasant sensation of boredom. And in that way, it makes palpable the falsity of the theoretical rhetoric of the "Camera Eye." The camera is not like the typical human eye. It is capable of a relentless stare that few, if any, humans can muster. Camera "vision" is inhuman to all literal intents and purposes. Machine "vision" is not human vision.

Although Christian Marclay's *The Clock* (2010) is three times longer than *Empire*, it is in no way as unwatchable as *Empire*, not only because it articulates the human narrative of the daily routine, but because, like Marclay's earlier *Telephones* (1995), via editing, the image track keeps changing, refreshing attention by serving up something new to look at.[1] Our visual apparatus, as Hugo Münsterberg suggested, operates more like editing than the long take, long shot. Thus, in the sixties, during the heyday of the debate in America between the realists and the montagists—between the photographers and the editors—the virtual unwatchability of *Empire* testified, albeit indirectly, on behalf of the Russians.

But *Empire* not only entered debates in film theory; its defiance of the mechanisms of human attention and its resulting unwatchability also challenged one of the deepest presuppositions of philosophical aesthetics, what has been called "acquaintance principle."[2] This is the claim, implicit in Kant's aesthetics, that in order to appreciate a work of art, you need to experience it in its entirety, firsthand, yourself. You cannot rely on the testimony of others. After all, they might have missed something that you would have caught, or they might have reported their observations inaccurately either by omission or commission. Nor could your appreciation rest on documents, like photographs, of a portion of the artwork, since the document might be misrepresentative. Consequently, a condition of appreciation, properly so-called, putatively was that you experience the artwork whole and face-to-face.

However, *Empire* appears to be a metacinematic artwork that can be appreciated philosophically by those who have not seen it themselves and thus are without direct experience but who rather must depend on the reliable testimony of others. This is a cinematic affront to the principle of acquaintance that parallels the achievement of Marcel Duchamp's *Fountain* (1917)—that toilet that few saw directly but only through the photograph by Edward Steichen and yet who nevertheless have since, so to speak, plumbed its depths endlessly.

The practical unwatchability of *Empire*, surrounded as it is with bountiful interpretive debate about the nature of cinema, demonstrates that appreciation without acquaintance is possible, at least, if you agree with Arthur C. Danto, the foremost philosophical exegete of Warhol's work, that interpretation can be a form of aesthetic experience.[3]

That *Empire* need not be watched—and for many cannot be watched, unwatchability being its theme—and yet can be legitimately discussed and interpreted and thereby appreciated is probably *Empire*'s singular philosophical achievement, but not its only one.

For *Empire* also advances on the cinematic front the profound discovery of Warhol's *Brillo Box* (1964). If Warhol's *Brillo Box*, by being effectively indiscernible from the Brillo cartons manufactured by Procter & Gamble, drove home the idea that art was not something that one could discern by looking, *Empire*, by being indiscernible from surveillance footage (which was becoming increasingly familiar in the sixties), reinforced the indiscernibility thesis with respect to film. That *Empire* is art is not something you can determine simply by watching it. It is art because, given its avant-garde, filmworld context of presentation, you can interpret its content even without watching it.

Many films are unwatchable because they are disgusting (e.g., *The Human Centipede* [2009] and its sequels) or because their violence is unbearable (Jordan Wolfson's virtual reality spectacle *Real Violence* [2017]). *Empire* is visceral in a different way. It exhausts our capacity to attend, but not our capacity to speculate. And therein lies its genius.

Notes

I wish to thank P. Adams Sitney and Amy Taubin for their assistance in preparing this essay, but only I am responsible for its imperfections.

1 Even Warhol's *Sleep* is less demanding than *Empire*, since the camera changes position occasionally. Another film, also titled *Clock* (by Yoko Ono with John Lennon), is perhaps also worth mentioning in this context. Made in September 1971, it was a single shot, long take of the face of a clock recording one hour in the lobby of the St. Regis hotel, recording and accompanied by Lennon's soundtrack. Since the film apparently no longer exists, it is difficult to interpret it. Perhaps it was an affirmation of Ono's Fluxus commitment to dismantling the boundary between art and the ordinary. But, in any event, it was probably less taxing experientially than Warhol's experiments with temporality insofar as it had music to make it more endurable.

2 See Paisley Livingston, "On an Apparent Truism in Aesthetics," *British Journal of Aesthetics* 43, no. 3 (2003): 260–278; Malcolm Budd, "The Acquaintance Principle," *British Journal of Aesthetics* 43, no. 4 (2003): 386–392; James Shelley, "The Problem of Non-perceptual Art," *British Journal of Aesthetics* 43, no. 3 (2003): 363–378; and Noël Carroll, "Non-perceptual Aesthetic Properties," in *Art in Three Dimensions* (Oxford: Oxford University Press, 2010).

3 Danto believes that aesthetic experience is essentially a matter of interpretation. One need not go this far to buy the argument above. One need only claim that interpretation can be a species of art appreciation, especially when it comes to metacinematic motion pictures. See Arthur C. Danto, *The Transfiguration of the Commonplace: A Philosophy of Art* (Cambridge, MA: Harvard University Press, 1981).

Watching Paint Dry

ERIKA BALSOM

I.

In order for a film to be shown commercially in cinemas in the United Kingdom, it must receive an age-appropriateness rating from the British Board of Film Classification.[1] And in order to receive such a rating, one must pay a fee. To review a submission, the BBFC charges a flat amount of £101.50 per film, plus a £7.09 per-minute tariff. One can object to this requirement on the grounds that it imposes an additional financial burden on the already-precarious practice of independent film distribution, or because it treats cinema unfairly when compared with other artistic forms, which require no such certificate. As Jonas Mekas put it in 1964, criticizing a similar system then in place in New York City, "There may be a need for licensing guns and dogs, but not works of art."[2]

Charlie Lyne's silent 607-minute film *Paint Drying* (2016) consists of a single, unedited shot of paint drying on a white brick wall. It is an absurdist work created for the sole purpose of drawing attention to BBFC fees and procedures, humorously punishing the censors by subjecting them to the eminently unwatchable nonevent of paint drying. Its running time is not arbitrary, but determined by how much money

Still from Charlie Lyne's *Paint Drying.*

Lyne could raise on Kickstarter; the more donations, the longer the film would be.

The censors persevered through the ten hours—for a fee of £5,937—and awarded the film a "U" certificate, suitable for all audiences.

II.

Near the beginning of Arthur Penn's *Night Moves* (1975), private eye Harry Moseby declines his wife's invitation to go and see *Ma nuit chez Maud* (1969) with her gay friend Charles: "I saw a Rohmer film once, it was kind of like watching paint dry."

Harry's remark superficially resonates as a feminizing rebuff of high culture. It points to a state of utter boredom, to be avoided at all costs. It captures a sneer often directed at so-called "difficult" cinema. Yet when one begins to dig in to the depths of the trope, something more emerges. Watching, as a specialized form of perceptual activity, is tied to duration, to an expectation of change. Even when T. J. Clark spends months in front

of two Poussin canvases to write *The Sight of Death*, the art historian doesn't *watch*; he looks closely. We have all seen "WET PAINT" signs affixed to park benches, doors, and walls, but perhaps never suspected that their very existence offers insight into a key trope of cinematic tedium. Such signs are posted because wet paint doesn't look that dissimilar to dry paint, even though it very much is. Watching paint dry is, then, not a confrontation with pure stasis but a condition that demands attunement to differences that are barely perceptible, even imperceptible, yet crucial.

As with so many such episodes of macho posturing, Harry's dismissal of Rohmer inadvertently discloses an insecurity. He reveals an anxiety about failing to grasp the complexity of what is in front of him, about missing the crucial change. Despite indications to the contrary, he does show up at the Rohmer screening and waits outside in his car, only to see his wife on the street with Charles and a man with whom she is clearly having an affair. Her infidelity hits him as a total surprise. To watch paint dry is to know that a transformation is indeed occurring, just below one's threshold of intelligibility. Harry's jibe names a relation not only to cinema, but also to a slow marital decay, a disintegration that remained invisible to him until the paint had dried and the screen went dark.

III.

Tony Conrad's *Yellow Movies* (1972–1975) are works of what Jonathan Walley has called "paracinema," in that they assert, in this case via their title and aspect ratio, their status as cinematic works even though they do not take the filmic apparatus as their material support. Conrad's *Yellow Movies* are, more obviously, paintings: they are bordered rectangles covered with cheap white house paint that gradually yellows as it is exposed to light and dirt over time. If the *Yellow Movies* are indeed movies, they are movies longer than a human life, movies that ask their viewer to watch paint dry—and age and degrade. What is for Lyne and Moseby an insult is here an artist's conceptual move.

The *Yellow Movies* are often understood as an intervention into prevailing discourses of materialist medium specificity in 1960s and 1970s

avant-garde cinema. Conrad has described them as playing out "an endgame" in relation to the reductionist tendencies of structural film, toying with the latter's essentialism by affirming the specificity of cinema by other means.³ But these works are equally the apotheosis of the interest in durational experience that marks artistic production at the dawn of the Information Age, an attitude Pamela Lee has termed *chronophobic*, but which might just as easily be deemed *chronophilic*.⁴ If Warhol's *Empire* (1964) aimed to empty action so as to induce an awareness of time itself, it remains nonetheless bound by the material limitations of photochemical film. A long take on celluloid is in fact not so long. Conrad's paracinematic gesture goes farther, creating a film of potentially infinite duration that evades the segmentation of time. Its movement is so slow that it cannot be seen.

The endless crawl of the *Yellow Movies* might bespeak the anxiety of a time that cannot be consumed but that dwarfs. Yet their rejection of rationalization and quantification suggests simultaneously a reclamation of time's qualitative continuousness—an attribute increasingly under threat during this period, as Lee details. In this, the *Yellow Movies* serve as a cipher for the demand much experimental cinema made of its viewer in the 1970s and, indeed, does to this day: to look differently, harder, longer. Such is the utopian promise nestled in the boredom so many experience in relation to this field of practice. To watch paint dry— that is, to watch much experimental film—is to inhabit a different economy of signification and attention; it is to submit to an experience of subtlety that frustrates ingrained norms and demands a recalibration. We are called upon to attend to the nuances of what Marcel Duchamp termed the *infrathin*.

IV.

When asked their opinion of David Gatten's first digital work, the 175-minute *The Extravagant Shadows* (2012), more than one critic replied with the same quip: it was like watching paint dry, literally. Gatten layers oil-based enamel and acrylic on top of one another in the open air and films the paints, which are not fabricated to be used together, as they dry. Fragments of appropriated text appear on-screen between the

application of successive coats. If others invoke watching paint dry as punishment and/or joke, Gatten's interest in it is absolutely sincere—a question of color, form, and process.

The dispossession and acceleration of time indexed by the art of the 1960s and 1970s has only exacerbated in the intervening years. For Jonathan Crary, today's globally networked society is a 24/7 cage from which sleep is the only escape. Crary describes this regime as characterized by an all-pervasive glare that disables vision, one in which screen-based media play a central role: the subject is confronted with "white-out conditions, in which there is a paucity of tonal differentiation out of which one can make perceptual distinctions and orient oneself to shared temporalities."[5] To watch paint dry, to watch for the unspectacular, to strain at the edges of perception: this might offer just the pedagogy of attunement needed in this numbing blizzard.

Many have denigrated digital technologies for their cancelling of durational experience, but they also make possible images of unprecedented unfolding. Whereas the maximum duration of an image made on sixteen-millimeter film—until *The Extravagant Shadows*, Gatten's preferred medium—would clock in at approximately eleven minutes, here the camera rolls and rolls. Forget sleep, stay awake, turn the screens toward another time. Or, better, turn away from the plurality of screens and toward the single rectangle: the movie theater, once aligned with distraction, now sweeps away the pings of real-time communication. Where else can we be so blissfully offline? The durational tradition of the avant-garde, so long at the margins of cinema, is now arguably the mode of filmmaking that most actualizes the radical potential of its architecture at this historical juncture.

Perhaps Lyne was offering the censors a gift. As Walter Benjamin knew, "Boredom is the dream bird that hatches the egg of experience."[6]

Notes

1 Local authorities are responsible for determining what may be exhibited in their jurisdictions but generally defer to BBFC rulings. In the absence of a BBFC certificate, permission from the local authority is sufficient.
2 Jonas Mekas, "On Obscenity," in *Movie Journal: The Rise of a New American Cinema, 1959–1971* (New York: Macmillan, 1972), 127.

3 Jay Sanders, "Tony Conrad," *Bomb Magazine* 92 (Summer 2005), http://bomb-magazine.org/articles/tony-conrad.

4 Pamela Lee, *Chronophobia: On Time in the Art of the 1960s* (Cambridge, MA: MIT Press, 2004).

5 Jonathan Crary, *24/7: Late Capitalism and the Ends of Sleep* (London: Verso, 2014), 33–34.

6 Walter Benjamin, "The Storyteller: Observations on the Works of Nikolai Leskov," trans. Harry Zohn, in *Selected Writings: Volume 3, 1935–1938,* edited by Howard Eiland and Michael W. Jennings (Cambridge, MA: Belknap, 2002), 149.

8

Visceral Responses to Horror

No other mainstream genre flaunts its unwatchability like horror. As film critic Mark Kermode notes in "Horror: On the Edge of Taste," "Even the most narratively reactionary, moralistic horror movies feed upon the ecstatic shock of speaking the unspeakable, of showing the unwatchable." Oozing with graphic images of bodily violence and abject carnage, horror films elicit visceral, personal, and often highly gendered responses. Film phenomenologist Vivian Sobchack theorizes her experience (not) watching two horror films, *Isolation* (2005) and *The Descent* (2005), whose displays of terror and gore sent her to oblique, off-screen spaces: "I watched [major portions] through my ears, or by staring down at my lap, or, at most, from the corners of my eyes." Waiting for dreaded images to pass before uncovering her eyes, Sobchack participated in a curious game of "peekaboo" with the screen. Film critic and scholar B. Ruby Rich explains her irreducibly personal reasons for avoiding the horror genre, recounting a childhood trauma that overdetermined a chain of subsequent moviegoing experiences including Alfred Hitchcock's *Psycho* (1960) and Roman Polanski's *Repulsion* (1965). Finally, media scholar Genevieve Yue places the *Ring* franchise in relation to myths of unwatchability extending back to Medusa. Drawing from feminist theorists such as Hélène Cixous and Barbara Creed, Yue urges a sustained look at the abjected, ostensibly monstrous women from whom we would otherwise avert our gaze.

"Peekaboo"

Thoughts on (Maybe Not) Seeing Two Horror Films

VIVIAN SOBCHACK

Some years ago, in 2005, the magazine *Film Comment* asked me to write a short piece on two (then new) low-budget horror films: *Isolation* from Ireland and *The Descent* from the United Kingdom. True to its name, *Isolation* takes place on a remote and (increasingly) depopulated Irish dairy farm; and all of *The Descent* is set, but for a few bracketing exterior scenes, in the darkened and (increasingly) narrowed confines of an unmapped Appalachian cave system.

The main figure in *Isolation* is a pregnant dairy cow that, submitted to nefarious DNA experiments before the film's beginning, eventually gives birth to a highly problematic calf in the most harrowing and literally drawn-out scene in the film. Suffice it to say that complications ensue, and a fetal and bloodthirsty thing with fangs emerges from the dead calf to slither and kill through the film until both are brought to an end. *The Descent* (which became very popular) begins as a spelunking adventure and follows six women who eventually become lost underground and find themselves hunted by subterranean and flesh-eating humanoid creatures. Their search for an exit is relentlessly suspenseful and leads to moments of intense terror and gory bodily trauma—and, at the end, it is not clear they escape.

Audience reaction footage shown as part of the publicity for *The Gallows*, from YouTube.

But, enough of plot. What really interests me here are the dark, off-screen, and imageless spaces my vision seeks when I am confronted by such on-screen terror and gore—particularly in those contemporary horror films that refuse to wink at themselves and take both their terror and gore seriously. Thus when I was asked to write about these two films, I cringed at the assignment (although I took it since I wanted to write for the magazine again). Indeed, I go out of my way to avoid such films; given my various experiences of physical pain over the years, my aging body has become increasingly sensitive to visceral images of its imminent potential for violation. As Mark Kermode, in a rave review of *The Descent*, writes: "Horror is a genre that feasts upon its own entrails."[1] Well, yes—but it always also feasts upon mine.

All this is to say that I was not the best audience for these films, much as I respected their effective economy of means, their commitment to creating a truly palpable atmosphere, and their serious entertainment of the fragility not only of human flesh but also of human community. The point is that, unlike in my youth when I felt my body and psyche invulnerable and could watch anything (well, almost anything), I now find it extremely difficult to submit myself to the particularly dreaded form of "unpleasure" that horror films offer me. Thus how could I be fair to *Isolation* and *The Descent*?—major portions of which I watched through my ears, or by staring down at my lap, or, at most, from the corners of my eyes.

Confronting "fleshy" on-screen horror, I retreat into literal off-screen space—a different kind than the so-called "obscene" space in which the films' respective "creatures" lurk, ready to jump out into on-screen visibility. I would call my off-screen space "oblique" rather than "obscene": this because it expresses my own presently "biased" physical position in relation to straight-on cinephilic spectatorship. "Oblique" also because it offers me only the partial psychic safety of a place to hide *from* the cinema *in* the cinema. To a great degree, then, this oblique space is extra-filmic: I sit there aware of mostly my lap, but also of the darkened theater, and others around me. It admits only sound and stroboscopic bursts of light (rather than image) that cue me when it is safe to look up at, rather than down, or obliquely away from the screen. This oblique space also has a specific temporality: it creates a hermetic and perverse form of anticipation. Rather than fixating on the screen and bracing myself for the imminent moment when terror will come, the creatures will strike, there will be blood and guts and gore, I sit there blindly waiting for these moments to pass—to be past—so I can look up again. And, when I do look up again, I want what I was about to see, what I had begun to see, *not* to be there! This is surely a strange, inverted game of "peekaboo." Rather than covering my eyes so that I can uncover them and delight in the *pleasurable* return of the visible (a pleasure derived from *my* spectatorial agency and power), here I *dread* what I will see when I return my vision to the screen perhaps too soon—and this is a dread emergent from the *cinema's* agency and power.

In an appreciative book on the genre, Tom Hutchinson succinctly summed up its appeal: "Horror is the appalling idea given sudden flesh."[2] Thus the horror film too plays this perverse form of "peekaboo"—hiding things from on-screen visibility and then bringing them to light again appallingly, in "sudden flesh." It too oscillates between the delight of seeing *everything* and the dread of seeing *something* that might be better left unseen. Indeed, *Isolation* plays peekaboo most effectively, constituting its own oblique space on-screen. Given dark close-ups in which farm fences and parts of a barn occlude and fragment cinematic vision from the film's very beginning, viewers must *strain* to see, to visually "figure out" where they are in the cramped and claustrophobic space-time of this isolated, muddy, rusted, and dark Irish dairy farm. And then, in a number of appalling and fleshy "suddenlys," the film takes

the visual occlusion away—leaving one to watch (through the corners of my eyes) not only the detailed and endless winching of an altered and near still-born calf from its mother's womb but also the calf's own slithery, metamorphic, and mutant offspring scurrying though mud and hay and water to seek and find either a next meal or another host body.

Using fewer generic clichés and given the dank darkness and hermetic enclosure of its underground setting, *The Descent* plays an even more sophisticated and suspenseful game of "peekaboo." Eventually trapped within the claustrophobic cave system by a rock slide, the six women separate to find a way out, each person or little group fitfully lit through different means that allow viewers to see their struggles in stroboscopic glimpses—and, for me, often wish I hadn't. In the film's own oblique spaces, helmet lights, flashlights, green glow sticks, and the infrared of a handheld video camera conceal and reveal the visible as both too little and too much—each revelation coming at exactly the right (wrong) time if your eyes are still on the screen.

I am not alone. Several of my friends and colleagues have admitted that they, too, turn away from on-screen gore, and one wondered aloud if her squeamishness was a sign of some lack or incapacity to love the cinema. Never disappearing, horror has long been the most beloved of genres—and, these days, the more appalling and gory the idea made flesh, the more passionate cinephilic devotion. Hence, Kermode's enthusiastic response to *The Descent*: "As a long-term horror fan sorely starved of no-nonsense shocks, I am thrilled to report that I jumped, I gasped, I winced, I cringed and, for lengthy periods, I simply held my breath."[3] Hence, one of many viewers praising the film on the Internet Movie Database posts: "Keeps you on the edge of your seat throughout, struggling for breath as you feel the walls in the cinema closing in"—and this even before the cave's flesh-eating humanoid "crawlers" appear. Hence, summing up *Isolation* (and the pleasures of the genre), another online cinephile writes: "Includes all the things that make a horror flick worthwhile: imaginative kills, frequent goriness, a more than palpable sense of impenetrable dread, creepy creatures, and a grim setting that easily gets under your skin from the very first frame."[4]

These are the sorts of things that do *not* give me pleasure, that I do not love—or so it emphatically seems. Pondering my squeamishness, however, I find myself suddenly conjoined with those self-avowed hor-

ror cinephiles who cannot take their eyes from the screen. Although opposites, we are also the same in the genre's compulsion not merely of our assaulted vision but also of our intensely felt *presence*. Wherever and however we locate ourselves in theatrical space (straight on, obscenely, or obliquely), whether blind or not to the film's images and pervaded by sound, we both are indubitably "here" before it—and intensely aware of the heightened sense of our own material being. Whether a horror cinephile or cinephobe, confronted with the images and/or sounds of flesh, blood, bone, viscera, breath, and heartbeat at their most threatened (both on and off-screen), all of us are subject to the intransigent power of the cinema to engage us in the most profound and bodily way.

Along with our material "here," those cinephiles and I are also conjoined in the mutual intensity of the "now" in which we (and the characters) are caught up—indeed, trapped—whether willingly or not. Serious horror films such as *Isolation* and *The Descent* make the temporality of the present *concrete*—sealing it off in space to extend its (and our) presence, and bringing it into autonomous relief in all its terrifyingly fated contingency. What will happen will happen and although it could be "anything," we know it will be "something"—and something that matters *now*. Thus, all the "wills" involved here do not refer us (and the characters) to a future but, rather, to the intensity of a present that not only contains but also phenomenologically "draws out" and extends the "now."

Usually, we live the present transparently, unaware of its force in our active and expansive engagements with the world. Lost to reflection in its own moment, the present is particularly phantasmatic—except in extreme moments when we do not retrospectively *think* it but *feel* it as the palpable "now" that is "here." Certainly, it has long been noted that we tend to feel this intense sense of presence, to feel most alive, when we are most at bodily (and psychic) risk. Faced with a present threat to our being, we have "no time" to think about the past or future, but this could also be reversed: it is the past and future that have "no time" because the extended "now" excludes them as it subtends us. Thus, a sense of "aliveness"—of being just here, just now—emerges both from, and as, the simultaneous extension of our present and the heightening of our presence.

All this philosophizing is meant to say that, even if I do not "love"— or even properly "watch"—horror films, I share the same intensification

of my material "being" as do the genre's most ardent fans. Unlike Kermode, I was not "thrilled" that I jumped, gasped, winced, cringed, and held my breath obliquely watching but not seeing parts of *Isolation* or *The Descent*. Nonetheless, without loving it (or perhaps loving it in such a fierce way that I cannot call it love), I, too, was absorbed in, and by, the "now" that both these horror films spatialize and extend, and in, and by, the intense presence of my body as fleshy and vulnerable even to the screen—aware not only that I was definitively, unpleasurably "here" but also, dare I say, intensely and very pleasurably *alive*.

Notes

1 Mark Kermode, "What Lies Beneath," *Observer*, July 10, 2005.
2 Tom Hutchinson, *Horror and Fantasy in the Movies* (New York: Crescent Books, 1974).
3 Kermode, "What Lies Beneath."
4 Scott Weinberg, *Isolation*, EfilmCritic.com, November 5, 2005.

Why I Cannot Watch

B. RUBY RICH

In other hands, this essay might trace the territory of the unwatchable by cataloguing the films that have been denounced or avoided for reasons of identity or ideology, such as the spirited 1980s community-based protests against the scripts and releases of *Cruising* (1980), *Fort Apache, The Bronx* (1981), and *Basic Instinct* (1992) for negative and stereotypical depictions of their targeted communities and neighborhoods. Or turn to the 1970s when early feminist theoretical advances led some male avant-garde filmmakers in the United Kingdom to swear off the depiction of the female body altogether. Or trace the U.S. anti-pornography attempts of the 1970s and 1980s to ban films deemed pornographic to "protect" women. Or take up today's targets of trigger warnings, as varied and unpredictable as they are.

But, no. This taxonomy of the unwatchable is, for me, a far more personal one: a coming to terms with the self that dives below the ever-present categories of politics, ideology, even personal injury, into deeper straits. My unwatchables are surgically encoded to my own childhood and lived experience, as if encapsulating a genre tuned to my own DNA and braided into the very essence of my nerve cells.

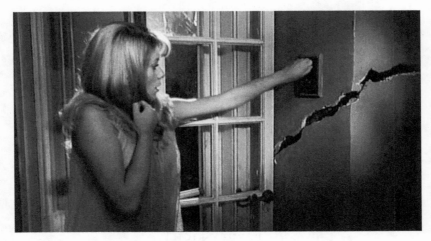

Still from Roman Polanski's *Repulsion*.

1.

Start with the soundtrack. Consider the tritone, for instance: the musical term for a combination of two notes that provoke an unsettling sensation when juxtaposed or played together, as in a diminished fifth or augmented fourth. It creates such an unsettling effect that it was called the devil's music in medieval times.[1] Scary emotional music, it exploits dissonances instead of resolving them. Commonly used in . . . horror films.

I was eight or nine years old when I went to the Falmouth movie theater with my cousins. I was spending a week on Cape Cod and this tacky second- or third-run house playing old junk films for summer tourists was a pre-VCR/Internet ritual, and their weekend tradition. The show that night was a trashy Cormanesque horror movie. It was a variation on the portrait-in-the-attic trope, in this case a magical elixir of immortality kept in a safe to be sipped in the nick of time.[2] Without his regular dose of the potion, the handsome undead protagonist would begin to age and rot, a spectacle that provoked screams in the theater. The score amped up the horror, and surely had something to do with my reaction. "Pitch and dynamics also influence bodily reactions."[3]

Terrified, I looked away, shut my eyes, swiveled my head. But I couldn't escape the terrifying soundtrack. My hands turned clammy, I began to

shake, couldn't breathe, even without looking. My aunt brought me to the tiny lobby to wait, but it offered no shelter from the soundtrack, pulsing through the thin walls by the candy stand, terrifying me. I shook for hours.

My grandfather, the hero of my childhood, had died three years earlier of lung cancer. The children weren't allowed to see him until the family relented, when he was near death, and I was finally allowed into the hospital for one last embrace. By then, after a few short months, this withered greenish patient bore little resemblance to the beloved Papa who had rocked me to sleep every night for the first three years of my life. I suspect his brutal transformation has something to do with my relationship to horror movies ever after.

A few years later, in early adolescence, I went to a local matinee of *Psycho* (1960) in Boston with my best friend. We knew nothing at all about it, just heading into the Saturday tradition with discount Table Talk pies from the factory to eat. As if. I spent nearly the entire film hiding behind my coat. It was the soundtrack, in part, the shrieking screed of terror that marked me indelibly forever after. What sweet revenge when, years later, Sally Potter took up the shower music for her film *Thriller* (1979), mixed with arias from *La Bohème* in a defiant reclaiming of all the women killed off for art.[4]

It wasn't only Bernard Herrmann's soundtrack, though: it was *Psycho*'s structuring point of view, the camera work, the set-up of a woman alone and in danger, the stalking, the anticipation, and then the violence. I must have cast off the coat at some point, for I saw enough to become terrified of showers. For the next ten years, I took nothing but baths; it would be decades before I'd take a hotel room shower if traveling alone.

In college, I went off to the film society with my best guy pals to see Roman Polanski's *Repulsion* (1965). I didn't want to go, but they were obsessed cult fans who wanted to share their favorite object with me. I'd explained my terror, dating back to that elixir and that shower, but they solemnly vowed to warn me in advance of every single scary turn of the plot. Then they crucially forgot the first one. I finished the film in the lobby, sat there until it was over. Afterward, I couldn't be left alone in the house for weeks, even months, so unsafe did I feel. After all, if hands had sprung out of her own apartment's walls to grab Catherine Deneuve, what chance did I have?

2.

I became a film critic, curator, scholar, professor, editor, and film festival regular. Movies are my life's work. Surely, I've outgrown these childish responses. Guess again.

3.

I did begin to wonder if horror were gendered. It wasn't just high school where the guys took their dates to horror movies so they'd snuggle up in fear and it was not just college where the guys brought *Nightmare on Elm Street* over to their date's apartment hoping to get lucky. Horror was everywhere: all over the multiplex, throughout the canon. I began to suspect that women and men had differing visceral responses baked in.

Carol Clover tried to disabuse me of such notions, what with her theories of shared subjectivities and vulnerabilities, with her figure of the "final girl" who fights back and wins.[5] But the analysis didn't change my reactions, nor my reluctance to expose myself to these films and their genre. Eventually, I began to explain my occupational disability: "I live in the wrong body for this film," I'd say, invoking a rather mild gender critique for my refusal to see films in which predominantly female actors are inevitably harmed, sliced and diced, stalked and terrorized. Then I realized the horror genre overlapped with the thriller, so I stayed away from both. I declared my psyche off-limits, a one-woman boycott.

Sometimes I couldn't avoid them. In 1991, I was invited to conduct an onstage interview with Jodie Foster at the Walker Art Center. Because of the monograph I was commissioned to write for the occasion, I was included in an advance screening of *Silence of the Lambs*. A college friend who remembered my terror responses warned me what the film was about—to my dismay—and lent me his copy of the Thomas Harris novel so I'd be prepared. I read it the night before (devoid of music and lenses, texts don't trouble me). Luckily, Jonathan Demme was supremely faithful to the book and I made it through the screening undamaged.

4.

I began to work out a personal horror/thriller glossary to figure out which of these movies I could see and which I could not allow into my psyche or memory. Apart from enduring the visceral physical responses, I developed a fairly simple rule to guide my decisions: open text or closed text.

In the closed-text version of a thriller or horror film, the universe is created within the film and ends when the lights come up at the end of the movie. Exiting the theater, you also exit the film and therefore are freed of its terror. It was only a movie, after all. In the open-text thriller or horror film, however, the world of the film is precisely the world outside. You exit the theater and the movie exits with you, accompanying you into the street. There is no escape, the horror is still there, "they" are still after you. And will never go away.

5.

In the 1980s, I was saved by technology: with the invention of the VCR, I could finally watch horror and thrillers of most any kind. I could fast-forward to find out how they would end, thereby disarming the suspense; I could turn off the sound, defanging the dreaded tritone and its ilk; I could freeze-frame any scene that became too much to bear, draining the image of its animism. Best of all, the VCR let me change the set: seated in daylight instead of darkness, I was fearless; no longer tiny compared to the big screen, I was in charge.

The advent of video, digital, and streaming platforms has given me agency, allowing me to see enough of the essential horror and thriller films to figure out what spooked me. It's not the violence or brutality, I discovered, that most unnerved me. In part, it was the anticipation built up by the camera angles and soundtrack; the dread of what was coming, around the next corner, preordained by plot conventions; and the certain knowledge that a female body would be violated or extinguished by a sadistic scriptwriter before the end credits could roll. A half century past the childhood trauma that set off the original reactions, decades past the psychoanalysis that uncovered it, after eons of

queer living and its attendant agency, I've been freed in the end by technology.

Those are images and narratives that I do not accept to this day. Few things in life are preventable; these movies, happily, are. All grown up now and living three thousand miles from Falmouth, I still avoid most horror films and thrillers, and refuse to be complicit in my own terrorizing. I claim my right to withhold my consent as a spectator. No completist, I am happy to leave lacunae in future itemizings of the Best Films of All Time. My list will never have any horror movies on it, and I'm not even sorry.

Notes

1 Thanks to Claudia Gorbman for her expert navigation through this subject. See also Janet Burns, "A Brief History of the Devil's Tritone," *MentalFloss*, March 29, 2016, http://mentalfloss.com/article/77321/brief-history-devils-tritone.

2 I've been unable to track down the film from that night. I once thought it was *The Man Who Wouldn't Die* (Herbert I. Leeds, 1942) but it seems too old a film to be playing reruns in my childhood, and the plot does not match my memories. Perhaps it really is a Roger Corman film, an obscure one that hasn't been revived.

3 See Irwin Bazelon, *Knowing the Score: Notes on Film Music* (New York: Van Nostrand Reinhold, 1975).

4 *Thriller*'s composer Lindsay Cooper was the first to explain the tritone to me.

5 Carol J. Clover's *Men, Women, and Chain Saws: Gender in the Modern Horror Film* (Princeton, NJ: Princeton University Press, 1993) remains the defining text.

Apotropes

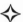

GENEVIEVE YUE

Long before I saw *The Ring* (Gore Verbinski, 2002), I was subjected to an exhaustive secondhand plot summary. The person describing it was not a particularly gifted storyteller, but he was clearly rattled by what he had just seen. By the end of his blow-by-blow retelling, I was also seized with fear. Knowing that the *way* I was frightened was also how fear spread within the film itself—through secondhand accounts of a horrifying image—only contributed to this effect. "Promise me you'll never watch it," my interlocutor said, but a patronizing note in his admonition annoyed me. What would happen if I did?

The story of *The Ring* and *Ringu* (Nakata Hideo, 1998), the "J-horror" original, goes like this: a rumor of mysterious videotape is being passed around with the warning that anyone who watches it dies exactly one week later, their faces contorted in an expression of extreme fear. A plucky reporter on the urban legend beat decides to investigate. She eventually finds and watches the tape, but when it becomes clear that the curse is real, she spends the rest of the movie trying to rid herself of it. In this she narrowly succeeds, but not before contaminating most of her family members with the same fatal viewing.

The tape itself is fairly unremarkable, like a student film imitation of a Nine Inch Nails music video. There are shots of maggots, a woman

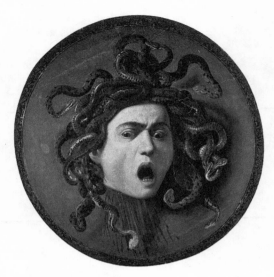

Caravaggio, *Medusa* (1597).

combing her hair in a mirror, a ladder against a wall, and the illuminated rim of a well—spooky, but nothing particularly frightening. (The *Ringu* version has considerably fewer bugs.) Though sound is often used to extend a horror film's effects, here it's little more than a minimalist noise composition, with the sound of static, a few chirps, and mostly silence. But the reportedly malevolent effects of watching it, both in the film and in *The Ring*'s advertising blitz, are something else. These recall other examples of images too terrible to be seen, from the story of Lot's wife ill-advisedly glancing back at Sodom to the Nazi face melt in *Raiders of the Lost Ark* (Steven Spielberg, 1981).

The *Ring* tape could be added to an entire shelf of (fictional) films deemed too dangerous to be viewed. The horror genre has many: *Remote Control* (Jeff Lieberman, 1988) features a schlocky fifties horror film on VHS that turns out to be the vehicle for an alien mind-control plot. (A similar premise features in several episodes of *The Twilight Zone*, including "A Thing About Machines" [1960], "A Most Unusual Camera" [1960], and "What's in the Box" [1964].) In Tanizaki Jun'ichirō's story "The Tumor with a Human Face" (1918), the frame story concerns a mysterious film called *Vengeance*, and anyone who watches it becomes ill. In David Foster Wallace's *Infinite Jest* (1996), the book's title is also the

name of a film (also referred to as "The Entertainment" or "the samiz-dat") that causes anyone who watches it to fall under its spell, desiring only to watch it repeatedly. A more benign form of the prohibited yet irresistible image, which takes the form of a nightmare, is described in Hollis Frampton's 1972 essay "A Pentagram for Conjuring the Narra-tive": a woman lives a full and accomplished life with every moment filmed. When she dies in old age, she bequeaths her sizeable fortune to the next child born in the same city, on the condition that he watch all of the footage. The infant who inherits this fate becomes a sedentary asthmatic who grows increasingly dependent on the film until he can no longer meaningfully separate his own viewing from what he sees. Moments after the old woman expires, he does too, never to claim his reward. Frampton uses this as cautionary tale against narrative's clutches, which entrap and slowly suck the life out of the viewer.

Robert Aldrich's *Kiss Me Deadly* (1955) gets closest to the origin of these myths of unwatchability. In the film's closing sequence, the reckless Lucy opens a box that unleashes a blinding and, the film implies, nuclear light. The doctor she has just murdered called it "the head of Medusa," and its destructive force, which consumes Lucy, the house, and possibly everything else, is a fitting midcentury analogue for that half-human, half-gorgon creature who causes the death of anyone that looks at her. Medusa is the paradigmatic forbidden image; only Perseus, the hero who has been amply prepared with weapons, can defeat her, and then only with a reflective shield that he uses to deflect her gaze. Holding the shield like a camera, and walking backward as if shooting a track-ing shot, Perseus triumphantly lops off her snake-haired head and stuffs it into a sack. He then departs for greater exploits; her body, meanwhile, is presumably left on the cold floor of her cave.

There's more than a bit of Medusa in the *Ring* films, where death comes by way of a gangly girl with long, wet hair (Samara in *The Ring*; Sadako in *Ringu*). But there's a technological twist: she can only kill someone *who watches her video*, which she has psychically spawned. Unlike Medusa, who was just minding her own business, Sadako is on a vengeful tear, but her wrath is pretty understandable given the fact that her parents shoved her down a well and left her to die. Both figures possess an indiscrimi-nately destructive force: Medusa by her look (or looks—whether her deadly power is active or passive is never settled), and Sadako by her

somewhat anachronistic videocassette. The latter makes up for the awkward choice of medium with a sadistic loophole: the curse can be averted only if the tape is replicated and passed onto another person. If nothing else, she has concocted an ingenious distribution scheme.

The chatter that circulates about the videotape, heard at the beginning and end of the film, is a kind of metatextual bait, enhancing its horrific effect rather than diminishing it. Perhaps this is why the *Ring* franchise, beginning with Suzuki Kôji's novel from 1991, has grown so enormous. Currently at thirteen films, two television series, six books, and two videogames, it's a narrative that feeds its own notoriety. The story of *The Ring*'s remaking at DreamWorks also plays into its mythos: Verbinski was apparently drawn to the project after having viewed a degraded video copy of Nakata's film. This kind of reverse psychology works well enough for movie taglines (the original "Before you die, you see the ring" was recently amended to the even blunter "First you watch it. Then you die") but it also conceals something else. The choice between curiosity and caution, both of which assume that the image in question is truly terrible, misses the figures buried beneath these rumored effects. One of the namesakes for Sadako's character is Sasaki Sadako, a child victim of the bombing of Hiroshima who, suffering from leukemia, attempted to fold a thousand paper cranes in the hopes of having her wish of survival granted. With only 644 cranes completed, however, she died at the age of twelve. Sasaki's undeserved and untimely death reveals the heart of the *Ring* story, and also the Medusa myth: not a monster hell bent on vengeance, but a woman forced to face her own demise.

Famously, Siegfried Kracauer uses the Medusa myth as a metaphor for film viewing when he likens Perseus's conquest to the viewer's courage in confronting traumatic images on-screen: "Perhaps Perseus' greatest achievement was not to cut off Medusa's head but to overcome his fears and look at its reflection in the shield. And was it not precisely this feat which permitted him to behead the monster?"[1] Kracauer suggests that this monster, not unlike the citation of Hiroshima in *Ringu*, is the catastrophes of World War II; the "Head of Medusa" passage in *Theory of Film: The Redemption of Physical Reality* (1960) coincides with the book's only reference to the Holocaust. This historical grounding lends Kracauer's account of film viewing a moral urgency: we must look at the horrors of the past, and cinema is the vehicle for doing so.

Perseus's shield is apotropaic, a word that comes from the Greek *apotrepein*, "to turn away or from." Like garlic used to ward off a vampire, it is a counter-curse meant to neutralize the anticipated menace. Sometimes the monster itself becomes the apotrope, like a vaccine; in ancient Greece, the image of Medusa's fearsome head, called the gorgoneion, adorned everyday household items like pots, dishes, and clothing in a generically apotropaic way.

The problem with the apotrope, however, is its encouragement to look away. Viewers avert their gaze or guard themselves by looking through a reflected image in a shield or movie screen. While the Medusa myth valorizes the apotrope, as Kracauer does when he congratulates the viewer for braving terrible sights, they conceal the way that certain people, so often women, are routinely overlooked. I propose a different approach.[2] If, instead of raising shields, or heeding the overheated warnings of mansplainers, we lay down our defenses—by daring to look, and steadily, at the supposed threat—we might better perceive these individuals and the tragic circumstances for which they are blamed. More than this, we might understand how the myth of unwatchability itself is what turns our gaze away from the woman, and in doing so, transforms her into a monster.

Notes

1 Siegfried Kracauer, *Theory of Film: The Redemption of Physical Reality* (1960; Princeton, NJ: Princeton University Press, 1997), 305 and 306.
2 Numerous feminist scholars have addressed the gendered politics of horror, including Barbara Creed's study of the trope of the monstrous feminine (Barbara Creed, *The Monstrous-Feminine: Film, Feminism, Psychoanalysis* [London: Routledge, 1993]); Carol Clover's discussion of the gender-bending spectatorial identifications in 1970s slasher films (Carol J. Clover, *Men, Women, and Chain Saws: Gender in the Modern Horror Film* [Princeton, NJ: Princeton University Press, 1993]), and Adriana Cavarero's theorization of the "horrorism" of the weaponized female body (Adriana Cavarero, *Horrorism: Naming Contemporary Violence* [New York: Columbia University Press, 2011]). My approach comes closest to Hélène Cixous's retort to Freud's remarks on the horror of the Medusa's head, which she elaborates in "The Laugh of the Medusa": "You only have to look at the Medusa straight on to see her" (see Hélène Cixous, "The Laugh of the Medusa," trans. Keith Cohen and Paula Cohen, in *The Medusa Reader*, ed. Marjorie Garber and Nancy J. Vickers [London: Routledge, 2003], 133).

9

Pornography and the Question of Pleasure

While humans have long been driven to represent sex acts in every conceivable medium, the term "pornographic" has been applied to representations (of sex or anything else) that are deemed obscene, in bad taste, and otherwise harmful. Many of the laws that have regulated representation as such have focused on keeping pornography at bay. Thus, pornography has a strong and perhaps even constitutive relationship to the unwatchable. Of course, pornography is also eminently watchable: one popular site, PornHub, receives no fewer than 78 billion page views annually, as Shira Tarrant notes in *The Pornography Industry: What Everyone Needs to Know* (2016).

While "pornographic" was originally used to separate "bad" forms of sexual representation from other sorts, today porn generally refers more neutrally to content—explicit representations of sex acts—rather than moral worth. Leaving aside the debate regularly revived by conservatives and a contingent of feminists over whether pornography as such ought to be made and viewed, our contributors consider what makes particular instances of porn unwatchable for them.

Feminist erotic writer and publisher Susie Bright celebrates the lusty appreciation of fat women's bodies and sexual performances in videos like *Let Me Tell Ya 'Bout Fat Chicks* (1987), but finds her pleasure abruptly

cut short by a supposedly comedic interlude depicting aggressive force-feeding. Documentary scholar Bill Nichols finds it hard to watch porn marked by "bad" formal qualities (from poor lighting in amateur videos to scratches on old films) that make it difficult to discern the bodies depicted on-screen. In such cases, Nichols suggests, sexual excitement turns into a moment of confrontation with one's finitude—*la petite mort* is preempted by a more diffuse anxiety around the inevitability of death.

I Am Curious (Butterball)

SUSIE BRIGHT

I once met a new branch of my lover's family, which included six teen-age daughters. All of them were very pretty, and they let me know that each one of them had a boyfriend, "except for Sally," the youngest.

"Well, she's only twelve, why would she have a boyfriend?" I asked.

Her elders rolled their eyes. The problem isn't that Sally is too young for romance—the problem is that Sally is a little butterball. All night long her sisters berated her about second helpings, too many turkey sandwiches, and secret food binges.

It's a familiar scene, the tyranny of slenderness, but I wonder how it manages to hold up against the erotic evidence of real life. I see fat women married to, dating, and cruising men of all types, who clearly rejected the Twiggys.

Never to miss a kernel of sexual truth, the adult video world covered the fat girl beat from its earliest days. One company in the 1980s, Big Top, exclusively featured big women and made the biggest splash. Another company that pioneered gonzo porn, 4-Play, made headlines in the fat fetish genre with a tape called *Let Me Tell Ya 'Bout Fat Chicks* (1987) and a sequel, *Let Me Tell Ya 'Bout Fat Chicks, Too* (1988). I reviewed them for *Penthouse Forum* when they first arrived on the scene.[1]

These old-school porn videos that focus on big women are not remotely feminist tracts on how fat is a women's issue. They assume the viewer is male, that fat shame is how the world works, and fuck you if you can't take a mean joke while you get your rocks off.

These same videos do, however, display an erotic, blatant appreciation of big women that is missing from all the mainstream how-to-love-your-fat-self bibles that cradle the self-help best-seller lists—books that often exhibit the puritan nature of bourgeois feminism.

The actresses in a "fat chicks" tape—like Layla La Schell and Lotta Love, to name two stars—are not just voluptuous and big breasted, like the burlesque star Candy Samples. They are *fleshpots*, with heavy stomachs, huge behinds, and enormous legs. They perform every kind of sex act that skinny girls do; in fact, one can easily make the case they do it better.

The honesty of fat appeal in such videos is a slap in the gaunt cheekbones to every diet-crazy lecture on sex appeal. As soon as a novice viewer gets over the shock of seeing obese women fuck on-screen—fat girls who are supposed to hide themselves in sackcloths until *The Biggest Loser* liberates them—it's apparent that there are a lot of sex-positive pornographic myths about fat ladies, and these videos exploit every one of them.

The most important fat sex myth is that once a fat woman decides to be sexual, she is "insatiable." She can't get enough; her desire to get fucked is borderline masochistic. She's so big, she needs bigger and more dicks than the average-weight woman. She's got a sexual need as big as her belly and it needs to be filled all the time.

Again, in this mythology, because she isn't hung up on vanity like the slim woman, the fat woman can let her body be free—she can let go of her inhibitions and be louder, wetter, and less inhibited than the girl who measures up to the Metropolitan Life weight chart.

Intriguingly, twenty-five years later, when Lena Dunham created her indelible Hannah Horvath character on the television series *Girls* (2012–2017), we were treated to a defiant, plump young heroine who indeed had better, more orgasmic, and kinkier sex than all her more slender costars combined!—and with the hottest guy on the show. I wonder if Dunham ever saw fat pornos from the vaults. Or, if it just occurred to her to exact the most obvious of feminist just desserts!

The surprising bottom line is if you're fat, you're allowed to be unpretentious in bed. One fat video I reviewed for *Forum—Let Me Tell Ya 'Bout Fat Chicks, Too*—has by far the most well-relished cock-sucking scenes you'll see in a straight porn movie. Every one of the actresses treats her lover's penis as if it were delicious candy. Yes, that's it! Fat porn stars treat their lovers like food: they consume them, and demand even more.

If any one of these women were a svelte mainstream star, she'd have to worry about her touch-me-not appearance. A skinny girl, in this notion, is too cool, too beautiful to come. On the other hand, fat women are never portrayed as aloof. There is no ice princess façade.

In every fat fetish video I screened, the men were skinny, handsome, and well-built, and frequently men of color. In *Fat Chicks, Too*, Ray Victory, Johnny Cole, Dennis Johnson, and Randy Cochran were the top stars: bodybuilder types. These actors are all black; the actresses are all white. The interracial coupling is part of the frisson, but I wondered why I never saw white men in these tapes. They're certainly part of the audience. It hints at parallel race porn canards about cuckolding.

Porn never dictates social convention, but it follows it like a bloodhound, showing us the stereotypes that the mainstream culture doesn't have the nerve to talk about. The "legend" on white men is that they are supposed to be the ones who are the most uptight about fatness. Black, Latin, or Asian men are "allowed," representationally, to have a sensuousness and an appreciation of the female form that is bigger, wider, and more earthy than the average WASP.

Meanwhile, the white porn studs, for their own professional motives, once considered it degrading to work in a "fat video." They said that fat couldn't get them hard, even though the thing they were mainly worried about going soft was their compensation check. This stance collapsed along with the big business of theatrical-release sex cinema.

The black men in fat videos don't seem compromised by their large partners. They swagger their way through the sex scenes, larger-than-life pantomime as if they expect every woman to fall down with her legs open when they enter the room. This, too, is part of the race trope. And the girth of these fat girls doesn't make them the exception to the rule.

The motto that rang through my head as I watched fat videos is that you can never be too thin or too rich. A svelte figure apparently goes hand

in hand with luxury, and consequently, the fat tapes seem intentionally cheap. Their production values are as "unwatchable" as their subject, deliberately daring the viewer to sink so low.

Before fat fetish movies, I had never seen a video where the women didn't have their hair done and a professional makeup job. (Remember, this was pre-web-cam-amateur days.) A classic golden age porn set was properly dressed.

But, not in *Fat Chicks, Too*. Only Layla was made up to look at all classy. Some of the other stars are completely *au naturel*. Actress Lotta Love's screen presence in the 1980s was ahead of her time: hair standing straight up and prison tattoos from shoulder to wrist.

Fat appreciation, to this day, is still compromised by the constant snooty reminder that fat-lover sex is tacky, an embarrassment—and that if you had any class you'd be watching "thin" women, who of course would be in well-to-do, well-lit surroundings.

The one truly sickening part of *Fat Chicks, Too* comes during the short breaks between sex scenes. A small skinny white guy (who doesn't perform sexually at all) force-feeds a variety of sloppy foods to his fat costars. He shoves it in their faces, à la James Cagney mushing the grapefruit in Mae Clarke's face in *The Public Enemy* (1931)—only with less friendliness.

It's an outright humiliation, not an erotic spoon-feeding. The media message to the fat woman is, "We know you're a pig; now show the viewers what your piggy self is made of."

For a woman to really participate in sex, this video seems to be saying, there's got to be something wrong with her. Whatever arousal I enjoyed during the steamy fucking that preceded the dinner table scene was forgotten. I turned away, angry and insulted.

The gross food scenes are played vaudeville style, for rancid humor. I remember a male friend of mine telling me once that men and women have different senses of humor, and that's why girls never liked the *Three Stooges*. It also seems like an apology, a cop-out. Is this "humor" the justification for the viewer who is attracted to such a tape? Is the message to tell your friends that it's all a colossal joke, a freak show, not for serious erotic entertainment? What would happen if someone made a fat sex video minus the hair-shirt? Only independent lesbian feminist filmmakers have taken that dare, and few people have seen their work.

Sure, sometimes erotic humiliation is arousing. Sometimes one craves a lover to treat you like "you're only good for one thing," to reduce the bottom-player to nothing but a sex hunger, a desire that only wants to please and has no pride. Classic S/M scenario.

But *Fat Chicks, Too*'s attempt at shaming its stars and its audience doesn't eroticize humiliation. It's a sad defensive posture that says, "We know what turns you on, but we're going to ridicule you for it."

Fat or skinny, we don't need that kind of attitude when we're looking to contemplate and please our sexual desires. Cut the cake.

Note

1 Susie Bright, "I Am Curious: Butterball," *Penthouse Forum*, June 1989.

At the Threshold to the Void

BILL NICHOLS

Axiom #1: No class of films is necessarily unwatchable. Were it so, it would be a class for which there are no viewers.

Axiom #2: Any film may be unwatchable to some but not all. From disgust and revulsion to unavailability the reasons will be manifold.

Documentary films that have a strong indexical quality can often be unwatchable in whole or part due to the graphic, realistic nature of what they depict, from tribal rituals that involve circumcision, bloodletting, or scarification, to instances of extreme violence and destruction within our own culture. This is to be expected.

A film genre that possesses a high indexical quotient and yet is seldom regarded strictly as documentary is the adult movie or pornography. It trades in fantasy. Viewers identify with or desire the subjects who perform sexual acts within the film. Many such works that now populate websites such as xHamster, Xtube, or XNXX are fragmentary rather than complete narratives or comprehensive depictions. Many are but a few minutes long. Most focus on a specific sex act, and are often classified accordingly, rather than by genre conventions or the psychological makeup of the characters. (xHamster, for example, lists eighty categories of work under the letter "A" alone, from "anal beads" to

Still from Naomi Uman's *Removed* (1999), an experimental take on 1970s European pornography.

"Albanian.") Few attend to issues of social context, narrative suspense, or allegorical significance.

Within the array of sex acts covered by the adult movie, some will be uninteresting, boring, undesirable, disgusting, and, indeed, unwatchable to some. But none will be so by dint of what they depict consistently, regardless of how extreme, gender hierarchical, or taboo laden such depictions are.

In this context, it is of little interest to speak of specific subcategories of the adult movie that I find unwatchable myself. There is no category that automatically demands rejection. Laws may mandate rejection, labeling some forms such as child pornography or even the entire spectrum of such work criminal, but even this does not render such work unwatchable for some.

And yet, there is a particular type of adult movie that I do find unwatchable. It does not relate to content, the plane of the signified, but to form, the plane of the signifier. These are adult movies that are extremely difficult to watch in a literal sense. They are works in which the lighting,

cinematography, and mise-en-scène are simply bad from the outset or severely degraded with the passage of time. The former is more often the issue with digital work, especially amateur offerings; the latter more common in the day of celluloid prints several generations removed from the original. In either case, expressions, gestures, and bodily features cannot be easily identified. Actors and actions are hard to distinguish. They fail to reveal what adult films normally show in defiant and elaborate detail. A level of frustration arises that renders the work unwatchable. It does not deliver what the genre conventionally promises.

I experience this form of frustration as different from that of watching bad, degraded versions of films in other genres. Fragments or hints of formal choices remain decipherable and reward the viewer in all but the worst of prints. Even in a very bad print, surviving aspects of the formal organization of the work continue to suggest what noteworthy qualities might distinguish it from other works. A dim recognition of the distinctive use of depth of field or composition, for example, remains available. These formal elements were typically crucial to the status of the film and hints, however limited, of their distinctiveness continue to warrant attention. They were not unwatchable until they became literally devoid of decipherable sound and image.

With adult movies this is seldom the case. Qualities of lighting, composition, and other formal qualities hold little intrinsic value. Their only function is to serve the indexical goal of representing sexual activity in a highly recognizable form. If the activity is not indexically secured, the formal elements have failed in their mission. Bodies and body parts, actions and gestures require indexical representation so that their authenticity, the documentary value, is maximized, no matter how extreme or fantastic they may otherwise be. They are the polar opposite of classic Hollywood's "fade to black" at moments of sexual intimacy.

If the indexical bond is severely compromised by the quality of the representation, the traces of the work's formal elements fail to possess sufficient interest in and of themselves to retain my attention. They do not point, however poorly, to an artistic vision or aesthetic style that deserves attention.

Such degraded versions of adult movies are ugly.

They are unwatchable. For me.

Conceivably, some might find the loss of indexical clarity a lure, mimicking the taboo status of the work with a "fallen" form of representation, but this is decidedly not the case for myself.

Ugly is an apt choice of words for such works. One definition of ugly is "unpleasant or repulsive, especially in appearance." Unwatchable adult movies are exactly that: unpleasant or repulsive in appearance.

But ugly is even more interesting in its etymology. It derives from the Old Norse *uggligr* "to be dreaded," from *ugga* or *uggr* "to dread."

What is to be dreaded from an ugly adult movie? I would answer for myself that beneath the frustration and revulsion is a deep fear for the loss of the body. Like that image of a face that a young boy tries, and fails, to touch at the start of Ingmar Bergman's *Persona*, something I desperately want to identify with, something that should ignite if not fulfill desire, cannot be reached. What is already but an image disintegrates into grain or pixels, signifying nothing. The body—of the actor, of the film—fades, dissolves, and disappears. That grand but primal use of the body for sexual pleasure is proposed but denied.

My fear is that my body will lose its ground of being and become as ephemeral as the degraded image that no longer re-presents it in a recognizable, performative condition. The image is ugly. I dread confronting it in the thick of what ought to foster what Susan Sontag so aptly and richly described as the "pornographic imagination." Instead, I turn away, desire fades, and dread pervades the space between image and reality. I am at the threshold to a void, distinct from the transcendent loss of self and discovery of an ineffable unity that sex in all its myriad forms proposes, and I flee.

10

Archives and the
Disintegrating Image

The texts in this chapter address films that have become unwatchable in the most literal sense of the word: censored, incomplete, or materially corroded. While some works are withheld due to shifts in cultural values or missing information, others are physically impossible to see after their storage medium becomes fragmentary or deteriorated.

Elif Rongen-Kaynakçi, silent film curator at the EYE Filmmuseum, often sees the discovery of obscure, long-forgotten works. She discusses the specific challenges of restoring *Blood Money*, a 1921 British-Dutch detective mystery that resurfaced as a sticky, decayed nitrate print around 2005. Beyond the requisite lab work, *Blood Money* had to be pieced together from a variety of archival materials—intertitles, film reviews, and newspaper ads—for the story to make enough sense to justify a screening for a public audience.

Film historian Jan Olsson relates problems of archival storage to female beauty ideals and discourses of national identity. He focuses on negotiations around Greta Garbo's screen body, from her days as an ugly duckling in Swedish cinema until she became the swan of Hollywood, the quintessence of watchability. Detailing Garbo's transformation from "unseasoned bread bun" to iconic *Temptress*, Olsson draws on extensive archival research to reveal how star images change in their meanings and cultural reception.

Finally, film historian Philipp Stiasny and subtitler Bennet Togler reflect on their work curating vintage sixteen- and thirty-five-millimeter prints of cult and exploitation films at Berlin's Kino Babylon in the mid-2000s. From a German-language version of Roger Corman's *War of the Satellites* (1958) to the Canadian Nazisploitation film *Ilsa, She Wolf of the SS* (1975), these worn-out prints—often with scratches, gaps, and vinegar syndrome—flickered across the screen one last time, marking the twilight of the analog era and the dawn of the digital.

Restoring *Blood Money*

ELIF RONGEN-KAYNAKÇI

Archives are full of films that would be considered "unwatchable." Some are materially incomplete, others are irrelevant to current audience tastes or are deemed too "politically incorrect" (such as films that represent blackface or demeaning ethnic stereotypes). Some films never get watched because programmers find them too obscure for their audiences. Unidentified films rarely play at festivals because they are difficult to find in archival databases and to explain in festival brochures.

In my position as the curator of silent cinema at the EYE Filmmuseum, I constantly witness the discovery of films that nobody is looking for. Many actors and directors who have by now been completely forgotten appear before my eyes, and my task as the curator is not simply to identify and register them into our database and provide safe shelter, but also to find ways to get these films (at least the ones that we actively decide to restore and preserve) to be watched again. My conviction that a film deserves to be seen again is one justification for spending money on a particular restoration. This implies also that part of my job is to come up with ideas to revive interest in these films, while also presenting them and making them available in watchable versions.

In the early 1990s, our institute got awarded a big budget and started preserving many films. Despite numerous presentations at home and

Frame enlargement from *Blood Money*. Courtesy of the EYE Filmmuseum.

abroad, some lesser known films ended up never being used. Many others that were incomplete or unidentified were considered unwatchable and had to be put on hold. The constant pressure to select and prioritize what can and should be preserved prompted the curators of EYE (back then called Nederlands Filmmuseum) to assert more radical policies toward the definition of what is watchable and what not. Thus, Peter Delpeut and Erik de Kuyper declared their intent to preserve even the shortest unidentified fragments, to prevent them from wasting away in a corner. In multiple essays, they maintained that a film didn't have to be complete or well-known (or even identified) in order to be relevant. Their criterion was "cinematographic appreciation," and this could mean several things ranging from aesthetically pleasing to historically revealing or astonishing. These materials have become the Bits & Pieces Collection, which is still growing, being handed over from generation to generation of EYE curators.[1] Based on similar principles, EYE has taken the position that not only well-known films but also obscure films deserve our attention and resources. While the EYE collection contains fewer

major titles, we have discovered in our archives incredible amounts of astonishing films that have been wrongly excluded from the official film history books. Over the years this radical revisionist attitude has evolved to become an essential part of EYE's curatorial policy.

The gender and social politics of our preservation policy bear further elaboration. Focusing on the ignored portions of film history led us to reconsider a number of topics, such as the role of women that seems to have been largely neglected within film history. To draw attention to this omission and highlight some of the very successful careers of women, EYE went ahead to preserve and make available unique prints of films even if they have no endings, such as Rosa Porten's two films *Die Landpommeranze* (1917) and *Die Barfusstänzerin* (1918), and *Tragico convegno* (1915) starring Maria Jacobini. Also, we preserved and screened films of which only the last minutes remain, such as *The Courageous Coward* (1919) with Sessue Hayakawa and Tsuru Aoki, and even other unique diva films that are so fragmentary that there is practically no narrative to hold on to, including, among others, Lyda Borelli in *Una notte a Calcutta* (1918), Asta Nielsen in *Die Filmprimadonna* (1913), and Francesca Bertini in *Fedora* (1916).

But some archival prints that get discovered after many decades present even further hidden levels of unwatchability, beyond the question of their mere completeness.

This is the case with *Blood Money/Bloedgeld* by F. Goodwins, a British-Dutch coproduction by Granger-Binger Film in 1921 that had been lost for decades. Around 2005, a print started to surface: several reels were found over ten years, scattered around the by now notorious Van Liemt Collection.[2] The nitrate appeared to be so severely decayed and sticky that it was impossible even to rewind the reel on a flatbed table. This meant that the reels first got sent to the lab, unwatched. When the reels came back (miraculously copied onto polyester negative stock), we could finally watch the film to see how much of it had survived and what could still be seen. Despite the image in some scenes being almost completely erased due to nitrate decay, the film appeared nearly complete.

However, then a new and unexpected level of unwatchability revealed itself. Up until then, the only images from the film were the two- to three-minute fragments (or outtakes) that were found and preserved by

EYE (arrived in 1984, duplicated in 1992). The script of the film is lost, and the very few reviews provided enough detail of the story. However, even having access to almost all the scenes of the film, the story still did not make a lot of sense. The film was promoted as a "Harper's Mystery," implying a detective story, but it seemed to be completely unhinged, as the detective character appeared only toward the end! (The plot revolves around a marriage of convenience that goes wrong, leading to a messy love triangle and fight over the inheritance between a casino owner, his secret lover, and the wealthy tycoon who impregnates her.)

On closer inspection—and due to complete lack of other historical sources, close inspection was the only available method—the print appeared to offer some anomalies. For example, it contained a couple of the original English intertitles, such as the one introducing the detective (and the name of the actor playing him) and several others, like the one announcing "Jealousy!" This one-word English title card was completely in contradiction with the other lengthy Dutch titles (only twenty for this feature length film!) that came along very sporadically (sometimes at a rate of once every five to six minutes) and containing what we would today call "spoilers." Also, some scenes showed sudden, inexplicable changes in the actors' gestures, obviously reacting to dramatically powerful dialogue that was completely missing, since the present intertitles employed an almost detached narrative voice, merely summarizing the action. This style caused some of the most dramatic scenes in which characters are confronting each other to become lengthy and almost nonsensical; we watch them having an argument, but we have no idea what they are saying or how and when they are supposed to react to each other.

More research made us even more suspicious of the print as it was found, indicating that this could not have been the version that came out in 1921. The few newspaper ads refer to the length of the film as being five reels, although some others mention a prologue and four reels. The found print is in four cans, and the reel endings and beginnings seem to be in unusual places like the middle of the reel. Another suspicious element is the distribution company "Filmprojectie Blina, Amsterdam-O." This name is on the Dutch title cards. However, in our database of Dutch cinema, we have no other entries about this company! Could this be an unauthorized version by an unofficial firm that was made sometime

after the first release and reissued outside the control of Granger-Binger, perhaps after their bankruptcy in 1923?

Once we decided to preserve this film (which we realized due to the level of active nitrate decay could not wait for another decade to allow more research), we wanted to aim for a "temporary" version that would be "watchable" by today's standards. Obviously from a preservation point of view it is important to duplicate the source material onto new stock (to arrest the decay, as it were), which stored under the right conditions is expected to last for centuries. However, this duplicated version, under the circumstances, would not result in a film that anybody would want to watch. When a "lost film" is found, it is essential for the archive not only to safeguard it, but also to make it available to those willing to watch it. The preserved version of the film must deliver the story clearly and engagingly if the audience is asked to stick with it for the whole seventy minutes. This means that the film must be understandable and enjoyable, with solid pacing, dramatic suspense, comprehensible narrative, and so forth. In the case of *Blood Money*, this meant going beyond the usual work of copying the film onto polyester stock, or digitizing, stabilizing, and fixing the projection speed, and so on.

Since there are no standards to achieve this new version, the solutions we came up with are highly speculative. Nevertheless, we adhered to some self-imposed rules, based on what we can observe within the film material. We tried to stay faithful to the plot information that was available, avoiding speculative words (though it is always tempting to take creative liberties). Sometimes we inserted titles even in the dialogue form, but always based on the existing title texts and closely following the cuts within the shots. We also completely removed some of the information that was given in the titles, since it was sometimes redundant and other times revealed too much, far ahead of the action that could be seen and easily understood.[3] We used all the material found in our collection in the final edit. The fragments we had for decades do not overlap with the recently found print but complement it, thus confirming our suspicions that these were literally the cutouts from perhaps the very same nitrate at the time of the reissue.

The question remains whether what we deem watchable for today's audiences in any way does justice to how the film was shown and received at the time of its release, something that the film restoration generally

aims to achieve. What if the film was flawed from the start, and perhaps various attempts were made back then already to reedit it in different orders, or with different titles to improve its narration? Given the scarcity of published information, it doesn't seem like this was a film that was watched and reviewed very widely. Perhaps this was due to its original weaknesses? Regardless of the print's historicity, today there might be all sorts of reasons why we would still want to watch this film (anything ranging from the Dutch locations doubling for England to the performances of the forgotten international stars like Adelqui Migliar). I guess it is safe to say that it is always better to present something watchable to an audience so they can engage with it, rather than keeping unwatchable versions on the shelves that no one cares about.

Notes

1 As of today, the Bits & Pieces Collection contains 647 items. To read more about the Bits & Pieces, please see Peter Delpeut, "Bits & Pieces—De Grenzen Van Het Filmarchief." *Versus* 2 (1990): 75–84; Christian Olesen, "Found Footage Photogénie: An Interview with Elif Rongen-Kaynakçi and Mark-Paul Meyer," *Necsus: European Journal of Media Studies* 2, no. 2 (2013): 555–562.

2 The Van Liemt Collection contains roughly three thousand cans of film, of which two thousand are nitrate prints. As the original collector had not left an inventory behind and the cans were all unlabeled, the sorting out and registration of this collection has become a process that has so far taken more than fifteen years and is still ongoing. Despite some early spectacular discoveries (such as a complete print of the much sought-after *Beyond the Rocks*, restored and repremiered in 2005), the collection still harbors many unexpected unique prints that are slowly resurfacing.

3 For example, the "original" title text *"Right after his brother's suicide, Harper is kidnapped. Sarne tells Bruce that his father has committed suicide"* has become *"Your father has committed suicide!."* The first part of the sentence is totally omitted since we can see Harper being kidnapped in the film. Similarly the "original" title *"Sarne reminds Margerit of her promise to him, but he realizes that he has been cheated when he overhears Margerit referring to him as 'a fool' during a conversation with Victor. He threatens to betray their secret"* is now split into two separate titles and changed into *"Overhearing Margerit calling him 'a fool' he realizes that he has been deceived"* and *"You have betrayed me! I shall go at once to Detective Bell and tell him everything!"*

Turning Garbo Watchable

From Swedish Bread Bun to Hollywood Goddess

JAN OLSSON

In 1923, comments from a visiting French actor provoked an intense debate over the unwatchability—or ugliness—of Swedish film actresses. In attempts to combat such offensive notions, Greta Garbo, then acting in the not-yet released *Gösta Berlings saga* (1924), was part of a mash-up of putative local film beauties lined up in magazine articles and in a short, now lost, film.[1] I'll follow the negotiations swirling around Garbo's body from her duckling days in Swedish cinema up until she was firmly established as the epitome of screen watchability, a veritable swan, after the makeover work at MGM. Her absolute pulchritude was confirmed, as it were, by a Garbo character admiring herself in a mirror after a passing moment of beauty despair.

Garbo drew praise for her role in *Gösta Berlings saga*. However, a critic, in a sport publication, *Idrottsbladet*, vehemently disagreed, and described her as decidedly unwatchable, in line with the 1923 debate: She is a "plumpish, unseasoned bread bun that neither excites nor nourishes—entirely colorless."[2] Louis B. Mayer saw her differently, as Hollywood star material, and contracted Garbo for MGM after watching the film in Berlin, where she was busy working in *Die freudlose Gasse* (1925).

The plumpish, unseasoned Greta Gustafsson before she became Garbo. Courtesy of the Swedish Film Institute.

Notions concerning Garbo's screen body in its different guises evidence a shift in Swedish culture at large toward American ideals of beauty and otherwise. Female pulchritude was key when Swedish cinema abandoned the peasant-film tradition of the so-called golden age, allegedly ending with Mauritz Stiller's *Gösta Berlings saga*, for a more

cosmopolitan line of production. New faces and bodies on the screen aligned with Hollywood corporeality came to the fore, embodied, for example, by Margit Manstad, emerging as a star when Garbo left. For many, the new deal was a sellout, ushering in a bona fide film decadence.

Simultaneously fascinating and deeply problematic, incompatible signifiers were affixed to Garbo's film body in the transition from Sweden via Germany to Hollywood and subsequent status as divine woman or beauty icon.[3] Greta Gustafsson became a name, Garbo, via Stiller's film, even if she was cast under her erstwhile name a year before for *Luffar-Petter* (1922), Eric A. Petschler's film, which billed Greta Gustafsson as one of three bathing beauties.[4] Critics overall dismissed *Luffar-Petter*. The sport tabloid *Swing*, an avid critic of domestic cinema, unfavorably compared the Swedish bathing trio with Mack Sennett's beauties, claiming that the latter's were augmented by costume details with a racy effect: "How exquisite aren't these high-shafted bathing shoes with their laces and with silk stockings rolled down on the calf. . . . The Swedish director doesn't achieve this effect of refined piquancy."[5] This lack of sophistication was indicative of a national fault, dilettantism, also affecting cinema, *Swing* argued. The *Swing* critic didn't voice misgivings concerning the girls, only the director's backwardness. In fact, *Swing* later published a photograph of Gustafsson captioned "Possibly a Swedish movie star. Reason—Anglo-Saxon Appearance."[6] Further underwriting Hollywood's attractiveness, the paper claims that screen-star bodies more or less had to display Anglo-Saxon traits.

In 1945, a fragment from *Luffar-Petter* was donated by director Petschler's widow as one of the first items at the Film Historical Collections, the precursor to the film archive at the Swedish Film Institute (SFI). This collection initiative found its home at the Swedish National Museum of Science and Technology in 1938 under the curatorship of Einar Lauritzen. His tenure lasted up until 1963, when SFI took over the collections.

MoMA had successfully acquired a handful of Swedish silent titles in the 1930s, and on several occasions when Garbo's stardom soared, tried to acquire the fragment from *Luffar-Petter*. Fearing that the circulation of this first Swedish incarnation of the star, prior to the MGM

makeover, could "much too easily be used to hold Garbo up to ridicule," the Swedish archive didn't want to share the fragment and turned down Richard Griffith's request.

The Stockholm archive was committed to showcasing Swedish cinema's so-called golden era, culminating with *Gösta Berlings saga*. Having Garbo's career virtually starting with the end of this epoch played into Einar Lauritzen's response to Richard Griffith's request for *Luffar-Petter*: "I have to admit quite frankly that I would find it a great disservice to the Swedish cinema in general as well as Garbo in particular if this picture were to circulate among the American film societies or were shown at your museum."[7] The Swedish archive's "ban" on *Luffar-Petter* seemingly sought to contain evidence of Garbo's bodily makeover and the possible circulation of negative sentiments around her erstwhile film body, besides keeping a mediocre Swedish film from this celebrated production phase under wraps. The archive's practice ties in with the 1923 debate concerning unwatchable Swedish screen bodies.

Ironically, images of Gustafsson as bathing beauty had already circulated in America: *New York World-Telegram* held a composite image captioned "Hollywood Transformation"; *Boston Daily Globe* in 1934 published another still from *Luffar-Petter*; the Hearst press in 1935 had access to the same illustration.[8]

Garbo's beauty was underscored already on the gangplank when arriving in New York City. A first photograph was widely published and captioned "Comely Visitor."[9] During her stopover, photographer Arnold Genthe created a Garbo different from her role in *Gösta Berlings saga*, but somewhat in tune with the close-ups of her in *Die freudlose Gasse*. Via Genthe, she ended up on the cover of *Vanity Fair*, captioned as a star from the North. This photo series prompted MGM to briskly summon her to Hollywood.[10]

Michaela Krützen still considers Genthe's version as decidedly non-Garbo prior to the MGM makeover. The studio carved out—by scalpel, she claims—a new Garbo parallel to orthodontic work, stern dieting, and exercising.[11] The change away from her Swedish screen body was displayed to great effect already in Garbo's first MGM title, *Torrent* (1926), where she was cast as Latin, but even more clearly in her second feature, *The Temptress* (1926). As a new, unknown star, Garbo was of course introduced as Swedish, but also as a big name in Germany. A

repeated reference was "a Swedish Norma Shearer," occurring thrice in the columns of the *LA Times* in 1925—Shearer was born in Canada. Garbo's beauty and acting skills took center stage in the reception of *Torrent*. *Variety* headlined her a sensation; Mordaunt Hall in the *New York Times* further elaborated, "Greta Garbo, a Swedish actress, who is fairly well known in Germany, makes her screen bow to American audiences. As a result of her ability, her undeniable prepossessing appearances and her expensive taste in fur coats, she steals most of the thunder in this vehicle."[12]

In 1927, hoping to capitalize on Garbo's fame after her three successes in 1926—*Flesh and the Devil* the last one—Pabst's film opened in the United States in a heavily edited version. The release afforded critics opportunities to measure Garbo then and now, and (unfavorably) gauge European cinema's prowess in relation to Hollywood's. In this context, Pabst's film was dismissed as utterly unwatchable, while Garbo was described as a rough gem before the MGM machinery transformed her.

The *New York Times*' critic was one of the more tempered: "There are moments when this picture doesn't seem so bad, but then these are killed by some preposterous exhibitions of agony. Greta Garbo, who has since become a finished screen actress, at the time this picture was produced did not know the elementary rudiments of make-up. She has spoiled her own attractive features through her efforts to add to the languidness of her eyes."[13] Harriet Underhill bluntly offered a collective opinion regarding the film: "With one accord every one rushed in to see it and then with one accord the critics pronounced it terrible. But, hoping to find some good in it, we stepped in . . . to look it over. Now the verdict is unanimous—it is terrible!"[14]

A handful of years later, Mae Tinée ran into the film in Chicago and attributed it to Stiller. "I could only compare it to a Dostoyefsky [sic] novel adapted for photoplay purposes by that ludicrous man, Mack Sennett." Regarding Garbo: "Despite an ill-advised manner of applying her cosmetics and a slightly cow effect when she rolled her eyes, I could see where, even at that early day, Miss Garbo might well have impressed photoplay producers."[15] Indeed, and Louis B. Mayer and MGM turned her into the unsurpassed benchmark for screen stardom.

A condensed moment in *The Temptress* metonymically highlights Garbo's corporeal flux and travail—from Swedish plumpness to Hollywood

glory. Garbo's Latin character catches her own image in a distorting mirror and is taken aback by the unwatchable grotesque of her facial features, only to immediately turn to a hand mirror that reassuringly confirms her sublime beauty and flawless features. Henceforth, critics and audience alike have been riveted to Garbo's unmatched watchability.

Notes

1 For a full account of the debate, see Jan Olsson, "National Soul/Cosmopolitan Skin: Swedish Cinema at a Crossroads," in *Silent Cinema and the Politics of Space*, ed. Jennifer M. Bean, Anupama Kapse, and Laura Horak (Bloomington: Indiana University Press, 2014), 245–269.

2 Torsten Tegnér, "På språng," *Idrottsbladet*, March 12, 1924, 8. "En halvmullig och okryddad brödbulle som varken kittlar eller mättar—rena vita plåstret."

3 For a negotiation of the goddess discourse, see Ruth Suckow, "Hollywood Gods and Goddesses," *Harper's Monthly Magazine* 173 (June 1, 1936): 189–200.

4 The film was rereleased in 1926, and again in a shorter version in 1929, retitled *Borgmästarns flickor* (The Mayor's Girls). This release's poster featured a drawing of Garbo in swimsuit and a text informing that this was her first film role.

5 Jacobus, "Det svenska nationalfelet återspeglas i svensk film" [The Swedish national fault is mirrored in Swedish cinema], *Swing*, no. 36 (September 1922): 7.

6 Candido, "Svenska filmdivor," *Swing*, no. 52 (December 1922): 14.

7 Letter from Einar Lauritzen to Richard Griffith, May 4, 1956, Svenska Filminstitutet, Filmhistoriska Samlingarnas arkiv, Uncataloged Correspondence.

8 The Library of Congress's Prints & Photographs Division holds a photograph dated July 20, 1931, in the New York World-Telegram and the Sun Newspaper Photograph Collection, labeled "Hollywood Transformation." It features Garbo as a bathing beauty from *Luffar-Petter* next to a production still from *Grand Hotel* (MGM, 1932). It's unclear if the composite was published. A slightly different bathing still was however published in 1934: "Garbo as You Never Saw Her," *Boston Daily Globe*, September 23, 1934, B6. The still, captioned "Greta Was Bathing Beauty" and dated December 13, 1935, is available in Hearst Corporation Los Angeles Examiner Photographs, Negatives, and Clippings—Portrait Files (G-M), Special Collection, University of Southern California. It's unclear if it was published in a Hearst paper at this time.

9 First published in the *New York Herald Tribune*, July 7, 1925, 9.

10 "A New Star of the North," *Vanity Fair* 25, no. 3 (November 1, 1925): 80.

11 Michaela Krützen, *The Most Beautiful Woman on the Screen: The Fabrication of the Star Greta Garbo* (New York: Peter Lang, 1992), 66–85. Stiller had already subjected her to dieting for *Gösta Berlings saga*.

12 Mordaunt Hall, "The Screen: A New Swedish Actress," *New York Times*, February 22, 1926, 14.
13 "A German Film," *New York Times*, July 6, 1927, 23.
14 Harriet Underhill, "A Star's Equipment Is Just a Bathing Suit and a Book," *New York Herald Tribune*, July 10, 1927, D18.
15 Mae Tinée, "Critic Locates an Old Garbo Movie in City," *Chicago Daily Tribune*, July 11, 1933, 15.

Twilight of the Dead

PHILIPP STIASNY AND BENNET TOGLER

For all the promise of its title, *Dawn of the Dead* (1978) never saw the light of day. At least that has been the case in Germany for several decades, ever since George A. Romero's zombies were accused of glorifying violence and subsequently banned from public exhibition. Only severely cut versions and illegal bootlegs have circulated.

But censorship is just one reason why films—and here we are mainly talking about vintage thirty-five- and sixteen-millimeter prints—become unwatchable in the most literal sense of the term. They may also be unwatchable because they are inaccessible, lost, or damaged; because the projection equipment has been replaced; because there is no commercial or cultural impulse to digitize and preserve them; or because their subject matter is (or has been deemed) difficult or socially unacceptable, as with racist, misogynist, pornographic, or otherwise obscene content. Not least, films become unwatchable—and unwatched—simply because nobody knows about them.

Usually, public archives are the place to look for films and prints that are out of distribution and thus threatened with unwatchability. But don't bet too high on finding an old, German-dubbed print of *Dawn of the Dead* in a publicly funded German film archive. This also goes for most other foreign films that ran in West German cinemas in the

Poster for *Ilsa, She Wolf of the SS*.

1950s, 1960s, and 1970s, shaping generations of movie fans. For less "respectable" popular genres such as horror, fantasy, martial arts, action, exploitation, and skin flicks, you are more likely to find prints in private collections and smaller archives run by die-hard enthusiasts. It is here that we enter the realm of a long-gone cinema culture of which so few traces are found in the more official histories of film and moviegoing—and not only in Germany. Here we can be sucked into the realm of Brazilian melodramas and Belgian vampire films, Italian *gialli* and Japanese *pinku eiga*, Mexican El Santo sequels and French police thrillers, and get spit out onto the shores of Doris Wishman, Jesús Franco, and Walerian Borowczyk.

When we started ransacking archives and private collections in order to program genre films in the mid-2000s, it went without question that we were after the real McCoy: historical prints that were about to become "unwatchable" for one reason or another. Obviously the era of analogue filmmaking was coming to an end as producers, distributors, and cinema operators were looking forward to the new age of digital projection and cost reduction. The stuffy and hellishly hot projection booth would finally be replaced by an almighty computer. And visitors would worship lifeless, sterile digital images that have no future and no past—or so we feared.

It wasn't solely that we wanted to allow for a *dawn* of the dead. At the same time, we wanted the old and forgotten films to receive a decent *twilight* and farewell. Before analogue projection became the exclusive business of cinematheques, framed by "curatorial" fuss and pretension, we convinced the head of Kino Babylon, a cinema palace on Berlin's Rosa-Luxemburg-Platz designed by architect Hans Poelzig in the late 1920s, to let us run late-night screenings there every week on a shoestring budget (together with a preprogram of short educational, documentary, and animation films). We were free to do whatever was possible. And here we really began to appreciate the work—oh no, the art—of the projectionist (healer and king of the apparatus). No sweet without sweat. We came to love the stunning beauty of an immaculate thirty-five-millimeter print—but also the erratic inscriptions of scratches, the hallucinatory effect of fading colors and blurring, the whispers of an ancient audio track, the hypnotic movement of a tiny piece of dust sailing across the screen, "as idle as a painted ship / upon a painted ocean."[1]

Sentiments aside, love is a battlefield, and that's a fact. Many of the prints that we screened were in poor shape: dried out, cockled, shrunken, sometimes afflicted with vinegar syndrome. You can try to repair the print to make it run through the projector. But you cannot really preserve it unless you lock it away. In other words, every week we took part in the destruction of what we enjoyed. Each time we screened a film print, we proceeded to render it ever more unwatchable.

One time we were offered a unique thirty-five-millimeter German-language print of Roger Corman's *War of the Satellites* (1958), probably dating back to its first German run in 1963. (Curiously enough, the German title translates as "Planet of Dead Souls.") With this, we encountered a particularly stubborn obstruction on the part of the material. All went well up until the very end, when the couple should be saved and the space mission should succeed. Yet this happy ending proved too much for the old print, which had been screened a hundred times or more. It rebelled and denied us from ever seeing it: the last two or three minutes were devastated in a grim struggle between a relatively modern projector and an old and weary science fiction film. For us, the story did not end but merely came to a stop. The collector who owned the print simply shrugged: his print had given one great and memorable final performance. What more can a work of art hope for in the age of mechanical reproduction?

Much-loved films can become unwatchable over time, and unwatchable films may become watchable. We witnessed this process, for instance, with *Ilsa, She Wolf of the SS* (1975), a somewhat notorious Canadian Nazisploitation film never released in Germany. We found an English-language thirty-five-millimeter print and asked a friend to introduce the film to our audience. In her address, she stated that we were about to watch an utterly sick piece of film. Is there any good reason to watch such a film? Yes, she said. By running this print of *Ilsa* through the projector, we would actively contribute to its further physical destruction and eventually make it unwatchable. And what a rotten print it was! There were so many scratches, jumps, gaps, and tears that it felt like gazing at, not through, a curtain behind which—far away—the actual story was taking place. You started to wonder how often this print had already been shown and how many other people had sat through it, delighted or annoyed. There wasn't the ghost of a chance to fully

immerse ourselves in the story. On the contrary, watching this worn-out print and noticing all the dropouts, streaks, and other signs of usage made it rather impossible not to register both its historicity and vanity. Impermanence prevailed over impertinence.

In doing so, did we partake in the further destruction of a vile film and help to make it unwatchable, as our guest speaker had claimed? Is *Ilsa* a film that had better remain locked away? Or has despicable Ilsa, in her altered form, changed for the better? Has she by way of deficiency become multilayered and thus watchable in her own right? Much later we got our hands on a "restored" DVD edition of the film, flawless and clean. What a disappointment! It had nothing to do with the film we had seen.

Bringing unwatchable films back to the screen has been adventurous and rewarding. While we did not always support our audiences' reactions, like laughing at the wrong moments, we also learned how ignorant some general assumptions about public reception can be. We came to respect the knowledge and sensitivity of fans, collectors, and regular patrons who are barely present and rarely heard. We also learned that the objects of our desire, the vintage prints, are not fixed but are rather fluid and changing. The experiences and memories that are tied to watching a historic print are unique and have been enriching for us to consider. Destruction and decomposition are the destiny of each and everything. Why should it be any different with the films we love?

Are we analogue fatalists? Necromancers even? We probably are. The end is near and the digital deluge will infest the planet with its ever-pristine and never-aging images. So while the stocks last, let's get back to business and enjoy rendering yet another thirty-five-millimeter print unwatchable. They'll all go down the drain sooner or later, with or without us.

Note

Many thanks to Jürgen Dittrich, Zoe Goldstein, Michael Schneider, Sonja M. Schultz, Wolfi Bihlmeir at Munich's glorious Werkstattkino, and—last but not least—the Unknown Projectionist.

1 Samuel Taylor Coleridge, "The Rime of the Ancient Mariner," in *Selected Poetry*, ed. William Empson and David Pirie (New York: Routledge, 2002), 124.

Part III

Spectators and Objects

11

Passionate Aversions

Why do we love to hate particular films? This chapter addresses the curious mode of aesthetic experience and judgment that has become known as "hate-watching." Humorous and often polemical in tone, the four essays enact a critical discourse of mockery and antipathy, whether based in compulsive consumption or willful refusal of the works in question.

For film critic Jonathan Rosenbaum, the decision not to watch Lars von Trier's *Antichrist* (2009) is deeply principled. Rosenbaum finds in von Trier's ahistorical, cynical nihilism—exemplified by his sadistic depictions of an evil and soulless universe—an alibi or cause for political inaction. Explaining how he arrived at this position of extreme contempt, Rosenbaum traces von Trier's career from *Zentropa* (1992) up to *Nymphomaniac* (2014).

Like Rosenbaum, media theorist Nathan Lee focuses on the theme of nihilism, sourcing apparent meaninglessness not in arthouse provocation but in the *Transformers* film franchise. Lambasting the series for its vacuous characters, overpacked effects sequences, and explicit misogyny, Lee nonetheless asks, "Why do such mindless spectacles keep forcing me to think?" As Lee suggests, the *Transformers* films may not be addressed to a human gaze at all.

Film scholar Julian Hanich becomes irritated not by sadistic cruelty or sterile idiocy, but by relentless cuteness. He introduces the category

252 ◆ PASSIONATE AVERSIONS

of "precious cinema," or "films [that] harass me with their makers' senses of their own creativity, originality, and imaginativeness." From *Amélie* (2001) to *Moonrise Kingdom* (2012), these films leave nothing to the viewer's cognitive faculties, which are steamrolled by the directors' quirky, self-satisfied creations.

Finally, cultural historian Jeffrey Sconce excoriates the long-standing genre of the Hollywood biopic, with its insufferably naïve and self-serious pretense to verisimilitude. Not only does the actor's performance of a historical personage signify "a body too much," in Jean-Louis Comolli's well-known formulation; the genre also comes up against a fundamental tension in cinema between fantasy and reality, maintaining an untenable relationship to both terms.

"Sad!"

Why I Won't Watch Antichrist

JONATHAN ROSENBAUM

My refusal to watch Lars von Trier's *Antichrist* (2009), even after Criterion generously sent me a review copy, isn't a position I arrived at suddenly or lightly. Even though the film premiered the year after I retired as a weekly reviewer, thus obviating any possible professional obligation, my decision wasn't only based on the near certainty that I would hate it—which, after all, hadn't prevented me from twitching all the way through *The Passion of the Christ* five years earlier. Nor was it founded on any conviction that von Trier is devoid of talent, a conviction I don't have.

Trying retroactively to account for my steadfast refusal to see the film, arrived at eight years ago, I can only take the blatantly ahistorical, illogical, and quintessentially Trieresque tack of citing a remark of his quoted in the *Guardian* only six months ago. It concerns his latest project (I won't assist his ad campaign by mentioning the title)—a feature about a serial killer (natch) that takes the serial killer's viewpoint (ditto). It's a film, he says, that "*celebrates the idea that life is evil and soulless, which is sadly proven by the recent rise of the* Homo trumpus— *the rat king.*"[1] That's von Trier in a nutshell: a depressive who hopes to tarnish even our shared hatred of Donald Trump by "celebrating" the

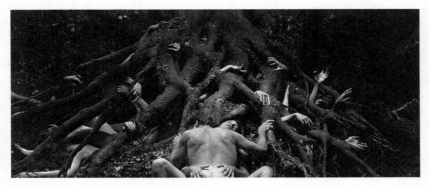

Still from Lars von Trier's *Antichrist*.

philosophical postulate that we had no role in creating or empowering him and have no political way of getting rid of him. We're automatically let off the hook and then invited to remain (and be entertained) as passive spectators. Trump is simply and ineluctably a fact of nature, the clenching proof that the cosmos is innately soulless and evil regardless of what we might say or do about it or about him. As one of the few Jewish defenders of William Styron's *Sophie's Choice* for its powerful grasp of bipolar dynamics, which I've experienced in my own family, I'm not knocking von Trier for being a manic depressive, only for what he does with it.

Of course his defenders might counter that his use of the word "celebrates" is a form of irony—caustic wit. If that's the case, forgive me for not laughing or sharing in the benefits of his amused cynicism. It's a perfect case of the Trump calling the kettle black, and the cinema of Lars von Trier is chock-full of such glibness. Even the meaning of "sad" (as in "sadly proven by," above) in his fractured lexicon—suggesting in some ways that what's sad is also worthy of celebration, or at the very least a very spirited public denunciation that functions in part as promo—sounds pretty close to certain tweets of the rat king. And there's no such thing as bad publicity.

I haven't always had these reflexes in relation to von Trier. In 1992, I labeled his *Zentropa* "the most exciting failure to come along in ages," even after deciding that its formidable technique overwhelmed its theme and characters. And being intoxicated by its own sense of hyper-

bole, I concluded that "as history *Zentropa* may be bunk, but as a comic nightmare about the present it gnaws at the imagination and ravishes the senses; it might even be said to live."

My subsequent encounters with *Medea* (1988) and *Breaking the Waves* (1996) were comparably ambivalent, even if my opinion of the film-maker himself steadily plummeted as I saw the postmodernist hash he was making out of my favorite filmmaker (and his alleged role model) Carl Dreyer in both. *Medea* claims to be based on Dreyer and Preben Thomsen's unrealized screenplay adapting the Euripides tragedy, but reading the Dreyer text is all that's needed to expose von Trier as something of a con artist.

His opening title reads, "This is not an attempt to make another 'Dreyer film,' but rather a personal interpretation which treats the material with due respect and pays homage to a great master." Due respect? The Dreyer-Thomsen script dictates that the film open in "a circular arena, fenced in by a low stone wall and surrounded by green meadows," backed by "a slope toward the sea that is not as yet visible"; it's to be entered by a chorus "dancing with rhythmical, stylized movements to the accompaniment of recorders, string instruments, and kettledrums." The leader is a veiled woman in black who exposes a face "which is luminous white, as white as chalk" before she delivers the opening speech, punctuated by the chorus's lamentation. Von Trier "adapts" this by eliminating the arena, the stone wall, the green meadows, the musical instruments, and the entire chorus, lamentation included, and reducing the opening lines of the soliloquy—all that he bothers to include—to another printed title. Skipping a couple of other scenes, he then provides us with an opening of his own invention. No less crucially, Dreyer's radical feminism and his concern for women's suffering get trampled under by all the distractions of von Trier's three-ring circus, finally settling on Jason's death throes in the final shot rather than on Medea herself.

For *Breaking the Waves*, he asked Emily Watson to study both Renée Falconetti in *La Passion de Jeanne d'Arc* and Giulietta Masina in Fellini's *La strada*, ignoring the grotesque incompatibility between these two styles of intense female suffering, thereby suggesting that von Trier's positioning himself as "the new Dreyer" was rather like Tarantino positioning himself as "the new Godard."

But truthfully, the two moments that clinched my contempt for him as a thinker and an artist (as well as my admiration for his uncommon skill as a self-promoter) came in 1995 and in 2000, with the launching of Dogme 95 at the Cannes Film Festival and then with the release of *Dancer in the Dark* five years later.

Seeing the immediate effect of Dogme 95 as a sales pitch and buzz word on a prominent *Variety* reviewer, who suddenly became interested in Danish cinema for the first (and possibly last) time, I quickly realized how well von Trier had absorbed the lessons of the New German Cinema, in which the cult of personality and the thrill of sadomasochism could almost take the place of (and thus eliminate the need for) aesthetics and politics, even while it pretended to brandish both of the latter proudly on its sleeve. (Please excuse the exaggeration here; von Trier's brand of jive is contagious.) I realize that there are still some cinephiles who regard Dogme 95 as an honest-to-Pete aesthetic and philosophical manifesto and not as a marketing strategy, ignoring that as far back as 2000, official Dogme Certificates were being sold in Denmark for roughly a thousand dollars apiece—presumably as a counterpart to another source of von Trier's income, his ongoing career as a producer of porn movies (which has also been widely ignored—or else defended as politically correct because they're largely targeted at female viewers). If only these defenders had anything of interest to say about this supposedly groundbreaking vow of technical chastity, quickly abandoned by von Trier himself, I might have taken it more seriously. But technical chastity isn't his forte.

As for *Dancer in the Dark*, apart from acknowledging that a few non-Americans have mounted intriguing arguments about the value of von Trier's ersatz version of the United States as a sort of global preserve, I'm confronted, as a lover of musicals, by the mediocrity of the songs and dancing, and as a refugee from Alabama, by the fact that when Catherine Deneuve asked to be cast in the film, she was rewarded with a part originally conceived for a poor black woman. Meanwhile, von Trier's talent for both overkill and hype yielded the alleged use of a hundred stationary digital cameras for one lousy musical number and no fewer than thirty-four wounds inflicted with a gun and a money box by the blind heroine (Björk) on her cop landlord, although I can't imagine

that thirty-four digital cameras and a hundred flesh wounds would have produced significantly different results.

Antichrist isn't the only von Trier film I've passed up; I've also stayed away from *Manderlay* (2005) and the second part of *Nymphomaniac* (2014), although this was mainly out of fear of further boredom rather than the fear of further torture that the plot summaries of *Antichrist* promised. On the other hand, I was mainly bored by *The Idiots* (1998), *Dogville* (2003), and *Melancholia* (2011), apart from a few pretty shots in the latter. As for *Dogville*, those who have called this blend of Brecht and *Our Town* anti-American may be overrating its ideological coherence. As in *Breaking the Waves* and *Dancer in the Dark*, the heroine (Nicole Kidman) suffers greatly, but whether this is at the hands of humanity or von Trier himself isn't entirely clear. My favorite von Trier opus, the one I find most entertaining, is *The Five Obstructions* (2003), coauthored by Jørgen Leth. The fact that it's both a comedy and a documentary owning up to von Trier's sadism undoubtedly helps.

Note

1 Catherine Shoard, "Lars von Trier Inspired by Donald Trump for New Serial-Killer Film," *Guardian*, February 14, 2017, emphasis added.

Transforming Nihilism

NATHAN LEE

*This is why we always have the beliefs, feelings and thoughts
that we deserve given our way of being or our style of life.*
—Gilles Deleuze, *Nietzsche and Philosophy*

The *Transformers* films have the distinction of being at once the most visually spectacular and flagrantly stupid of contemporary films. Premised on the intergalactic conflict among dueling clans of metamorphic robots and the earthly nitwits caught up in their mess, they define something like an outer limit of the cinematic ridiculous—and one doesn't go that far without achieving something. There is nothing quite like submitting oneself to the stupefaction of *Transformers: Age of Extinction* (2014), a film whose onslaught of fatuous characterization, superfluous stylization, and prodigious formal élan leaves one bewildered at the composition of an object so ingeniously . . . idiotic.

My nomination of the *Transformers* films to the negative honor of unwatchability rests on three claims. First and most obviously, they are *unbearably* irritating at the level of their characters. It may be too much to expect movies based on a line of toys to muster substantially empathetic humans, but I have met lumps of smoldering plastic more conge-

Still from *Transformers: Dark of the Moon.*

nial than the puppets that pass for people here. The films are excessively long, and for long stretches of time there is nothing to watch but the gibbering antics of the nominal heroes: spasmodic, lizard-brained Sam Witwicky (Shia LaBeouf); and frantic, mouth-breathing Cade Yeager (Mark Wahlberg). These two personify, and aggressively act out, the films' total desecration of human sympathy. They seem, in the end, to scurry around the frame only as a gesture to the obsolete notion that a movie should, in some sense, feature human beings. Their only plausible function is to assist the organization of scale, establishing anchor points to modulate the corkscrewing vectors and wild shifts of perspective in the action sequences.

This catastrophic failure to render sympathetic characters attenuates the narrative, such as it is, so that what really matters, when it arrives, pops with a vengeance. The second unwatchable dimension of the *Transformers* belongs to the gargantuan effects sequences, for it seems to me physiologically impossible to register the density of visual information or comprehensively track the velocity of their controlled delirium. The enormously complex effects pack the screen with so many moving parts, rendered in such minute detail, that the image is legible only in general terms. You grasp the gist of events—midflight metamorphosis of a fighter jet, tumult of grappling robots careering down a freeway, voracious appetite of a mechanical worm leveling skyscrapers to dust—without reading their component parts in any detail. It's too much, too fast, at too many scales, in too many directions. And yet the *vectors of force* come

through with tremendous verve and clarity; it may not be entirely clear, from moment to moment, how a particular transformation develops, but the impression of metamorphic energy is overwhelming. What's at stake is not the usual complaint leveled at chaotic montage and indifference to spatial clarity. The frenzy of the image, no matter how extreme, is contoured by exact modulations of proportion, trajectory, and rhythm maintained, in no small part, by a range of sonic textures that intensify the sense of gargantuanism while indexing for the ear the whizz, screech, and deep space ringtones produced by countless autonomous widgets. The flabbergasting assault on Chicago that climaxes *Transformers: Dark of the Moon* (2011) is a sustained tour de force of expanding and collapsing spatial form that affirms the speed and intelligence of the eye even as it rockets beyond the limits of visual comprehension, bidding us catch up to a level of image processing just over the horizon. The cumulative effect is of images produced by and *for* an algorithmic entity.

It may not be that the *Transformers* films are unwatchable per se, but rather that everything at the human level is so dispiriting and pointless, so little worth attending to, that another form of looking is compelled to take over, an inhuman gaze fixed on the only credible protagonists of the image: texture, shape, light, momentum. This dehumanized formalism is exhilarating and depressing in equal measure, and often at the same time. It is shared out among every object that comes into view, though its ugliest expression is reserved for the women ornamenting the franchise. The tendency of female characters to enter the narratives literally from behind has been noted in the press; the quintessential variation on this trope may be found in *Transformers: Revenge of the Fallen* (2009), where the camera introduces us to Megan Fox hunched over a Harley, offering up her Daisy be-Duked hindquarters as if to some lascivious off-screen orangutan. What is one to make of such cartoon sexism? How can one critique the representational politics of an object that hides nothing, produces no subtext or symptom, generates no real problem or question? There is, at the level of such grotesquerie, effectively *nothing to criticize*. The misogyny bears no code; it is outrageously, nakedly *there*, blazoned with all the subtlety of liquid testosterone firehosed at your eyeball.

This is not to say that the *Transformers* disable critique, but it is to maintain that one must formulate a critical perspective that does more than state the obvious. Beyond their numberless local crimes of taste and politics and without apologizing for them, what needs to be developed is a question aimed at their *totalized* inhumanity. The films lay to waste to the idea that large-scale Hollywood filmmaking lives and dies by the human dimension that supports and gives meaning to its spectacle. By this criterion—which remains an unshakable arbiter of worth in popular film criticism and, I would argue, tacitly selects the kinds of films afforded serious scholarly attention—the *Transformers* are vapid abominations. It is crushingly obvious how little the films, unequivocally terrible from any point of view attached to classic cinematic humanism, abide by those values. We can't think about these movies, can't really *see* them, without confronting them at their level, from their point of view, in the terms of their image making. And this leads us to the paradox of my third claim for unwatchability. The *Transformers* movies do not seem, in some strange and fundamental sense, to be addressed to a human spectator at all.

The saga is devoted to one thing only: the elaboration and expression of an apocalyptic petrochemical imaginary in which the human persists as a something like a bad habit or residue. They are masterpieces of mechanized alienation, supremely devoted to soulless robot ecstasy. I can think of no films that produce a stronger sense of being addressed to the inorganic. They represent, in Nietzschean terms, something like the high noon of cinematic nihilism, when the sun is highest in the sky, ablaze with simulated lens flares, and our moral values are forced from the shadows and exposed as illusion. When nihilism reaches this stage two possibilities open up. As a *transitional* phenomenon, nihilism is the point that must be reached before new values can arise, a terrible tabula rasa for overcomings without guarantee. But the exhaustion of values (the "death of God") is a disorienting experience, depriving us of normative criteria for action, ethics, and what it means to be human.

Spectacular nihilism is, to be sure, as normative a cinematic value as one finds these days, and if the *Transformers* films accelerate this condition to a singular intensity, one is hard-pressed to see what values are being summoned beyond the infinite enrichment of puerile masculinity.

This diagnosis is both perfectly true and obvious to the point of banality, the starting point for a critique, not the final destination. So where does that take us? My fascination with these films is, I confess, an ongoing problem. They provoke, again and again, questions I haven't been able to shake: Why do such mindless spectacles keeping forcing me to think? Why am I compelled by own dehumanization? Can cinematic nihilism lead to transformation? The films are blindingly awful. I can't take my eyes off them.

Oh, Inventiveness! Oh, Imaginativeness! Precious Cinema and Its Discontents

A Rant

JULIAN HANICH

> Without something to hate, we should lose the very
> spring of thought and action.
> —William Hazlitt, "On the Pleasures of Hating"

In his biography of the fictitious early nineteenth-century British art theorist Sir Andrew Marbot—a pastiche as brilliant as it is unknown in the English-speaking world—German novelist Wolfgang Hildesheimer lends the following words to his protagonist: "Just like the painter is not always in the condition to give his best, we are not always in the condition to receive the best, even when it offers itself to us. The true beholder of art knows certain moments of illumination in which an artwork seems to reveal itself completely, the mystery of which he was unable to solve in moments of unreceptivity."[1] Unreceptivity: I often think of this intriguing term when I am watching a certain type of film dear to countless viewers. Filled with derision and at the brink of misanthropy, I sit in the cinema and ask myself if this is merely a momentary phase in my cineaste biography that will ultimately turn into true appreciation (as

Still from *The Science of Sleep.*

happened, for instance, in the case of Abbas Kiarostami or Jacques Tati, filmmakers I couldn't relate to as a teenager) or if I will always be unable to find value in what is so beloved by others. What is it about these films, I wonder, that makes me so unreceptive that I am barely able to watch them and, in fact, watch them only for professional reasons?

Before I attempt to answer this question let me first—at the risk of alienating some of my readers—identify the kind of films that annoy me so deeply: Foregrounding an overly "quirky" directorial sensibility, these include some of Wes Anderson's films, Michel Gondry's post–Charlie Kaufman films, the more mediocre of Tim Burton's films, most films by Jean-Pierre Jeunet, and the second feature film by Miranda July. Now, there seems to be no established aesthetic category that unites such films as *Moonrise Kingdom* (2012), *Be Kind Rewind* (2008), *Big Fish* (2003), *Amélie* (2001), and *The Future* (2011). To some degree they might be described as what Sianne Ngai calls "the cute": works characterized as unthreatening and vulnerable that evoke tenderness, a desire to be sensuously close and to respond in an infantilized and diminutive language, works that can also induce a sense of being manipulated or exploited and (in my case) feelings of contempt and aggression.[2] Certainly, in the films I find unwatchable many of the characters have strong elements of cuteness, epitomized by the wide-eyed, small-mouthed Amélie (Audrey Tautou) and *Moonrise Kingdom*'s Sam Shakusky (Jared

Gilman). However, more than "cute" these films ask for adjectives like "twee," "whimsical," "quirky," or "precious." Trying to find an umbrella term, I toyed with "magical quirkyism," but eventually decided that "precious cinema," in all its ambiguity, seemed most appropriate.

What is it, then, that I find deplorable about precious cinema? Primarily, it is how relentlessly these films harass me with their makers' sense of their own creativity, originality, and imaginativeness. Hiding behind a cute harmlessness, they nastily force their inventiveness upon me. Since every frame is a painting (of sorts), filled with visual puns and lovely arrangements and funny little things to discover, I feel like I am standing in front of crammed wall in the Louvre, Uffizi, or Hermitage, dizzy with cinematic Stendhal syndrome. All I can do is watch, with wide eyes, the relentless and overstimulating visual gimmicky flow. Of course, I am not implying that feeling overwhelmed by mental overload cannot be a form of pleasure. The foregrounding of twee details in precious cinema is quite different from the overload Daniel Yacavone discusses with regard to films like Tati's *Playtime* or Mike Figgis' *Time-code*: "Here the sheer quantities of visual information and the multiplication of perceptual and imaginative elements verges on a kind of cinematic sublimity, in the basic Kantian sense."[3] Precious cinema, instead, leaves nothing for me to fill in, as everything is already given to me down to the very last detail on the screen. Watching precious cinema, I cannot but sense the directors—as nerdy, eccentric, or quirky their public personas might be—shouting at me with full force: "Oh, my glorious inventiveness! Oh, my impressive imaginativeness! Look, oh viewer, how nicely I have arranged the colors, how unusually I have placed the camera, how lovingly original and detailed are my sets." Yet I'm not alone in this impression. Manohla Dargis, for instance, writing for *LA Weekly*, discovers in *Amélie* "a sensibility too in love with its own cleverness," and Anthony Lane, in the *New Yorker*, writes negatively of *Be Kind Rewind* because, among other things, "Gondry was too busy giggling over his own script."[4]

As every Kantian knows, aesthetic judgments strive for intersubjective recognition: paradoxically, they are not only an assertion of distinction ("I am the one who feels like this—and not you!"), but also a cry for confirmation ("Is it only me who feels like this? Please not!"). I therefore cannot deny a certain distrust of those who love these films: I

feel excluded and left behind by a group of devotees whose admiration is conspicuous to me. Here the much-maligned website *Rotten Tomatoes* offers relief and confirmation. Clicking on the green splattered-tomato icon that indicates a negative review, I seek textual remedies from major film critics. Consider the almost physical reaction of Jonathan Rosenbaum, who finds it "hard not to gag on the cuteness" of *Be Kind Rewind*.[5] Maybe most relieving was reading a passage in an otherwise positive portrait of Miranda July in the *New York Times Magazine*: "To her detractors ('haters' doesn't seem like too strong a word) July has come to personify everything infuriating about the Etsy-shopping, Wes Anderson-quoting, McSweeney's-reading, coastal-living category of upscale urban bohemia that flourished in the aughts. Her very existence is enough to inspire, for example, an I Hate Miranda July blog, which purports to detest her 'insufferable precious nonsense.'"[6]

Anderson, Gondry, Burton, Jeunet, July: Whether young or not, these are wunderkind filmmakers glowingly proud of their idiosyncratic creations, like narcissistic children showing off their handicraft fabricated in kindergarten: Please, ADMIRE me, viewer! And it's not that I cannot appreciate some of their grandstanding: *The Grand Budapest Hotel* (2014), *Eternal Sunshine of the Spotless Mind* (2004), *Mars Attacks!* (1996), *Me and You and Everyone We Know* (2005) come to mind as films that are edgier, more socially aware, satirical, or simply less show-offy. But once these directors seem to start humming, to the melody of the Pointer Sisters, "I'm so creative, I just can't hide it," my patience quickly wears thin. *The Future* contains nothing less than a creeping T-shirt, a speaking moon, and a narrating cat called Paw Paw, whose "mew-over" (Anthony Lane) is voiced by Miranda July herself.[7] *Moonlight Kingdom* not only fashions Anderson's (in)famous signature style—no need to resort to the oft-repeated verdict that "symmetry is the aesthetics of fools" here—but also presents us with a dollhouse stuffed with eccentric characters donning strange clothes, glasses, and haircuts, who call each other to dinner with a megaphone or take off a shoe to throw at the person they are angry with.

Part of my contempt also derives from the overly proud fashioning of the handmade in much precious cinema, from the papier-mâché oddities in Gondry's *The Science of Sleep* (2006) and *Be Kind Rewind* and the dollhouse sets in many of Anderson's films to the "cute" paws of

Paw Paw in *The Future*. Then again, the proud display of handmade artifice does not get on my nerves in Jan Švankmajer's work. Nor do I find Roy Andersson's films unwatchable. Quite the contrary. The extremely stylized work of the Swedish director also foregrounds its meticulously handmade sets, but what distinguishes Andersson from Anderson and other precious filmmakers is his engagé auteurism and critical reference to a really real world beyond the hermetic confines of his studio sets.[8]

Much more damning for precious cinema is the fact that it traps itself in the cute world of its own imaginative eccentricities. Todd McCarthy, for one, rejected *The Future* as "irrelevant to anything connected to real life."[9] That's why many critics were so positively surprised by *The Grand Budapest Hotel*, where Wes Anderson showed the first signs of critical-historical consciousness. Precious cinema's nice and harmless films show no social or political urgency: if only they had something more important on the agenda than their self-aggrandizing inventiveness! Sianne Ngai points out that the cute excites a contradictory desire to protect and to cuddle, on the one hand, and to dominate, to be sadistic or contemptuous, on the other hand.[10] However, my response to precious cinema is slightly different, as my contempt is directed at what wishes to *elevate* itself above me and my fellow detractors. As historian of emotion Tiffany Watt Smith characterizes contempt, "Whether smirking and sneering, peering down our noses or turning away in cold indifference, being filled with contempt is an aristocratic emotion. It inflates us with a sense of superiority, curled at the edges with derision or disgust."[11] In the end, then, my contempt for precious films is nothing less than vengeful: assuming an air of superiority myself, I look down on them in a perpetual state of unreceptivity.

Notes

1 Wolfgang Hildesheimer, *Marbot* (Frankfurt am Main: Suhrkamp, 1981), 201. The translation is mine, but the word "unreceptivity" appears in·English in brackets in Hildesheimer's text.

2 Sianne Ngai, *Our Aesthetic Categories: Zany, Cute, Interesting* (Cambridge, MA: Harvard University Press, 2012).

3 Daniel Yacavone, *Film Worlds: A Philosophical Aesthetics of Cinema* (New York: Columbia University Press, 2015), 106.

4 Manohla Dargis, "Sleepless in Montmartre," *LA Weekly*, October 31, 2001, www .laweekly.com/film/sleepless-in-montmartre-2133987; Anthony Lane, "Beamed Down," *New Yorker*, February 25, 2008, www.newyorker.com/magazine/2008 /02/25/beamed-down.

5 Jonathan Rosenbaum, "Be Kind Rewind," *Chicago Reader*, n.d., www.chicagoreader .com/chicago/be-kind-rewind/Film?oid=1066669.

6 Katrina Onstad, "Miranda July Is Totally Not Kidding," *New York Times*, July 14, 2011, www.nytimes.com/2011/07/17/magazine/the-make-believer.html.

7 Anthony Lane, "Distant Shores," *New Yorker*, August 8, 2011, www.newyorker .com/magazine/2011/08/08/distant-shores.

8 For a more detailed account of my position on Roy Andersson, see Julian Hanich, "Complex Staging: The Hidden Dimensions of Roy Andersson's Aesthetics," *Movie: A Journal of Film Criticism* 5 (2014): 37–50.

9 Todd McCarthy, "The Future: Sundance Review," *Hollywood Reporter*, January 22, 2011, www.hollywoodreporter.com/review/future-sundance-review-74658.

10 Ngai, *Our Aesthetic Categories*, 65.

11 Tiffany Watt Smith, *The Book of Human Emotions: An Encyclopedia of Feeling from Anger to Wanderlust* (London: Profile Books, 2015), 59.

The Biopic Is an Affront to the Cinema

JEFFREY SCONCE

The Hollywood biopic is an affront to the cinema and is therefore, in my opinion, unwatchable. Exemplars of the genre—from Warner Bros.' *The Story of Louis Pasteur* (1936) to the Spielberg factory's *Lincoln* (2012)—purport to capture the real lives of real historical figures, narrativized in such a way as to remove the more quotidian boredom that inevitably creeps into the life of even a Malcolm X or Queen Elizabeth. To do this, biopics typically infuse Hollywood's already insufferable faith in self-evident verisimilitude with the deadening impulses that accompany "quality" filmmaking. As a general rule, the more significant the historical personage and the greater the budget, the more truly unwatchable the film will be.

Biopics speak, poorly, to a fundamental tension at the heart of the cinema—the always contentious and most likely specious divide between fantasy and reality. Jean-Louis Comolli addresses this tension in historical fiction as "the body too much," noting the inevitable gap between our fantasies of a historical personage (or period) and the actual actor (and mise-en-scène) offered to depict said personage and period.[1] Put simply, makeup artists, dialogue coaches, and set dressers can do their best to transform Daniel Day-Lewis into Abraham Lincoln, but in the

Daniel Day-Lewis as Abraham Lincoln, looking all Lincoln.

end, what appears on film can only be Daniel Day-Lewis *pretending* to be Abraham Lincoln. He may at times seem uncannily convincing in conforming to our fantasies of the "real" Lincoln, but at best, one is left to marvel more at the process of a sustained masquerade. And for those who already find the entire enterprise of serious acting somewhat ridiculous, even this pleasure is at best fleeting. Imagine, for example, how much more interesting if, at the center of Spielberg's huge budget and two-month shoot, Lincoln was portrayed instead by Nicolas Cage or Adam Sandler. After witnessing Day-Lewis's freakishly "realistic" performance, what sane person would subject herself to *Lincoln* a second time? But Cage or Sandler as Lincoln, following the same script with the same level of dramatic commitment, would be a film for the ages.

Some would critique Comolli's point by noting that all performances by famous actors present a "body too much," and I would agree. At a certain point, Tom Cruise became Tom Cruise no matter what role he sought to play, be it Vietnam vet Ron Kovic (*Born on the Fourth of July*, Oliver Stone, 1989), action-dynamo Ethan Hunt (assorted *Mission: Impossibles*, 1996–????), or "A-list celebrity head-over-heels in love with Katie Holmes" (*Oprah*, 2005). In this configuration of the body-too-much, however, it is now the fantasized actor who exceeds the role, be it a once real person or

a wholly fictional entity. As it turns out, the early architects of Hollywood were wise in attempting to forestall the "star system" for as long as possible. Studio bosses were worried about clout and money, but the "star system" has had an equally toxic impact on film art itself. If we are to have a cinema so relentlessly anchored in the plodding conventions of narrative realism, audiences should at least enjoy a full commitment to this reality effect unencumbered by the extratextual adventures of the stars. In an ideal world (of realist poverty), any film aspiring to verisimilitude would have a completely disposable cast—never seen on-screen before and never to be seen again. Every performance would aspire to Anthony Perkins in *Psycho* (Alfred Hitchcock, 1960)—an absolute and irrevocable merger of actor and character. Or, as I have suggested elsewhere, stars who do amass a certain incredible amount of wealth over their decades-long careers (let's say five hundred million) should be required to *pay us* to witness any further antics on the screen. That money could be placed in a bank that funds new filmmakers with better ideas.

Perhaps one's inclination to watch a biopic speaks to the deeper philosophical stakes involved in the cinematic image's relationship to reality. There is a long tradition in film theory speculating on the ontology of the image, from Bazin's cine-spiritualism to Deleuze's panic materialism. Film theory's interest in ontology has always been somewhat puzzling, given that the cinema as a historical institution has proven (so far at least) to be most cherished by those motivated, at times desperately, *to avoid reality at all costs*. In this respect, quality biopics are unwatchable because they are doomed to failure from the very first frame, brought down by their untenable relationship to both reality and fantasy. Employing the body (and mise-en-scène) "too much," biopics can only fall short of the reality effect they seek to evoke. Tethered to what are ultimately our fantasies about real history, they can only conform to these fantasies intermittently and imperfectly. Bad at fantasizing reality, the biopic is equally impoverished in the realization of fantasy. For those who hope, most often futilely, that each new movie experience might deliver them into unexpected and unimaginable hallucinations of affect and wonder, biopics fail because they are already constrained by our recognition that the film, no matter how well executed, will operate within certain tired boundaries of plausibility. I may not know all the details in the lives of Jackie Robinson, Mozart, or Loretta Lynn, but I am reasonably confident they faced and

overcame various struggles familiar within *l'humaine condition*. And who needs that? I have my own demons to stare down, a process that in the end will unlikely afford me the fame, influence, or self-realization of a Jackie Robinson, Mozart, or Loretta Lynn.

Of course, not all biopics are completely horrible. Those that have only a marginal or problematic relationship to the genre can be worthwhile. *Life of Adolf Hitler* (Paul Rotha, 1961) and *Freud* (John Huston, 1962) present bodies that are so utterly "too much" as to foreground and thus sabotage the efforts of all involved. *Lisztomania* (1975) is pleasingly goofy because it features the Who's Roger Daltrey as Franz Liszt in an allegory about pop music and fascism as imagined by Ken Russell. Tim Burton's *Ed Wood* (1994) succeeds because it understands that Ed Wood Jr., like Christ or Buddha, cannot be captured convincingly through the codes of naturalism, and so instead employs a sleazy magic realism to capture the tragic, pathetic, yet intrepid margins of fantasy-fifties-Hollywood. Todd Haynes's *I'm Not There* (2007) has the good sense to subvert the "body too much" by using multiple actors to portray Bob Dylan as a boomer black hole of fantasy investment. Watching Meryl Streep pretend to be *Florence Foster Jenkins* (Stephen Frears, 2016) can be diverting (on an airplane, perhaps) inasmuch as no one beyond opera mavens and vinyl junkies has any clue who Florence Foster Jenkins is or was. For all intents and purposes, she might as well be the figment of someone's imagination. *Valkyrie* (Bryan Singer, 2008) is hilarious because it stars Tom Cruise as real-life reformed Nazi Colonel Claus von Stauffenberg (with an eye patch, no less). Admittedly, it is a decadent pleasure to watch *Valkyrie*'s producers burn money on a project that most sane observers would have nipped in the bud at the first pitch meeting, but often this is all Hollywood gives us no matter what the genre. Other than these strays and oddballs, however, the pleasures of the biopic are few and far between. To be trapped in a theater with a high-gloss biopic is to condemn oneself to an evening of rudimentary history married to rudimentary filmmaking. You might learn a somewhat surprising detail here and there, but mostly likely, you will be bored to tears.

Note

1 Jean-Louis Comolli, "Historical Fiction: A Body Too Much," trans. Ben Brewster, *Screen* 19, no. 2 (1978): 41–54.

12

Tedious Whiteness

How did we move from an allegedly "postracial America" to a presidency guided by the ideology of white supremacy? As the authors in this chapter argue, the writing was on the wall in the form of self-pitying, narcissistic, and recklessly ableist representations of whiteness, exemplified here by Oscar-winning films and popular Internet videos. Queer theorist Jack Halberstam views *Manchester by the Sea* (2016), a sad film about a bad white man (and vice versa), as a hinge between life before Trump (BT) and after Trump (AT). For Halberstam, the film's compassionate and sorrowful depiction of an outcast, downtrodden white man was eerily congruent with the logic that ushered Trump into office. Whereas *Manchester by the Sea* romanticizes white male pathos, *The Help* (2011) exalts an idealistic white woman in the Jim Crow South. Drawing on black feminist theory and writings on racial melodrama, media scholar Brandy Monk-Payton critiques the tiresome, self-serving fantasy of a "white savior" in a film purportedly about the plight of black women. Finally, queer theorist Mel Y. Chen extracts the discourse of ability from the "watchability" of Reddit GIFs titled "What Could Go Wrong?" (WCGW). For Chen, the looped repeatability of the GIF becomes a cipher for the privilege of able-bodied white masculinity, which can experience spectacular falls while suffering only temporary or minor injuries.

White Men Behaving Sadly

JACK HALBERSTAM

We now must measure apocalyptic time with the parlance of before and after Trump. Before Trump (BT), we were protesting police brutality, narrating neoliberal economic exploitation, and pointing to the contradictions of a black president presiding over a landscape still marked by and inclined to white supremacy. After Trump, the police are given free rein to enforce "law and order"; the poor will remain poor and any gains that Obama was able to shuffle toward struggling families in the form of health benefits will be removed; and white supremacy is the logic of the land. Before Trump, there were warning signs that any steps toward reparations, resource sharing, and responsible stewardship of the environment would be met with resistance. After Trump, all bets are off—there will be no more discourse about international collaboration, better futures, the desire to do good—there is only brutal quotidian violence shaped by fascist "America first" rhetoric and trained on protecting the strong and excoriating the weak. America first, we now know, means more for the corporations, more for lazy business men and their indolent and entitled families, more for white people, more for men, less for everyone else. This is a zero-sum game and we are all going to lose.

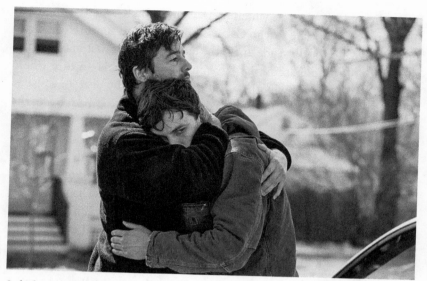

Sad white men: Joe Chandler (Kyle Chandler) hugs Lee Chandler (Casey Affleck) in *Manchester by the Sea*.

After Trump was elected and as the contours of his world became clearer over time, we looked to the movies to entertain us, to distract us, to save us from ourselves and from the predations of a runaway government. We looked for new worlds in cinema but we only found remnants of the old one. No film more precisely captured the coordinates of American patriarchy and its logic of winners and losers and losers who are winners than *La La Land* (2016) on the West Coast and *Manchester by the Sea* (2016) on the East Coast. While West Coasters were treated to a truncated history of jazz in LA centered upon a white dude who has just not been given a break, East Coasters thrilled to another story of downtrodden white masculinity. These stories in which white men were used, abused, and kicked to the curb played beautifully to audiences who believed that this was the true meaning of a black presidency—the continued harassment and brutalization of the sad, mad, white man.

In what follows, I try to lay out the narrative of masculinity in *Manchester by the Sea* in terms of what it told us about black presidents, white working-class men, and the end of everything.

At the end of a year in which men behaved badly, madly, and even gladly, how appropriate that an Oscar-contending film appeared in which men behave, yup, sadly. Indeed, all the ladly behaviors that make up the repertoire of white masculinity have culminated in this—a film where we finally understand why the white man is sad, why everyone else is bad, and why despite being sad because everyone else is bad, he learns to be a dad.

Manchester by the Sea is a self-indulgent but pretty picture in which Affleck Junior, Casey, that is, mopes around for a full hour on-screen before we understand that *something terrible* has happened to him. His brother dies but that barely merits a tear from our sad sack chap. So, could it be that he has a really bad job as a handy man that puts him in the way of verbal abuse from women and people or color and even an episode that comes close to sexual harassment from a woman of color? No, the sad white man mostly just takes the abuse and keeps on keeping on. He soldiers on because he is a white man behaving sadly and that is what white men do. So what is the terrible thing that has happened to Affleck Junior to make him move around in the world like a zombie, silent and brooding, angry and resentful? Well, spoiler alert, let me explain. Lee Chandler (played by Affleck Junior), we find out in flashbacks, once had a wife and some kids. And he was a good man. And he behaved gladly and sometimes even a little badly. Like, one night he had his buddies over and they made too much noise. So his wife broke up the party and made them go home. Sulking, Lee makes a fire in the living room and then steps out into the night to get some more beer. By the time he gets home, his house has burned down with his children in it and only his wife escapes.

After an episode in the police station where you think that maybe he might be charged with something, manslaughter perhaps, he finally wigs out about what has happened and tries to grab a police officer's gun, presumably to kill himself. The police politely restrain him and he is released to his brother's care. Well, wow. So he burned his own house down and waved a gun around in a police station and lived to tell the tale because . . . sad white men's lives matter and so accidently burning your kids and waving a gun at cops is not a big deal and just requires a little TLC! Don't you get it? He is hurting and we are expected to cry for him because it is all so sad . . . for him! Not for his wife, not for those

kids, not for his brother, but *for him*. All the bad things that happen around him, are his bad things.

Why are white men so sad? Well, in this film, they are sad because women are fucked up shrews and alcoholics who drag them down, give them heart attacks and, for god's sake, try to talk to them and offer them food. They are also sad because they work for very little money and do the worst jobs in the world. They clean other people's toilets, fix their showers, and live in small garrets alone and with very bad furniture. Poor sad white men. This sad white man also has to take on the burden of parenthood after his brother's death. His brother left his only son in Lee's care and Lee and the boy tussle about girls, sex, and authority until Lee learns to see the boy as his heir, as another white man who should enjoy his adolescence because soon everything will be taken from him too.

Yes, reader, this is a film made to measure for the coming Trump era, a time when white men can stop being sad, feel very glad and grab lots of pussy with impunity. Like Trump's entire campaign, this film does not need to trumpet its white supremacy because this doctrine is embedded in every scene, it saturates every shot, it controls the camera, and it lives in every hangdog moment that Lee Chandler spends staring silently off into space. Whiteness, the film tells us, is part of the frayed beauty of America and its power hangs in the balance in a world where bad things can and do happen to white men . . . even when they themselves cause those bad things to happen! Indeed, off-screen Casey Affleck has been cast as a serial sexual abuser, and while accusations of sexual harassment brought black director Nate Parker's Oscar hopes to a sordid conclusion, Affleck's history with sexual harassment suits barely merits a mention. Even a year later, as multiple accusations were launched at Harvey Weinstein for his serial sexual predation, attention did not turn back to Affleck. This film gives us a clue as to how powerful white men see the world, women, love, loss, and violence—it is all one tragic narrative about how hurt and misunderstood they really are.

The world of *Manchester by the Sea* is the world imagined by white men in an era when a black man was in the White House and women held public offices at many levels. It is a world where the white working-class man has no power—he dies young (Lee's brother), he lives alone (Lee), he cannot even enjoy spending time in his basement with other

white men. His wife treats him badly and then later, after the tragic event (that he himself caused) his black boss and his female customers abuse him. The white world of *Manchester by the Sea* is elegiac, brimming with a sense of tragedy that exceeds the events on the screen and asks us, begs us even to find a reason for why things should be this way.

There are great tragedies written about women who have killed or been forced to kill their children—think of Sethe in Toni Morrison's *Beloved* who takes a hatchet to her baby rather than relinquish her back to slavery. Think of Medea who kills her children to take revenge on her husband and their father, Jason, for leaving them. Think of Sophie in William Styron's *Sophie's Choice* who must choose to let one child live and the other die upon entering Auschwitz. These stories show infanti-cide as a deliberate action taken as part of a sacrifice or to prevent something worse than death from happening. No such logic under-writes *Manchester by the Sea*—the death of the children is almost gra-tuitous, it means nothing in the film except as its function as the source of irreducible melancholia for the white man. This same melancholia does not affect his wife (played by Michelle Williams), who quickly mar-ries and has another child. There is no setup in the film to show us the bond between Lee and his children; there is little that explains the melancholia—is it guilt? Anger?

While critics fell over themselves to give this film an Oscar, we should ask what the film is really about. If this film is an allegory, then it is a perfect symbolic landscape of the territory that ushered Trump into office—the film sees the world only through the eyes of working-class white men. It sees such men as tragic and heroic, as stoic and moral, as stern but good. The film knows that the tragedy from which the white man suffers is of his own making, but nonetheless the film believes that the tragedies that they have created happen to them and not to other people. This is the same logic by which Dylann Roof took the lives of nine African American churchgoers in South Carolina while claiming to be defending white people from black criminality, and it is the logic by which Elliot Rodger killed six people and wounded fourteen others in Isla Vista near UC Santa Barbara in 2014. Rodger left a manifesto behind that represented him as a victim of women who had sexually rejected him. It is the logic of every lone white gunman in America, and while the media depict these killers as mad and marginal, American cinema

romanticizes them as sad and solitary. Obviously, *Manchester by the Sea* is not about a serial killer who turns a gun on innocents and yet innocents do die by his hand, and rather than seeing this as a tragic narrative about white male narcissism or about the dangers of centering one group in a complex society, we are asked to read the film as just another story about white men behaving sadly.

That Oscar season, we could hear the storm troopers outside on the streets. Films that a few months ago had just seemed to be about sad things or happy things, now appeared in a new light and became part of our national tragedy in which all attempts to make diversity mean something, to resist systems that criminalize communities of color while representing white crime as law and order, to rethink sex, were quickly dismissed as identity politics, political correctness, or authoritarian feminism. It was time, apparently, to make America great again, to cater to the sad white man, to feel his pain, to lift him up and dry his tears. White men have been sad for too long apparently, now it is our turn.

"You Is Kind, You Is Smart, You Is Important"; or, Why I Can't Watch *The Help*

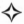

BRANDY MONK-PAYTON

While many melodrama films are compulsively watchable, the ones dealing with racial politics and white liberal guilt are cringeworthy for me—so disgustingly overwrought that I cannot help but sigh. I found myself sighing as I sat in a theater watching *The Help* (2011), a Hollywood movie about African American maids navigating adversity in the mid-twentieth-century Jim Crow South. *The Help*, which had tremendous success at the box office and gained an Oscar nomination for best picture, was released at a time when Barack Obama's presidency signified hope for a "postracial" moment. Postfeminism, too, remained a fashionable sensibility in media culture.[1] These two discourses inform the film's historical fiction that seeks to represent past issues of race and gender, which the nation has ostensibly moved beyond.[2] Yet, as the film makes agonizingly apparent in its overcompensation, the more things change, the more they stay the same. *The Help* exhibits how cinema's melodramatic displays of white feminism result in strained viewing practices for black women. These practices are predicated on black women's simultaneous endurance and exhaustion, both as film char-

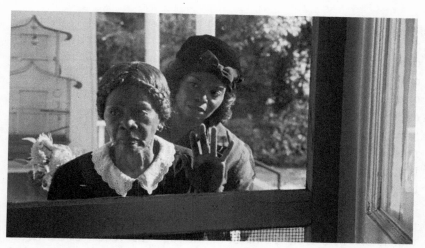

Constantine (Cicely Tyson) as "the help" averts her gaze in an expression of black women's spectatorial endurance and exhaustion.

acters in the narratives and as audience members in their reaction to tired screen imagery.

Accounts of black viewing practices notably emphasize the collective and embodied qualities of watching movies, or what Jacqueline Najuma Stewart has termed a "reconstructive spectatorship."[3] Such interpretive and participatory spectatorship emerges in the face of African American exclusions from cinematic spaces and representations. Black female audiences in particular, as Jacqueline Bobo has importantly chronicled, are incisive cultural readers and critics. We have cultivated what bell hooks describes as an "oppositional gaze"—an interrogating look that calls attention to and resists identification with constructions of white femininity.[4] Black women enact a wariness and weariness at the movies when bearing witness to that which is unwatchable—images of blackness offered by melodrama that are motivated by the whiteness of female complaint.[5] In what Linda Williams conceptualizes as the melodrama of black and white, black women are pushed to the margins of interracial conflict in popular media narratives.[6] Such marginalization compels alternative forms of scopic scrutiny when black women are presented on-screen to do racialized and gendered labor in their encounters with the liberal guilt of the "white savior."

The "white savior" genre of Hollywood moviemaking approaches racial politics through the celebration of liberalism as epitomized by depictions of benevolent white individualism.[7] The problems of discrimination and oppression in such cinematic texts are solved by a kind of messianic progressive whiteness that appears as a light at the end of a dark tunnel, a beacon of hope to those less fortunate victims of color. In films such as the historical drama *Amistad* (1997) and even parts of the musical *La La Land* (2016), justice is predicated on a logic of paternalism that highlights the authoritative quality of white patriarchy to allay the grievances of black folk. Yet the genre takes on further ideological and affective complexity as it intersects with the woman's film. In particular, it is paternalism coupled with expressions of *maternalism*— understood here as the power of mothering—that rehearses the virtuous quality of white womanhood with regard to populations deemed in need of rescue. *The Help* is an exemplar of the tensions surrounding such melodramatic work in its employment and deployment of the black female help.

Inspired by Kathryn Stockett's 2009 debut novel of the same name, *The Help* chronicles the plight of African American domestic workers living in Jackson, Mississippi, during the 1960s. These black women perform the labor of cleaning the houses and caring for the children of their white bosses. The film revolves around budding author Eugenia "Skeeter" Phelan (Emma Stone), an unmarried and childless white college graduate, who decides to write a book-length exposé on the experience of working for the young white housewives of Jackson through the perspective of the maids. As she remarks to her editor in the pitch, "No one ever asked Mammy!" Aibileen Clark (Viola Davis), Minny Jackson (Octavia Spencer, who won an Oscar for her role), and other domestics give testimonials about their jobs to an eager Skeeter, who aspires to move beyond penning women's work advice columns and to become a "serious writer." Thus, the professional and personal anecdotes that she records take on a legitimating function for her own uplift. Despite the impulse to document the real material conditions of the black help, the uplift of white women is the primary theme of the film. The mantra "You is kind, you is smart, you is important" that Aibileen teaches to Mae Mobley (Emma and Eleanor Henry), the little girl for whom she serves as caretaker, is meant as encouragement in the service of the pro-

duction of white mattering.[8] Aibileen's reassurance of white innocence, intellect, and impact through this mantra that is repeated in the film becomes a consuming routine.

This focus on white mattering provoked the Association of Black Women Historians (ABWH) to make a public statement challenging the accuracy and authenticity of the representation of the early civil rights era. Crucially, the ABWH deemed that the film "is the coming-of-age story of a white protagonist, who uses myths about the lives of black women to make sense of her own."[9] Such commentary instantiates Hortense Spillers's pronouncement: "My country needs me, and if I were not here, I would have to be invented."[10] The overdetermination of the African American woman in this contemporary women's weepy results in a kind of fabulation that is the figure of "the help." It is no coincidence, then, that the final story that Skeeter desires to tell for the exposé is of her own vested interest—the story of her mammy.

Constantine Bates (Cicely Tyson) is *The Help*'s specter who is only presented on-screen in folkloric flashback. Questions surrounding Constantine's purported decision to quit working for the Phelan family and leave the life she had known for decades are in many ways the driving narrative force of the entire film. When confronted about the circumstances of her departure, Skeeter's mother Charlotte (Allison Janney) recounts the fateful day that the beloved help left. The scene opens with a dinner for the Daughters of America sororal order at the Phelan home. After Constantine's daughter Rachel (LaChanze) shows up unannounced at the house, the leaders of the organization express disdain at the northern young black woman's degree of comfort with and lack of deference to Charlotte. Pressured to assert her power, Charlotte demands that both black women leave immediately. A point-of-view tracking shot forward depicts Rachel ushering her dejected mother out of the house. Multiple frames are activated in this moment that dictate character and spectator looking relations. Before they exit the property, Constantine takes the opportunity to stare at Charlotte through the glass screen door, the slow zoom indicting her lifelong employer. There are no words spoken. Forlorn, she presses a single hand against the pane. Her eyes shift away. Finally, the door is closed.

Constantine's averted gaze highlights the unwatchability of *The Help* for black female moviegoing audiences. The scene points to the quotidian

nature of continually enduring the disappointing politics of representation to the point of exhaustion. An elderly Tyson, whose career in the entertainment industry has spanned over half a century, is particularly difficult to witness in this role. In the twilight of her time working in Hollywood, she finds herself playing to a fantasy of black female subservience via a character steeped in nostalgic stereotypes from which African American actresses across generations have tried to break free. Within the film, Skeeter's conclusion that Constantine's untimely death was the result of a "broken heart" is a perception that reveals its implication in a "white savior" fantasy—one that is in alignment with the emotional economy capitalized on by the text. Yet the larger discursive issue concerns the tedium of representation; black women, always already marked as the help, are spent. There is no more to give.

At the conclusion of the film, Aibileen faces off with the most influential of the Jackson high society housewives, Hilly Holbrook (Bryce Dallas Howard). When Hilly forces Aibileen's employer to fire her, the maid looks Hilly squarely in the eye. "Ain't you tired?" she asks. Her premature retirement in this moment stands in contrast to the fate of Skeeter, who fulfills a dream of leaving the confines of the South to take a job in New York City and join the ranks of the East Coast liberal elite. Such an ending presents sentimentality as a ruse for the black subject. Aibileen has "reclaimed her time," to riff on Congresswoman Maxine Waters's 2017 viral phrase, but her reclamation is contingent upon the melodrama of white feminism that she has lived through and tolerated. The look on her face in close-up during this exchange sticks with me and is made palpable in its expression of defiance amid fatigue.

Ain't you tired? Indeed, I am.

Notes

1 See Yvonne Tasker and Diane Negra, *Interrogating Post-Feminism: Gender and the Politics of Popular Culture* (Durham, NC: Duke University Press, 2007).

2 Tanya Ann Kennedy, *Historicizing Post-Discourses: Postfeminism and Postracialism in United States Culture* (Albany: State University of New York Press, 2017).

3 Jacqueline Najuma Stewart, *Migrating to the Movies: Cinema and Black Urban Modernity* (Berkeley: University of California Press, 2005).

4 bell hooks, *Black Looks: Race and Representation* (Boston: South End, 1992).

5 See Lauren Berlant, *The Female Complaint: The Unfinished Business of Sentimentality in American Culture* (Durham, NC: Duke University Press, 2008).

6 Linda Williams, *Playing the Race Card: Melodramas of Black and White from Uncle Tom to O.J. Simpson* (Princeton, NJ: Princeton University Press, 2001). Melodramatic narratives of black men caught in a cycle of being virtuous or villainous have been part of the fabric of American culture, from the nineteenth century to the trial of O. J. Simpson; it is the compulsive repetition of such a configuration that has marginalized black women.

7 For more, see Hernán Vera and Andrew M. Gordon, *Screen Saviors: Hollywood Fictions of Whiteness* (Lanham, MD: Roman & Littlefield, 2003).

8 Richard Dyer, *White: Essays on Race and Culture* (New York: Routledge, 1997).

9 Ida E. Jones, Daina Ramey Berry, Tiffany M. Gill, Kali Nicole Gross, and Janice Sumler-Edmond, "An Open Statement to the Fans of *The Help*." *Association of Black Women Historians*, August 12, 2011. http://truth.abwh.org/2011/08/12/an-open-statement-to-the-fans-of-the-help/.

10 Hortense Spillers, "Mama's Baby, Papa's Maybe: An American Grammar Book," *Diacritics* 17, no. 2 (1987): 65.

Two Tables and a Ladder

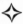

WCGW?

MEL Y. CHEN

Comic physicality—and more generally, the most profound capacity of the physical to be *moving*—has always enraptured me. Over time, I've become an avid student of the motional incitement to laugh—whether the classic flat-on-face fall or the gestural microcosm of a lip pucker registering a sense of dawning failure. More generally, watching stunts or tumbles is for me a guilt-free pleasure accompanied by vivid mental self-animations and sweaty hands. Why aren't these harder to watch?

The dual valence of so much popular contemporary media seems to be that of simultaneous unwatchability-watchability, even as each of these qualities has been the nonobjective result of cultivation, market, and taste. Much discussed is the watchability of the ongoing spectacle of racial, gendered, sexual killing in news and serial entertainment; they disproportionately and perhaps pedagogically rehearse certain deaths, staging relative vulnerabilities, grievabilities, and murderous intents. In "watchability," "-ability" makes of the word a nominalized adjective, meaning the quality of being watchable and perhaps grammatically sidelining the question of the witness. Another reading, which would key in on nonsuffixed "ability," refers to capacities and incapacities, as well as the dynamic line between disability and ability: watch

Two Tables and a Ladder: What Could Go Wrong? Submitted Tuesday, October 17, 2017, by Syncoped to www.reddit.com/r/Whatcouldgowrong/.

this ability, watch this disability. Both of these senses are relevant for WCGW (what could go wrong?) videos,[1] which are largely in the form of purely visual looping GIFs (there are a limited number of videos that have the fuller sensory benefit of audio) and evoking silent film aesthetics.[2] WCGW videos exist in a subreddit on the media site Reddit, / wcgw. The pleasure some ascribe to these videos is akin to that of writings about Darwin Awards "winners"—that is, egregiously "stupid" and self-canceling acts—attributed here is a form of mental incapacity in the sense of a lapse of judgment, foresight, or awareness of risk. In WCGW, there seem to be combinations of mental and physical problematics, even if mental allegations appear mostly in the form of textual comments. In both cases, the distinction between the lack of "situational awareness" attributed to certain lifestyles of privilege or modernity and the possibility of an immanent difference becomes quite complex. How much does disability do hidden work? And to what extent is it racialized? The resemblance to the pratfalls represented in comics suggests an obscured contribution of minstrelsy.[3]

In the titular GIF, "Two tables and a ladder: What could go wrong?,"[4] an apparent cisman in a T-shirt and long, checkered shorts partially appears in a fixed-view shot of a large grass backyard scattered with patio tables and chairs, a ball, a yellow slide, and a lawnmower. A superimposed late-afternoon date-time of 28/9/2016 in the upper left, and

"Camera1" on the lower right, suggest the unmotivated recording of a security camera. To the lower right, closest to the camera, are positioned a wood picnic table on the ground, atop which rests a long folding table, above which is perched a ladder at about a thirty-degree angle from the vertical. An orange extension cord dangles to the ground where a thick coil awaits, then trails off to the distant right. As the man begins to climb the ladder, cord agitating, a blond child, perhaps a son, walks out from under the ladder around the table, looking up, and then moving out of sight to the left. The man has now climbed the ladder high enough to be out of view. After a pause, the ladder gives way, tiddly-winking the white table on its sidelong end, and the man plunges down into the mess, leg caught in the ladder which is for a moment horizontal, then bouncing off it toward the earth, arms out stiffly. The ladder extension skews off-kilter, tracing a possibly parallel injury experienced by the man. The GIF ends abruptly—and begins again—just as the man nearly reaches the ground.[5] Are there pleasures in this? What could they be, dare we ask? He'll be all right, won't he, after a period of accessible care and rehab? I think about what "all right" can mean, barely a year into my own newfound tenderness after a painfully herniated disc and post-injury medication threw a multiplicative wrench into my chronic illness; it's never so simple. With repeated viewings, there is also a pedagogy of physics, a way to learn what not to do—look at the placement of the objects, look at the genesis of the fail, learn about friction, learn about momentum, learn about the placement of limbs, look at the ways that sequences spiral into the zone of hurt and damage. It is this pedagogy of physics that holds my fascination; while I find police murders or violence against feminine people unwatchable, here I avidly learn, with specific attentions to movement, perception, and balance, how I will try to survive a like "accident" when the time comes.

Scrolling through the WCGW archive, one is treated to a tour of almost exclusively able-bodied (at least at the outset) white masculinities, with some nondisabled white women here and there. We will see beer chuggers, golfers, skateboarders, BMX bikes, agricultural machinery, casual stunts involving rotation, and so many men on ladders. Viewing these in rapid succession, the effect is not unlike, I think, what happens in *Jackass* (2000–2002). Except that I never saw what Jack

Halberstam would call the "witless white males" in that show.[6] Nor have I ever had the taste for the nominally representative, also white male, slapstick comedians the Three Stooges, Buster Keaton, Laurel and Hardy, Charlie Chaplin, or their contemporary comparator, Jim Carrey. (I didn't know that slapstick comediennes of color such as Bertha Regustus or white comediennes such as Marie Dressler and Sarah Duhamel existed.) WCGW videos, unlike these elaborate filmic productions, occupy an entirely different space: both the "performer" and the documentation share an identity of the aleatory, the DIY, what Scott Herring, in referring to queer life, might call the "rustic"—spaces outside of metronormative, chic sexualities.[7] Sometimes the view wanders away from the accident in progress and returns just in time. The GIFs often end before we know what has happened to the fallen, so that in comments, the question is often, "did he die?"[8] More infrequent are musings about permanent disability. Commenters ask what happened, but rarely does an original poster have inside information, since all they did was produce a GIF of someone else's video for fast consumption. By the sheer continuous animation of WCGW GIFs, "did he die?" is countered with the certainty of renewal, a lifely repetition also found in greater variation in video game cultures since the time of Atari.[9] Perhaps this is where the whiteness that is all over these videos comes in: Regardless of a viewer's politics, one entertains the quiet question: can and do white people, even poor white people, bounce and get back up as if nothing happened? What representational value do they have? The political distinctions in how this is answered may lie in how vulnerability and optimism are understood. One can level the broader sense of socially produced capitalist "capacity" against temporary or permanent "disabilities," such that the first could make less consequential the second.[10] The optimism of unperturbable masculinity fantasizes whiteness beyond its classed idealization and attempts to belie the realities of white disabled poverties. And the story of the day seems to be that limited capacity for empathy, for long sentences, for honest exchange, for multiple pieces of information works just fine for some white men, especially if the money and power are there, and can provide endless renewal. The WCGW archive suggests, finally, that vitality was never the point.

Notes

I wish to thank the co-editors and Julia Bryan-Wilson for their incisive edits and suggestions.

1 The subreddit "whatcouldgowrong," or /wcgw, was created by reddit user peanutbuttered on April 27, 2013.

2 Amanda Hess, "The Silent Film Returns—On Social Media," *New York Times*, September 13, 2017, www.nytimes.com/2017/09/13/movies/silent-film-youtube-videos.html.

3 Scott Bukatman, *The Poetics of Slumberland* (Berkeley: University of California Press, 2012).

4 See www.reddit.com/r/Whatcouldgowrong/comments/76v85p/two_tables_and_a_ladder_what_could_go_wrong/.

5 This may recall a distinct but perhaps related gesture of filmic "temporality of rehearsal," the Lumière 1896 film *Démolition d'un mur*, which shows a sequence of demolition in its first half, then reverses it for the second: www.youtube.com/watch?v=9poHI9t5IB0.

6 Jack Halberstam, "Dude Where's My Gender? Or, Is There Life on Uranus?" *GLQ: A Journal of Lesbian and Gay Studies* 10, no. 2 (2004): 308–312.

7 Scott Herring, *Another Country: Queer Anti-Urbanism* (New York: New York University Press, 2010). In line with Herring's relating of form to spatial politics, many of the WCGW videos are set in rural locations and seem to emulate, for commenters, "hillbilly" stereotypes.

8 Two abbreviations assist with the curation of different kinds of propriety: NSFW and NSFL, "not safe for work" and "not safe for life," respectively. The latter signals videos that represent a moment that is likely to have represented an actual death.

9 For one examination of "lifeliness," see Mel Y. Chen, *Animacies: Biopolitics, Racial Mattering, and Queer Affect* (Durham, NC: Duke University Press, 2012).

10 Jasbir K. Puar, *The Right to Maim: Debility, Capacity, Disability* (Durham, NC: Duke University Press, 2017).

13

Reality Trumpism

Some phenomena are initially unwatchable and yet worthy of our sustained gaze, like the sun in Plato's Allegory of the Cave. Others, by contrast, are easy to behold but ultimately malign, like the culture industry that offers "enlightenment as mass deception," in Theodor W. Adorno and Max Horkheimer's famous argument. Perhaps no contemporary figure embodies the latter form of unwatchability more than President Donald Trump, who parlayed reality television celebrity into electoral victory through fraudulent populist rhetoric.

At once shocked and unsurprised by the election of Trump in 2016, television scholar Lynne Joyrich contends that American politics now operates according to the mass-cultural logic of shows such as *American Idol*, *The Voice*, *Survivor*, *Amazing Race*, and, of course, *The Apprentice*. Shedding light on the collapsing distinction between reality TV entertainment and electoral politics, Joyrich suggests that everything unwatchable about Trump's presidency arises from what was all too watchable about his media persona.

If Trump rode to power by mobilizing the rhetoric of reality TV shows, Hillary Clinton suffered a loss that can be explained via the tropes of daytime soap operas, with their arsenal of loathsome, thwarted villainesses. For new media scholar Abigail De Kosnik, the unwatchability of the 2016 election lies in the punishing defeat of Clinton, a complex

and often-demonized politician who was so easily relatable to many women of color precisely because she embodied the social contradictions of a white, patriarchal order.

TV Trumps

LYNNE JOYRICH

Ever since Donald Trump was declared the winner of the 2016 U.S. presidential election against almost all expectations, it's been said that the media "failed" the public. It's true that the great majority of reporters did not predict this, and so the more than seventy-one million television viewers who witnessed Trump's surprising win had good reason to be shocked.[1] As not only a television scholar but an avid viewer, I was among those stunned spectators—but, while finding this almost unbearable to watch, I was not surprised. That's because this election was not operating through the usual logic of political discourse, centered on policy, arguments, and goals; instead, it operated fully through a media logic—through, precisely, the "reality televisualization" of political formations.

The media thus did not "fail"; rather, they succeeded in producing a particular effect, even if media workers didn't realize this. Not a simple instrumental effect, this involved a televisual epistemology and affect, meshing modes of thinking and feeling. That stew has become the "medium" in which politics exists—with "medium" indicating not only mediatization but used in the scientific sense of the substance in which something is "cultured" and even the occult suggestion of auratic communications.

Dystrumpia.

Within that logic of reality televisualization, policy, reason, and divisions between truth and fantasy, real and unreal, action and appearance don't matter. What matters for a candidate is what matters for a reality TV contestant: constructing a strongly profiled persona—a branded, celebrified image of self ("Winner!")—while also defining personae for one's opponents ("Lyin' Ted," "Crooked Hillary"). What works, that is, is the production of a personality able to "survive" on the island, "make it work," return to perform again instead of getting kicked off: precisely the staple reality television brand personality who shows that he is able to manage risks and rewards, balance alliances and betrayals, "lip-sync for [his] life," act out in ways that read as both strategic and authentic—or, as Trump said, engage in "truthful hyperbole."[2] By presenting such a persona—one that, for all who found this unwatchable, was arguably all-too-watchable as reality entertainment—Trump

established himself as "the idol," "the voice," "the survivor," making it to the end of the "amazing race," and garnering votes from an audience used to making that kind of choice.

This construction of media personality is what's been called "personification," projecting a persona in which ordinary private person and extraordinary public image are equated and equivocated: each acts as alibi for the other, becoming mutual guarantees (like a product guarantee). The reality television celebrity can therefore stand, simultaneously, for himself as subject, the brand image, and everyone invited to identify with it. The persona becomes effective and affective through the attachments that connect the personality to his public.

A focus on this enhanced persona yields a kind of tribal individualism and an individualist tribalism. That loaded term comes from reality television itself, used to divide contestants into teams with which we're encouraged to affiliate (like the "tribes" on *Survivor*, or claiming ourselves on, say, "Team Jon" or "Team Kate"). But the notion of a "tribal individualism"/"individualist tribalism" also perfectly describes Trump's racialized, populist nationalism, in which the perceived possibility of individual success binds rather than separates his affiliated group. This is a televisual logic, as television—bringing the world into our homes just as we're invited into the spaces and times seen on-screen—is located at exactly the borders of public/private, individual/social, everyday/exceptional. Given Trump's reality TV instincts in manipulating his persona and those categories, his electoral success was thus not that surprising from a television studies perspective.

Yet winning an election and governing a country are quite different things, demanding different genres and personae (different "TV Trumps"). These characters might also be considered via televisual formations, as TV is not lacking in presidential representations: in addition to "real presidents," a number of "television presidents" have graced our screens (on *The West Wing, Battlestar Galactica, 24, Commander in Chief, House of Cards, Scandal, Designated Survivor*, and more). Almost all of these operate as serial melodrama—like reality TV, an enormously important television genre yet one that might offer a different model of media politics.

The Trump presidency does seem very melodramatic, with its hyperbolic rhetoric, spectacles of (im)morality, and orchestration of emotion. One might thus argue that the Trump presidency has gone from a reality

competition to a soap opera. But the problem, I'd suggest, is not that this presidency is too much like a soap; rather, it is not quite soap-like enough—or at least not like the soap opera in its most inventive mode. Through ongoing, complex stories (with their character webs, intersecting plotlines, and expansive yet everyday space-times), soap operas, at best, can go beyond the simple good/bad, winner/loser structure of traditional melodrama, offering instead complications, interrelations, transformations. They create multifaceted, intersectional worlds and give viewers—positioned as both overseeing and immersed, distant and close, included and fragmented—a unique kind of vision: one Tania Modleski famously labeled a maternal consciousness, able to recognize and "read," critique yet care about "all her children."[3]

Of course, the thought of inhabiting a maternal position is likely horrifying to Trump, who wants to claim the status of patriarchal "father of his country" but certainly not that of mother. He's worked to cultivate a tough-guy image but exudes a palpable gender anxiety, yielding an aggressive acting out. He uses women and/as possessions to bolster his image of masculine prowess, appearing most comfortable when women are adornments competing for his favor (whether as potential wives or Miss Universe or *The Apprentice* contestants). This has carried over from his media to political persona: his "Make America Great Again" slogan harnesses that fantasy of male prowess and harkens back to an era before women, "foreigners," and "others" of all kinds challenged the centrality of white men in America. He seems deeply threatened by women with political or media clout, whether primary rival Carly Fiorina (whose appearance he insulted), electoral rival Hillary Clinton (about whom he said, if she "can't satisfy her husband, what makes her think she can satisfy America"), news personality and debate host Megyn Kelly (whose question about women he dismissed by saying, "You could see there was blood coming out of her eyes . . . blood coming out of her wherever"), or countless other instances in which he's insulted—or, worse, assaulted—women. And in light of my comments on the (gendered) possibilities of soap opera, it's worth noting that it was while visiting a soap set, to be guided by the female star, that Trump made his most egregious remarks about "grab[bing] them by the pussy."[4]

Yet Trump's persona is a profoundly insecure one, exhibiting fear of emasculation (as evident from his anxiety over the size of his hands and crowds, his alpha-male handshake competitions, etc.). These have been the subject of late-night television humor, in which other "TV Trumps" (comical impersonators) figure him as weak, small-handed, not a full-grown man—"castrated." The most famous of these is Alec Baldwin's caricature for *Saturday Night Live*, with skits in which "Trump" is ordered around by Strategist "Steve Bannon" (with Trump sent to a miniature desk to play with an expandable toy as Bannon-as-Grim-Reaper takes the presidential desk) and placated by Counselor "Kellyanne Conway," who coddles him and calls herself "mommy." Upset by these portrayals, Trump himself declared *SNL* "unwatchable."[5]

But the portrayal that most disturbed him was of then press secretary Sean Spicer, played by Melissa McCarthy in drag. According to reporting, the "White House [was] rattled by McCarthy's spoof of Spicer. . . . More than being lampooned as a press secretary who makes up facts, it was Spicer's portrayal by a woman that was most problematic in the president's eyes. . . . 'Trump doesn't like his people to look weak' [here equated with female], added a top Trump donor."[6] How much more upsetting, then, must it have been to witness McCarthy singing "I Feel Pretty," taken from the musical *West Side Story* to *SNL*'s fantasy West Wing, as we see McCarthy transformed from feminine exemplar in pink, flowy clothes to pugnacious Spicer. Turning the Trump administration into not only a melodrama but a musical and makeover show (i.e., toward multiplying feminized genres), the skit reveals the gender anxieties—and media formations—that underpin the Trump presidency.

Given such portrayals, Trump declared war on the media, demanding the end of not only *SNL* but some news outlets. I began by saying that, with Trump's election, the media "won" even if they didn't recognize it. Given Trump's attacks (his calls to "retire" TV programs and people, cut public television funding, jail journalists, dismiss legitimate reporting as "fake news," etc.), the media *must* win. We must insist on media freedom and fight for a truly open media. But we must also think about media formations and what they may impede and/or make possible.

The "reality televisualization" of political discourse—how reality television "trumped" politics—is troubling, and responding is no simple

matter. Must we equally move toward reality televisualization, relinquishing other modes of discourse to operate via branded, celebrified entertainment? I would not suggest that—though, as apparent from my comments about the potential of certain TV forms (like soap opera and comedy-as-commentary), I think we can learn from television, particularly since politics isn't operating according to old logics any more. We need to engage with media epistemologies and affects, with what Walter Benjamin called "aura" (here, the kind of media-produced aura linked to consumer culture).[7] While we can't cede political debate, we must make not just arguments but connections—even ones that start off feeling forced, "soapy," or "fake" but that become, through our involvement, a new kind of "real" (real affinity, real participation). In that way, we might begin to produce a different kind of "mediation"—an intervention in media-defined politics and culture.

Notes

1 Oriana Schwindt, "Election Night Ratings: More Than 71 Million TV Viewers Watched Trump Win," *Variety*, November 9, 2016, http://variety.com/2016/tv/news/election-night-ratings-donald-trump-audience-1201913855/.

2 Donald Trump and Tony Schwartz, *Trump: The Art of the Deal* (New York: Random House, 1987), 58.

3 Tania Modleski, *Loving with a Vengeance: Mass-Produced Fantasies for Women* (Hamden, CT: Archon, 1982).

4 All of these comments—and more—are catalogued by Adam Lusher, "Donald Trump: All the Sexist Things He Said," *Independent*, October 9, 2016, www.independent.co.uk/news/world/americas/us-elections/donald-anything-a7353006.html.

5 Donald Trump (@realDonaldTrump), "Just tried watching Saturday Night Live—unwatchable! Totally biased, not funny and the Baldwin impersonation just can't get any worse. Sad." Tweet, December 3, 2016, 9:13 PM.

6 Annie Karni, Josh Dawsey, and Tara Palmeri, "White House Rattled by McCarthy's Spoof of Spicer," *Politico*, February 6, 2017, http://www.politico.com/story/2017/02/melissa-mccarthy-sean-spicer-234715.

7 Walter Benjamin, "The Work of Art in the Age of Its Technological Reproducibility: Third Version," trans. by Harry Zohn and Edmund Jephcott, in *Walter Benjamin: Selected Writings: Volume 4, 1938–1940*, ed. Howard Eiland and Michael W. Jennings (Cambridge, MA: Belknap, 2003), 251–283.

The Once and Future Hillary

Why I Won't Watch a TV Miniseries about the 2016 U.S. Presidential Election

ABIGAIL DE KOSNIK

In 1992, I learned about the U.S. Democratic presidential nominee's wife, Hillary Rodham Clinton (HRC), through her magazine and television interviews. On television, HRC struck me as brilliant, articulate, passionately feminist, fierce, defensive, canny. A fighter. "I would vote for her," I said to myself, though it was her husband on the ticket. Throughout the next eight years, my respect and support for HRC deepened as she faced crisis after crisis with steely aplomb, and then won a Senate race in New York.

I realize, in retrospect, that I saw in HRC what I saw in my Filipina American culture. I grew up with implicit and explicit messages that, as immigrant, Catholic, mestiza women in family systems governed by patriarchal *machismo*, we middle-class Filipina Americans had to embody contradictory traits in order to have a chance at success in the United States: we must be respectful of our men and well-educated, independent thinkers, who choose ambitious careers that earn a good income and still nurture our loved ones and tend to our homes, and also be positive public representatives of our entire people. Interestingly, the only media depictions of these paradoxical but very real expectations put

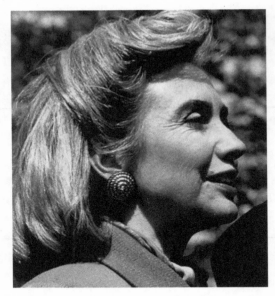

Hillary Rodham Clinton, 1993. By the White House,
via Wikimedia Commons.

upon me that I saw during my childhood were in soap operas. I loved
soap opera heroines—the virtuous ingénues and weepy mothers—but I
loved the villainesses more, who seemed to have more guts and initia-
tive, who reached for what they wanted without apology, who were
inventive and cunning. In a 1979 essay, Tania Modleski writes, "The
[soap] villainess is able to transform traditional feminine weaknesses
into the sources of her strength. . . . [She] reverses male/female roles. . . .
[She] continually works to make the most out of events which render
other characters totally helpless."[1] Soap opera villainesses seemed to ful-
fill the set of expectations put upon Filipina Americans far better than
the protagonists. Immigrant women of color cannot afford to be only
"good." We have to relentlessly take action, make things happen, hatch
plots and see them through, strategize and scheme and strive for what
we want, sometimes (often) with desperation.

HRC was a hero to me, but my affinity for her did not resemble hero
worship so much as the admiration I felt for daring antagonists such as
Erica Kane of *All My Children* and Dorian Lord of *One Life to Live*, who
embodied manifold contradictions and made it work. I, like the major-

ity of U.S. women of color who voted in 2016 (81 percent of whom voted for HRC), didn't mind HRC's lack of perfection, didn't mind that she didn't always seem kind and sweet and gracious, didn't mind that she was a complicated woman with a complicated past and a complicated marriage.[2] We *loved* all that about her, for that made her like us, caught in the knot of irreconcilable directives: *Be this, be that, be something we've never seen, be everything we recognize and already want.* To be clear, the social contradictions to which women of color are subjected do not stifle their political agency: more women of color (thirty-eight) won congressional seats in the 2016 elections than ever before,[3] and women of color are "front and center in the anti-Trump resistance."[4] But it is frustrating that the candidate whom women of color chose for the highest office in the land seemed to be defeated partly *because* of the complexities in her work and life that allowed many of us to so easily identify with her.

It didn't surprise me that many white women (53 percent of whom voted for Trump),[5] for whom the soap opera genre was developed, despised HRC as a villainess.[6] I think a passage in the Modleski essay well explains white women's hatred of both the soap villainess and HRC: "The spectator, encouraged to sympathize with almost everyone, can vent her frustration on the one character who refuses to accept her own powerlessness, who is unashamedly self-seeking. . . . [The spectator] watches the villainess act out her own hidden wishes, but simultaneously sides with the forces conspiring against the fulfillment of those wishes."[7] In other words, it's possible that many white women secretly want what a "bad" woman wants (which is to act from pure self-interest, and do whatever is necessary to get what they feel they deserve), but they know they're not supposed to want that (they're supposed to serve others and live in a permanent state of self-denial), so they don't want the bad woman to ever get what she wants. They need to see her thwarted.

For years, I waited for HRC to become the Democratic nominee for president. Finally, the 2016 election came into view, and I knew it was her time. But the press in 2016 had little to say about HRC's policies, experience, or intelligence. While most news media outlets endorsed HRC in the race, they also devoted far more sentences to HRC's emails—the scandal that wasn't—than to Trump's myriad defects, and characterized HRC as a "flawed" candidate.[8] Sarah Lerner writes, "All through-

out Hillary Clinton's historic campaign, one word followed her around everywhere she went: 'flawed.' . . . 'Flawed,' when attached to Clinton, didn't take on the connotation of 'We all make mistakes and that's okay.' That's reserved for men. Instead, it became an insidious reminder of the perfection that the world expects from women."[9] But it is the "flaws" of HRC to which many women of color relate. A similar dynamic seems to be playing out with Senator Kamala Harris, who was deemed too "flawed" to run for president by some Bernie Sanders supporters in July 2017 because, they claimed, she is too centrist and not left-leaning enough (a criticism they also made of HRC).[10] It is the fact that, in their long careers, these women politicians made some decisions that many people, even their own supporters, disagree with, and other decisions that have garnered praise, that make them legible to women of color like me, who must be so many things to so many different people, and cannot ever afford to be pure or singular in our philosophies or actions.

As of this writing in August 2017, multiple television miniseries about the 2016 election are going into production.[11] One of them is an adaptation of *Shattered*, a book by journalists Jonathan Allen and Amie Parnes about HRC's campaign. HRC's staffers have already dismissed *Shattered* as largely inaccurate. *Politico* reporter Nolan D. McCaskill wrote, just after *Shattered*'s April 2017 publication, "Hillary Clinton's campaign aides are aggressively pushing back against a newly released book that portrays their operation as a dysfunctional knife-fest, insisting that, despite its flaws"—!—"the campaign was focused and supportive throughout the hard-fought election."[12] I won't watch the miniseries when it airs.

The fictionalization of HRC's campaign as riven with conflict is laden with gendered stereotypes. HRC's campaign staffers claim that their team was "dedicated" and "cohesive," yet *Shattered* will apparently depict them as backstabbers and climbers, disloyal to one another and to their candidate.[13] *Because that's what the woman candidate's campaign must have been like.* I know that this (predictive) description makes *Shattered* sound like a daytime melodrama, in which HRC is the villainess— and, the reader will ask, don't I *like* villainesses in daytime melodrama?

But there is a crucial difference between a miniseries like *Shattered* and a decades-long serial daytime soap, which is that a miniseries comes to an end after a few episodes, giving its characters a story arc

with a definitive ending, while a soap allows its villainesses long, dynamic lives with manifold story arcs. Modleski writes, "If the villainess never succeeds . . . then she obviously never permanently fails either. . . . And if the villainess constantly suffers because she is always foiled, we should remember that she suffers no more than the good characters, who don't even try to interfere with their fates."[14] Because the villainess is allowed to endure, and does not experience greater punishment than the heroines, Modleski argues that soaps actually resist "the usual imperatives of melodrama, which demands an ending to justify the suffering of the good and punish the wicked."[15] I suspect that *Shattered* will fall in line with melodrama's typical conventions, and "punish the wicked" by showing HRC's defeat to be well-deserved. I prefer the ending that soap villainesses get—the ending that HRC actually got after the election—which is no ending at all, just more days and more ways to fulfill their ambitions, upend the social order, and defy the expectation of female powerlessness, despite the suffering that their defiance causes them.

Notes

1 Tania Modleski, "The Search for Tomorrow in Today's Soap Operas: Notes on a Feminine Narrative Form," *Film Quarterly* 33, no. 1 (Autumn 1979): 16.
2 Aamna Mohdin, "American Women Voted Overwhelmingly for Clinton, Except the White Ones," *Quartz*, November 9, 2016, https://qz.com/833003/election-2016-all-women-voted-overwhelmingly-for-clinton-except-the-white-ones/.
3 Amber Phillips, "One Election Bright Spot for Democrats: Women of Color," *Washington Post*, November 10, 2016, https://www.washingtonpost.com/news/the-fix/wp/2016/11/10/one-election-bright-spot-for-democrats-women-of-color/?utm_term=.8febb3016b06.
4 Carimah Townes, "Women of Color Are Front and Center in the Anti-Trump Resistance," *ThinkProgress*, January 31, 2017, https://thinkprogress.org/meet-the-women-of-color-leading-the-resistance-against-trump-e0a5985ad27d/.
5 Katie Rogers, "White Women Helped Elect Donald Trump," *New York Times*, November 9, 2016, www.nytimes.com/2016/12/01/us/politics/white-women-helped-elect-donald-trump.html?_r=0.
6 Mohdin, "American Women."
7 Modleski, "Search for Tomorrow," 17.
8 Reid Wilson, "Final Newspaper Endorsement Count: Clinton 57, Trump 2," *Hill*, November 6, 2016, http://thehill.com/blogs/ballot-box/presidential-races

/304606–final-newspaper-endorsement-count-clinton-57–trump-2; Rob Faris et al., "Partisanship, Propaganda, and Disinformation: Online Media and the 2016 U.S. Presidential Election," (Cambridge, MA: Harvard University, Berkman Klein Center for Internet & Society, August 16, 2017), https://cyber .harvard.edu/publications/2017/08/mediacloud.

9 Sarah Lerner, "'Flawed': Perfect Is the Enemy of the Good if You're a Female Presidential Candidate," *Medium*, January 6, 2017, https://medium.com/@ sarahlerner/flawed-perfect-is-the-enemy-of-the-good-if-youre-a-female -presidential-candidate-48392e7d849b.

10 Andrew Joyce, "Democratic Rising Star Kamala Harris Has a 'Bernieland' Problem," *Mic*, July 31, 2017, https://mic.com/articles/183105/democratic-rising -star-kamala-harris-has-a-bernie-sanders-problem#.5iLxmWB4K.

11 Yohana Desta, "Yet Another TV Series about the Hellish 2016 Election Is Coming," *Vanity Fair*, March 9, 2017, www.vanityfair.com/hollywood/2017/03/hbo -2016–election-mini-series.

12 Nolan D. McCaskill, "Clinton Aides Deny Infighting Captured in 'Shattered' Book," *Politico*, April 20, 2017, www.politico.com/story/2017/04/20/clinton-aides -shattered-book-denials-237404.

13 Ibid.

14 Modleski, "Search for Tomorrow," 17.

15 Ibid., 17.

14

Pedagogy and Campus Politics

Sounds and images have always been policed and controlled, and campuses are a particularly volatile site. Which individuals have the power to speak and present audiovisual material at universities? Who is allowed to criticize, protest, or prevent those acts, and under what conditions? What kind of speech and media experiences can and should be endured, and who gets to decide? These questions roil higher education today. While debates over so-called free speech and trigger warnings have become polarizing, the essays in this chapter refuse easy answers and instead delve into the complexities of these claims and demands.

Sociologist and comedy scholar Raúl Pérez explains why he finds the documentary *Can We Take a Joke?* (2015) so unbearable. Willfully misrecognizing where social and financial power lies, this right-wing-funded film frames racist and misogynist comedians as victims of sensitive student killjoys and claims outrageous parallels between the criticism faced by these comedians and the state retaliation against figures like Lenny Bruce in the 1960s.

Film and new media scholar Jennifer Malkowski, an expert on documentary representations of death, explains that there are some films they will no longer screen for their students, among them *The Bridge* (2006), which risks inspiring suicide contagion through its formal and narrative qualities. Though initially skeptical of student requests for

trigger warnings, Malkowski has developed a system that enables concerned students to prepare themselves for difficult content without giving away the plot for others in the classroom.

Finally, media scholar Katariina Kyrölä asks whether the demand for trigger warnings itself produces a traumatic reaction through the viewer's fantasy of what might appear. She describes her students' discussions of trigger warnings and state-organized film censorship in relationship to the brutal scenes of sexual coercion and rape in Catherine Breillat's *Fat Girl* (2001). Rather than defaulting to a generic idea of the traumatized spectator, Kyrölä calls for more empirical research on how viewers react to and reflect on particular audiovisual works.

Why We Can't Take a Joke

RAÚL PÉREZ

Can We Take a Joke? (2015) is a documentary that looks at "modern outrage culture" in comedy and on American college campuses. It centers on how audiences and universities are infringing on the "free speech" of comedians and speakers today. From angry emails to "mob censorship," the film tries to sound the alarm bells on "creeping authoritarianism" in contemporary American society. As the film suggests, "One of the first things you know when a society is turning authoritarian is the comedians start to worry. When they start going for the comedians, everyone else needs to worry." The film focuses on the case of comedian Lenny Bruce, the 1960s counterculture icon who was convicted of obscenity by the state of New York in 1964, following a string of arrests for profanity in clubs across the country. The film features a number of comedians who exploit Bruce's example to argue that comic speech (and free speech in general) is being stifled in the current cultural climate.

I have studied issues of racism and sexism in comedy over the last decade, and I argue that comedy controversies are on the front lines of larger ideological battles over expression and the politics of (mis)representation. I put off watching this film, believing it to be politically and ideologically unwatchable, based on what I learned about the film prior

Offensive comedy is in the eye of the beholder. Illustration by Kristian Hammerstad.

to watching it. I suspected it lacked thoughtful analysis of historical and current speech issues in comedy, and I knew it veered toward right-wing propaganda. Watching it not only reinforced my hunch, but also made me dread the impact this film might have.

The film begins with a reel of white comedians publicly apologizing for jokes they have made. What were they apologizing for? The film doesn't say, but frames them as victims. This opening is followed by a roster of mostly white, forty- to fifty-year-old, male, straight, cisgender comedians (with few token exceptions) lecturing viewers on why they should "learn to take a joke" and "grow thicker skin," as they condemn not state censorship, as Bruce faced, but growing audience criticism. "I think people like to be offended," states comedian Jim Norton. "There is a really weird sense of empowerment with being offended . . . and I think it's an attention seeking device." Over the last several years, comedians like Norton have increasingly framed any audience criticism as "censorship" and "political correctness." This notion is reinforced throughout the film, and it is absolutely nauseating. The film fails to make even the slightest attempt to explore why audiences take issue with specific comedians, how audience preferences change over time, and the fact that audiences are not homogeneous.[1]

But the real focus of this documentary is not the plight of comedians or free speech. Its main target is the modern college campus, which it presents as a censorship mill. Comedians such as Adam Carolla, featured in the film, have increasingly questioned "political correctness" and "censorship" on college campuses. Carolla himself testified before Congress in 2016 against allowing "safe spaces" on campuses alongside Ben Shapiro, conservative provocateur and author of *Brainwashed: How Universities Indoctrinate America's Youth*.[2] Along with Campus Reform, a conservative organization that spotlights "liberal bias" and "free speech restrictions" on American college campuses, and the Foundation for Individual Rights in Education (FIRE), a civil liberties organization that routinely defends racist speech on college campuses, a right-wing ideological apparatus is what converges as the backdrop of this seemingly innocuous film that is purportedly concerned with comedians and campus speech today.[3]

Issues over political correctness on campus are far from new. Over the last twenty-five years, the right has used the term "political correctness" to discredit the political and cultural changes that emerged in the United States in the aftermath of the civil rights, feminist, environmental, and antiwar movements.[4] By highlighting the demographic and cultural changes on campuses and in broader society (e.g., the curbing of public racist/sexist speech, a focus on identity), conservatives pointed to universities as the institutions at the center of these major shifts. Conservative writers sought to convince the public that these changes illustrated how "liberal elites" were greatly disconnected from the issues faced by "real Americans." While two decades ago conservative scholars and writers were the vanguard of this movement, today it is seemingly comedians. But behind comedians and pundits are deep-pocketed conservative organizations, such as the Olin, Scaife, and Koch foundations, shaping right-wing thought, discourse, and politics.

Greg Lukianoff, executive producer of this film and CEO of FIRE (an organization funded by the Olin and Scaife foundations), notes that this documentary is intended to "'trick' people into learning about the philosophical principles that undergird freedom of speech."[5] As I see it, this film teaches right-leaning white American youth (and their allies) how to think about free speech, particularly on college campuses—not for the sake of an abstract "free speech," but to give those on the right a

larger platform to be heard on campus. This is exemplified by the recent efforts and attacks against "political correctness" on college campuses by right-wing provocateurs, such as Milo Yiannopoulos and Ann Coulter, and their supporters.

It is a mistake to think that these current speech battles will ultimately benefit and uphold everyone's speech equally. Notice how conservative media and organizations across the board are silent when it comes to protecting progressive faculty members and their free speech rights on and off campus (e.g., Steven Salaita, Keeanga-Yamahtta Taylor, Johnny E. Williams). These individuals are not championed as martyrs of "censorship" when they lose academic positions, are placed on leave, or cancel public appearances due to threats of violence. No, they are placed on "watchlists,"[6] their words are taken out of context and circulated on right-wing media, and they are then harassed with intimidating attempts to silence their voices as soon as the public begins to take note of their message.[7] Moreover, as K-Sue Park observes, even liberal-leaning civil liberties organizations, like the ACLU, fail to protect the free speech rights of historically marginalized groups and individuals when they define and defend the First Amendment in narrow and neutral terms.[8]

This film is correct in suggesting a "creeping authoritarianism" is on the rise. But it is not coming from comedy audiences or college campuses. White supremacists and neo-fascists have been emboldened in the era of Trump, in Charlottesville and beyond, and are even defended by organizations like the ACLU.[9] Trump jokes about police brutality, pardons racist police officials, and further militarizes the police. And while this film was produced prior to the Trump election, it fits squarely in the Trump-era narrative. The film's mostly middle-aged white comedians display their rehearsed outrage as they yearn for the days when they could use words like "nigger," "cunt," and "faggot" unapologetically and without fear of losing a booking or airtime. Such sentiment channels Trump's disregard for "political correctness" and his nostalgic white supremacist mantra "Make America Great Again."

Counterculture comedians of the 1960s and 1970s routinely used obscenity, but not for its own sake. It was often in the service of social justice. Bruce, like Dick Gregory and Richard Pryor, made use of racial slurs to critique racial segregation, militarism, and the racism of white liberals, as in his famous bit "How to Relax Your Colored Friends at

Parties." Bruce wasn't "censored" merely because he was "obscene" (segregation, police brutality, the KKK, and the war in Vietnam were far more obscene), and he wasn't censored by the audience. In fact, audiences enjoyed what he had to say because figures like Bruce were publicly exposing the myths and hypocrisies of a racist, sexist, imperialist, and undemocratic society. Comedians like Bruce consciously exercised a comedy that "punched up" at those with social, political, and economic power, in contrast to the kinds of jokes that "punched down" and ridiculed those with little to no power and privilege. But you wouldn't know it from watching this film.

Notes

1 Julia Serano, "That Joke Isn't Funny Anymore (and It's Not Because of 'Political Correctness')," *Medium*, August 18, 2015, https://medium.com/@juliaserano /that-joke-isn-t-funny-anymore-and-it-s-not-because-of-political-correctness -469b92312536.

2 Aaron Blake, "The Politicization of Adam Carolla," *Washington Post*, August 29, 2017, www.washingtonpost.com/news/the-fix/wp/2017/08/28/the-politicization-of -adam-carolla/?tid=sm_fb&utm_term=.271b6ee725e2.

3 Wendy Moore and Joyce Bell, "The Right to Be Racist in College: Racist Speech, White Institutional Space, and the First Amendment," *Law & Policy* 39, no. 2 (2017): 99–120.

4 Moira Weigel, "Political Correctness: How the Right Invented a Phantom Enemy," *Guardian*, November 30, 2016, www.theguardian.com/us-news/2016/nov/30 /political-correctness-how-the-right-invented-phantom-enemy-donald -trump.

5 Greg Lukianoff, "The Story Behind the New Documentary 'Can We Take a Joke?'," *Huffington Post*, August 11, 2016, http://www.huffingtonpost.com/entry/the-story- behind-the-new-documentary-can-we-take a_us_57aca5ade4b08c46f0e4df6f.

6 Christopher Mele, "Professor Watchlist Is Seen as Threat to Academic Freedom," *New York Times*, November 28, 2016, www.nytimes.com/2016/11/28/us/professor -watchlist-is-seen-as-threat-to-academic-freedom.html?mcubz=3.

7 Keeanga-Yamahtta Taylor, "The 'Free Speech' Hypocrisy of Right-Wing Media," *New York Times*, August 14, 2017, www.nytimes.com/2017/08/14/opinion/the-free -speech-hypocrisy-of-right-wing-media.html?mcubz=3.

8 K-Sue Park, "The A.C.L.U. Needs to Rethink Free Speech," *New York Times*, August 17, 2017, www.nytimes.com/2017/08/17/opinion/aclu-first-amendment -trump-charlottesville.html?mcubz=0&_r=0.

9 Ibid.

The Bridge and Unteachable Films

JENNIFER MALKOWSKI

"What if one of my students kills themselves because I screened this film?"

This thought kept me up at night sometimes when I was a graduate student instructor at UC Berkeley. I had screened *The Bridge* (2006), a documentary I was writing about in my dissertation, for an undergraduate class. To make the film, director Eric Steel set up two camera stations overlooking San Francisco's Golden Gate Bridge and kept them running, staffed continuously by camera operators, for every daylight minute of 2004. During that time, he recorded footage of most of that year's twenty-four suicides off the bridge.[1] Via extreme telephoto camera lenses, these suicides are depicted in *The Bridge* in detail. The jumpers' facial expressions are visible as they climb the railing, as are the subtleties of their flailing limbs and flapping clothes when they rapidly descend.

Viewers may feel moral outrage at Steel or acute empathy for the jumpers during *The Bridge*, but I would not categorize this film as viscerally "unwatchable." As I have written about in *Dying in Full Detail: Mortality and Digital Documentary*, its aesthetic and narrative techniques make it surprisingly watchable (especially compared to other material I researched about people dying on camera).[2] The towering splash that

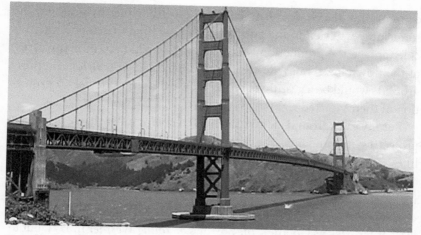

One of *The Bridge*'s most restrained displays of suicide: a wide shot of the site, with a jumper's small splash.

ends each fall shields the viewer from the sight of bodily violence, there is no graphic footage of corpses, and the film ends with the most graceful jump the production recorded—preceded by an interviewee's verbal framing of that suicide, "maybe he just wanted to fly one time."

What I've decided about *The Bridge*, though, is that it is unteachable.

What qualities make a film unteachable? By "unteachable," I'm not referring to films that are pedagogically unproductive or just really crappy. I'm referring to films we make an ethical choice not to teach. We all have our own standards, and these standards can spark debate. Some consider *Birth of a Nation* unteachable, for example, because of its horrific racism and the pain that racism might cause to students of color. Others continue teaching it, in part to demonstrate that conventions we still use in film today are intertwined with American ideologies of racism.

The Bridge might be unteachable for some purely because of its violation of documentary's "informed consent" practices. These informal professional guidelines dictate that people recorded for a documentary production should consent to their recording, and they should do so with a reasonable understanding of the project and the possible effects of their participation in it. When unanticipated deaths occur in front of cameras, of course, there is no opportunity for traditional informed

consent. But *The Bridge* also violated these guidelines by interviewing some jumpers' friends and families without telling them about the suicide footage the production was collecting—including, in many cases, of their own loved ones' deaths. To refuse to teach *The Bridge* on these grounds would be a gesture of respect toward its interviewees, a protection of their violated rights.

But my own grounds for declaring *The Bridge* unteachable are about protecting my students. The film violates not just documentary guidelines for informed consent, but also media guidelines for preventing "suicide contagion." This well-researched phenomenon involves an increase in suicide rates among people exposed to certain kinds of suicide representations and inspired to imitate them.[3] Its origins stretch at least as far back as Goethe's *The Sorrows of Young Werther* in 1774, but to provide a recent example, fears about suicide contagion put school officials and mental health professionals on high alert after Netflix's 2017 release of *13 Reasons Why*.[4] This teen drama spends a whole television season picking through the details of one beautiful girl's suicide, graphically depicting that suicide, and romanticizing its effects. Although no direct link has yet been proven between the show and any individual suicide committed in its wake, researchers documented an approximately 20 percent increase in Google searches for suicide-related phrases like "how to kill yourself" in the weeks after the show's release.[5]

The representational elements that increase the likelihood of suicide contagion include going into detail about the method of a suicide, depicting its location, fixating on an individual person who committed suicide, and romanticizing the act (e.g., *The Bridge*'s framing of a fatal fall as "flight").[6] *The Bridge* arguably does all of these things, and its status as nonfiction media gives it an even higher chance of motivating suicides, according to research on contagion.[7] As I learned more about these imitation effects while writing about *The Bridge*, I felt increasingly anxious that I had screened the film for a group of college students just across the bay from the Golden Gate Bridge itself. I hoped it would help that I dismantled the film's romanticization of these quite grizzly deaths in my lecture, and that we discussed the ways *The Bridge* might still be used to advance activist efforts to install a suicide barrier at the site. But I knew that I had to stop teaching *The Bridge*, whose viewing carried such unusually severe potential consequences, which could

not necessarily be mitigated with a warning before the screening. While I don't actually *like* this film personally, I mourned the loss to my future courses of a text that could spark such productive debates about documentary ethics and aesthetics—and one that my research had prepared me to teach about expertly. Even if it sounds paranoid, though, I care more about protecting students who might be vulnerable to suicidal ideation than I do about designing the perfect course.

In recent years, battle lines have been drawn about issues like this one, where a conflict exists between a text's educational value and its potential effect on students. The trigger warning wars have pitted students against professors, falsely opposing the former group's desire for self-protection from disturbing course content against the latter group's ability to teach whatever is most educational. Reporting on trigger warnings has reinforced this oppositional dynamic, imagining a zero-sum game wherein professors "lose" by considering student well-being when choosing course materials or how to present them.

My own feelings about trigger warnings remain complex, but have shifted considerably in recent years.[8] I provide them routinely now in a few categories, posted to a document on the course website that covers everything we're scheduled to read, watch, play, and so on. I tell students in our first session that it's their responsibility to consult this document if they would like content warnings. That's the last I say about it for the semester. I usually hear nothing further from my students about the disturbing content I teach, other than an occasional thanks in teaching evaluations for providing this system. As one student put it, a system like this (or one even more basic) is all that students are usually asking for: a warning so that those struggling with trauma can prepare themselves and engage fully with the text, not a pass to get out of doing work or avoid feeling disturbed.

When I started to resist the prevailing rhetoric about trigger warnings and allowed myself to feel somewhat accountable for student well-being, I realized that there are some simple but powerful ways to protect my students psychologically while still challenging them intellectually. My syllabi are still frequented by disturbing films—*Night and Fog, The Arbor, Caché, S-21, Blue Velvet*, and so on. But offering basic warnings and very rarely discarding a text like *The Bridge* as ethically "unteachable" has gone a long way to satisfying student concerns.

My case study about suicide contagion and *The Bridge* underscores a sobering reality of teaching that some educators don't want to admit is weighing on our shoulders: the things we ask our students to watch actually can have substantial and harmful psychological effects on them. It is indeed rare for those effects to carry life-or-death stakes, as they do with suicide contagion. But I hope this extreme example helps intervene in wrongheaded dismissals of trigger warnings and sensitive millennial snowflakes.

Notes

1 The production also prevented some suicides when camera operators called the bridge patrol to alert them to potential jumpers.

2 Jennifer Malkowski, *Dying in Full Detail: Mortality and Digital Documentary* (Durham, NC: Duke University Press, 2017), 109–154.

3 Danuta Wasserman and Camilla Wasserman, eds., *Oxford Textbook of Suicidology and Suicide Prevention: A Global Perspective* (Oxford: Oxford University Press, 2009), 515–522; Ronald W. Maris, Alan L. Berman, and Morton M. Silverman, eds., *Comprehensive Textbook of Suicidology* (New York: Guilford, 2000), 254–256.

4 Sophie Gilbert, "Did *13 Reasons Why* Spark a Suicide Contagion Effect?," *Atlantic*, August 1, 2017, www.theatlantic.com/entertainment/archive/2017/08/13-reasons-why-demonstrates-cultures-power/535518/.

5 John W. Ayers, Benjamin M. Althouse, Eric C. Leas, Mark Dredze, and Jon-Patrick Allen, "Internet Searches for Suicide Following the Release of *13 Reasons Why*," *JAMA Internal Medicine*, July 31, 2017, http://jamanetwork.com/journals/jamainternalmedicine/article-abstract/2646773.

6 American Foundation for Suicide Prevention, "Reporting on Suicide: Recommendations for the Media," www.afsp.org/wp-content/uploads/2016/01/recommendations.pdf.

7 Wasserman and Wasserman, *Oxford Textbook of Suicidology*, 520–521.

8 For more on my misgivings about trigger warning culture, see Malkowski, *Dying in Full Detail*, 16–18.

Squirming in the Classroom

Fat Girl *and the Ethical Value of*
Extreme Discomfort

KATARIINA KYRÖLÄ

This essay sets up a parallel between two (by now) widespread ways to call for or claim unwatchability: censorship and so-called trigger warnings. My starting point is that the refusal or the prohibition to watch might sometimes not protect at all from what it is meant to protect from. Paradoxically, the gesture of averting one's eyes or covering one's ears can reproduce or even enforce a traumatic reaction. Just ask yourself: have you ever been haunted by what you have *not* seen, or only caught a glimpse of before looking away? A refusal to watch— whether planned and intentional, or a gut reaction in the moment— means you are already deeply affected by the image. And unless you also succeed in blocking out the sounds, they may conjure terrifying images in your mind's eye. What is at stake is not actually the image itself but one's fantasy of it, possibly worse than what actual viewing would be. As queer film theorist Patricia MacCormack has noted in relation to extreme horror, "Even if the eyes are shut, the body is reacting."[1]

Indeed, there can be great ethical value in enduring and staying with extreme discomfort, to keep engaging, even when and sometimes especially when that discomfort derives from portrayals of gendered,

Anaïs Pingot (Anaïs Reboux) in the final shot of *Fat Girl*.

sexualized, and/or racialized abuse and violence—rather than take such discomfort as a sign of an ethical need *not* to engage. I am not categorically against or for censorship or trigger warnings but see them as serving various purposes in various contexts.[2] In this essay, however, I ask if a refusal, a ban, or otherwise denied engagement based on a (potential) affective reaction can actually dramatize that reaction and obscure other issues that should require attention.

This question concretized in my experience of teaching the film *Fat Girl* (*À ma soeur!*, 2001), directed by Catherine Breillat. I screened the film for a course on theorizing the relations between media and the body that I taught in Finland in the spring of 2015. The course syllabus included trigger warnings—however, not as warnings about course content, but as a topic. The students read blog posts for and against trigger warnings, as well as the main points of an empirical study by Martin Barker and his research group, who had been commissioned by the British Board of Film Classification (BBFC) to study audience reactions to five films that included sexually violent content.[3] One of those films was *Fat Girl*. The students were then asked to compare their own reactions and reflections to those of Barker and his group's respondents, as well as to form an opinion of whether trigger warnings or censorship were necessary in relation to the film.

Most of the students had not heard of trigger warnings before. However, the debates about depicting rape on film and television were a

topic familiar to many of them, with TV series such as *Game of Thrones* (2011–) attracting attention for "excessive" or "gratuitous" use of rape scenes as a narrative device. Also, *Fat Girl* ends in a notorious rape scene that has been the film's most debated feature and was censored in some countries.[4] In this scene, a twelve-year-old girl, Anaïs (Anaïs Reboux), is raped in the woods by a nameless male attacker after he has brutally killed her sister with an axe and strangled her mother at a rest stop by a highway. Afterward, Anaïs claims to the police that she was not raped, and the film ends in a long freeze frame of her face, while cheerful guitar music starts playing and continues in the background of the credits. Otherwise, the murder and rape scene has only the sounds of struggle and eerie ambient noise of highway traffic. The scene can be interpreted to promote the deeply sexist idea that women who are raped actually "want it," but as Catherine Wheatley has suggested, it also alludes to broader problems in distinguishing between coercion and seduction within normative heterosexuality.[5]

In the course, the students were given access to the censored version of the film, and separately to the rape scene (which is about five minutes long). I did not require them to watch the rape scene, but all of them chose to do so. They were, however, required to reflect on what kind of an ethical engagement a refusal to watch could and could not be. Most students articulated their extreme discomfort while watching the film, but they also claimed that this was exactly how it should be, since sexual abuse and violence on-screen should make the viewer squirm—that is how the body reacts ethically. Since they viewed the rape scene after having seen the censored film, they were in agreement that the scene was "not as bad" as they had imagined it might be.

Instead of the rape scene, many of the students wanted to discuss the more insidious sexual abuse elsewhere in the film, particularly a lengthy scene earlier in the film where a young man (Libero De Rienzo) pressures Anaïs' fifteen-year-old sister Elena (Roxane Mesquida) to have sex with him, with Anaïs in the room. To the students, it seemed hypocritical that the scene that directly portrayed rape was censored while the scene about blurry consent was not even an issue, as the two scenes seemed purposefully parallel to each other. They also echo each other audiovisually: both feature a prolonged medium close-up shot of the "couple," with the unmoving camera on their right side,

without any non-diegetic sound, as if the scene were unfolding in real time in front of the frozen viewer. The very long scene (about twenty-five minutes) with Elena, where sexual persuasion gradually turns into coercion, allows only a brief moment of apparent release when the camera moves to Anaïs's face as the young man presumably penetrates Elena. The viewer sees Anaïs's blank face but hears the sounds of Elena's screams, shortly replaced by the man's moans of pleasure. In my own viewing experience, however, the shift in the camera's view only opened up space for even more disturbing images, memories of similar dynamics perhaps having been played out on my body at some point in my life, instead of making the viewing experience any easier. Many of the students commented that the viewer had to see both of the two scenes in order to understand the juxtaposition, and I wholeheartedly agreed.

We also discussed how censorship as well as trigger or content warnings seem to address only relatively easily identifiable things represented in an easily identifiable way, like rape depicted as a shocking act of violence by a stranger in the woods, but not more subtle scenes or structures of abuse. At least the rape scene in *Fat Girl* was clearly about rape and the coercion scene was clearly meant to make viewers squirm. In contrast, a lot of films and TV series have scenarios where a male hero forcefully kisses a woman who, after struggling for a bit, "melts" into the kiss and the "seduction"—one classic example being the kiss that Han Solo forces on Princess Leia in *The Empire Strikes Back* (1980), disregarding her requests to stop, with romantic music swelling in the background. In these much more common instances, the framing is that of a sweet encounter and the audience is even expected to go "awww ." In *Fat Girl*, we all agreed, there were absolutely no "awww" moments.

The comparisons with other viewers' reactions, obtained through Barker et al.'s empirical research, made it easier to take some distance from one's own affective reactions, think through their background and potential effects, and avoid the trap of elevating singular personal experiences to anecdotal evidence of how the "audience" perceives the film. This brings us back to the trigger warning debate: how both the pro–trigger warning side and the anti–trigger warning side have been accused of an overemphasis on interiority and the personal, a me-me-me attitude. The pro–trigger warning side has been criticized for idealiza-

tion and overemphasis of individual victimhood; the possibility of some individuals being traumatized overrides a broader possibility of discussing difficult and hurtful matters in a productive way.[6] The anti–trigger warning side, however, has also been seen to demand individual responsibility for the ability to deal with offensive or disturbing material, and to learn enough tools to cope.[7] Without drawing on empirical studies of how different viewers actually react to and reflect on media products, it is too easy to make policies and claim injury based on *figures* of traumatized audiences. Barker et al.'s study showed, for example, that the BBFC had made its censorship or "unwatchability" decisions based solely on "Refuser" responses, ignoring "Embracers" who saw transformative ethical value in extreme discomfort.[8]

The language of trigger warnings, just like the language of prohibition, should be seen as performative. Through the circulation and repetitive framing of certain kinds of scenes as triggering, traumatizing, or "unwatchable," they also become *experienced* as traumatizing. This is not to say that the experiences are not real, deeply felt, and worth taking seriously. But this short reflection on teaching in a context where trigger warnings were *not* (yet) an issue raises uncomfortable questions about the degree to which the very discourse of triggering can produce figures of (potentially) traumatized audiences, and construct specific kinds of scenes as traumatizing, while ignoring the simultaneous coercion and seduction in others.

Notes

1 Patricia MacCormack, "Pleasure, Perversion and Death: Three Lines of Flight for the Viewing Body" (PhD diss., Monash University, 2000), 140.

2 For more discussion on why an against-or-for approach is not productive in my view, see Katariina Kyrölä, "Toward a Contextual Pedagogy of Pain: Trigger Warnings and the Value of Sometimes Feeling Really, Really Bad," *Lambda Nordica: Nordic Journal on LGBTQ Studies* 1 (2015): 131–144, www.lambdanordica .se/wp-content/uploads/were-here2.pdf.

3 Martin Barker et al., *Audiences and Receptions of Sexual Violence in Contemporary Cinema* (Aberystwyth: University of Wales, 2007); Jack Halberstam, "You Are Triggering Me! The Neoliberal Rhetoric of Harm, Danger and Trauma," *Bully Bloggers*, July 5, 2014, https://bullybloggers.wordpress.com/2014 /07/05/you-are-triggering-me-the-neo-liberal-rhetoric-of-harm-danger-and -trauma/; Valéria M. Souza, "Triggernometry," *It's Complicated*, May 21, 2014, http://valeriamsouza.wordpress.com/2014/05/21/triggernometry/.

4 For a summary of the academic discussion around *Fat Girl* and its depiction of rape, see Catherine Wheatley, "Contested Interactions: Watching Catherine Breillat's Scenes of Sexual Violence," *Journal of Cultural Research* 14, no. 1 (2010): 27–41.

5 Ibid., 28.

6 E.g., Halberstam, "You Are Triggering Me!"

7 E.g., Natalia Cecire, "On the 'Neoliberal Rhetoric of Harm,'" July 7, 2014, http://nataliacecire.blogspot.fi/2014/07/on-neoliberal-rhetoric-of-harm.html.

8 See also Martin Barker, "The Challenge of Censorship: 'Figuring' Out the Audience," *Velvet Light Trap* 63 (2009): 58–60.

15

The Triggered Spectator

One of the arguments against requests for "trigger warnings" is that one cannot anticipate what kinds of representations will provoke intense responses in a viewer. The authors in this chapter vividly illustrate this point, describing varied experiences of being grabbed by a particular combination of sounds and images, often when they least expect it, and being thrown out of their everyday lives, their spectatorial habits, and even their senses of self. The media genres and forms that spark these experiences are eclectic and unpredictable, ranging from art films to pharmaceutical ads, and from cooking shows to opening credit sequences.

Feminist film scholar E. Ann Kaplan describes her experience of watching, often through her fingers and with tears running down her cheeks, the disintegration of the female protagonists of *Amour* (2012) and *Still Alice* (2014) due to dementia. Turning to cultural critic Barbara Creed, Kaplan analyzes her feelings of unbearable closeness to these on-screen women as they struggle with losing their language and identity. Filmmaker and visual artist Barbara Hammer, who is living with cancer, is set off by far more banal media—namely, the pharmaceutical ads aimed at older audiences that show flitting butterflies and laughing "white-hairs" while speed-talking through the side effects. In a poetic polemic drawing from feminist disability studies, Hammer rejects the use of military metaphors in conceptualizing cancer.

Samuel England, an Arabic literary scholar, is largely bored by cooking shows until a Sunni Egyptian chef, sparked by prank callers, launches into impromptu anti-Shi'i tirades before returning to his calm and controlled food preparation. But whether the chef's tirade or the cynical excerpting of these moments by the U.S. right-wing Middle East Media Research Institute is more triggering, England leaves open. Performance studies scholar Rebecca Schneider tries to understand why she finds the scene of a fox being eaten by maggots in the title sequence of *True Blood* (2008–2014) so unwatchable. Discovering unexpected resonances with a traumatic family experience, Schneider theorizes uncanny kinds of "unwatchables" that may have been seen but not recognized, that slip in through a side door regardless of whether the viewer is on watch, off watch, or in the dangerous time in between.

What Is an "Unwatchable" Film?
(With Reference to *Amour* and *Still Alice*)

E. ANN KAPLAN

How can one approach the fascinating issue of a film being "unwatch-able"? I am the right person to ask since I am an incredibly vulnerable watcher of films. Quite regularly, I have to look away from the screen, put my thumbs over my ears while my fingers cover my eyes. I may try to sneak a peek, as it were, but if it gets too bad, I have to leave the room. Other films cause hairs on my arms to rise, or leave me with tears streaming down my face. But it's clear that this is a very personal kind of response. My husband, sitting next to me, has no such reactions and seems able to tolerate whatever the screen offers. So "unwatchable" is a subjective category, depending on who one is, one's age, one's personal (and psychic) history, one's gender (I suspect), and one's kind of sexuality, among many other such specifics.

My interest in social transformation long guided me toward scholarly methods focused on ideology and psychoanalysis. I was drawn to films critiquing the status quo and often using experimental techniques. Psychoanalysis provided insight into unconscious individual and collective social mechanisms by which male dominance in cinema

Still from *Still Alice*.

prevailed long after feminist movements and scholarship had revealed women's secondary status across many cultures and diverse groupings. However, turning to trauma studies in the 1990s led me to think about images of catastrophes in socially conscious films as "unwatchable" and to theorizing such unwatchability.[1] My interests focused on the question of empathy and vicarious trauma for the plight of those struck by disasters of various kinds: I asked whether images promoted empathic engagement in viewers or whether on the contrary they elicited secondary trauma. Such images, I theorized, perhaps turned spectators away because of a sort of compassion fatigue.

In this essay I want to contrast the kind of unwatchability in films about people suffering disasters or various forms of oppressions with a different reason of turning away from the screen. Instead of vicarious trauma or a haunting by images of people caught up in tragic historical events, now I turn away from films I study that deal with memory loss from dementia or brain damage. I'll explain the different psychological mechanisms at work in the two kinds of challenging images that make me put fingers over my eyes, alternately peeking through my fingers and shutting my eyes tightly. It's fascinating that in these cases (I'll be referring to Richard Glatzer and Wash Westmoreland's *Still Alice* [2014] and Michael Haneke's *Amour* [2012]), it's *not* because of empathic

overload, but because now "unwatchable" has to do with my very subjectivity being put on the line.

My first example is the scene at the end of *Still Alice*. Throughout this family melodrama we have watched Alice (Julianne Moore) gradually succumb, by slow stages, to Alzheimer's disease. Alice, a linguistics professor, has been brave for most of the time, as she first loses her way jogging on campus, fumbles a lecture, loses her job, and remains at home looked after by her family. In the end, Alice is cared for by the one child, Lydia (Kristen Stewart), with whom she was originally somewhat at odds with. It is the scene with this child at the end of the film that I could not watch. How does it create such an impact?

The scene starts with Lydia and Alice sitting on a park bench, shot in medium close-up. We hear sounds of children's voices, the wind, and very faintly a pop song. Alice has a blank, sad face, and seems distracted, lost. It's clear that she cannot focus on where she is or whom she's with. Lydia tries to connect with her, but Alice can't manage speaking and leans on Lydia like a child. Once home, there's silence. Alice can't recognize the housekeeper: "I don't know you," she says. We cut to Lydia in close-up facing Alice, with a countershot to Alice also in close-up, as the theme music (just piano and strings) starts softly, evoking sadness (as it has done throughout the film). Lydia, now shot from the side, book just in view, reads an evocative text from *Angels in America* dealing indirectly with death but also with renewal. There's only intermittent music as she reads. As she comes to an end, she is shot looking directly at Alice but essentially at the camera: Thus, she's also looking directly at me, the viewer, situated *as Alice*. Lydia asks if Alice liked what she heard. We see her mouth move, we hear her make noises, but barely words. What I found almost unbearable was being asked to look at Alice struggling to speak. Tears streamed down my face, and I had to look away. This was not only because of the unutterable sadness the sequence evoked in me, but because I was threatened by Alice seeming no longer to be a subject, *not to be there*.

Lydia finally gathers that Alice has said "Love." It's understood that the two are talking about their love, which, paradoxically, has developed from their difficulties, to this new way of being together. It offers a small measure of hope, but we know Alice will only get worse.

My second example comes from Michael Haneke's *Amour*. Stylistically, if not via content, *Amour* qualifies as a horror film. Readers will recall the violent opening to the film that totally shocked me, as the sequence ends with the camera resting on the body of a woman embalmed with flowers. The film then flashes back to show us what led up to this. The apparently comfortable life of a couple of retired professors, Anne (Emmanuelle Riva) and Georges (Jean-Louis Trintignant), living in Paris, is totally upset by Anne's suffering a minor stroke one morning at breakfast. Anne returns home from the hospital a changed woman, now in a wheelchair, with much of her body paralyzed.

From this point on, the film is basically unwatchable. Anne's condition leaves her finally bedridden, unable to speak, drink, or eat. Haneke is ruthless in wanting to make sure the viewer fully engages in the suffering of both Anne, enduring increasing symptoms of the stroke, and Georges, increasingly desperate seeing his lifelong partner suffer bodily indignities and mental struggles produced by the illness.

In one excruciating scene, without extradiegetic sounds (we just hear Georges's words), Anne is in bed, and Georges brings her food. The camera holds still for what seems an eternity in a medium-shot as Georges tries to push the sauce into Anne's reluctant mouth. I could only watch through my fingers. With each new attempt, I felt sickened. It was too much to identify with someone who is losing language, and whose memory too is failing. Anne finally refuses to eat or drink. A related scene soon after shows Georges trying to get Anne to join him in singing "Frère Jacques." Anne's struggle to shape the words reminded me of Alice struggling to speak. Haneke insists on repeating the efforts, holding the scene longer than I could bear. Anne struggles against all odds to shape her mouth and to speak the song's words, but fails to do more than mumble. Without language or coherent memory, Anne's self appears to disintegrate.

In a scene worthy of a horror film, Georges gets up at night, hearing a noise; he opens the apartment door to find water outside. As we wonder what's going on, a hand emerges out of nowhere and appears to suffocate Georges. Both times I saw the film in a theater, I gasped out loud, and heard the entire audience gasp along with me. The shock of the suffocating was shattering. Clearly, Haneke is showing Georges's identification with Anne, more or less suffocating from the paralysis, as

well as preparing the audience for George's ultimate suffocation of his wife in what he considers a "mercy" killing.

Despite their vastly differing strategies, both films shook me to the core. Barbara Creed strangely offers help in understanding the process while making arguments about the "monstrous-feminine" in horror film. Largely relying on Kristeva's theory of abjection, Creed does a terrific job in showing how it is fears of female sexuality, reproduction, and motherhood that drive images of utter abjection, revealing the nasty, putrid, bloody emissions from the female body—horrific yet fascinating. In the case of my films, it is dementia that renders the female protagonists abject.

In the course of her argument, Creed suggests what may underlie the unwatchability of both *Amour* and *Still Alice*.[2] She argues that, unlike other classic movies, "the horror film does not work to encourage the spectator to identify continually with the narrative action."[3] Instead, Creed suggests that filmic processes are undermined, challenging the spectator "to run the risk of continuing to look." According to Creed's theory, the horror film punishes the spectator for her voyeuristic desires. She suggests adding a new look to the ones of established feminist film theory—this being the act of "looking away"—the look that I have been talking about above. According to Creed, the sight of the monstrous puts the viewing subject's sense of a unified self into crisis: "Boundaries, designed to keep the abject at bay, threaten to disintegrate, collapse."[4] The only way the spectator can "reconstruct the boundary between self and screen" is to look away, not look, and attend to reconstructing the subjectivity which is threatened with disintegration. This is a very different psychic process than compassion fatigue, which involves a viewer haunted by the traumas of others, but keeping her subjectivity intact.

Amour eschews all sentimentalism, insists the viewer watch Anne's decline head-on, step-by-step. I am asked to consider severe stroke and resulting paralysis from Haneke's point of view. This view constructs the illness as a devastating horror that should not be endured. The family melodrama *Still Alice* draws upon well-tried Hollywood strategies to grab the spectator's emotions, resulting in unbearable sadness, such as to incite me to look away. But instead of the sadness and fear I experienced in watching Alice decline, in *Amour* I was sickened by

George's desperate effort to free his wife from her seemingly intolerable situation. How could anyone smother a loved one?

The causes for "unwatchability" vary according to the subject watching, the cinematic genre and its stylistic strategies, and, I would add, one's historical moment. In the case of the movies I address, the context is one of increasing numbers of people living longer so that cases of dementia and stroke are on the up and up. It's no accident that many films about dementia feature female protagonists. Five million women are said right now to suffer from one or another kind of dementia. As the baby boomer generation ages, these numbers will grow. If the films have helped me struggle with my desire *not* to look, not to know, thereby in fact *having to "know"* in part, they will have done us all a service.

However, we also need films about dementia that *are* watchable. The sadness and horror in *Still Alice* and *Amour* arise partly from the problematic attitude both films take toward dementia and illness. That's a story that, along with others, I tell elsewhere.[5]

Notes

1 E. Ann Kaplan, *Trauma Culture: The Politics of Terror and Loss in Media and Literature* (New Brunswick, NJ: Rutgers University Press, 2005); E. Ann Kaplan and Ban Wang, eds., *Trauma and Cinema: Cross-Cultural Explorations* (Aberdeen and Hong Kong: Hong Kong University Press, 2008).
2 Barbara Creed, *The Monstrous-Feminine: Film, Feminism, Psychoanalysis* (London: Routledge, 1993). Creed builds on the few feminist film theorists thinking about the viewer's emotions and anticipates those to come. See humanities research by Eve Kosofsky Sedgwick, Lauren Berlant, Ann Cvetkovich, Elspeth Probyn, Sara Ahmed, Sianne Ngai, Greg Seigworth, Melissa Gregg, and more.
3 Creed, *Monstrous-Feminine*, 28.
4 Ibid., 29.
5 See films, articles, and books by Margaret Gullette, Kathleen Woodward, Leni Marshall, Ulla Kriebernegg, Sally Chivers, myself, and more, which offer alternative views that encourage hope with new strategies for care in long-term facilities.

Watch at Your Own Peril

BARBARA HAMMER

There are many reasons TV audiences are shrinking—the barrage of advertisements tops the list. For those of us who still watch the nightly network news, we very quickly figure out that the ads are geared toward the aging population. These geriatric-focused ads don't reflect us sitting in comfy chairs or lying on our beds, exhausted from a day's work. No, they show glamorous "white-hairs" romping with children and dogs because they've taken one of the drugs advertised. These ads speed through the side effects, but we do learn there are many. Once we've heard them, we'd be a big risktaker to try the new drug that promotes sleep, but could also cause this and this and this . . . and the list goes on. We are left to wonder if the new drug also produces the butterflies that hover over the bed in the ad. These unwatchable and annoying TV ads that precede and interrupt the news programs night after night make me sick—and I already am living with cancer.

When the ads turn to drugs for cancer patients, we see people in full makeup with flattering studio lighting and the proper, somber music to introduce a new treatment. The numerous, nearly uncountable side effects then take center stage. The patients using these drugs are described as heroes for doing everything they can on the battlefield as they fight the

Photo by Hannah Ensor.

war on cancer. This is as misleading and unrealistic as the glossy feel-good advertisements.

Let me tell you:

CANCER IS NOT A BATTLE.
CANCER IS A DISEASE.

THERE IS NOT A WAR ON CANCER.
THERE IS CONCENTRATED RESEARCH.
CANCER HAS NOTHING TO DO WITH THE MILITARY.
MILITARY LANGUAGE IS MISLEADING AND WRONG.
THERE ARE ABERRANT CELLS NOT DEADLY FOES.

SHE IS NOT A SURVIVOR.
SHE IS LIVING WITH CANCER.
SHE IS NOT COMBATIVE AND BRAVE.
SHE IS LIVING WITH CANCER.

SHE IS NOT A HERO.
SHE IS LIVING WITH CANCER.
SHE IS NOT GOING TO "BEAT" CANCER.
SHE IS NOT A WARRIOR.
SHE IS NOT GOING TO WIN OR LOSE HER BATTLE.
SHE IS NOT SHERMAN, CHURCHILL, OR BRADLEY.
SHE IS NOT LEADING ANY FIGHT.
SHE'S NOT IN ALEPPO, RAMALLAH, OR ODESSA.

NO ONE IS GOING TO CONQUER CANCER.
NO ONE IS WAGING A WAR AGAINST CANCER.
IT'S NOT A BATTLEGROUND, IT'S A HOSPITAL.
DON'T BUY A WAR BOND, SUPPORT CANCER RESEARCH.

Sects, Fries, and Videotape

SAMUEL ENGLAND

I watch a huge number of cooking shows and enjoy almost none of them. It has become a years-long ritual of family life for me, far from torturous but not my first choice of activity. It ranks a little below pruning bushes, a little above taking the dog to obedience class with a pouch full of smelly, giblet-based treats. My wife loves the brilliantly lit studio kitchens, the welcoming theme songs, and the quips that the chefs make to themselves about curry paste, as if the audience were party to a private joke. I like melting into the sofa, gazing past the TV, not quite focusing my eyes, content in the knowledge that, even though I like to cook, I'll never need to retain any of the advice they offer so sincerely while their professional-grade Cuisinarts hum away.

So far I haven't found a way to become a good student of food television, but I made one important step forward in recent years, when I started watching the Egyptian cooking show *Sufra Dayma* (a phrase with which one thanks a host for preparing a meal, or simply wishes fellow eaters *bon appétit*). Before that point, everything about the genre had appeared to me as instruction without an event. Professionals talk about cooking, talk about food, compare tastes, test my patience, whet my appetite, and somehow nothing appears in my own kitchen, ready for me to eat and astonish guests with. Then, one day, what had been, for me,

Receiving an inflammatory call on the air, Chef Mohamed Fawzy prepares himself for a battle over religion and rhetoric.

unwatchably boring became riveting, disturbing, and, after many replays, unwatchably violent.

Credit for shaking me out of my stupor goes to the Middle East Media Research Institute (MEMRI), a U.S. right-wing organization based in Washington, D.C., with unspecified "branch offices in various world capitals."[1] A few years ago, I stumbled upon an online video from an Egypt-based satellite television company, which MEMRI had subtitled and featured on its Web site. The clip splices together two excerpts of *Sufra Dayma*, in which the show's normally jovial host, Mohamed Fawzy, excoriates a prank caller.

I found myself watching and rewatching the three minutes of Arabic excerpts, their style part Jacques Pépin, part Jerky Boys. Then I sought out uncut episodes hosted by Fawzy. He is a middling celebrity in Egypt. His official Facebook page has fewer than a quarter of the followers that the major Egyptian cooking shows enjoy. Still, he looms large, both in the American neoconservative imagination of the Middle East and in my own perception of what television can be. My *Sufra Dayma* binge now finished, I fantasize about cutting myself off from all MEMRI clips. But this organization is relentless: I have found about sixteen hundred videos on the MEMRI Web site, and it reposts some of them on a popular YouTube channel.

Watch almost any of Fawzy's episodes and his soothing studio presence might lull you into a deep, apolitical slumber. He narrates his techniques as clearly as a motivational speaker, but he speaks tenderly to the viewer, so that his words almost dance with the miked-up chopping sound of his knife. He pauses at times, adjusting his gleaming white chef's outfit while looking directly into the camera, making sure we know he's staying with us, even if we've failed to clarify our butter and our kitchen is currently filled with smoke. Things are fine. People call in with questions. Fawzy cordially gives them titles like "Effendi" and "Mademoiselle" (*mazmazeel* in Egyptian dialect) to show his warm sense of TV hospitality. He trades compliments with them, acknowledges their powers of perception in noticing that the honey in a honey cake could indeed liquefy too quickly. How to avoid that? It's simple, really. Three steps to a perfect crust. I nod along.

The film and media theorist Mary Ann Doane established a language for understanding this kind of earnest, explanatory chef's work.

"Information, Crisis, Catastrophe," her model of television and the title of her 1990 essay, would suggest that chef-hosts dwell in the informational moment. And that's the problem for me. In the archetypal cooking show, Doane's invigorating notion of crisis (the discrete time at which televised people and audience members must make important decisions, oftentimes political) becomes something closer to "Hot or smoky paprika? Well, it depends on who's going to eat these croutons!" All the rarer is any hint of the communal emoting that she associates with catastrophe. TV news and dramas broadcast train derailments, family disintegrations, former football stars in white Ford Broncos pursued by police. How could the studio kitchen hope to get in on this kind of action? To observe the neatly contained world of *Sufra Dayma*, the crisis is disappointing, the chef's chipper competence ruling out any real sort of risk. Catastrophe is therefore an impossibility.[2]

In the clips selected and subtitled by MEMRI, a most unlikely figure disturbs *Sufra Dayma*'s bland, perfect order. A young-sounding caller comes on the air, his accent suggesting origins in the Arabian Gulf. He starts with the customary greetings to Fawzy, just long enough to seem like a normal fan. Then he launches into snide remarks about Sunni Muslims, and strips away the chef's smooth veneer. Whenever religious topics arise in less charged circumstances, such as the episodes Fawzy hosts on the proper slaughtering of sheep for the holiday Eid al-Adha on a festive street somewhere in Cairo, he hardly seems dogmatic. The rituals of Muslim life play a minor role in his show, and he handles them with much the same aplomb with which he watches his potatoes turn gold in hot oil. But this caller presents him with a crisis that accords with Doane's definition.

Fawzy grasps the political potential in the prank call. In one relatively tame instance, the caller makes a tasteless joke about Sunnis being mindless bigots. The caller suggests that Sunnis fawn over the family of the Prophet Muhammad, particularly over Aisha, one of the Prophet's wives who, according to some accounts, sowed dissent in her own family and among the core group of early Muslims. It is the kind of Sunni-Shi'i antagonistic talk that MEMRI treasures in its archive, for it provides a simple, two-person model of the American media cliché: the Middle East torn apart by rival sects!

Fawzy chuckles and launches into a tirade about getting rid of "all the Shi'is who've been calling in." A "real" Islamic regime, he says, would never allow any group like the Shi'a to continue undermining the orthodoxy of Sunnism. He stops, surveys his miniature crisis, and says that it's high time he returned to the onions and meat frying at the bottom of his soup pot.

The relationship between Fawzy and his invisible, long-distance antagonist takes one more sharp turn, prompted by another prank call, this one truly brazen. All we see at first is a slab of dough, as perfectly round as a full moon. Fawzy tells us how we too can master the rolling pin, then effortlessly switches from narrating the recipe to taking an on-air call. A certain "Yusuf" asks, "Is this dough made with the breast milk of Wahhabi women, or with the milk of Aisha?"

"Do you understand that you're a total scumbag?" Fawzy asks the caller. "You call in, using a Sunni name, a respectable name. . . . Even if you're a Shi'i and you believe things that Muslims don't believe, you still should show respect for Muslims, you scumbag." He hesitates a moment, nearly ready to return to his cooking, but the caller's brazenness still irks him. "If you were a man, a real man, you'd use a name like Kazim—one of the names you people have, so we'd know exactly who you are."

Yusuf is hardly a name exclusive to Muslims, let alone Sunnis, but Fawzy picks "Kazim" for its strong associations with Shi'ism.[3] That is the reason MEMRI has chosen this clip. A Middle East in which prominent Sunnis hate Shi'is (and vice versa), berate them on television, and demand that they show their faces so as to be punished, is a binary Middle East that makes sense to the American and European right wing.

In other words, Fawzy and MEMRI itself start to overlap in the three minutes of video. Fawzy's desire to isolate and identify his Yusuf/Kazim, to stigmatize him as different from "the Muslims," is not so different from MEMRI's own mission to shine a cynical, ideological spotlight on Arab people whom it perceives as dangerous. The chef in Cairo and the political organization in Washington would like to use whatever confidence we have in television as a medium of recording and replaying people's speech, in order to persuade us that an enemy is out there and requires their forceful intervention. Fawzy wants to remember this call-

er's voice; MEMRI wants to magnify Fawzy and his Sunni self-righteousness. Furthermore, both the chef and the nonprofit organization see themselves as disciplining forces. If you are the wrong kind of Muslim, and have the temerity to tread into their video purview, they will confront you so that you might be put in your place. This gets to the essence of the video's unwatchable character for me. A televisual world in which the prankster shocks the host, who responds with a didactic kind of rage-monologue, fits a little too well into MEMRI's own didactic mission. At the moment of on-air crisis, it is hard for me to determine whether Fawzy or MEMRI is more insufferable.

Having cut off the voice of the prank caller, the perturbed chef stares once more directly at the camera, then returns to his cooking project. He frowns as the residues of his anger disperse or dissolve in the oil he is now pouring onto his gloved hand, which he will massage into the dough. Things will be fine now, he assures us with a look. He has steered us all through the conflict, declared himself victorious, and it is time to return to the pleasant information of food. We can nearly smell the recipe approaching completion as the lovely ingredients come back into the camera's view. The dough, flexing a little, seems to relax in Fawzy's hand. Where were we?

Notes

1 Middle East Media Research Institute, "About Us," www.memri.org/about.
2 Mary Ann Doane, "Information, Crisis, Catastrophe," in *New Media, Old Media: A History and Theory Reader*, ed. Wendy Hui Kyong Chun and Thomas Keenan (New York: Routledge, 2006), 251–264. The lack of catastrophe in the cooking show genre highlights a gap in Doane's theory, despite how illuminating the essay is. TV programs that meld instruction with entertainment tend to dampen crisis and preclude catastrophe. Further, the category of "reality television" has reshaped the entire medium. In 2003, when Doane revisited the original text of her 1990 essay, she argued that "the tendencies [that the essay] describes have only intensified and deepened" (262), but I would respond that reality television has collapsed crisis and catastrophe, not just in its own programming but also in fictional TV drama, a topic that "Information, Crisis, Catastrophe" does not explore.
3 Musa al-Kazim (745–99) was the seventh imam in Shiʻi history, a crucial position in the succession of political and clerical legitimacy. Musa became known as al-Kazim ("the Levelheaded") by his followers. One irony in Kazim's

current status as a stereotype for Shiʿi men, to distinguish them from Sunnis, is that Musa al-Kazim is an ecumenical figure in Islamic history. Despite the controversies that centered around him vis-à-vis the Sunni Abbasid power structure, which some medieval chroniclers claim resulted in his execution by the caliph, modern research leaves little doubt that al-Kazim was an active interlocutor with other Muslim scholars from a wide variety of theological backgrounds (Hamid Algar, "Imam Musa al-Kazim and Sufi Tradition," *Islamic Culture* 64 [1990]: 9).

Off Watch

REBECCA SCHNEIDER

BERNARDO: Who's there?
FRANCISCO: Nay, answer me: stand, and unfold yourself.

There is danger in the changing of the guard. Two police figures essentially shout a version of "Hey, you there" to each other at the opening of *Hamlet*, if we were to reboot the encounter through Louis Althusser.[1] To accentuate the blind spot in the interval between watches, Laurence Olivier films the scene in the rolling fog, dressing the set for misrecognition.

An audience watching others on watch is something of a primal scene. The *Oresteia* begins with a watch; Shakespeare's *Hamlet* reboots Aeschylus. Olivier remakes that reboot, and on and on in the long cross-medial life of sentries on shift. Over the shoulders of the crew on endless revamps aboard Starship Enterprise, we watch others being on watch, looking at the vast nothing "where no man has gone before"—again. Againness "without succession" in fact seems wedded to scenes of guards replacing guards.[2] Does what is unwatchable occur at the edges of our shifting guards, paradoxically confronting us as something *seen* that is, at once, unseeable?

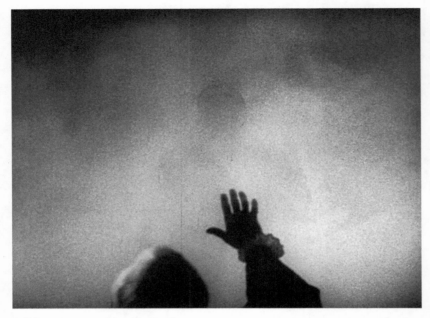

Still from Laurence Olivier's *Hamlet*.

I recently had the opportunity to carry out a watch on an overnight passage across the Gulf of Maine, though the material support was a sailing vessel and an ocean rather than a couch and a TV. In the long hours that unfolded at night, and against a bracing boredom, it became clear that "nothing happening out of the ordinary" is the paradoxical condition of watchability. Between midnight and three o'clock nothing caused me to raise alarm. But, don't misunderstand. Despite previous training, it was edgy and scary for me, and several times I thought to shout out—but the spine tinglers and breath catchers turned out only to be passing white caps, ghostlike against the flanks of the hull, and the blinking lights of other vessels, sometimes mistaken for stars. Staring into the night, I had to be vigilant *in case I saw something* to rip the screen of the night's norm. The degree to which a watch goes on uninterrupted is the degree to which, outside of "obviousnesses as obviousnesses," *nothing is seen.* At least nothing that can be seen to turn a watch into a witness.[3]

Unwatchables surface as moral indignation, political disgust, or excess of duration. But others, more uncanny, contain a minor detail, maybe something almost seen, or already seen, or something not really understood for the force of its unbearability. Though the example is banal, there's a moment in the TV series *True Blood* that I find unwatchable. In 2009, when we were still slipping discs into DVD players, *True Blood* arrived in the little red Netflix envelope among other selections, always several episodes at a time. My partner and I settled in, cooking a meal together and eating in front of the show. But several shows into the first season, I found my anxiety rising at the switch between episodes. There are about one and a half seconds of the title sequence that I could not watch. It's the clip of a dead fox head, in time lapse, its eyes and face devoured by maggots.

When bingeing a season, a title sequence will recur at or near the changes between episodes. Like sentries shifting, you might turn your back during the sequence, or check your phone, or otherwise take a minor break in preparation for a watch. As a result, you don't know exactly where you'll be in the sequence when you look again. So, the maggoty head might hit just as you've returned with dessert, or as you randomly glance up from some other domestic task. The brief clip could hit the side of your face, coming at you from the periphery while you are otherwise occupied. This is the "off watch" aspect of the unwatchable. It happens in the background somewhere, slipping in under the limen, escaping your regular watch but bobbing there in the corner of your eye. You may miss it the first time, but it's always there when you look again.

Thus the fox clip began to creep me out. I soon learned to avoid it by being on alert, memorizing the music and the lead-in before it. I could also choose to stay out of the room entirely, listening for when it was over from where the television couldn't see me. Please don't say I could fast-forward. I know that. I wasn't alone so . . . it's complicated. One needs the breaks that title sequences afford, and they are pleasurable in their own right. It's the ritual recurrence, the againness of the sequence that lets you know you are, in fact, bingeing.

Of course, eating and maggots are not good compatriots. But, lest you dismiss me as merely maggot-phobic, I have no problem watching Sam Taylor-Wood's 2002 film *A Little Death*. In it, a rabbit carcass is

overrun with parasites at high speed. In an essay for *Representations* I discuss the scene as an ecstasy of little lives.[4] And the maggots on *Battleship Potemkin*? Meaningful, but not a problem. So there's something else here, probably to do with the intimacy of repetitive interruption into a down time "family" event. *True Blood* was not an object of my contemplation (the series was actually my partner's choice), so the fox clip hit like a drive-by. In all its minor meaninglessness, it burst like a painful blemish in the periphery of my domestic space. But mostly, the clip made me strangely ungrounded. At first, I felt that I might fall through the eye socket of the fox. Then I felt that it was the fox who watched me. And then, I was the fox who watched me. In each case, in less than a second, confusion overtook me and I had to turn away. There must be more to this, I thought. Indeed. Slowly I came to realize that it ushered in historical losses where they were neither invited, anticipated, nor recognized.

When I was sixteen, I used to tell my little sister stories. She was three and then four at the time. We settled on a saga in many episodes about a family of eyeballs who lived under our house. At night, I told her, these single eyeballs would come out from the basement and fly around the house, coming into our rooms, and checking on everything, having eyeball family dramas, and generally whooping it up while we slept or whenever we were away on vacation. We collected these episodes for several weeks one summer as our family drove across country. One afternoon later that fall, well after we had returned home, I noticed my sister's pupil wandering out of synch with its mate. I asked her to stand still as I peered into it, trying not to alarm her, watching for errant movement. I can still see precisely where we are on the green shag carpet of my parents' living room, and I can still feel myself on my knees with her, and I can still gauge the autumn light through the window. And, too, I still witness her eyeball on its own trajectory. She stood still and I covered the wandering eye with one of my hands. With my other hand, I held up a pencil I'd hidden behind my back. What do you see, I asked her. She didn't say anything. What do you see? I asked again. And then, her young voice said: "A knife."

Eventually we found out that her small body had become the intimate home to another being. A parasite had traveled her blood stream until it selected her retina as a nice resting place for a good meal, leav-

ing her blind in one eye. Having eaten away her vision, the parasite then went dormant. We were told that it can only wake again if my sister is herself eaten, eyeballs and all, by another animal. At that point, the parasite can enter a new blood stream, find a new resting place, and make another meal. For now, we assume, the parasite is still curled in her retina.

There's more to this story, of course. But I suspect there's always more to stories that cluster around unwatchables. My guess is that unwatchables sneak in through a side door to slide across the screen as a stray might do, looking for a meal. It might come in fragments or pieces of errant interruptive too-muchness. It might linger in a corner like a forgotten detail (the eyeball under the house, the madwoman in the attic, the shadow moving too slowly on the porch, the unclaimed suitcase in the stairwell). Such unwatchables might demand watching, but the watch they demand has always already failed. Unwatchables may even be unwatchable because, forever after, you can't *not* see them.

We can watch for what we cannot quite see, looking for it endlessly. We can hang out watching for what has not yet fully happened, episode after episode. But is being off watch a necessary condition for the irruption of the already occurred, especially those occurrences that, not fully accounted for, might have *already* ripped open our eyeballs from the inside? Perhaps unwatchables find us, rather than vice versa. This is simply to say, with psychoanalysis as well as the specters of Marx, that some things that are unwatchable may be historical events making demands for a witness rather than a spectator. The demands can be collective. Think of the reminder in Christina Sharpe's *In the Wake: On Blackness and Being*, that parasitical, flesh-eating sailing vessels of the Middle Passage still sail in the wake of a "past that is not past."[5] If unwatchables are tragedies calling for account at the peripheries of our comfort, then in the wake of history, unwatchables should in fact be legion. The question becomes, if we can't necessarily watch for some unwatchables (because they catch us off watch), how do we begin to let them in otherwise? How do we listen to what sounds through their sockets? If we, *or our sisters*, have (been) failed on our watch, can we still sound an anachronistic alarm and turn that watch into a matter of witness?

Unwatch slips into your retina unannounced and unwanted. There, the minor image eats your vision. And there, the unwatchable stays,

rebooting till it finds a new host. Maybe that's the unbearable promise of the unwatchable. Wit(h)ness. Be that host.

Notes

1 Louis Althusser, "Ideology and Ideological State Apparatuses," in *Lenin and Philosophy and Other Essays*, trans. Ben Brewster (London: New Left Books, 1971), 121–176, 163.
2 Althusser writes of the "little theatre" of interpellation, which he illustrates through a policeman's hail, as happening repeatedly "without any succession" (ibid., 163). Remake after remake, it is arguably againness that occurs as both familiar and strange, poised in a moment of danger as watch is replaced by watch.
3 Ibid., 161.
4 Rebecca Schneider, "What Happened; or, Finishing Live," *Representations* 136, no. 1 (2016): 99.
5 Christine Sharpe, *In the Wake: On Blackness and Being* (Durham, NC: Duke University Press, 2016), 9.

ACKNOWLEDGMENTS

We would like to thank all of our contributors, who made the creation of this book so enjoyable and intellectually stimulating. Our gratitude also goes to Leslie Mitchner for her early commitment to the project, to Nicole Solano for picking up the torch, and to Lisa Banning, Jasper Chang, Vincent Nordhaus, Victoria Verhowsky, and the rest of the team at Rutgers University Press for guiding the volume to publication. Thanks to Mary Ribesky for serving as production editor at Westchester Publishing Services, Joseph Dahm for extraordinary copyediting, and Jay Marchand for the excellent index. Casey Haskins, Daniel Morgan, and Dana Polan offered invaluable feedback and references, and Vanessa Cambier provided crucial editorial assistance. Finally, Matthew Moses and Alex Tolleson were lovingly supportive throughout the entire process.

FILMOGRAPHY

*An asterisk designates that an audiovisual work is discussed more extensively.

12 Years a Slave (US/UK, Steve McQueen, 2013)

13 Reasons Why (series, US, 2017–)

24 (series, US, 2001–2010)

À ma soeur! (*Fat Girl*, France, Catherine Breillat, 2001)*

Ai no korīda (*In the Realm of the Senses*, Japan/France, Nagisa Oshima, 1976)

All My Children (series, US, 1970–2011)

Amélie (France/Germany, Jean-Pierre Jeunet, 2001)

American History X (US, Tony Kaye, 1998)*

Amistad (US, Steven Spielberg, 1997)

Amour (France/Germany/Austria, Michael Haneke, 2012)*

Antichrist (Denmark/France/Germany/Italy/Poland/Sweden, Lars von Trier, 2009)*

The Arbor (UK, Clio Barnard, 2010)

Die Barfusstänzerin (Germany, Rosa Porten, 1918)

Basic Instinct (US/UK/France, Paul Verhoeven, 1992)

Battleship Potemkin (USSR, Sergei Eisenstein, 1925)

Battlestar Galactica (series, US, 2004–2009)

Be Kind Rewind (UK/France/US, Michel Gondry, 2008)

Big Fish (US, Tim Burton, 2003)

The Birth of a Nation (US, D. W. Griffith, 1915)

Black Mirror (series, UK, 2011–)*

Bloedgeld (*Blood Money*, UK/Netherlands, Fred Goodwins, 1921)*

Blue Velvet (US, David Lynch, 1986)

Born on the Fourth of July (US, Oliver Stone, 1989)

Breaking the Waves (Denmark/Sweden/France/Netherlands/
Norway/Iceland, Lars von Trier, 1996)

The Bridge (UK/US, Eric Steel, 2006)*

Caché (France/Austria/Germany/Italy, Michael Haneke, 2005)

Can We Take a Joke? (US, Ted Balaker, 2015)*

Un chien andalou (*An Andalusian Dog*, France, Luis Buñuel, 1929)

A Clockwork Orange (UK/US, Stanley Kubrick, 1971)*

The Clock (UK, Christian Marclay, 2010)

Commander in Chief (series, US, 2005–2006)

The Courageous Coward (US, William Worthington, 1919)

Cruising (US/Germany, William Friedkin, 1980)

Dancer in the Dark (Denmark/Germany/Netherlands/US/UK/
France/Sweden/Finland/Iceland/Norway, Lars von Trier,
2000)

Dawn of the Dead (US/Italy, George A. Romero, 1978)

The Descent (UK, Neil Marshall, 2005)*

Designated Survivor (series, US, 2016–)

Dogville (Denmark/UK/Sweden/France/Germany/Netherlands/
Norway/Finland/Italy, Lars von Trier, 2003)

Ed Wood (US, Tim Burton, 1994)

Empire (US, Andy Warhol, 1964)*

The Empire Strikes Back (US, Irvin Kershner, 1980)

Eternal Sunshine of the Spotless Mind (US, Michel Gondry, 2004)

Eût-elle été criminelle (*Even If She Had Been a Criminal*, France,
Jean-Gabriel Périot, 2006)*

Extase (*Ecstasy*, Czechoslovakia/Austria, Gustav Machatý, 1933)

The Extravagant Shadows (US, David Gatten, 2012)

Fedora (Italy, Gustavo Serena and Giuseppe De Liguoro, 1916)

Die Filmprimadonna (Germany, Urban Gad, 1913)

Flesh and the Devil (US, Clarence Brown, 1926)

Florence Foster Jenkins (UK/France, Stephen Frears, 2016)

Fort Apache, The Bronx (US, Daniel Petrie, 1981)

Freud (US, John Huston, 1962)

Die freudlose Gasse (*Joyless Street*, Germany, G. W. Pabst, 1925)

The Future (Germany/US/France, Miranda July, 2011)

Game of Thrones (series, US, 2011–)

Get Out (US, Jordan Peele, 2017)*

Girls (series, US, 2012–2017)

Giverny 1 (Négresse Impériale) (US/France, Ja'Tovia Gary, 2017)*

Gösta Berlings saga (*The Saga of Gosta Berling*, Sweden, Mauritz Stiller, 1924)

The Grand Budapest Hotel (US/Germany, Wes Anderson, 2014)

The Great White Silence (UK, Herbert Ponting, 1924)*

The Help (US, Tate Taylor, 2011)*

Homeland (series, US, 2011–)*

La hora de los hornos (*The Hour of the Furnaces*, Argentina, Octavio Getino and Fernando Solanas, 1968)

House of Cards (series, US, 2013–)

The Human Centipede (First Sequence) (Netherlands, Tom Six, 2009)

Hurlements en faveur de Sade (*Howls for Sade*, France, Guy Debord, 1952)*

Idioterne (*The Idiots*, Denmark/France/Italy/Netherlands/Spain/ Sweden, Lars von Trier, 1998)

Ilsa, She Wolf of the SS (Canada, Don Edmonds, 1975)*

I'm Not There (US/Germany, Todd Haynes, 2007)

Irréversible (France, Gaspar Noé, 2002)*

Isolation (Ireland/UK/US, Billy O'Brien, 2005)*

Jackass (series, US, 2000–2002)

Kiss Me Deadly (US, Robert Aldrich, 1955)

Koroshiya 1 (*Ichi the Killer*, Japan, Miike Takashi, 2001)

La La Land (US, Damien Chazelle, 2016)

Die Landpommeranze (Germany, Rosa Porten and Franz Eckstein, 1917)

Last Tango in Paris (France/Italy, Bernardo Bertolucci, 1972)

Das Leben von Adolf Hitler (*Life of Adolf Hitler*, West Germany, Paul Rotha, 1961)

Let Me Tell Ya 'Bout Fat Chicks (US, Guillermo Brown, 1987)*

Let Me Tell Ya 'Bout Fat Chicks, Too (US, Loretta Sterling, 1988)*

Lincoln (US, Steven Spielberg, 2012)

Lisztomania (UK, Ken Russell, 1975)

A Little Death (UK, Sam Taylor-Wood, 2002)

Love (France/Belgium, Gaspar Noé, 2015)

Luffar-Petter (Sweden, Erik A. Petschler, 1922)*

Manchester by the Sea (US, Kenneth Lonergan, 2016)*

Manderlay (Denmark/Sweden/Netherlands/France/Germany/UK/Italy, Lars von Trier, 2005)

Ma nuit chez Maud (*My Night at Maud's*, France, Éric Rohmer, 1969)*

Mare's Tail (UK, David Larcher, 1969)

Mars Attacks! (US, Tim Burton, 1996)

Me and You and Everyone We Know (US, Miranda July, 2005)

Medea (Denmark, Lars von Trier, 1988)*

Melancholia (Denmark/Sweden/France/Germany, Lars von Trier, 2011)

Memory of the Camps (episode of *Frontline*) (UK/US, Sidney Bernstein, 1985)

Mission: Impossible (US, Brian De Palma, 1996)

Moonrise Kingdom (US, Wes Anderson, 2012)

The Murder of Emmett Till (US, Stanley Nelson, 2003)

A Nightmare on Elm Street (US, Wes Craven, 1984)

Night Moves (US, Arthur Penn, 1975)

Nuit et brouillard (*Night and Fog*, France, Alain Resnais, 1956)

Nymphomaniac (Denmark/Germany/Belgium/UK/France, Lars von Trier, 2014)

One Life to Live (series, US, 1968–2012)

Paint Drying (UK, Charlie Lyne, 2016)*

Persona (Sweden, Ingmar Bergman, 1966)

La passion de Jeanne d'Arc (*The Passion of Joan of Arc*, France, Carl Theodor Dreyer, 1928)

The Passion of the Christ (US, Mel Gibson, 2004)

Playtime (France/Italy, Jacques Tati, 1967)

Poltergeist (US, Tobe Hooper, 1982)

Psycho (US, Alfred Hitchcock, 1960)

The Public Enemy (US, William A. Wellman, 1931)

Raiders of the Lost Ark (US, Steven Spielberg, 1981)

Ravished Armenia (US, Oscar Apfel, 1919)*

Remote Control (US, Jeff Lieberman, 1988)

Repulsion (UK, Roman Polanski, 1965)

The Ring (US/Japan, Gore Verbinski, 2002)*

Ringu (*Ring*) (Japan, Nakata Hideo, 1998)*

S-21 (Cambodia/France, Rithy Panh, 2003)

Salò o le 120 giornate di Sodoma (*Salò, or the 120 Days of Sodom*, Italy/France, Pier Paolo Pasolini, 1975)*

Salò: Fade to Black (UK/Canada/Italy, Nigel Algar, 2001)

Le sang des bêtes (*Blood of the Beasts*, France, Georges Franju, 1949)

Saturday Night Live (series, US, 1975–)

Scandal (series, US, 2012–2018)

La science des rêves (*The Science of Sleep*, France/Italy, Michel Gondry, 2006)

Seul contre tous (*I Stand Alone*, France, Gaspar Noé, 1998)

Silence of the Lambs (US, Jonathan Demme, 1991)

Sleep (US, Andy Warhol, 1963)

Sommaren med Monika (*Summer with Monika*, Sweden, Ingmar Bergman, 1953)

Sophie's Choice (US, Alan J. Pakula, 1982)

Still Alice (US, Richard Glatzer and Wash Westmoreland, 2014)*

The Story of Louis Pasteur (US, William Dieterle, 1936)

La strada (Italy, Federico Fellini, 1954)

Sufra Dayma (series, Egypt, 2008–)*

Telephones (UK, Christian Marclay, 1995)

The Temptress (US, Fred Niblo, 1926)

Thriller (UK, Sally Potter, 1979)

Timecode (US, Mike Figgis, 2000)

Torrent (US, Monta Bell, 1926)

Tragico convegno (Italy, Ivo Illuminati, 1915)

Traité de Bave et d'Éternité (*Venom and Eternity*, France, Isidore Isou, 1951)*

Transformers: Age of Extinction (US, Michael Bay, 2014)*

Transformers: Dark of the Moon (US, Michael Bay, 2011)*

Transformers: Revenge of the Fallen (US, Michael Bay, 2009)*

Transmisión/Desencuadre (*Transmission/Deframing*, Mexico, Los ingrávidos, 2014)*

Triumph des Willens (*Triumph of the Will*, Germany, Leni Riefenstahl, 1935)

True Blood (series, US, 2008–2014)

The Twilight Zone (series, US, 1959–1964)

Twin Peaks: The Return (series, US, David Lynch, 2017)*

Una notte a Calcutta (Italy, Mario Caserini, 1918)

Unwatchable (UK, Mark Hawker, 2011)*

Valkyrie (US/Germany, Bryan Singer, 2008)

War of the Satellites (US, Roger Corman, 1958)

Wavelength (Canada/US, Michael Snow, 1967)

The West Wing (series, US, 1999–2006)

Zentropa (Denmark/Spain/Sweden/France/Germany/Switzerland, Lars von Trier, 1991)

Zorns Lemma (US, Hollis Frampton, 1970)

BIBLIOGRAPHY

"About Us." *Middle East Media Research Institute*. www.memri.org/about.

Adorno, Theodor W. *Aesthetic Theory*. Translated by Robert Hullot-Kentor. 1970. London: Continuum, 1997.

Agamben, Giorgio. *Remnants of Auschwitz: The Witness and the Archive*. Translated by Daniel Heller-Roazen. New York: Zone Books, 1999.

Ahmed, Sara. *The Cultural Politics of Emotion*. New York: Routledge, 2004.

Alexander, Elizabeth. "'Can You Be Black and Look at This?' Reading the Rodney King Video(s)." *Public Culture* 7 (1994): 77–94.

Algar, Hamid. "Imam Musa al-Kazim and Sufi Tradition." *Islamic Culture* 64 (1990): 1–14.

Allen, Lori. "The Polyvalent Politics of Martyr Commemorations in the Palestinian Intifada." *History and Memory* 18, no. 2 (2006): 107–138.

Althusser, Louis. "Ideology and Ideological State Apparatuses." In *Lenin and Philosophy and Other Essays*, translated by Ben Brewster. London: New Left Books, 1971.

Anderson, Carol. "The Policies of White Resentment." *New York Times*, August 5, 2017. www.nytimes.com/2017/08/05/opinion/sunday/white-resentment-affirmative -action.html.

Angell, Callie. *The Films of Andy Warhol: Part II*. New York: Whitney Museum, 1994.

Aristotle. *Poetics*. Translated by Stephen Halliwell. Chapel Hill: University of North Carolina Press, 1987.

Asad, Talal, Wendy Brown, Judith Butler, and Saba Mahmood. *Is Critique Secular? Blasphemy, Injury, and Free Speech*. New York: Fordham University Press, 2013.

Ayers, John W., Benjamin M. Althouse, Eric C. Leas, Mark Dredze, and Jon-Patrick Allen. "Internet Searches for Suicide Following the Release of *13 Reasons Why*." *JAMA Internal Medicine*, July 31, 2017. http://jamanetwork.com /journals/jamainternalmedicine/article-abstract/2646773.

Azoulay, Ariella. *The Civil Contract of Photography*. Translated by Rela Mazali and Ruvik Danieli. New York: Zone Books, 2008.

Badiou, Alain. *The Century*. Translated by Alberto Toscano. Cambridge: Polity, 2007.

Bakare, Lanre. "*Get Out*: The Film That Dares to Reveal the Horror of Liberal Racism in America." *Guardian*, February 28, 2017. www.theguardian.com/film/2017/feb/28/get-out-box-office-jordan-peele.

Baker, Courtney R. *Humane Insight: Looking at Images of African-American Suffering and Death*. Urbana: University of Illinois Press, 2017.

Balázs, Béla. "Reel Consciousness." Translated by Christopher M. Geissler. In *The Promise of Cinema: German Film Theory 1907–1933*, edited by Anton Kaes, Nicholas Baer, and Michael Cowan. Oakland: University of California Press, 2016.

Barker, Jennifer M. *The Tactile Eye: Touch and the Cinematic Experience*. Berkeley: University of California Press, 2009.

Barker, Martin. "The Challenge of Censorship: 'Figuring' Out the Audience." *Velvet Light Trap* 63 (2009): 58–60.

Barker, Martin, Ernest Mathijs, Jamie Sexton, Kate Egan, Russell Hunter, and Melanie Selfe. *Audiences and Receptions of Sexual Violence in Contemporary Cinema*. Aberystwyth: University of Wales, 2007.

Barthes, Roland. *Camera Lucida: Reflections on Photography*. Translated by Richard Howard. 1981. New York: Hill & Wang, 2010.

———. "The Grain of the Voice." In *Image, Music, Text*, translated by Stephen Heath. New York: Hill & Wang, 1977.

———. "The Rustle of Language." In *The Rustle of Language*, translated by Richard Howard. Berkeley: University of California Press, 1989.

Battcock, Gregory. "Notes on Empire: A Film by Andy Warhol." *Film Culture* 40 (1966): 39–40.

Bazelon, Irwin. *Knowing the Score: Notes on Film Music*. New York: Van Nostrand Reinhold, 1975.

Bazin, André. *The Cinema of Cruelty: From Buñuel to Hitchcock*. Edited by François Truffaut. Translated by Sabine d'Estrée and Tiffany Fliss. New York: Seaver, 1982.

———. "Death Every Afternoon." Translated by Mark A. Cohen. In *Rites of Realism: Essays on Corporeal Cinema*, edited by Ivone Margulies. Durham, NC: Duke University Press, 2003.

———. "Ontology of the Photographic Image." In *What Is Cinema?* translated by Timothy Barnard. Montreal: Caboose, 2009.

Bean, Jennifer M. "Technologies of Early Stardom and the Extraordinary Body." In *A Feminist Reader in Early Cinema*, edited by Jennifer M. Bean and Diane Negra. Durham, NC: Duke University Press, 2002.

Belting, Hans. *Likeness and Presence: A History of the Image before the Era of Art*. Translated by Edmund Jephcott. Chicago: University of Chicago Press, 1994.

Benjamin, Walter. "The Storyteller: Observations on the Works of Nikolai Leskov," translated by Harry Zohn, and "The Work of Art in the Age of Its Technological Reproducibility: Second Version," translated by Edmund Jephcott and Harry Zohn. In *Selected Writings: Volume 3, 1935–1938*, edited by Howard Eiland and Michael W. Jennings. Cambridge, MA: Belknap, 2002.

———. "The Work of Art in the Age of Its Technological Reproducibility: Third Version," translated by Harry Zohn and Edmund Jephcott, and "On the Concept of History," translated by Harry Zohn. In *Walter Benjamin: Selected Writings: Volume 4, 1938–1940*, edited by Howard Eiland and Michael W. Jennings. Cambridge, MA: Belknap, 2003.

Berger, John. *Ways of Seeing*. New York: Viking, 1972.

Berlant, Lauren. *The Female Complaint: The Unfinished Business of Sentimentality in American Culture*. Durham, NC: Duke University Press, 2008.

Berlant, Lauren, and Lee Edelman. *Sex, or the Unbearable*. Durham, NC: Duke University Press, 2014.

Beugnet, Martine. *Cinema and Sensation: French Film and the Art of Transgression*. Edinburgh: Edinburgh University Press, 2007.

Blake, Aaron. "The Politicization of Adam Carolla." *Washington Post*. August 29, 2017. www.washingtonpost.com/news/the-fix/wp/2017/08/28/the-politicization-of-adam-carolla/?tid=sm_fb&utm_term=.271b6ee725e2.

Bloom, Lisa E., and Elena Glasberg. "Disappearing Ice and Missing Data: Climate Change in the Visual Culture of the Polar Regions." In *Far Field: Digital Culture, Climate Change, and the Poles*, edited by Jane D. Marsching and Andrea Polli, 117–142. Bristol: Intellect Press, 2012.

Blumenberg, Hans. *Shipwreck with Spectator: Paradigm of a Metaphor for Existence*. Translated by Steven Rendall. Cambridge, MA: MIT Press, 1996.

Bokris, Victor. *Warhol: The Biography*. New York: Da Capo Press, 1997.

Boltanski, Luc. *Distant Suffering: Morality, Media, and Politics*. Translated by Graeme D. Burchill. Cambridge: Cambridge University Press, 1999.

Bondavalli, Simona. *Fictions of Youth: Pier Paolo Pasolini, Adolescence and Fascism*. Toronto: University of Toronto Press, 2015.

Bonitzer, Pascal. "Deframings," In *Cahiers du Cinéma, Vol. 4, 1973–1978: History, Ideology, Cultural Struggle*, translated by Chris Darke, edited by David Wilson, 197–203. New York: BFI, 2000.

Bordun, Troy. *Genre Trouble and Extreme Cinema: Film Theory at the Fringes of Contemporary Art Cinema*. Cham: Palgrave Macmillan, 2017.

Bordwell, David, Janet Staiger, and Kristin Thompson. *The Classical Hollywood Cinema: Film Style & Mode of Production to 1960*. New York: Columbia University Press, 1985.

Brennan, Teresa, and Martin Jay, eds. *Vision in Context: Historical and Contemporary Perspectives on Sight*. New York: Routledge, 1996.

Bright, Susie. "I Am Curious: Butterball." *Penthouse Forum*, June 1989.

Brinkema, Eugenie. *The Forms of the Affects*. Durham, NC: Duke University Press, 2014.

Bronson, Jennifer, and Marcus Berzofsky. *Disabilities among Prison and Jail Inmates, 2011–12*. Washington, DC: U.S. Department of Justice, Office of Justice Programs, Bureau of Justice Statistics, 2015.

Brown, Wendy. *Undoing the Demos: Neoliberalism's Stealth Revolution.* New York: Zone Books, 2015.

Brown, William. "Violence in Extreme Cinema and the Ethics of Spectatorship." *Projections* 7, no. 1 (2013): 25–42.

Buck-Morss, Susan. *The Dialectics of Seeing: Walter Benjamin and the Arcades Project.* Cambridge, MA: MIT Press, 1990.

Budd, Malcolm. "The Acquaintance Principle." *British Journal of Aesthetics* 43, no. 4 (2003): 386–392.

Bukatman, Scott. *The Poetics of Slumberland.* Berkeley: University of California Press, 2012.

Burns, Janet. "A Brief History of the Devil's Tritone." *MentalFloss*, March 29, 2016. http://mentalfloss.com/article/77321/brief-history-devils-tritone.

Butler, Judith. "Endangered/Endangering: Schematic Racism and White Paranoia." In *Reading Rodney King/Reading Urban Uprising*, edited by Robert Gooding-Williams. New York: Routledge, 1993.

———. *Frames of War: When Is Life Grievable?* London: Verso, 2009.

———. "Photography, War, Outrage." *PMLA* 120, no. 3 (2005): 822–827.

Cabañas, Kaira M. *Off-Screen Cinema: Isidore Isou and the Lettrist Avant-Garde.* Chicago: University of Chicago Press, 2015.

Candido [pseud.]. "Svenska filmdivor." *Swing*, no. 52 (December 1922).

Carroll, Noël. "Non-perceptual Aesthetic Properties." In *Art in Three Dimensions.* Oxford: Oxford University Press, 2010.

Carter, Angela M. "Teaching with Trauma: Disability Pedagogy, Feminism, and the Trigger Warnings Debate." *Disability Studies Quarterly* 35, no. 2 (2015). http://dsq-sds.org/article/view/4652/3935.

Casetti, Francesco. "Why Fears Matter: Cinephobia in Early Film Culture." *Screen* 59, no. 2 (2018): 145–157.

Cashell, Kieran. *Aftershock: The Ethics of Contemporary Transgressive Art.* London: I.B. Tauris, 2009.

Cavarero, Adriana. *Horrorism: Naming Contemporary Violence.* New York: Columbia University Press, 2011.

Cavell, Stanley. "On Makavejev on Bergman." *Critical Inquiry* 6, no. 2 (1979): 305–330.

Cecire, Natalia. "On the 'Neoliberal Rhetoric of Harm.'" July 7, 2014. http://nataliacecire.blogspot.fi/2014/07/on-neoliberal-rhetoric-of-harm.html.

"Censors Slash 'Extreme' Japanese Film." *BBC News*, November 13, 2002. http://news.bbc.co.uk/1/hi/entertainment/2465265.stm.

Chakrabarty, Dipesh. "The Climate of History: Four Theses." *Critical Inquiry* 35, no. 2 (2009): 197–222.

Chakravorty, Vinayak. "No Censors Here! Gaspar Noé's Graphic 3D Film 'Love' Defies 'Sanskari' Rules at IFFI 2015." *Daily Mail*, November 30, 2015. www.dailymail.co.uk/indiahome/indianews/article-3339978/No-censors-Gasper-Noe-s-graphic-3D-film-Love-defies-sanskari-rules-IFFI-2015.html.

Chambers, Ross. "Death at the Door." In *Untimely Interventions: AIDS Writing, Testimonial, and the Rhetoric of Haunting.* Ann Arbor: University of Michigan Press, 2004.

Charney, Leo, and Vanessa Schwartz, eds. *Cinema and the Invention of Modern Life.* Berkeley: University of California Press, 1995.

Chen, Mel Y. *Animacies: Biopolitics, Racial Mattering, and Queer Affect.* Durham, NC: Duke University Press, 2012.

Chiesi, Roberto. *Pier Paolo Pasolini: Salò o le 120 giornate di Sodoma.* Turin: Lindau, 2001.

Choi, Jinhee, and Mattias Frey, eds. *Cine-Ethics: Ethical Dimensions of Film Theory, Practice, and Spectatorship.* New York: Routledge, 2014.

Choi, Jinhee, and Mitsuyo Wada-Marciano, eds. *Horror to the Extreme: Changing Boundaries in Asian Cinema.* Hong Kong: Hong Kong University Press, 2009.

Chouliaraki, Lillie. *Spectatorship of Suffering.* Thousand Oaks, CA: Sage, 2006.

Chow, Rey. *The Age of the World Target.* Durham, NC: Duke University Press, 2006.

Chun, Wendy Hui Kyong. *Updating to Remain the Same: Habitual New Media.* Cambridge, MA: MIT Press, 2016.

Cixous, Hélène. "The Laugh of the Medusa." Translated by Keith Cohen and Paula Cohen. In *The Medusa Reader,* edited by Marjorie Garber and Nancy J. Vickers. London: Routledge, 2003.

Clover, Carol J. *Men, Women, and Chain Saws: Gender in the Modern Horror Film.* Princeton, NJ: Princeton University Press, 1993.

Coleridge, Samuel Taylor. "The Rime of the Ancient Mariner." In *Selected Poetry,* edited by William Empson and David Pirie. New York: Routledge, 2002.

"Comely Visitor." *New York Herald Tribune,* July 7, 1925.

Comolli, Jean-Louis. "Historical Fiction: A Body Too Much." Translated by Ben Brewster. *Screen* 19, no. 2 (1978): 41–54.

Contrera, Jessica. "Trump Says 'SNL' Is 'Unwatchable.' Then Why Can't He Stop Watching?" *Washington Post,* December 4, 2016. www.washingtonpost.com/news/arts-and-entertainment/wp/2016/12/04/trump-says-snl-is-unwatchable-then-why-cant-he-stop-watching/?utm_term=.e7ecc8319639.

Cormon, Irin. "Donald Trump's Worst Offense? Mocking Disabled Reporter, Poll Finds." *NBC News,* August 11, 2016.

Crary, Jonathan. *Techniques of the Observer: On Vision and Modernity in the Nineteenth Century.* Cambridge, MA: MIT Press, 1990.

———. *24/7: Late Capitalism and the Ends of Sleep.* London: Verso, 2014.

Creed, Barbara. *The Monstrous-Feminine: Film, Feminism, Psychoanalysis.* London: Routledge, 1993.

Cvetkovich, Ann. *An Archive of Feelings: Trauma, Sexuality, and Lesbian Public Cultures.* Durham, NC: Duke University Press, 2003.

Danesi, Fabien. *Le Cinéma de Guy Debord, 1952–1994.* Paris: Paris expérimental, 2011.

Daney, Serge. "Notes sur Salò." *Cahiers du Cinéma*, nos. 268–296 (July–August 1976): 102–103.

Danto, Arthur C. "Art and Disturbation." In *The Philosophical Disenfranchisement of Art*. New York: Columbia University Press, 1986.

———. *The Transfiguration of the Commonplace: A Philosophy of Art*. Cambridge, MA: Harvard University Press, 1981.

Dargis, Manohla. "Sleepless in Montmartre." *LA Weekly*, October 31, 2001. www .laweekly.com/film/sleepless-in-montmartre-2133987.

Dean, Carolyn J. *The Fragility of Empathy after the Holocaust*. Ithaca, NY: Cornell University Press, 2004.

Debord, Guy. *Complete Cinematic Works: Scripts, Stills, Documents*. Translated and edited by Ken Knabb. Oakland, CA: AK Press, 2003.

———. "Report on the Construction of Situations." In *The Situationist International Anthology*, edited and translated by Ken Knabb. Berkeley, CA: Bureau of Public Secrets, 1981.

———. *The Society of the Spectacle*. Translated by Donald Nicholson-Smith. New York: Zone Books, 1994.

Deleuze, Gilles. *Nietzsche and Philosophy*. Translated by Hugh Tomlinson. London: Continuum, 2006.

Delpeut, Peter. "Bits & Pieces—De Grenzen Van Het Filmarchief." *Versus* 2 (1990): 75–84.

Del Río, Elena. *The Grace of Destruction: A Vital Ethology of Extreme Cinemas*. New York: Bloomsbury, 2016.

DeNavas-Walt, Carmen, and Bernadette D. Proctor. *Income, Poverty, and Health Insurance Coverage in the United States*. Washington, DC: U.S. Census Bureau, Current Population Reports, 2015.

Descartes, René. *Discourse on Method, Optics, Geometry, and Meteorology*. Translated by Paul J. Olscamp. Indianapolis: Hackett, 2001.

Desta, Yohana. "Yet Another TV Series about the Hellish 2016 Election Is Coming." *Vanity Fair*, March 9, 2017. www.vanityfair.com/hollywood/2017/03/hbo-2016-election-mini-series.

Devaux, Frédérique. *Le Cinéma lettriste, 1951–1991*. Paris: Paris expérimental, 1992.

Didi-Huberman, Georges. *Images in Spite of All: Four Photographs from Auschwitz*. Translated by Shane B. Lillis. Chicago: University of Chicago Press, 2008.

Dixon, Wheeler Winston. *The Exploding Eye: A Re-visionary History of 1960s American Experimental Cinema*. Albany: State University of New York Press, 1997.

Doane, Mary Ann. "Information, Crisis, Catastrophe." In *New Media, Old Media: A History and Theory Reader*, edited by Wendy Hui Kyong Chun and Thomas Keenan. New York: Routledge, 2006.

Dupin, Eric. "Dronestagram." 2013. www.dronestagr.am/.

Dyer, Richard. *White: Essays on Race and Culture*. New York: Routledge, 1997.

Ebert, Roger. "Cannes #6: A Devil's Advocate for *Antichrist*." *Roger Ebert's Journal*, May 19, 2009. www.rogerebert.com/rogers-journal/cannes-6-a-devils-advocate -for-antichrist.

——. Review of *Irréversible*. *Chicago Sun-Times*, March 14, 2003. http://rogerebert .suntimes.com/apps/pbcs.dll/article?AID=/20030314/REVIEWS/303140303 /1023.

Fain, Kimberly. "Viral Black Death: Why We Must Watch Citizen Videos of Police Violence." *JSTOR Daily*, September 1, 2016. https://daily.jstor.org/why-we-must -watch-citizen-videos-of-police-violence/.

Falcon, Richard. "Reality Is Too Shocking." *Sight and Sound* 9, no. 1 (1999): 10–13.

Fanon, Frantz. *Black Skin, White Masks*. Translated by Richard Philcox. New York: Grove, 2008.

Faris, Rob, Hal Roberts, Bruce Etling, Nikki Bourassa, Ethan Zuckerman, and Yochai Benkler. "Partisanship, Propaganda, and Disinformation: Online Media and the 2016 U.S. Presidential Election." Cambridge, MA: Harvard University, Berkman Klein Center for Internet & Society, August 16, 2017. https://cyber .harvard.edu/publications/2017/08/mediacloud.

Felke, Naldo. "Cinema's Damaging Effects on Health." Translated by Michael Cowan. In *The Promise of Cinema: German Film Theory, 1907–1933*, edited by Anton Kaes, Nicholas Baer, and Michael Cowan. Oakland: University of California Press, 2016.

Felman, Shoshana, and Dori Laub. *Testimony: Crises of Witnessing in Literature, Psychoanalysis and History*. New York: Routledge, 1992.

Fernandez, Ingrid. "The Lives of Corpses: Narratives of the Image in American Memorial Photography." *Mortality* 16, no. 4 (2011): 343–364.

Fleetwood, Nicole R. *Troubling Vision: Performance, Visuality, and Blackness*. Chicago: University of Chicago Press, 2011.

Foster, Hal, ed. *Vision and Visuality*. Seattle: Bay Press, 1988.

Freedberg, David. *The Power of Images: Studies in the History and Theory of Response*. Chicago: University of Chicago Press, 1989.

Frey, Mattias. *Extreme Cinema: The Transgressive Rhetoric of Today's Art Film Culture*. New Brunswick, NJ: Rutgers University Press, 2016.

——. "Tuning Out, Turning In, and Walking Off: The Film Spectator in Pain." In *Ethics and Images of Pain*, edited by Asbjørn Grønstad and Henrik Gustafsson. New York: Routledge, 2012.

Friedberg, Anne. *Window Shopping: Cinema and the Postmodern*. Berkeley: University of California Press, 1993.

Friedlander, Saul, ed. *Probing the Limits of Representation: Nazism and the "Final Solution."* Cambridge, MA: Harvard University Press, 1992.

——. *Reflections on Nazism: An Essay on Kitsch and Death*. Translated by Thomas Weyr. New York: Harper & Row, 1984.

Fusco, Coco. "Censorship, Not the Painting, Must Go: On Dana Schutz's Image of Emmett Till." *Hyperallergic*, March 27, 2017. https://hyperallergic.com

/368290/censorship-not-the-painting-must-go-on-dana-schutzs-image-of
-emmett-till/.

Galloway, Alexander R. *The Interface Effect*. Cambridge: Polity, 2012.

Galloway, Patrick. *Asia Shock: Horror and Dark Cinema from Japan, Korea, Hong Kong, and Thailand*. Berkeley, CA: Stone Bridge Press, 2006.

"Garbo as You Never Saw Her." *Boston Daily Globe*, September 23, 1934.

Gell, Alfred. "Technology and Magic." *Anthropology Today* 4, no. 2 (1988): 6–9.

"A German Film." *New York Times*, July 6, 1927.

Gilbert, Sophie. "Did *13 Reasons Why* Spark a Suicide Contagion Effect?" *Atlantic*, August 1, 2017. www.theatlantic.com/entertainment/archive/2017/08/13-reasons -why-demonstrates-cultures-power/535518/.

Gormley, Paul. *The New-Brutality Film: Race and Affect in Contemporary Hollywood Cinema*. Portland, OR: Intellect, 2005.

Greenaway, Jon. "Let the Traumatic Image Haunt Us." *JSTOR Daily*, September 19, 2015. https://daily.jstor.org/photographs-european-refugee-crisis/.

Grønstad, Asbjørn. *Screening the Unwatchable: Spaces of Negation in Post-millennial Art Cinema*. Basingstoke: Palgrave Macmillan, 2012.

———. "On the Unwatchable." In *The New Extremism in Cinema: From France to Europe*, edited by Tanya Horeck and Tina Kendall. Edinburgh: Edinburgh University Press, 2011.

Grønstad, Asbjørn, and Henrik Gustafsson, eds. *Ethics and Images of Pain*. New York: Routledge, 2012.

Guerin, Frances, ed. *On Not Looking: The Paradox of Contemporary Visual Culture*. New York: Routledge, 2015.

Gunning, Tom. "The Cinema of Attraction: Early Cinema, Its Spectator and the Avant-Garde." *Wide Angle* 8, nos. 3–4 (1986): 63–70.

———. "'Now You See It, Now You Don't': The Temporality of the Cinema of Attractions." *Velvet Light Trap* 32 (1993): 3–12.

Habermas, Jürgen. *Die neue Unübersichtlichkeit*. Frankfurt am Main: Suhrkamp, 1985.

Halberstam, Jack. "Dude Where's My Gender? Or, Is There Life on Uranus?" *GLQ: A Journal of Lesbian and Gay Studies* 10, no. 2 (2004): 308–312.

———. "You Are Triggering Me! The Neoliberal Rhetoric of Harm, Danger and Trauma." *Bully Bloggers*, July 5, 2014. https://bullybloggers.wordpress.com/2014 /07/05/you-are-triggering-me-the-neo-liberal-rhetoric-of-harm-danger-and -trauma/.

Hall, Mordaunt. "The Screen: A New Swedish Actress." *New York Times*, February 22, 1926.

Hanes, Roy. "None Is Still Too Many: An Historical Exploration of Canadian Immigration Legislation as It Pertains to People with Disabilities." *Developmental Disabilities Bulletin* 37, nos. 1–2 (2009): 91–126.

Hanich, Julian. "Complex Staging: The Hidden Dimensions of Roy Andersson's Aesthetics." *Movie: A Journal of Film Criticism* 5 (2014): 37–50.

Hansen, Miriam. "The Mass Production of the Senses: Classical Cinema as Vernacular Modernism." In *Reinventing Film Studies*, edited by Christine Gledhill and Linda Williams. New York: Oxford University Press, 2000.

———. "*Schindler's List* Is Not *Shoah*: The Second Commandment, Popular Modernism, and Public Memory." *Critical Inquiry* 22, no. 2 (1996): 292–312.

Harries, Martin. *Forgetting Lot's Wife: On Destructive Spectatorship*. New York: Fordham University Press, 2007.

Harris, Brandon. "The Giant Leap Forward of Jordan Peele's *Get Out*." *New Yorker*, March 4, 2017. www.newyorker.com/culture/culture-desk/review-the-giant -leap-forward-of-jordan-peeles-get-out.

Hartman, Saidiya V. *Scenes of Subjection: Terror, Slavery, and Self-Making in Nineteenth-Century America*. Oxford: Oxford University Press, 1997.

Hartman, Saidiya V., and Frank B. Wilderson III. "The Position of the Unthought." *Qui Parle* 13, no. 2 (2003): 183–201.

Hazlitt, William. "On the Pleasures of Hating." In *The Plain Speaker: Opinions on Books, Men, and Things, Volume 1*. London: Templeman, 1851.

Hegel, G. W. F. *Phenomenology of Spirit*. Translated by A. V. Miller. Oxford: Oxford University Press, 1977.

———. *Vorlesungen über die Ästhetik I*. In *Werke in 20 Bänden*, Band 13. Frankfurt am Main: Suhrkamp, 1970.

Heidegger, Martin. *The Origin of the Work of Art*. In *Basic Writings*, translated by Albert Hofstadter, edited by David Farrell Krell. San Francisco: HarperCollins, 1977.

Herring, Scott. *Another Country: Queer Anti-Urbanism*. New York: New York University Press, 2010.

Hesford, Wendy. *Spectacular Rhetorics: Human Rights, Recognitions, Feminisms*. Durham, NC: Duke University Press, 2011.

Hess, Amanda. "The Silent Film Returns—On Social Media." *New York Times*, September 13, 2017. www.nytimes.com/2017/09/13/movies/silent-film-youtube-videos.html.

Hildesheimer, Wolfgang. *Marbot*. Frankfurt am Main: Suhrkamp, 1981.

Hitt, Allison. "Melanie Yergeau, 'Disable All the Things' ~ KN1." June 24, 2014. www .digitalrhetoriccollaborative.org/2014/06/24/melanie-yergeau-disable-all-the -things-kn1/.

The Holy Scriptures. Philadelphia: Jewish Publication Society of America, 1917.

hooks, bell. *Black Looks: Race and Representation*. Boston: South End, 1992.

Horeck, Tanya, and Tina Kendall, eds. *The New Extremism in Cinema: From France to Europe*. Edinburgh: Edinburgh University Press, 2011.

Hugo, Victor. *Les Misérables*. Translated by Charles E. Wilbour. New York: Carleton, 1862.

Hutchinson, Tom. *Horror and Fantasy in the Movies*. New York: Crescent Books, 1974.

Huyssen, Andreas. *Miniature Metropolis: Literature in an Age of Photography and Film*. Cambridge, MA: Harvard University Press, 2015.

"Iceberg That's Four Times Bigger Than London Breaks from Antarctica." *Twitter*, July 12, 2017. https://twitter.com/i/moments/885125929206333440?lang=en.

Irigaray, Luce. "This Sex Which Is Not One." In *This Sex Which Is Not One*, translated by Catherine Porter and Carolyn Burke. Ithaca, NY: Cornell University Press, 1985.

Jacobus [pseud.]. "Det svenska nationalfelet återspeglas i svensk film." *Swing*, no. 36 (September 1922).

Jameson, Fredric. "Cognitive Mapping." In *Marxism and the Interpretation of Culture*, edited by Cary Nelson and Lawrence Grossberg. Urbana: University of Illinois Press, 1988.

Jay, Martin. "Diving into the Wreck: Aesthetic Spectatorship at the *Fin-de-siècle*." *Critical Horizons* 1, no. 1 (2000): 93–111.

———. *Downcast Eyes: The Denigration of Vision in Twentieth-Century French Thought*. Berkeley: University of California Press, 1993.

Johnston, Amy Boyle. "Ray Bradbury: Fahrenheit 451 Misinterpreted." *LA Weekly*, May 30, 2007. www.laweekly.com/news/ray-bradbury-fahrenheit-451-misinterpreted -2149125.

Jones, Ida E., Daina Ramey Berry, Tiffany M. Gill, Kali Nicole Gross, and Janice Sumler-Edmond. "An Open Statement to the Fans of *The Help*." *Association of Black Women Historians*, August 12, 2011. http://truth.abwh.org/2011/08/12/an -open-statement-to-the-fans-of-the-help/.

Joyce, Andrew. "Democratic Rising Star Kamala Harris Has a 'Bernieland' Problem." *Mic*, July 31, 2017. https://mic.com/articles/183105/democratic-rising-star -kamala-harris-has-a-bernie-sanders-problem#.5iLxmWB4K.

Juhasz, Alexandra. "#100hardtruths-#fakenews." 2017. http://scalar.usc.edu/nehvectors /100hardtruths-fakenews.

———. "How Do I (Not) Look? Live Feed Video and Viral Black Death." *JSTOR Daily*, July 20, 2016. https://daily.jstor.org/how-do-i-not-look/.

Kaplan, E. Ann. *Trauma Culture: The Politics of Terror and Loss in Media and Literature*. New Brunswick, NJ: Rutgers University Press, 2005.

Kaplan, E. Ann, and Ban Wang, eds. *Trauma and Cinema: Cross-Cultural Explorations*. Aberdeen and Hong Kong: Hong Kong University Press, 2008.

Kafer, Alison. "Un/Safe Disclosures: Scenes of Disability and Trauma." *Journal of Literary & Cultural Disability Studies* 10, no. 1 (2016): 1–20.

Karni, Annie, Josh Dawsey, and Tara Palmeri. "White House Rattled by McCarthy's Spoof of Spicer." *Politico*, February 6, 2017. www.politico.com/story/2017/02 /melissa-mccarthy-sean-spicer-234715.

Kendall, Tina, ed. "The Disgust Issue." *Film-Philosophy* 15, no. 2 (2011): 1–105.

Kennedy, Randy. "White Artist's Painting of Emmett Till at Whitney Biennial Draws Protests." *New York Times*, March 21, 2017. www.nytimes.com/2017/03/21 /arts/design/painting-of-emmett-till-at-whitney-biennial-draws-protests.html.

Kennedy, Tanya Ann. *Historicizing Post-Discourses: Postfeminism and Postracialism in United States Culture*. Albany: State University of New York Press, 2017.

Kermode, Mark. "Horror: On the Edge of Taste." In *Film and Censorship: The Index Reader*, edited by Ruth Petrie, 155–160. London: Cassell, 1997.

——. "What Lies Beneath." *Observer*, July 10, 2005.

Kerner, Aaron Michael, and Jonathan L. Knapp. *Extreme Cinema: Affective Strategies in Transnational Media*. Edinburgh: Edinburgh University Press, 2016.

Khatib, Lina. *Image Politics in the Middle East: The Role of the Visual in Political Struggle*. London: IB Taurus, 2013.

Kipnis, Laura. *Unwanted Advances: Sexual Paranoia Comes to Campus*. New York: Harper, 2017.

Kleege, Georgina. "Blindness and Visual Culture: An Eyewitness Account." *Journal of Visual Culture* 4, no. 2 (2005): 179–190.

Knox, Emily J. M., ed. *Trigger Warnings: History, Theory, Context*. Lanham, MD: Rowman & Littlefield, 2017.

Koch, Gertrud. "Mimesis and *Bilderverbot*." Translated by Jeremy Gaines. *Screen* 34, no. 3 (1993): 211–222.

Kracauer, Siegfried. "Photography." In *The Mass Ornament: Weimar Essays*, edited and translated by Thomas Y. Levin. Cambridge, MA: Harvard University Press, 1995.

——. *Theory of Film: The Redemption of Physical Reality*. 1960. Princeton, NJ: Princeton University Press, 1997.

Krützen, Michaela. *The Most Beautiful Woman on the Screen: The Fabrication of the Star Greta Garbo*. New York: Peter Lang, 1992.

Kyrölä, Katariina. "Toward a Contextual Pedagogy of Pain: Trigger Warnings and the Value of Sometimes Feeling Really, Really Bad." *Lambda Nordica: Nordic Journal on LGBTQ Studies* 1 (2015): 131–144. www.lambdanordica.se/wp-content /uploads/were-here2.pdf.

Lacan, Jacques. *The Four Fundamental Concepts of Psychoanalysis*. Translated by Alan Sheridan. New York: Norton, 1977.

——. "Kant with Sade." In *Écrits*. Translated by Bruce Fink. New York: Norton, 2006.

——. *The Seminar of Jacques Lacan, Book X: Anxiety*. Edited by Jacques-Alain Miller, translated by A. R. Price. Cambridge: Polity, 2014.

Lane, Anthony. "Beamed Down." *New Yorker*, February 25, 2008. www.newyorker .com/magazine/2008/02/25/beamed-down.

——. "Distant Shores." *New Yorker*, August 8, 2011. www.newyorker.com/magazine /2011/08/08/distant-shores.

Latour, Bruno, and Peter Weibel, eds. *Iconoclash: Beyond the Image Wars in Science, Religion, and Art*. Cambridge, MA: MIT Press, 2002.

Lee, Pamela. *Chronophobia: On Time in the Art of the 1960s*. Cambridge, MA: MIT Press, 2004.

Lerner, Sarah. "'Flawed': Perfect Is the Enemy of the Good if You're a Female Presidential Candidate." *Medium*, January 6, 2017. https://medium.com/@sarahlerner /flawed-perfect-is-the-enemy-of-the-good-if-youre-a-female-presidential -candidate-48392e7d849b.

Levi, Pavle. *Cinema by Other Means*. Oxford: Oxford University Press, 2012.

Levin, David Michael, ed. *Modernity and the Hegemony of Vision*. Berkeley: University of California Press, 1993.

Levin, Thomas Y. "Dismantling the Spectacle: The Cinema of Guy Debord." In *On the Passage of a Few People through a Rather Brief Moment in Time: The Situationist International, 1957–1972*, edited by Elisabeth Sussman. Boston: Institute of Contemporary Art, 1989.

Lingre, Michele. "Turning Off TV Gives Child a New View of Life." *Los Angeles Times*, January 9, 1994. http://articles.latimes.com/1994-01-09/local/me-10102_1_sesame-street.

Lippit, Akira Mizuta. *Atomic Light (Shadow Optics)*. Minneapolis: University of Minnesota Press, 2005.

Livingston, Paisley. "On an Apparent Truism in Aesthetics." *British Journal of Aesthetics* 43, no. 3 (2003): 260–278.

Lockhart, Eleanor Amaranth. "Why Trigger Warnings Are Beneficial, Perhaps Even Necessary." *First Amendment Studies* 50, no. 2 (2016): 59–69.

Lowenstein, Adam. *Shocking Representation: Historical Trauma, National Cinema, and the Modern Horror Film*. New York: Columbia University Press, 2005.

Lukianoff, Greg. "The Story Behind the New Documentary 'Can We Take a Joke?'." *Huffington Post*, August 11, 2016. www.huffingtonpost.com/entry/the-story-behind-the-new-documentary-can-we-takea_us_57aca5ade4b08c46f0e4df6f.

Lusher, Adam. "Donald Trump: All the Sexist Things He Said." *Independent*, October 9, 2016. www.independent.co.uk/news/world/americas/us-elections/donald-anything-a7353006.html.

MacCormack, Patricia. "Pleasure, Perversion and Death: Three Lines of Flight for the Viewing Body." PhD dissertation, Monash University, 2000.

Malkowski, Jennifer. *Dying in Full Detail: Mortality and Digital Documentary*. Durham, NC: Duke University Press, 2017.

Marcus, Greil. *Lipstick Traces: A Secret History of the Twentieth Century*. Cambridge, MA: Harvard University Press, 1990.

Mardiganian, Aurora. *Ravished Armenia*. Translated by Henry Leyford Gates. New York: Kingfield Press, 1918.

Maris, Ronald W., Alan L. Berman, and Morton M. Silverman, eds. *Comprehensive Textbook of Suicidology*. New York: Guilford, 2000.

Marks, Laura U. *The Skin of the Film: Intercultural Cinema, Embodiment, and the Senses*. Durham, NC: Duke University Press, 2000.

Martin, Daniel. *Extreme Asia: The Rise of Cult Cinema from the Far East*. Edinburgh: Edinburgh University Press, 2015.

Martinson, Jane. "Unwatchable Is Just That—Is It Doing Anything to Help Congo?" *Guardian*, September 28, 2011. www.theguardian.com/commentisfree/2011/sep/28/unwatchable-congo-rape-short-film.

Martschukat, Jürgen, and Silvan Niedermeier, eds. *Violence and Visibility in Modern History*. New York: Palgrave Macmillan, 2013.

McCarthy, Todd. "The Future: Sundance Review." *Hollywood Reporter*, January 22, 2011. www.hollywoodreporter.com/review/future-sundance-review-74658.

McCaskill, Nolan D. "Clinton Aides Deny Infighting Captured in 'Shattered' Book." *Politico*, April 20, 2017. www.politico.com/story/2017/04/20/clinton-aides-shattered-book-denials-237404.

McGibbons, Elizabeth Anne, ed. *Oppression: A Social Determinant of Health*. Winnipeg: Fernwood, 2012.

McWhorter, Ladelle. *Racism and Sexual Oppression in Anglo-America: A Genealogy*. Bloomington: Indiana University Press, 2009.

Mekas, Jonas. *Movie Journal: The Rise of a New American Cinema, 1959–1971*. New York: Macmillan, 1972.

———. "On Obscenity." In *Movie Journal: The Rise of a New American Cinema, 1959–1971*. New York: Macmillan, 1972.

Mele, Christopher. "Professor Watchlist Is Seen as Threat to Academic Freedom." *New York Times*, November 28, 2016. www.nytimes.com/2016/11/28/us/professor-watchlist-is-seen-as-threat-to-academic-freedom.html?mcubz=3.

Merica, Dan. "Trump Condemns 'Hatred, Bigotry and Violence on Many Sides' in Charlottesville." *CNN*, August 13, 2017. www.cnn.com/2017/08/12/politics/trump-statement-alt-right-protests/index.html.

Merriam-Webster. "Unwatchable." www.merriam-webster.com/dictionary/unwatchable.

Metz, Christian. *The Imaginary Signifier: Psychoanalysis and the Cinema*. Translated by Celia Britton, Annwyl Williams, Ben Brewster, and Alfred Guzzetti. Bloomington: Indiana University Press, 1982.

Mirzoeff, Nicholas. *The Right to Look: A Counterhistory of Visuality*. Durham, NC: Duke University Press, 2011.

Mitchell, W. J. T. *Cloning Terror: The War of Images, 9/11 to the Present*. Chicago: University of Chicago Press, 2011.

———. "Image." In *Critical Terms for Media Studies*, edited by W. J. T. Mitchell and Mark B. N. Hansen. Chicago: University of Chicago Press, 2010.

———. "The Unspeakable and the Unimaginable: Word and Image in a Time of Terror." *ELH* 72, no. 2 (2005): 291–308.

———. *What Do Pictures Want? The Lives and Loves of Images*. Chicago: University of Chicago Press, 2005.

Mitter, Siddhartha. "'What Does It Mean to Be Black and Look at This?' A Scholar Reflects on the Dana Schutz Controversy." *Hyperallergic*, March 24, 2017. https://hyperallergic.com/368012/what-does-it-mean-to-be-black-and-look-at-this-a-scholar-reflects-on-the-dana-schutz-controversy/.

Modleski, Tania. *Loving with a Vengeance: Mass-Produced Fantasies for Women*. Hamden, CT: Archon, 1982.

———. "The Search for Tomorrow in Today's Soap Operas: Notes on a Feminine Narrative Form." *Film Quarterly* 33, no. 1 (Autumn 1979): 12–21.

Mohdin, Aamna. "American Women Voted Overwhelmingly for Clinton, Except the White Ones." *Quartz*, November 9, 2016. https://qz.com/833003/election-2016–all-women-voted-overwhelmingly-for-clinton-except-the-white-ones/.

Moore, Alison M. "History, Memory and Trauma in Photography of the *Tondues*: Visuality of the Vichy Past through the Silent Image of Women." *Gender & History* 17, no. 3 (2005): 657–681.

Moore, Jonathan Fletcher. "Artificial Killing Machine." 2015. https://vimeo.com /131357384.

Moore, Wendy, and Joyce Bell. "The Right to Be Racist in College: Racist Speech, White Institutional Space, and the First Amendment." *Law & Policy* 39, no. 2 (2017): 99–120.

Morton, Timothy. *Hyperobjects: Philosophy and Ecology after the End of the World.* Minneapolis: University of Minnesota Press, 2013.

Moten, Fred. "Black Mo'nin'." In *Loss: The Politics of Mourning*, edited by David L. Eng and David Kazanjian. Berkeley: University of California Press, 2003.

———. "The Case of Blackness." *Criticism* 50, no. 2 (2008): 177–218.

Mulvey, Laura. "Visual Pleasure and Narrative Cinema." *Screen* 16, no. 3 (1975): 6–18.

Nancy, Jean-Luc. *After Fukushima: The Equivalence of Catastrophes.* Translated by Charlotte Mandell. New York: Fordham University Press, 2015.

Napolin, Julie Beth. "Scenes of Subjection: Women's Voices Narrating Black Death." *Sounding Out!*, December 19, 2016. https://soundstudiesblog.com/2016/12 /19/scenes-of-subjection-womens-voices-narrating-black-death/.

Nelson, Maggie. *The Art of Cruelty: A Reckoning.* New York: Norton, 2011.

"A New Star of the North." *Vanity Fair* 25, no. 3 (November 1, 1925): 80.

Ngai, Sianne. *Our Aesthetic Categories: Zany, Cute, Interesting.* Cambridge, MA: Harvard University Press, 2012.

———. *Ugly Feelings.* Cambridge, MA: Harvard University Press, 2005.

Noble, Safiya Umoja. "Teaching Trayvon: Race, Media, and the Politics of Spectacle." *Black Scholar* 44, no. 1 (2014): 12–29.

Noé, Gaspar. "I'm Happy Some People Walk Out during My Film: It Makes the Ones Who Stay Feel Strong." *Guardian*, March 12, 1999. www.theguardian.com/film /1999/mar/12/features3.

Oehmke, Philipp, and Lars-Olav Beier. "Jeder Film vergewaltigt." *Der Spiegel*, October 19, 2009.

Olesen, Christian. "Found Footage Photogénie: An Interview with Elif Rongen-Kaynakçi and Mark-Paul Meyer." *Necsus: European Journal of Media Studies* 2, no. 2 (2013): 555–562.

Olsson, Jan. "National Soul/Cosmopolitan Skin: Swedish Cinema at a Crossroads." In *Silent Cinema and the Politics of Space*, edited by Jennifer M. Bean, Anupama Kapse, and Laura Horak. Bloomington: Indiana University Press, 2014.

Onstad, Katrina. "Miranda July Is Totally Not Kidding." *New York Times*, July 14, 2011. www.nytimes.com/2011/07/17/magazine/the-make-believer.html.

Oxford English Dictionary Online. "Watch." www.oed.com.

Palmer, Tim. *Brutal Intimacy: Analyzing Contemporary French Cinema.* Middletown, CT: Wesleyan University Press, 2011.

Park, K-Sue. "The A.C.L.U. Needs to Rethink Free Speech." *New York Times*, August 17, 2017. www.nytimes.com/2017/08/17/opinion/aclu-first-amendment -trump-charlottesville.html?mcubz=0&_r=0.

Perry, David, and Lawrence Carter Long. *Media Coverage of Law Enforcement Use of Force and Disability*. Washington, DC: Ruderman Foundation, 2016.

Phillips, Amber. "One Election Bright Spot for Democrats: Women of Color." *Washington Post*, November 10, 2016. https://www.washingtonpost.com/news/the-fix /wp/2016/11/10/one-election-bright-spot-for-democrats-women-of-color/?utm _term=.8febb3016b06.

Phillips, Whitney. *This Is Why We Can't Have Nice Things: Mapping the Relationship between Online Trolling and Mainstream Culture*. Cambridge, MA: MIT Press, 2015.

Pitch Interactive. "Out of Sight/Out of Mind." 2013. http://drones.pitchinteractive .com/.

Plato. *Republic*. Translated by C. D. C. Reeve. Indianapolis: Hackett, 2004.

Pollard, Miranda. *Reign of Virtue: Mobilizing Gender in Vichy France*. Chicago: University of Chicago Press, 1998.

Price, Margaret. *Mad at School: Rhetorics of Mental Disability and Academic Life*. Ann Arbor: University of Michigan Press, 2011.

Puar, Jasbir K. *The Right to Maim: Debility, Capacity, Disability*. Durham, NC: Duke University Press, 2017.

Quandt, James. "Flesh & Blood: Sex and Violence in Recent French Cinema." *Artforum* 42, no. 6 (2004): 126–132.

Rabinovitz, Lauren. *For the Love of Pleasure: Women, Movies, and Culture in Turn-of-the-Century Chicago*. New Brunswick, NJ: Rutgers University Press, 1998.

Rae, Logan. "Re-focusing the Debate on Trigger Warnings: Privilege, Trauma, and Disability in the Classroom." *First Amendment Studies* 50, no. 2 (2016): 95–102.

Rancière, Jacques. *The Future of the Image*. Translated by Gregory Elliott. London: Verso, 2007.

"*Ravished Armenia* in Film; Mrs. Harriman Speaks at Showing of Turkish and German Devastation." *New York Times*, February 15, 1919.

"Reporting on Suicide: Recommendations for the Media." *American Foundation for Suicide Prevention*. www.afsp.org/wp-content/uploads/2016/01/recommendations .pdf.

"Report: Most Americans Now Getting Their News While Peeking Out between Fingers." *Onion*, August 11, 2017. https://politics.theonion.com/report-most -americans-now-getting-their-news-while-pee-1819580200.

Ristovska, Sandra. "Strategic Witnessing in the Age of Video Activism." *Media, Culture & Society* 38, no. 7 (2016): 1034–1047.

Rogers, Katie. "White Women Helped Elect Donald Trump." *New York Times*, November 9, 2016. www.nytimes.com/2016/12/01/us/politics/white-women-helped-elect -donald-trump.html?_r=0.

Rogoff, Irit. "Looking Away: Participations in Visual Culture." In *After Criticism: New Responses to Art and Performance,* edited by Gavin Butt. Malden, MA: Blackwell, 2005.

Rohmer, Éric. "Isou or Things as They Are (Views of the Avant-Garde) [1952]." In *The Taste for Beauty,* translated by Carol Volk. Cambridge: Cambridge University Press, 1990.

Ruby, Jay. "Post-Mortem Portraiture in America." *History of Photography* 8, no. 3 (1984): 201–222.

Rosenbaum, Jonathan. "Be Kind Rewind." *Chicago Reader,* n.d. www.chicagoreader .com/chicago/be-kind-rewind/Film?oid=1066669.

Sanders, Jay. "Tony Conrad." *Bomb Magazine* 92 (Summer 2005). http://bombmagazine .org/articles/tony-conrad.

Savage, Charlie. "Justice Dept. to Take on Affirmative Action in College Admissions." *New York Times,* August 1, 2017. www.nytimes.com/2017/08/01/us/politics /trump-affirmative-action-universities.html.

Scarry, Elaine. *The Body in Pain: The Making and Unmaking of the World.* New York: Oxford University Press, 1985.

Schmitt, Carl. *Political Theology.* Edited and translated by George Schwab. Chicago: University of Chicago Press, 2005.

Schneider, Rebecca. "What Happened; or, Finishing Live." *Representations* 136, no. 1 (2016): 96–111.

Schwartz, Vanessa. *Spectacular Realities: Early Mass Culture in Fin-de-Siècle Paris.* Berkeley: University of California Press, 1998.

Schwindt, Oriana. "Election Night Ratings: More Than 71 Million TV Viewers Watched Trump Win." *Variety,* November 9, 2016. http://variety.com/2016/tv /news/election-night-ratings-donald-trump-audience-1201913855/.

Sconce, Jeffrey, ed. *Sleaze Artists: Cinema at the Margins of Taste, Style, and Politics.* Durham, NC: Duke University Press, 2007.

Sentilles, Sarah. "How We Should Respond to Photographs of Suffering." *New Yorker,* August 3, 2017. www.newyorker.com/books/second-read/how-we-should -respond-to-photographs-of-suffering.

Serano, Julia. "That Joke Isn't Funny Anymore (and It's Not Because of 'Political Correctness')." *Medium,* August 18, 2015. https://medium.com/@juliaserano/that -joke-isn-t-funny-anymore-and-it-s-not-because-of-political-correctness -469b92312536.

Sexton, Jared. "The Social Life of Social Death: On Afro-Pessimism and Black Optimism." *InTensions* 5 (2011): 1–47.

Sharpe, Christina. *In the Wake: On Blackness and Being.* Durham, NC: Duke University Press, 2016.

———. *Monstrous Intimacies: Making Post-Slavery Subjects.* Durham, NC: Duke University Press, 2010.

Shaviro, Steven. *The Cinematic Body.* Minneapolis: University of Minnesota Press, 1993.

Shelley, James. "The Problem of Non-perceptual Art." *British Journal of Aesthetics* 43, no. 3 (2003): 363–378.

Shoard, Catherine. "Lars von Trier Inspired by Donald Trump for New Serial-Killer Film." *Guardian*, February 14, 2017.

Siegel, Rudolph. "Not Art." *Village Voice*, March 18, 1965.

Silverman, Kaja. *Male Subjectivity at the Margins*. New York: Routledge, 1992.

Singer, Ben. *Melodrama and Modernity: Early Sensational Cinema and Its Contexts*. New York: Columbia University Press, 2001.

Sinnerbrink, Robert. *Cinematic Ethics: Exploring Ethical Experience through Film*. New York: Routledge, 2016.

Sjöberg, Sami. *The Vanguard Messiah: Lettrism between Jewish Mysticism and the Avant-Garde*. Berlin: Walter de Gruyter, 2015.

Slide, Anthony, ed. *Ravished Armenia and the Story of Aurora Mardiganian*. Lanham, MD: Scarecrow Press, 1997.

Smith, Tiffany Watt. *The Book of Human Emotions: An Encyclopedia of Feeling from Anger to Wanderlust*. London: Profile Books, 2015.

Sobchack, Vivian. *The Address of the Eye: A Phenomenology of Film Experience*. Princeton, NJ: Princeton University Press, 1992.

——. "What My Fingers Knew: The Cinesthetic Subject, or Vision in the Flesh." In *Carnal Thoughts: Embodiment and Moving Image Culture*. Berkeley: University of California Press, 2004.

Sontag, Susan. *Regarding the Pain of Others*. New York: Picador, 2003.

——. "Regarding the Torture of Others." *New York Times Magazine*, May 23, 2004.

Souza, Valéria M. "Triggernometry." *It's Complicated*, May 21, 2014. http://valeriamsouza.wordpress.com/2014/05/21/triggernometry/.

Spillers, Hortense. *Black, White, and in Color: Essays on American Literature and Culture*. Chicago: University of Chicago Press, 2003.

——. "Mama's Baby, Papa's Maybe: An American Grammar Book." *Diacritics* 17, no 2 (1987): 64–81.

Stern, Lesley. *The Scorsese Connection*. Bloomington: Indiana University Press, 1995.

Stevenson, Karen, and Kyle Broadus. "Capturing Hate." New York: Witness Media Lab, October 2016.

Stewart, Jacqueline Najuma. *Migrating to the Movies: Cinema and Black Urban Modernity*. Berkeley: University of California Press, 2005.

Stimpson, Liz, and Margaret Best. *Courage Above All: Sexual Assault Against Women with Disabilities*. Toronto: DisAbled Women's Network, 1991.

Studlar, Gaylyn. *In the Realm of Pleasure: Von Sternberg, Dietrich, and the Masochistic Aesthetic*. New York: Columbia University Press, 1988.

Suckow, Ruth. "Hollywood Gods and Goddesses." *Harper's Monthly Magazine* 173 (June 1, 1936): 189–200.

Tampa, Vava. "Rebecca Masika Katsuva Obituary." *Guardian*, February 9, 2016.

Tarkovsky, Andrey. *Sculpting in Time.* Translated by Kitty Hunter-Blair. New York: Knopf, 1987.

Tarrant, Shira. *The Pornography Industry: What Everyone Needs to Know.* New York: Oxford University Press, 2016.

Tartaglione, Nancy. "Gaspar Noé's 'Love' at Heart of Film Ratings War; Age Limit Upped Mid-Run." *Deadline Hollywood,* August 5, 2015. http://deadline.com/2015 /08/gaspar-noe-love-french-rating-controversy-vincent-maraval-1201492107/.

Tasker, Yvonne, and Diane Negra. *Interrogating Post-Feminism: Gender and the Politics of Popular Culture.* Durham, NC: Duke University Press, 2007.

Taylor, Keeanga-Yamahtta. "The 'Free Speech' Hypocrisy of Right-Wing Media." *New York Times,* August 14, 2017. www.nytimes.com/2017/08/14/opinion/the-free -speech-hypocrisy-of-right-wing-media.html?mcubz=3.

Tegnér, Torsten. "På språng." *Idrottsbladet,* March 12, 1924.

Thompson, Janna. *Taking Responsibility for the Past: Reparation and Historical Injustice.* Cambridge: Polity, 2002.

Tinée, Mae. "Critic Locates an Old Garbo Movie in City." *Chicago Daily Tribune,* July 11, 1933.

Townes, Carimah. "Women of Color Are Front and Center in the Anti-Trump Resistance." *ThinkProgress,* January 31, 2017. https://thinkprogress.org/meet-the-women -of-color-leading-the-resistance-against-trump-e0a5985ad27d/.

Trump, Donald, and Tony Schwartz. *Trump: The Art of the Deal.* New York: Random House, 1987.

Underhill, Harriet. "A Star's Equipment Is Just a Bathing Suit and a Book." *New York Herald Tribune,* July 10, 1927.

Vera, Hernán, and Andrew M. Gordon. *Screen Saviors: Hollywood Fictions of Whiteness.* Lanham, MD: Roman & Littlefield, 2003.

Vertov, Dziga. "Kinoks: A Revolution." Translated by Kevin O'Brien. In *Kino-Eye: The Writings of Dziga Vertov,* edited by Annette Michelson. Berkeley: University of California Press, 1984.

Vighi, Fabio. *Sexual Difference in European Cinema: The Curse of Enjoyment.* New York: Palgrave Macmillan, 2009.

Villanueva, Raúl Plascencia. *Recomendación 51/2014: Sobre los hechos ocurridos el 30 de junio de 2014 en Cuadrilla Nueva, comunidad San Pedro Limón, municipio de Tlatlaya, Estado de México.* October 21, 2014. www.cndh.org.mx/sites/all/doc /Recomendaciones/ViolacionesGraves/RecVG_051.pdf.

Virgili, Fabrice. *Shorn Women: Gender and Punishment in Liberation France.* Translated by John Flower. London: Bloomsbury, 2002.

Virno, Paolo. *A Grammar of the Multitude: For an Analysis of Contemporary Forms of Life.* Translated by Isabella Bertoletti, James Cascaito, and Andrea Casson. New York: Semiotext(e), 2004.

Vonberg, Judith. "Large Ice Sheet 'Very Close' to Breaking Away from Antarctica." *CNN,* June 1, 2017. www.cnn.com/2017/06/01/world/iceberg-antarctic-larsen-c/index.html.

Wall-Romana, Christophe. "Reembodied Writing: Lettrism and Kinesthetic Scripts." In *Cinepoetry: Imaginary Cinemas in French Poetry*. Bronx: Fordham University Press, 2013.

Warhol, Andy, and Pat Hackett. *Popism: The Warhol '6os*. New York: Harcourt Brace Jovanovich, 1980.

Wasserman, Danuta, and Camilla Wasserman, eds. *Oxford Textbook of Suicidology and Suicide Prevention: A Global Perspective*. Oxford: Oxford University Press, 2009.

Waters, John. *Unwatchable*. Zurich: de Pury & Luxembourg, 2006.

Watson, Steven. *Factory Made: Warhol and the Sixties*. New York: Pantheon, 2003.

Wayne, Teddy. "The Trauma of Violent News on the Internet." *New York Times*, September 10, 2016. www.nytimes.com/2016/09/11/fashion/the-trauma-of-violent-news-on-the-internet.html.

Weaver, Caity. "Jordan Peele on a Real Horror Story: Being Black in America." *GQ*, February 3, 2017. www.gq.com/story/jordan-peele-get-out-interview.

Weigel, Moira. "Political Correctness: How the Right Invented a Phantom Enemy." *Guardian*, November 30, 2016. www.theguardian.com/us-news/2016/nov/30/political-correctness-how-the-right-invented-phantom-enemy-donald-trump.

Weinberg, Scott. *Isolation*. EfilmCritic.com, November 5, 2005.

West, Alexandra. *Films of the New French Extremity: Visceral Horror and National Identity*. Jefferson, NC: McFarland, 2016.

Wheatley, Catherine. "Contested Interactions: Watching Catherine Breillat's Scenes of Sexual Violence." *Journal of Cultural Research* 14, no. 1 (2010): 27–41.

Wilderson, Frank B., III. "Close-Up: Fugitivity and the Filmic Imagination: Social Death and Narrative Aporia in *12 Years a Slave*." *Black Camera* 7, no. 1 (Fall 2015): 134–149.

——. *Red, White & Black: Cinema and the Structure of U.S. Antagonisms*. Durham, NC: Duke University Press, 2010.

Williams, Linda. "Film Bodies: Gender, Genre, and Excess." *Film Quarterly* 44, no. 4 (1991): 2–13.

——. *Playing the Race Card: Melodramas of Black and White from Uncle Tom to O.J. Simpson*. Princeton, NJ: Princeton University Press, 2001.

Wilson, Reid. "Final Newspaper Endorsement Count: Clinton 57, Trump 2." *Hill*, November 6, 2016. http://thehill.com/blogs/ballot-box/presidential-races/304606-final-newspaper-endorsement-count-clinton-57-trump-2.

Yacavone, Daniel. *Film Worlds: A Philosophical Aesthetics of Cinema*. New York: Columbia University Press, 2015.

Zayid, Maysoon. "Disability and Hollywood, a Sordid Affair." *Women's Media Centre*, February 8, 2017.

Žižek, Slavoj. *Looking Awry: An Introduction to Jacques Lacan through Popular Culture*. Cambridge, MA: MIT Press, 1991.

NOTES ON CONTRIBUTORS

NICHOLAS BAER is Collegiate Assistant Professor in the Humanities and Harper-Schmidt Fellow in the Society of Fellows at the University of Chicago. He co-edited *The Promise of Cinema: German Film Theory, 1907–1933* (2016), which won the Limina Award for the Best International Film Studies Book and the Award of Distinction for Best Edited Collection from the Society for Cinema and Media Studies. Baer has published on film and media, critical theory, and intellectual history in numerous journals and edited volumes, and his writings have been translated into Dutch, French, German, Hebrew, and Italian.

ERIKA BALSOM is Senior Lecturer in Film Studies at King's College London. She is the author of *After Uniqueness: A History of Film and Video in Circulation* (2017) and *Exhibiting Cinema in Contemporary Art* (2013), as well as the co-editor of *Documentary Across Disciplines* (2016). Her work has been published in journals such as *Grey Room* and *e-flux*, and she is a frequent contributor to magazines such as *Artforum* and *Sight and Sound*.

KENNETH BERGER is a PhD candidate in the Department of Modern Culture and Media at Brown University. He received an MFA in Interdisciplinary Studio Art from the University of California, Los Angeles Department of Art and has taught art history and theory at the University of Southern California, UC Irvine, and Otis College of Art and Design. He currently teaches at the Rhode Island School of Design.

SUSIE BRIGHT is a feminist sex writer. She is a best-selling author and one of the world's most respected voices on sexual politics, as well as an award-winning author and editor.

ALEX BUSH is a PhD candidate in Film & Media at the University of California, Berkeley, and a 2017–18 Mellon/ACLS Dissertation Completion Fellow. Her dissertation, "Cold Storage: A Media History of the Glacier," examines the role of moving image and communications media in bringing nature into historical thought. At Berkeley, she has co-organized conferences on seriality and on expanded concepts of media, and worked as chief translator for the award-winning volume *The Promise of Cinema: German Film Theory 1907–1933* (2016).

ALEC BUTLER is an award-winning playwright and filmmaker. Their published play *Black Friday?* was a finalist for the Governor General's Award, Canada's national arts award, in 1991. Alec's animated video trilogy about growing up 2Spirit called *Misadventures of Pussy Boy* has been screened at numerous film festivals, including TranScreen: International Transgender Film Festival in Amsterdam, where it won the Audience Favorite award. *Rough Paradise*, a novella about growing up trans/intersex/2spirit in a rough working-class neighborhood, was published in 2014. Alec's story was featured on the BBC's online magazine in April 2016. www.bbc.com/news/magazine-36092431.

NOËL CARROLL is Distinguished Professor of Philosophy at the Graduate Center of the City University of New York. His most recent books include *Art in Three Dimensions* (2010), *Living in an Artworld* (2012), *Minerva's Night Out* (2013), and *Humour: A Very Short Introduction* (2014). He has also worked as a journalist and written five documentaries.

MEL Y. CHEN is Associate Professor of Gender & Women's Studies and Director of the Center for the Study of Sexual Culture at the University of California, Berkeley. Chen's book *Animacies: Biopolitics, Racial Mattering, and Queer Affect* (2012) explores racialization, queering, disability, and affective economies in animate and inanimate "life" through the extended concept of animacy. Chen's current project concerns conceptual territories of toxicity and intoxication and their historical involvement in the interanimation of race and disability. Chen co-edits, with Jasbir K. Puar, the "Anima" book series at Duke University Press, highlighting critical race theory scholarship that explores animal, disability, and queer inhumanisms.

JONATHAN CRARY is Meyer Schapiro Professor of Modern Art and Theory at Columbia University. His books include *Techniques of the Observer* (1990), *Incorporations* (1992), *Suspensions of Perception* (2000), and *24/7: Late Capitalism and the Ends of Sleep* (2013). He is a founding editor of Zone Books.

ABIGAIL DE KOSNIK is Associate Professor at the University of California, Berkeley, in the Berkeley Center for New Media and the Department of Theater, Dance & Performance Studies. She is the author of *Rogue Archives: Digital Cultural Memory and Media Fandom* (2016). She has published articles on media fandom, popular digital culture, and performance studies in *Cinema Journal, International Journal of Communication, Modern Drama, Transformative Works and Cultures, Verge: Studies in Global Asias, Performance Research*, and elsewhere.

SAMUEL ENGLAND is Associate Professor of Arabic at the University of Wisconsin–Madison. He teaches Classical and modern Arabic, Mediterranean cultures, and sub-Saharan African sources. England writes on Classical Arabic poetry and prose, courts in the Middle East and Europe, Crusades literature, Arab nationalist film and drama of the past century, and Romance-language treatments of Islam. He is the author of *Medieval Empires and the Culture of Competition: Literary Duels at Islamic and Christian Courts* (2017).

MATTIAS FREY is Professor of Film and Media at the University of Kent and General Editor of the journal *Film Studies*. He is the author or editor of six books, including *The Permanent Crisis of Film Criticism: The Anxiety of Authority* (2015), *Film Criticism in the Digital Age* (2015, co-edited with Cecilia Sayad), and *Extreme Cinema: The Transgressive Rhetoric of Today's Art Film Culture* (2016).

PETER GEIMER is Professor of Art History at the Freie Universität Berlin and Co-Director of the Center of Advanced Study "BildEvidenz. Geschichte und Ästhetik." He has held research positions at the University of Bielefeld, ETH Zurich, and the Max Planck Institute for the History of Science in Berlin. Geimer has published on the history and theory of photography, history painting, history film, and the history of science. His latest book is *Inadvertent Images: A History of Photographic Apparitions* (2018).

MICHAEL BOYCE GILLESPIE is Associate Professor of Film at the City College of New York, CUNY. His research focuses on film theory, black visual and expressive culture, popular music, and contemporary art. He is the author of *Film Blackness: American Cinema and the Idea of Black Film* (2016). He is the co-editor of "Dimensions in Black: Perspectives on Black Film and Media," a special dossier for *Film Quarterly* (Winter 2017), and "Black One Shot," an art criticism series devoted to black visual and expressive culture on *ASAP/J* (Summer 2018). Some of his work has appeared in *Film Quarterly, Black Camera, Post-Soul Satire: Black Identity after Civil Rights, Contemporary Black American Cinema,* and *Passing Interest: Racial Passing in U.S. Fiction, Memoirs, Television, and Film.*

ASBJØRN GRØNSTAD is Professor of Visual Culture in the Department of Information Science and Media Studies, University of Bergen, where he is also founding director of the Nomadikon Center for Visual Culture. He is the author/editor of nine books, and his most recent publications are *Film and the Ethical Imagination* (2016) and *Gestures of Seeing in Film, Video and Drawing* (2016, co-edited with Henrik Gustafsson and Øyvind Vågnes). He is currently a Fulbright Fellow and visiting professor in the Film & Media Department at the University of California, Berkeley. His current book project is tentatively titled *For an Ethics of the Opaque Image.*

BORIS GROYS is Professor of Russian and Slavic Studies at New York University and Professor of Philosophy and Art History at the European Graduate School in Saas-Fee, Switzerland. He is the author of *Art Power* (2008), *Going Public* (2010), *An Introduction to Antiphilosophy* (2012), *Under Suspicion: A Phenomenology of Media* (2012), *On the New* (2014), and *In the Flow* (2016).

FRANCES GUERIN teaches film at the University of Kent. She is the author of *A Culture of Light: Cinema and Modernity in 1920s Germany* (2005), *Through Amateur Eyes: Film and Photography in Nazi Germany* (2011), and *The Truth Is Always Grey: A History of Modernist Painting* (2018). She is the co-editor of *The Image and the Witness: Trauma, Memory and Visual Culture* (2007) and editor of *On Not Looking: The Paradox of Contemporary Visual Culture* (2015). She is currently work-

ing on a project on the role of art in the transformation from industrial to postindustrial landscapes in Europe.

JACK HALBERSTAM is Professor of English and Gender Studies at Columbia University. Halberstam is the author of six books, including, most recently, *Trans*: A Quick and Quirky Account of Gender Variability* (2018). Halberstam's next book is about the declassification of identity and is titled *Wild Things: Queer Theory after Nature*.

BARBARA HAMMER, a pioneering visual artist and filmmaker, has a multiple praxis for the past forty years with resonating impact on young artists today. Her work was included in the 1985, 1989, and 1993 Whitney Biennials and is included in the permanent collections of the Australian Center for the Moving Image, the Museum of Modern Art (New York), the Centre Georges Pompidou, and elsewhere. She is the author of *Hammer! Making Movies out of Sex and Life* (2009). She has had major retrospectives at the Museum of Modern Art (2010), the Tate Modern (2012), Jeau de Paume (2012), Kunsthall Oslo (2013), Toronto International Film Festival (2013), and Muzeum Sztuki, Kraków, Ujazdowski, Warsaw, and Muzeum Sztuki MS2, Łódź (2016).

JULIAN HANICH is Associate Professor of Film Studies at the University of Groningen. He is the author of two monographs: *Cinematic Emotion in Horror Films and Thrillers: The Aesthetic Paradox of Pleasurable Fear* (2010) and *The Audience Effect: On the Collective Cinema Experience* (2018). With Christian Ferencz-Flatz he co-edited a special issue of *Studia Phaenomenologica* on "Film and Phenomenology" (2016). His articles have appeared in *Screen, Cinema Journal, New Literary History, Projections, NECSUS, Movie, Film-Philosophy, Jump Cut, New Review of Film and Television Studies*, and others.

STEFANO HARNEY AND FRED MOTEN are the authors of *The Undercommons: Fugitive Planning and Black Study* (2013) and of the forthcoming *All Incomplete*. Stefano teaches at Singapore Management University and Fred teaches at New York University.

MAGGIE HENNEFELD is Assistant Professor of Cultural Studies and Comparative Literature at the University of Minnesota, Twin Cities. She is the author of *Specters of Slapstick and Silent Film Comediennes*

(2018). Her articles and criticism have appeared in journals including *differences, Discourse, Film History, Screen, Ms. Magazine, Cultural Critique*, and *Camera Obscura*. She is the co-editor of a special issue of *Feminist Media Histories* on "Gender and Comedy," and co-editor of *Abjection Incorporated: Mediating the Politics of Pleasure and Violence* (2019).

J. HOBERMAN is a recovering film critic (thirty-three years at the *Village Voice*) and the author, coauthor, or editor of thirteen books, including *On Jack Smith's Flaming Creatures* (2001) and, most recently, *Film After Film, or What Became of 21st Century Cinema* (2012).

LAURA HORAK is Associate Professor of Film Studies at Carleton University, with cross-appointments in the Pauline Jewett Institute for Women's and Gender Studies and the Institute for Comparative Studies in Literature, Art, and Culture. She is the author of *Girls Will Be Boys: Cross-Dressed Women, Lesbians, and American Cinema, 1908–1934* (2016), which the *Huffington Post* declared one of the Best Film Books of 2016. She also co-edited *Silent Cinema and the Politics of Space* (2014), winner of the Society for Cinema and Media Studies Award for Best Edited Collection.

GUNNAR IVERSEN is Professor of Film Studies at Carleton University and former Professor of Film Studies at Norwegian University of Science and Technology. He is the author, coauthor, and editor of more than twenty books. He has published articles on Norwegian and Scandinavian cinema, documentary, early cinema, and sound culture in *Film History, European Journal of Scandinavian Studies, Early Popular Visual Culture, Journal of Scandinavian Studies*, and others. He has also worked as a journalist.

LYNNE JOYRICH is Professor of Modern Culture and Media at Brown University. She is the author of *Re-Viewing Reception: Television, Gender, and Postmodern Culture* (1996) and of articles on film, television, cultural studies, and gender and sexuality studies that have appeared in such journals as *Critical Inquiry, Cinema Journal, differences, Transformative Works and Cultures*, and *Journal of Visual Culture* and such books as *Logics of Television* (1990), *Private Screenings* (1992), *New Media, Old Media* (2006), *Inventing Film Studies* (2008), *Queer TV*

(2008), and *Mad Men, Mad World* (2013). She has been on the editorial collective of the journal *Camera Obscura: Feminism, Culture, and Media Studies* since 1996.

ALEXANDRA JUHASZ is the chair of the Film Department at Brooklyn College, CUNY. She makes and studies committed media practices that contribute to political change and individual and community growth. She is the author or editor of *AIDS TV* (1995), *Women of Vision* (2001), *F Is for Phony*, with Jesse Lerner (2005), *Learning from YouTube* (2011), *A Companion to Contemporary Documentary Film*, with Alisa Lebow (2015), and *Sisters in the Life*, with Yvonne Welbon (2018). She is the producer of educational videotapes on feminist issues from AIDS to teen pregnancy. Her current work is on and about feminist Internet culture. With Anne Balsamo, she was founding co-facilitator of the network FemTechNet.

E. ANN KAPLAN is Distinguished Professor of English and Women's, Gender, and Sexuality Studies at Stony Brook University, where she also founded and directed the Humanities Institute for many years. She is Past President of the Society for Cinema and Media Studies. Kaplan has written many books and articles on topics in cultural studies, media, and women's studies from diverse theoretical perspectives including psychoanalysis, feminism, postmodernism, and postcolonialism. She has given lectures all over the world, and her work has been translated into six languages. Her many books include *Motherhood and Representation: The Mother in Popular Culture and Melodrama* (1992/2002), *Looking for the Other: Feminism, Film and the Imperial Gaze* (1997), and *Trauma and Cinema: Cross-Cultural Explorations* (co-edited with Ban Wang, 2004). The book *Trauma Culture: The Politics of Terror and Loss in Media and Literature* (2005) was followed in 2015 by *Climate Trauma: Foreseeing the Future in Dystopian Film and Fiction*. She is working on a third study of trauma, this time dealing with memory loss, age panic, and the politics of care.

KATARIINA KYRÖLÄ is Lecturer in Gender Studies at Åbo Akademi University, Finland. She worked previously as Lecturer in Media Studies at the University of Turku, Academy of Finland Postdoctoral Fellow, and Lecturer in Cinema Studies, Stockholm University, and is the author

of *The Weight of Images: Affect, Body Image and Fat in the Media* (2014) and articles in *Feminist Theory, Sexualities, Subjectivity, Feminist Encounters*, and *International Journal of Cultural Studies*. Her research interests include non-normative bodies in the media, queer theory, feminist fat studies, affect theory, and postcolonial and indigenous feminisms.

NATHAN LEE is a critic, curator, and PhD candidate in the Department of Modern Culture and Media at Brown University. He is a former film critic for the *New York Times, Village Voice*, and NPR, and a longtime contributor to *Film Comment* magazine. A graduate of the Curatorial Studies program at Bard College, he has curated numerous projects in New York, Istanbul, and Providence. His research examines contemporary digital cinema in relation to debates about the theory and practice of critique.

AKIRA MIZUTA LIPPIT teaches film and literature at the University of Southern California. He is the author of *Ex-Cinema: From a Theory of Experimental Film and Video* (2012), *Atomic Light (Shadow Optics)* (2005), *Electric Animal: Toward a Rhetoric of Wildlife* (2000), and, most recently, *Cinema without Reflection: Jacques Derrida's Echopoiesis and Narcissism Adrift* (2016).

JENNIFER MALKOWSKI is Assistant Professor of Film and Media Studies at Smith College. They are the author of *Dying in Full Detail: Mortality and Digital Documentary* (2017) and the co-editor of *Gaming Representation: Race, Gender, and Sexuality in Video Games* (2017). Their work has also been published in *Cinema Journal, Jump Cut, Film Quarterly*, the edited collection *Queers in American Popular Culture* (2010), and the forthcoming edited collection *A Tumblr Book: Platform and Cultures*.

W. J. T. MITCHELL is Gaylord Donnelley Distinguished Service Professor of English and Art History at the University of Chicago. He has been the editor of *Critical Inquiry* since 1978, and his latest book, *Image Science: Iconology, Media Aesthetics, and Visual Culture*, was published in 2015.

BRANDY MONK-PAYTON is Assistant Professor of Communication and Media Studies at Fordham University. She obtained her PhD in

Modern Culture and Media at Brown University. Her research focuses on the history and theory of African American media representation and cultural production. Her work on race in film, television, and digital media appears in various edited collections and the journals *Film Quarterly*, *Feminist Media Histories*, *The Black Scholar*, and *Reconstruction: Studies in Contemporary Culture*. Her first book project examines the aesthetics and politics of fame and considers the relationship between blackness and celebrity in the contemporary moment.

BILL NICHOLS is the author of the widely used *Introduction to Documentary* (2001/2017) and a dozen other books. He has served on film juries and consults with filmmakers. His two edited volumes, *Movies and Methods* (1976 and 1985), helped to establish film studies as an academic discipline.

JAN OLSSON is Professor of Cinema Studies at Stockholm University. His latest monographs are *Los Angeles before Hollywood: Journalism and American Film Culture, 1905 to 1915* (2008) and *Hitchcock à la Carte* (2015). His co-edited collection *Corporeality in Early Cinema: Viscera, Skin, and Physical Form* appeared in 2018. He is currently finishing a book on film archivism with an emphasis on Swedish films from the 1910s.

DANIELLE PEERS is a community organizer, artist, and Assistant Professor in the Faculty of Kinesiology, Sport, and Recreation at the University of Alberta. Danielle uses critical disability and poststructuralist theories to study disability movement cultures: from the Paralympics, to inclusive recreation, to disability arts. Their research builds on their experiences as a Paralympian, a filmmaker, and a dancer with CRIPSiE (Collaborative Radically Integrated Performers Society in Edmonton). Danielle is the Director of the Media in Motion Lab, which supports creative methods for producing and sharing knowledge about human bodies in motion.

RAÚL PÉREZ is Assistant Professor of Sociology at the University of Denver, where he teaches courses on racial and ethnic relations, racism and anti-racism, social problems, and comedy and society. His research centers on the intersections of race, racism, and humor and their connections to social inequality and social movements. His research has

been published in numerous academic journals and has received scholarly awards from the American Sociological Association. His works have also been featured in media outlets such as *Time*, the Grio, Zócalo Public Square, Latino Rebels, and Remezcla.

MAURO RESMINI is Assistant Professor of Film Studies and Italian at the University of Maryland, College Park. His essays on Italian and European cinema and critical theory have appeared in *American Imago*, *Camera Obscura*, *The Italianist*, and the edited collections *The Essay Film: Dialogue, Politics, Utopia* (2016), and *1968 and Global Cinema* (2018). He is currently working on a book manuscript on political cinema and radical thought in Italy from 1968 to 1989.

B. RUBY RICH is the author of *Chick Flicks: Theories and Memories of the Feminist Film Movement* (1998) and *New Queer Cinema: The Director's Cut* (2013). She is the editor of *Film Quarterly* and Professor at the University of California, Santa Cruz, where she teaches in the Film and Digital Media Department and the Social Documentation MFA Program. In 2017, she was honored with the series of screenings and panels "Being Ruby Rich" at the Barbican Centre and Birkbeck, University of London. She has received the Distinguished Lifetime Achievement Award from the Society for Cinema and Media Studies and the James Brudner Award from Yale University, as well as fellowships from the Mellon and Rockefeller foundations.

ELIF RONGEN-KAYNAKÇI is the Curator of Silent Film at EYE Filmmuseum. Since 1999, she has worked on the discovery, restoration, and presentation of many films that were presumed lost. These include *Beyond the Rocks* (1922), *The Floor Below* (1918), *Az utolsó hajnal* (1917), and many more. She is directly involved with the archival festivals Il Cinema Ritrovato, Le Giornate del Cinema Muto, and Istanbul Silent Cinema Days. She is also one of the curators who initiated "Views of the Ottoman Empire," a traveling archival presentation project that has been screening in various countries since the summer of 2014.

JONATHAN ROSENBAUM, principal film critic for the *Chicago Reader* from 1987 to 2008, now freelances as a writer and teacher and maintains a website archiving most of his work at jonathanrosenbaum.net. The most recent of his books are *Cinematic Encounters: Interviews and*

Dialogues (2018), *Abbas Kiarostami* (with Mehrnaz Saeed-Vafa, expanded 2nd ed. 2018), *Goodbye Cinema, Hello Cinephilia: Film Culture in Transition* (2010), *The Unquiet American: Transgressive Comedies from the U.S.* (2009), *Discovering Orson Welles* (2007), *Essential Cinema: On the Necessity of Film Canons* (2004), and, as co-editor, with Adrian Martin, *Movie Mutations: The Changing Face of World Cinephilia* (2003).

POULOMI SAHA is Assistant Professor of English at the University of California, Berkeley. Her research and teaching agenda spans eastward and forward from the late nineteenth-century decline of British colonial rule in the Indian Ocean through to the Pacific and the rise of American global power and domestic race relations in the twentieth century. She is interested in developing an expansive view of empire and of what constitutes Anglophone literature, routed not primarily through Great Britain and Western Europe but rather through circuits of affiliation and encounter between Asia and the Americas. She is currently completing her first monograph, *An Empire of Touch: Feminine Political Labor & the Fabrication of East Bengal, 1905–2015.*

REBECCA SCHNEIDER is Professor of Performance Studies and an affiliate of Modern Culture and Media at Brown University. She is the author of *The Explicit Body in Performance* (1997), *Performing Remains: Art and War in Times of Theatrical Reenactment* (2011), and *Theatre and History* (2014). She is the editor of a series of special issues of *TDR: A Journal of Performance Studies* and author of over fifty essays on late capitalism, performance-based art, theater, opera, dance, zombies, and other failed operations of obsolescence.

JEFFREY SCONCE is Associate Professor in the Screen Cultures Program at Northwestern University. He is the author of *Haunted Media: Electronic Presence from Telegraphy to Television* (2000) and *The Technical Delusion: Electronics, Power, Insanity* (2019). He is also the editor of *Sleaze Artists: Cinema at the Margins of Taste, Style, and Politics* (2007).

JARED SEXTON teaches African American Studies and Film and Media Studies at the University of California, Irvine. He is the author of *Amalgamation Schemes: Antiblackness and the Critique of Multiracialism*

(2008), *Black Masculinity and the Cinema of Policing* (2017), and, most recently, *Black Men, Black Feminism: Lucifer's Nocturne* (2018).

VIVIAN SOBCHACK is Professor Emerita in the University of California, Los Angeles Department of Film, Television and Digital Media. Her books include *Screening Space: The American Science Fiction Film* (1987), *The Address of the Eye: A Phenomenology of Film Experience* (1992), *Carnal Thoughts: Embodiment and Moving Image Culture* (2004), and two edited volumes, *The Persistence of History: Cinema, Television, and the Modern Event* (1996) and *Meta-Morphing: Visual Transformation in the Culture of Quick Change* (2000). Her essays have appeared in *Screen, Camera Obscura, Quarterly Review of Film and Video, Film Quarterly, Film Comment, Art Forum International,* and *Body and Society.* In 2012, she received the Society for Cinema and Media Studies Distinguished Career Achievement Award for the impact her wide-ranging scholarly work has had on the field.

PHILIPP STIASNY is a freelance film historian in Berlin and editor of the journal *Filmblatt.* He works at the Film Museum Potsdam and teaches at the Film University Babelsberg "Konrad Wolf." Together with Bennet Togler, he curated "The Nightshift" at Kino Babylon.

MEGHAN SUTHERLAND is Associate Professor of Cinema and Visual Studies at the University of Toronto and a founding co-editor of the online journal *World Picture.* She is also the author of *The Flip Wilson Show* (2008), a forthcoming book called *Variety: The Extra Aesthetic and the Constitution of Modern Media,* and a range of essays on the intersections between media, philosophy, and politics.

BENNET TOGLER lives in Berlin. He speaks about cinematic topics on occasion. Together with Philipp Stiasny, he curated "The Nightshift" at Kino Babylon.

LESHU TORCHIN is Senior Lecturer in Film Studies at the University of St Andrews. Her interest in film, human rights abuses, and video activism has led to a range of publications, including her monograph *Creating the Witness: Documenting Genocide on Film, Video, and the Internet* (2012) and the edited volume *Film Festivals and Activism* (2012, with Dina Iordanova). She has also written on film and human traffick-

ing, and is currently working on the representation of economic rights in documentary.

ALOK VAID-MENON is a gender-nonconforming writer and performance artist. Learn more at www.alokvmenon.com.

CHRISTOPHE WALL-ROMANA is Associate Professor in the Department of French and Italian at the University of Minnesota, and a member of the graduate faculty in the Moving Image Studies program. His books are *Cinepoetry: Imaginary Cinemas in French Poetry* (2012) and *Jean Epstein: Corporeal Cinema and Film Philosophy* (2013). His articles and essays have appeared in over twenty journals in French and English including *Lettre International*, *PMLA*, *Diacritics*, the *French Review*, and *SubStance*. He has translated books by Judy Blume, Philip K. Dick, Norbert Wiener, and William Merwin into French, and by Jean Epstein, Gilbert Simondon, and Stéphane Mallarmé into English. His forthcoming book is titled *Cosmopolitics Black and White: Astronomy, Race, and the Emergence of Photosentitive Modernity*.

MEIR WIGODER teaches at the School of Communication at Sapir College, Sderot, and taught for more than twenty years at the David and Yolanda Katz Faculty of the Arts at Tel Aviv University. A photographic theorist and practicing photographer, he writes mainly on the representation of the Israeli-Palestinian conflict in photography, film, and the media. His writings have appeared in *Critical Inquiry*, *Public Culture*, *Third Text*, *Parallax*, *Journal of Architectural Historians*, *History of Photography*, *Psychoanalytic Review*, *History and Memory*, and *Journalism: Theory, Practice and Criticism*.

EMILY REGAN WILLS is Assistant Professor of Comparative and American Politics at the University of Ottawa. She co-directs the Community Mobilization in Crisis project, documenting and supporting community organizing and mobilization in the Arab world. Her work focuses on transnational linkages and connections between the Arab world, its diasporas, and North America, as well as everyday politics, social movements, and transnationalism more broadly. She dabbles in media and fan studies, particularly analyzing how politics are read, enacted, and reinscribed in media and fannish contexts.

FEDERICO WINDHAUSEN is a film scholar and curator based in Buenos Aires. He has taught at California College of the Arts, Stanford University, University of California, Berkeley, and Sarah Lawrence College. For the Theme section of the 2016 International Short Film Festival Oberhausen, he curated an eight-program survey of contemporary Latin American shorts, which subsequently traveled throughout the United States, in venues such as the National Gallery of Art, and Mexico, via the festival Ambulante. He is editing the forthcoming anthology *A Companion to Experimental Cinema* and writing a book about Argentine experimental cinema.

STANLEY WOLUKAU-WANAMBWA is a photographer and writer who has contributed essays to publications by Vanessa Winship, George Georgiou, Rosalind Fox Solomon, Marton Perlaki, and Paul Graham, been an artist-in-residence at Light Work, guest edited the *Aperture Photobook Review*, and written for *Aperture*, *FOAM*, the Barbican, The Photographer's Gallery, and Rutgers University Press. His debut monograph, *One Wall a Web*, was published by ROMA Publications in 2018. He has lectured at Yale, Cornell, New York University, and the New School.

GENEVIEVE YUE is Assistant Professor of Culture and Media at Eugene Lang College, the New School. She is co-editor of *Discourse: Journal for Theoretical Studies in Media and Culture*, and her essays and criticism have appeared in *October*, *Grey Room*, the *Times Literary Supplement*, *Reverse Shot*, *Artforum.com*, *Film Comment*, and *Film Quarterly*. She is currently at work on *China Girls: Film, Feminism, and the Material Image*, a book on gender and materiality.

ALENKA ZUPANČIČ is a Research Advisor at the Institute of Philosophy of the Slovenian Academy of Sciences and Arts and Professor at the European Graduate School, Switzerland. Notable for her work on the intersection of philosophy and psychoanalysis, she is the author of numerous articles and books, including *The Shortest Shadow: Nietzsche's Philosophy of the Two* (2003), *Why Psychoanalysis: Three Interventions* (2008), *The Odd One In: On Comedy* (2008), *Ethics of the Real: Kant and Lacan* (2012), and *What Is Sex?* (2017).

INDEX

Page numbers in italic font refer to figures.